The Patrick Moore Practical

Series Editor
John Watson

More information about this series at http://www.springer.com/series/3192

Astrophotography on the Go

Using Short Exposures with Light Mounts

Joseph Ashley

Springer

Joseph Ashley
Marathon, Greece

ISSN 1431-9756 ISSN 2197-6562 (electronic)
ISBN 978-3-319-09830-2 ISBN 978-3-319-09831-9 (eBook)
DOI 10.1007/978-3-319-09831-9
Springer Cham Heidelberg New York Dordrecht London

Library of Congress Control Number: 2014947868

© Springer International Publishing Switzerland 2015
This work is subject to copyright. All rights are reserved by the Publisher, whether the whole or part of the material is concerned, specifically the rights of translation, reprinting, reuse of illustrations, recitation, broadcasting, reproduction on microfilms or in any other physical way, and transmission or information storage and retrieval, electronic adaptation, computer software, or by similar or dissimilar methodology now known or hereafter developed. Exempted from this legal reservation are brief excerpts in connection with reviews or scholarly analysis or material supplied specifically for the purpose of being entered and executed on a computer system, for exclusive use by the purchaser of the work. Duplication of this publication or parts thereof is permitted only under the provisions of the Copyright Law of the Publisher's location, in its current version, and permission for use must always be obtained from Springer. Permissions for use may be obtained through RightsLink at the Copyright Clearance Center. Violations are liable to prosecution under the respective Copyright Law.
The use of general descriptive names, registered names, trademarks, service marks, etc. in this publication does not imply, even in the absence of a specific statement, that such names are exempt from the relevant protective laws and regulations and therefore free for general use.
While the advice and information in this book are believed to be true and accurate at the date of publication, neither the authors nor the editors nor the publisher can accept any legal responsibility for any errors or omissions that may be made. The publisher makes no warranty, express or implied, with respect to the material contained herein.

Springer is part of Springer Science+Business Media (www.springer.com)

Contents

1 Introduction to Astrophotography on the Go .. 1
 1.1 Introduction ... 1
 1.2 Technology Considerations .. 2
 1.3 Why Lightweight Mount Astrophotography? 4
 1.4 Why Is "Astrophotography on the Go" Important? 5

2 A Short Review of Astronomy Basics Related to Astrophotography ... 9
 2.1 Introduction ... 9
 2.2 Celestial Coordinates ... 10
 2.3 Distances in Space ... 12
 2.4 Constellations ... 13
 2.5 Telescopes .. 14
 2.6 Telescope Characteristics .. 18
 2.7 Telescope Mounts .. 20
 2.8 Manmade Objects in the Sky ... 22
 2.9 Solar System Objects ... 22
 2.10 Deep Space Objects ... 24
 2.11 Messier Objects and the New General Catalog 29
 2.12 Magnitude of Objects in the Night Sky 29
 2.13 Skyglow ... 30

3 Astrophotography Basics .. 33
 3.1 Introduction ... 33
 3.2 Some Accessories and Terms Related to Astrophotography 35
 3.3 Digital Camera Basics ... 39

	3.4	Digital Cameras Used for Astrophotography	40
	3.5	How Cameras Are Attached to Telescopes	44
	3.6	Mounts	48
	3.7	Field Rotation	50
	3.8	Telescopes and Exposure Time	54
	3.9	Noise Reduction	56
	3.10	Signal to Noise Considerations	61
	3.11	Histograms	63
	3.12	Image Size and Field of View	64
	3.13	Focusing a Digital Single Lens Reflex Camera on a Telescope	67
	3.14	Planning to Insure a Successful Imaging Session	69
	3.15	Light Pollution	70
4	**Very Short Exposure Astrophotography**	73	
	4.1	Introduction	73
	4.2	Telescope Characteristics for Very Short Exposures	74
	4.3	Mount and Tripod Issues with Very Short Exposure Astrophotography	77
	4.4	DSLR Camera Considerations	78
	4.5	Total Integrated Exposure Time	81
	4.6	Very Short Exposure Astrophotography Techniques	83
5	**Alt-Azimuth Mount Astrophotography**	89	
	5.1	Introduction	89
	5.2	Equipment	90
	5.3	Equipment Issues	92
	5.4	Field Rotation Mitigation	94
	5.5	Planning Your Photographic Session	98
	5.6	Setting Up	101
	5.7	Measuring the Maximum Exposure Time for a Mount	102
	5.8	Imaging with an Alt-Azimuth Mount	104
6	**Astrophotography with Lightweight, Portable, Equatorial Mounts**	107	
	6.1	Introduction	107
	6.2	Lightweight Equatorial Mount Characteristics	108
	6.3	Precise Polar Alignment	111
	6.4	Planning Your Photographic Session	115
7	**Piggyback Astrophotography and NightScapes**	121	
	7.1	Introduction	121
	7.2	Cameras and Lenses	123
	7.3	Piggy Back Astrophotography; Telescopes and Mounts	125
	7.4	Deep Space Photography with a Piggyback Camera	127
	7.5	Nightscape Photography	130

Contents vii

 7.6 Capturing a Nightscape ... 132
 7.7 Star Trail Photography .. 133

8 Astrophotography in Light Polluted Areas 137
 8.1 Introduction .. 137
 8.2 Light Pollution Is Not a Friend ... 139
 8.3 How to Combat Stray Light? ... 139
 8.4 Artificial Skyglow ... 141
 8.5 Why the Concern About Skyglow? .. 142
 8.6 How Are Photographs Made of Objects That Have a Surface Brightness That Is Less Than the Brightness of Skyglow? 143
 8.7 Light Pollution Reduction Filters ... 147
 8.8 How Does This All Impact "Astrophotography on the Go?" 149

9 Computers and Computer Programs .. 151
 9.1 Introduction .. 151
 9.2 Research, Identifying Objects to Photograph 152
 9.3 Planning and Planetary Programs .. 154
 9.4 DSLR Camera Control .. 157
 9.5 Image Processing Programs .. 158
 9.6 Which Programs Should You Use? ... 161

10 Mastering DeepSky Stacker ... 163
 10.1 DeepSky Stacker Overview ... 163
 10.2 Getting Started .. 163
 10.3 Stacking Parameters Box .. 166
 10.4 Results Tab ... 167
 10.5 Comet Tab .. 169
 10.6 Light Tab .. 170
 10.7 Dark, Flat, and Bias/Offset Tabs ... 173
 10.8 Alignment Tab .. 174
 10.9 Intermediate Files Tab .. 175
 10.10 Cosmetic Tab .. 176
 10.11 Output Tab .. 176
 10.12 Raw Digital Development Process 177
 10.13 Loading Files into DeepSky Stacker 179
 10.14 Running Deep Sky Stacker ... 180

11 Processing Very Short Exposures ... 191
 11.1 Introduction .. 191
 11.2 Stretching Very Short Exposure Images Using a Curve Stretch .. 193
 11.3 Stretching Very Short Exposure Images Using a Levels Stretch .. 198
 11.4 Image Enhancement ... 200

11.5	Processing Very Short Exposures Using 8 Bit Photo Processing Programs	202
11.6	Processing Very Short Exposures Using PhotoShop Elements	207
11.7	Alternatives to Photo Processing Programs	208
11.8	Which to Use; Photo Processing or Astronomical Processing?	211

12 Lightweight Azimuth and Equatorial Mounts 213
12.1 Introduction 213
12.2 Significant Attributes of Lightweight Mounts and Tripods Related to Astrophotography 214
12.3 Celestron Mounts 217
12.4 iOptron Mounts 219
12.5 SkyWatcher Mounts 221
12.6 Meade Mounts 222
12.7 Traditional German Equatorial Mount 224
12.8 Mount Selection 225
12.9 Lightweight Alt-Azimuth and Equatorial Mounts and Telescope OTA Characteristics 229
12.10 Lightweight Mount and OTA Bundles 231
12.11 Economics of Using Lightweight Mounts and Tripods 234

13 Portable Observatories 239
13.1 Introduction 239
13.2 Three Portable Observatories 241
13.3 Downtown City Apartment or Urban Condo Dweller 246
13.4 Vacation in the Family Car 248
13.5 Commercial Air 248
13.6 Air Transportable Power Supplies 259

14 Eye Candy in the Night Sky to Photograph 263
14.1 Introduction 263
14.2 Summer; June, July, and August 265
14.3 Autumn; September, October, and November 270
14.4 Winter; December, January, and February 275
14.5 Spring; March, April, and May 280

Appendix A: Planning an Astrophotography Imaging Session 287

Appendix B: Lightweight Mount Tripod Modifications 293

Appendix C: Using a 4 SE Mount with a Wedge in the Equatorial Mode 303

Index 315

About the Author

My first view in a telescope was breathtaking, the Orion Nebula in December 1965, seen through the university's brand new Schmidt Cassegrain Telescope then only a few days old. Fast forward 20 years covering a career of engineering physics dealing mostly with energy conservation and it was time for Halley's Comet; time to get that first telescope. Which telescope to buy? Thumbing through the adverts in Sky and Telescope and there it was. Meade was advertising a "portable observatory," its 2045LX3, a 102 mm Schmidt Cassegrain Telescope complete with two eyepieces, a tabletop tripod, and an aluminum carrying case.

Fast forward another 20 years and now I am retired but still using my 2045LX3 to view the night sky. While surfing the net in 2008 I found a new Meade DS2090AT for $150 on eBay. Two weeks later it arrived and first light with no clouds in sight. The 90 mm goto refractor clicked and whirred and WOW! I was thoroughly hooked, an instant goto junkie and soon had a two more goto mounts: an iOptron GOTO conversion kit for my Celestron C6S's manually operated CG5 mount and a SkyWatcher SynScan AZ goto mount for my Meade 2045 SCT.

Then it happened. My granddaughter asked "Papou, can you make a picture of that?" Soon I was hooked. While I had a traditional astrophotography setup with my C6S, it was not convenient to use. On a whelm I put my DSLR at prime focus on my Meade 2045 I had on my SkyWatcher SynScan AZ goto mount and started photographing the night sky. The convenience of a grab and go astrophotography kit was simply wonderful. I soon learned to use very short exposures of 15–30 s and was thrilled at some of the images I made. I later added a 4 SE mount and entered into the world of unguided short exposures of a minute or so.

My efforts with very short exposure astrophotography with lightweight mounts span a 4-year period with the typical interruptions due to extended periods of cloudy weather, family considerations, and other personal commitments. This book

is an effort to document what I learned regarding the processes needed to photograph the night sky within the artificial sky glow from a city of three million people using lightweight and portable equipment. I do hope that it helps someone.

Deep space imaging is becoming increasingly challenging for astronomers living in or near urban areas with light polluted skies. However, dedicated amateurs still venture out at night in pursuit of the marvels of the universe. This book is dedicated to them. Hopefully the photographic techniques presented in this book using lightweight mounts and tripods can make their task less burdensome and encourage others to get out at night and observe and photograph the night sky.

In closing, I hang out on the Astronomy Forum, known as member "Sxinias." If you have any questions, please feel free to drop me a personal message.

(http://www.astronomyforum.net)

Chapter 1

Introduction to Astrophotography on the Go

1.1 Introduction

Do you live in a city and think you can't do astronomy, much less astrophotography, with your light polluted gray night sky or do you believe astronomy is impossible because you have no way to transport, store, or use a large telescope at your home? Perhaps you simply prefer small and lightweight telescopes or maybe physical constraints prevent you from using heavy traditional astrophotography gear. Have you ever wished your astrophotography kit could fly with you on a vacation and arrive in one piece at your destination? Maybe you simply want to take snapshots of what you see in your telescope to share with family and friends. If any of these scenarios fit or if you are simply just curious; welcome to the world of very short exposure astrophotography with light weight mounts; welcome to the world of Astrophotography on the Go.

Astrophotography on the Go is lean and mean. Its purpose is not to replace the traditional heavy German equatorial mount but to take astrophotography to places where heavy, bulky telescopes cannot go or are not welcomed. Its ultimate objective is to bring astronomy and astrophotography to the millions of people on this planet living in urban settings who have never seen the wonders of our universe.

Whether you are a beginner to astronomy or an experienced observer just now starting down the road to photograph the Milky Way, "Astrophotography on the Go," is appropriate for you. The photographic processes described are applicable for all alt-azimuth and equatorial goto mounts, however, the emphasis is on compact, lightweight, portable mounts and tripods weighing less than 16.5 lb (7.5 kg). Extraneous equipment, like a computer, is not welcome and must remain at home.

One philosophy describes the tone of this book: "If you can't carry your entire kit including your observing chair in one trip from its storage spot at your home to your observation site and back, it may be movable but it is not lightweight or portable."

1.2 Technology Considerations

Until recent times, amateur astrophotography was the exclusive providence of a very few dedicated astronomers with the fortitude and patience to sit hours on end staring at a guide star while imaging some distant deep space object. Then the digital revolution hit astronomy and changed everything; first with affordable computerized telescope mounts and more recently with the digital single lens reflex camera. Today, images that were only dreams of yesterday are routinely made by amateurs around the world using moderately priced equipment. Some even use entry level telescopes and mounts and make images that easily rival or surpass the best of the film days and often compete with images made with advanced level methods and equipment.

Today we live in a world of continuous technology advances. Early in the twenty-first century, digital imaging technology advanced to the point where digital single lens reflex (DSLR) cameras were available at affordable prices to the general public. Not only were digital cameras affordable, they had sufficient resolution and sensitivity to photograph faint objects located in deep space.

The development of the affordable digital camera was a paradigm shift for amateur astronomers. With digital technology, photographers could digitally combine several exposures into one image that was in many respects the equivalent of one longer exposure. This capability had a dramatic impact upon astrophotography. A photograph requiring hours and a very dark sky to capture with one exposure using a film camera could be duplicated by combining several shorter digital exposures. A passing jet plane or satellite no longer meant disaster that ruined a night's worth of work. Amateur astronomers worldwide readily embraced the digital camera and in a very short time were producing digital photographs that rivaled images produced by major professional observatories.

Parallel with the development of digital imaging technology was another digital revolution; computerized telescope mount technology that could automatically point a telescope at any selected object in the sky. These mounts were introduced to amateur astronomy in the early 1990s and became known as "GOTO" mounts or "GOTO" telescopes. The accuracy and tracking capabilities of these GOTO mounts rapidly improved and their prices dropped. Initially GOTO technology was limited to the premium telescope lines but during the first decade of the twenty-first century, the technology spread across the spectrum of amateur telescopes from beginner telescopes to those used by the most advanced amateur.

1.2 Technology Considerations

GOTO telescopes and digital cameras are a natural for astrophotography. Being digital devices both can connect to a personal computer. This allows computers to perform many of the chores associated with astrophotography that were previously done by hand. No longer is the astronomer glued to a chair for hours meticulously guiding a telescope keeping a star centered in a reticle eyepiece. Computers and automatic guiding routines do that task. These attributes and others married the telescope to personal computers.

Initially, photo-processing programs were used to digitally combine several short exposure images into an image equivalent to a longer exposure. This was done by meticulously aligning and combining each exposure one by one; a time consuming process called stacking. As digital astrophotography became more popular, several computer programs, commercial and freeware, became available that automated this stacking process. The development of digital stacking programs created another revolution for astrophotography. Now, instead of a few images literally hundreds of exposures could easily be digitally combined.

At the same time, amateurs realized that the tracking abilities of modern equatorial GOTO mounts that were precisely polar aligned were sufficient to obtain exposures of several minutes duration without needing guidance. This development combined with digital stacking programs gave birth to unguided astrophotography which is very popular today. This is especially true for people just starting astrophotography or who live in areas impacted by light pollution where long exposures are not possible.

However, two attributes of this digital revolution for astronomy are not fully appreciated by the astrophotography community at this time. These are:

- The sensitivity and internal noise characteristics of modern digital cameras are sufficient to capture images of a large number of deep space objects using very short exposures of 30 s or less and to do so with an usable signal to noise ratio even with relatively slow telescopes.
- No longer is a mount and supporting tripod or pier required that is vibration and movement free for long periods of time. All that is needed is a mount that can consistently provide short periods of stability while it tracks an object. This requirement is within the capabilities of many relatively inexpensive, lightweight GOTO azimuth and equatorial mounts used today with entry level telescopes.

These three developments—affordable digital single lens reflex cameras, computer stacking software, and computerized GOTO mounts—set the stage for a third category of astrophotography; very short exposure astrophotography using inexpensive, compact, lightweight GOTO mounts. Very little information, printed in books or cyberspace, is available regarding the techniques needed for very short exposure astrophotography using lightweight mounts. "Astrophotography on the Go" consolidates current knowledge related to astrophotography using very short exposures and lightweight GOTO mounts and is based upon personal experiences over a period of several years.

1.3 Why Lightweight Mount Astrophotography?

Lightweight alt-azimuth and equatorial mounts are capable of providing a platform suitable for making excellent images of a wide selection of deep space objects. However, most do not have the capability and versatility for astrophotography provided by a traditional heavy German equatorial mount. If this is the case, "why use a lightweight alt-azimuth mount for astrophotography?" This is a valid question and one that should be resolved before deciding to abandon the traditional approach to astrophotography.

Many scenarios exist where the portability aspects of a lightweight alt-azimuth or equatorial mount negates the advantages of a traditional heavy equatorial mount. In today's urban world a lightweight mount and tripod frequently is the difference between someone being able to pursue the hobby of astronomy or not. To put it in other words, there are many situations where a lightweight mount and tripod are preferable to a traditional, heavy German equatorial mount. Here are a few:

- Lightweight goto alt-azimuth mounts, and lightweight goto equatorial mounts are ideal for urban areas where the traditional heavy equatorial mount often is not practical. In today's world most people live in urban areas with light polluted skies and have limited time available to travel to a dark spot remote from their homes or apartments. Storage space at home is often very minimal. Even in this extreme, astronomy as well as astrophotography is feasile. A lightweight, astrophotography kit is easy to store, transport, setup, and use. Some kits can even be transported on public transportation such as a city bus or subway making them handy to take to a local park. Computerized mounts make possible locating objects even in the light gray polluted urban skies. In this situation, a lightweight astronomy or astrophotography kit is the difference between pursuing the hobby of astronomy or not.
- Lightweight mounts are ideal for people who want an astrophotography travel kit to take on business trips or on vacations. A lightweight mount, small telescope, digital single lens reflex camera, and accessories can easily fit into a small case to minimize space in the family car or to take aboard commercial airliners as carry-on luggage.
- People who already own a suitable telescope on a lightweight GOTO mount can try astrophotography to see if it is something they want to do without buying an expensive mount that they may not use later. All they need to get started is a digital single lens reflex camera, adapters, interval timer, and possibly a focal reducer. For them, using their existing lightweight mount is an inexpensive entry into astrophotography. This is especially true if they also own a digital single lens reflex camera.
- Unguided, very-short exposure astrophotography using an alt-azimuth GOTO mount is ideal for the "casual astrophotographer;" a person who primarily wants to visually observe the night sky and occasionally photograph what they see in their telescopes. For them the ease of use of an alt-azimuth GOTO telescope for visual work whether it be a heavy 10 in. Meade LX200 or a portable Celestron

6 SE is more important than the additional photographic capability provided by a wedge or a complex German equatorial mount that is seldom used.
- Lightweight telescopes and mounts provide a way for amateur astronomers who physically are not able to manhandle large heavy telescopes to enjoy or photograph the night sky.
- Many astronomers simply prefer small aperture telescopes and lightweight mounts even with the challenges and limitations associated with using this equipment. I must confess that I belong to this group.
- Last but not least is economics; a short tube refractor on a lightweight, portable, alt-azimuth GOTO mount is the lowest cost entry into the world of astrophotography for people on a severe budget. However, as shown in Chap. 12, the magnitude of the savings is not as significant many people may think.

1.4 Why Is "Astrophotography on the Go" Important?

Based upon statistics from the World Health Organization approximately 80 % of people living in developed countries such as the United States and the United Kingdom live in urban settings with its high density housing and light pollution (http://www.who.int/gho/urban_health/en/). The traditional dark back yard is only a dream for countless millions of people.

In today's urban society, hobbies like astronomy and astrophotography are typically pushed aside as too hard or impossible to do. After all only a hand full of stars, a few planets and the moon are visible in the gray night sky. However, the popularity of many television series about astronomy, space, and the universe shows that an interest in astronomy dwells in many an urbanite's soul. Unfortunately, at best, they become arm chair astronomers, watching TV or reading magazines and books like this one. The fact that they too can get out at night and view or photograph the universe is a well kept secret. Hopefully Astrophotography on the Go will inspire many urbanites to leave the armchair and go to the parks with their lightweight portable astronomy or astrophotography kits and behold the wonders of the universe.

Given the statistics of who reads astronomy books, most likely you dwell in a city and there is a very good likelihood that you live in an apartment, condo, or other high density type housing. There is no back yard or if there is, security and street lights turn night into day. Quite frequently "the rules" prohibit the use of common areas. However, in spite of these constraints, you can get out at night to view or photograph the night sky and do it in a meaningful way.

Let's assume the worst case that you live in a high rise apartment complex in the middle of one of today's mega cities. Yes, the view from your 20th floor apartment is breathtaking. Well read issues of astronomy magazines are neatly but conveniently placed next a comfortable recliner chair. Since taking that prized, career-enhancing job, you are now an armchair astronomer; no longer free to photograph the night sky with your trusty telescope you sold before moving to the city. Your apartment is spacious as apartments go but space is not in excess. No suitable viewing spots exist anywhere nearby.

True you can take a telescope, load up your car, and drive outside the city to a dark spot but the drive dependent upon traffic is well in excess of an hour or two each way. By the time you load the car parked in the basement garage, drive outside the city, set up and polar align your telescope; it will be time to pack up and return home. Also, you really want to use your coat closet for coats, not as a storage area for a large German equatorial mount and heavy tripod.

As you sit one evening, jealously surfing the astronomy forums, you do a search of astronomy clubs in your city and find several. You check websites and find one that has monthly gatherings in a park not too far away; a park appropriately called "Dark Spot City Park." The night of their next meeting, you drive to the park and to your dismay discover there is no parking for cars anywhere nearby. You are almost ready to call it quits when you spot an "all night parking lot" with its extraordinary parking fees only five long city blocks away. You park your car, pay the extortion in advance to the parking lot attendant, and after a quick trip on the subway you arrive at "Dark Spot City Park."

As you look around the park you notice a dozen or so telescopes set up and people milling about. You walk over and introduce yourself. The club members are friendly and you are warmly welcomed. As you chat, you learn that some members that live nearby walk to the site with their telescopes in carts. Others have people drive them and drop them off with their telescopes and return later to pick them up. Several members use the subway carrying their telescope in suitcases with roller wheels looking like lost tourist in the process. One club member has an ETX 80 and rides his bicycle to the park with his scope in a backpack. All are enjoying being out at night under the stars even if few stars are to be seen by the unaided eye in the city's light polluted sky.

All of the telescopes are portable and nearly all are on lightweight, alt-azimuth goto mounts. There are a couple of the ever popular 8 in. DOBs but smaller telescopes are the most numerous. The biggest telescope is the club's 10 in. DOB that is stored in a park's maintenance shed when the club is not using it.

You are pleasantly surprised at what you can actually see in their telescopes in spite of the light polluted sky and quickly realize that the members are serious astronomers. As one member put it, you take the deck of cards nature has to offer and do what you can with it. One thing that you notice is that no one is photographing the night sky. You ask why and the answer is uniform. "Equatorial mounts are too heavy to bring to the park and everybody knows you can't do astrophotography with an alt-azimuth mount."

Back home in your apartment your wheels are churning. You ask yourself the question, "Why can't I photograph in Dark Spot City Park?" You know there is far too much light pollution for long exposure work; however, how about short exposures? You sit back, relax, and start thinking. Here your armchair astronomy experience reading magazines and surfing the net pays off. One of the European members on a forum you visit frequently uses a SkyWatcher SynScan AZ GOTO mount with a short tube refractor to photograph in his light polluted city sky. His images of the brighter deep space objects are remarkable even though he is limited to very short exposures of 20–30 s. You send him a personal message asking about his experiences and he promptly tells you his story.

1.4 Why Is "Astrophotography on the Go" Important?

The Orion ST 80 refractor used by the European member is fast at f/5 which is highly desirable when using 20–30 s exposures. You know from seeing photographs done by the European member that the ST-80 will have some chromatic aberration and distortion of stars. But, the ST-80 is not expensive, frequently available from the manufacturer for around $160 bundled with some excellent eyepieces, finder scope, tube rings, and dovetail. Most of the distorted stars can be handled by cropping and chromatic aberration often reduced by processing.

The SkyWatcher mount used by the European member is not available in the USA but the Celestron SLT mount is available and is almost identical. You mentally mark the SLT mount as one possible mount to use. Another mount that interests you is a small, lightweight, German equatorial mount, the iOptron SmartEQ PRO. You know from your reading astronomy forum postings that this mount is capable of guided exposures of 30 min and longer. You tag it as another candidate to consider. Two other mounts also catch your eye, the Celestron 4/5SE mount and the iOptron Cube A mount. Both have built-in wedges but neither have a way to do a proper azimuth alignment required for a precise polar alignment.

As you think, you realize a major problem is how do you get your kit to the park and back again from your apartment on the 20th floor. You have to do it in one trip. The guy with the ETX 80 carried all his stuff on a bicycle. You rule out using a back pack and a bicycle; far too physical for your taste and peddling a bicycle in the middle of the night is not the safest thing to do. However, the local subway station is across the street from your apartment and another station is located at "Dark Spot City Park" with two train changes in between. Surely you can carry something useful for photography with you on the subway to the park. You recall that one of the club members was carrying an 8 SE on the subway using suitcase with wheels and with the tripod attached to the case's exterior. Ha, you think, "that red, wheeled, carry-on bag I have stored under the bed will be just perfect."

After a little thought and research on mount sizes and weights, you are favoring the SmartEQ PRO basically because of its higher precision gearing and advanced features. Unlike the SLT, the 4/5 SE, and the Cube A mounts, the SmartEQ PRO also has the capability for long exposure guided work should you ever decide to drive to a dark spot outside the city. All the mounts are similar regarding the space they require for transport and the weight difference between them is not significant. The price variation between them is slightly more than $200 with the iOptron SmartEQ PRO at $500 being the most expensive.

On a whim, you log onto the local "Craig's list." There you see a used Celestron 127 SLT on sale for only $150. This, as we say, is a no brainer as you probably can always sell the telescope later for the same or perhaps even more money. A telephone call and 3 h later you return home with your, new to you, used telescope. You know the 127 mm Maksutov Cassegrain Telescope at f/11.8 is slow for alt-azimuth mount photography. A focal reducer will increase the speed of the telescope to about f/7.4 which is adequate; however, it will cost just about as much as a f/5 short tube 80 mm achromat refractor. Since you can afford it, you decide to buy an Orion ST-80A due to its small size and weight even though it will have some chromatic aberration. It will attach to the SLT mount with no

modifications needed. You think about selling the 127 mm MAK OTA but decide to keep it as a viewing telescope for times when you are not in the mood for photography.

The camera is no problem. You already have a Canon EOS Rebel T3/1100D that you know is an excellent budget DSLR camera for astrophotography. Your android tablet has "DSLR Control," an app that controls late model Canon DSLRs. Getting down on hands and knees to see in a camera's view screen is not something you find pleasant to do. You decide to use your tablet to focus your camera, compose your images, and, if the battery can last long enough, to control your photographic session. If the battery runs out, you can always revert to using an inexpensive interval timer. You are also very skilled with PhotoShop and have a copy of the program on your computer.

You log onto the internet. A couple hours later all the components and accessories you need are on order including a collapsible camping stool to use as an observing chair. Locally you pick up some Velcro and bungee cords to make fasteners to attach the tripod and camping stool to the exterior of the carry-on bag with rollers you plan to use to transport your kit.

By the time of the local astronomy club's next meeting you are ready. You pack up your "Astrophotography to Go" portable observatory and catch the subway for "Dark Spot City Park." Your target for the night is M 45, the Pleiades. Your arrival at the park stirs up the members who are very pleased that you returned and they all congratulate you on your new rig. A few eyebrows are raised when you attach your camera to the little short tube 80 mm refractor and start clicking away. However, in the months to come, you and the club's members are astonished at the images you are capturing in the city's light polluted sky using your portable astrophotography kit.

Does all this sound farfetched? It is not. Ask the Baker Street Irregular Astronomers who meet monthly in Regents Park located in downtown London (http://www.bakerstreetastro.org.uk/). Better still, take a look at the images in the last chapter of this book; all taken in the artificial skyglow of a city with three million inhabitants. True, your city is not like London and there probably is no equivalent to the Baker Street Irregular Astronomers as they are rather unique. However, this does not keep you and maybe a buddy from finding a convenient viewing location and getting out at night under the stars. Who knows, perhaps one day you can organize your own version of the Baker Street Irregular Astronomers.

Chapter 2

A Short Review of Astronomy Basics Related to Astrophotography

2.1 Introduction

The conventional wisdom is that a person should have some knowledge of astronomy before attempting to photograph objects in deep space. After all, if you do not know what is out there and how to find it, how can you photograph it? Today this paradigm is under challenge. Computerized GOTO telescopes give the night skies to just about anyone. No longer is knowledge of the night sky a requirement for finding objects in the sky or is any knowledge of the sky required to setup and use some goto telescopes; all that is needed is to simply power up the mount and the computer takes over from there.

This advancement in technology is controversial and the subject of many a debate. One traditional school of thought is that newcomers should learn how to find objects in the sky unassisted by modern technology then progress onwards. Others retort "why?" Observing the sky is what is important, not the mechanics of finding dim illusive objects; besides for most of the population of developed countries, light pollution flunks the traditional approach. Some astronomers find the "hunt" for objects in deep space as rewarding or more rewarding than the actual viewing of them. Others find the hunt as exciting as watching a molasses flood in Boston during the winter. There is no need to debate the issue here but this chapter is included as an abbreviated primer for newcomers to astronomy who are following a parallel path of learning astronomy and astrophotography at the same time. Others may want to skip ahead to Chap. 3.

2.2 Celestial Coordinates

Go out one cloudless night and look up at the sky. What do you see other than the moon if it's out? The answer you say is simple; stars. If you are fortunate to live away from urban areas your answer may be slightly different; stars and the Milky Way. If you are in the middle of a large urban area, again, your answer may be different; a few stars.

Look some more. If you are not in the middle of a city, the night sky appears like a large dome with some stars high in the sky, others on the horizon close to the ground, and many more in between. While technically not the case, a dome in the sky is what our eyes see and our brain tells us. Now, from your vantage point, imagine that this dome is part of a sphere containing all the stars that are seen from our home, the earth, and the earth is inside this sphere at its center. Next, so we don't need to describe this sphere again, let's give it a name and call it the "celestial sphere" (see Fig. 2.1).

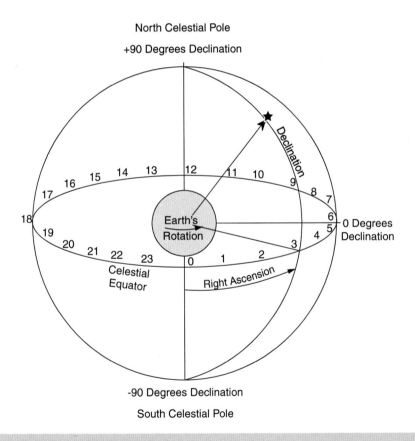

Fig. 2.1 The Celestial sphere

2.2 Celestial Coordinates

Like the earth, the celestial sphere has a north and a south pole. From our vantage point we can easily imagine we are standing still and the celestial sphere with all the stars is rotating above us. Go out just after sunset and find a bright star that you can easily recognize. A couple of hours later look again at your star. Most likely it has moved toward the west or, if it was close to the western horizon, it may no longer be visible at all. If the star you selected moved toward the east then you picked a circumpolar star that remains visible in the sky all night long. Actually the night sky did not move at all but the earth simply rotated on its axis. However, to an observer, it appears that the night sky moves in the heavens.

Now extend the North and South Poles of the earth until they intercept our celestial sphere. This marks the location of the celestial North Pole and the celestial South Pole. If we extend the earth's equator until it meets the celestial sphere, we now have the celestial equator.

Here on earth, we have arbitrarily sliced the earth into 180 slices with each slice being parallel to the equator; 90 slices north of the equator and 90 slices south of it. Each slice represents 1° of travel on our earthly sphere as we progress either north or south. We call these imaginary slices, degrees latitude with 0° located at the equator, and 90° north at the North Pole and 90° south at the South Pole. We have done the same with our Celestial Sphere; however, instead of calling them degrees latitude, we use the term degrees declination north or south with south represented by a minus sign.

If we carefully slice earth into two pieces starting at the North Pole, straight down through the center of the earth to the South Pole, we can arbitrarily make one of the edges of the slice pass through Greenwich, England. Again arbitrarily, we call this line the zero meridian and the line on the opposite side of the earth, the international date line. If we divide the equator into 360° we note that to that from zero meridian, we can travel to the International Date Line by either going 180° east or 180° west. These degrees we call degrees longitude. (Note: Just to add some possible confusion; today the International Date Line meanders considerably to placate politicians.)

We have done the same thing to our celestial sphere. However, instead of calling these divisions longitude, we call them ascension. Like our arbitrary selection of Greenwich, England as our zero meridian for longitude, we have an arbitrary spot on our celestial sphere for zero ascension. This zero spot is where the sun crosses our celestial equator at a certain time of the year each March. However, unlike longitude that we measure in degrees east or west of our zero meridian, ascension is measured differently. For ascension, we have divided the celestial sphere into 24 equal slices that corresponds to the 24 h in a day. Instead of using degrees to measure ascension, we measure it in hours, minutes, and seconds; identical to the way we measure time. Unlike longitude which is measured either east or west of the zero meridian, ascension is always measured to the east of the celestial sphere's zero meridian. One hour of ascension is equal to 15°.

Now imagine we take our celestial sphere and draw each star in the sky in the exact position that we see it from earth. We can measure its location on the sphere, just as we can measure locations here on earth. These measurements are known as the celestial coordinates of the star. The distance the star is north or south of the celestial equator is given in degrees declination and the distance east of the zero meridian is called right ascension and expressed in hours, minutes, and seconds.

One last detail concerning our celestial sphere; the earth is tilted 23.5° on its axis and so is our celestial sphere. The path the sun makes in our sky across our celestial sphere is called the ecliptic. If we look at the ecliptic, we notice that the ecliptic is not parallel to the celestial equator but crosses the celestial equator twice a year at an angle of 23.5°. Because the planets (if we exclude Pluto as a planet) lie in same plane as earth, they too follow paths across the sky very near the ecliptic which makes the task of finding them simpler.

The above sounds complex and in a way it is. However, all will become clearer in time. All you need to know at the moment is that we can measure our location on our celestial sphere using a method very similar to how we measure locations here on earth.

2.3 Distances in Space

When we look up at the sky we can easily see that some stars are appear close together and others appear far apart. These are relative distances as the stars are too far away to see any separation in depth so we measure the apparent distance between them using an angular measurement. A circle is divided into 360°, each degree is divided into 60 min, and each minute is divided into 60 s. In Astronomy we call minutes, arcminutes, and seconds, arcseconds, when using them as units of distance. The distance from a point on the horizon to the zenith, a spot directly overhead, is 90°, halfway is 45°, and a third of the way is 30°. Going smaller, the full moon measures about one half a degree or 30 arcminutes in diameter. The Great Nebula in Orion is 90 arcminutes by 60 arcminutes in size while the Ring Nebula measures 86 arcseconds by 62 arcseconds. The Big Dipper covers about 20° of the night sky. Your outstretched hand is an excellent yardstick for measuring angular distances. Your little finger covers about 1°, three closed fingers cover about 5°, and the width of your closed fist is about 10°.

The closest star to our sun, Alpha Centauri Proxima, is 24,600,000,000,000 miles or 39,900,000,000,000 km from our sun. Other than knowing that this is a big number, it really has little value as few people can visualize such distances. So, in astronomy other units are used:

- Astronomical Unit (AU). An astronomical unit is the average distance between the earth and the sun. Alpha Centauri Proxima is about 271,000 AU from earth.
- Light year (ly). A light year is the distance that light travels in a vacuum over a period of one earth year. Alpha Centauri Proxima is about 4.2 light years from earth.

- Parsec (pc). A parsec (pc) is the distance from the earth to a theoretical point that produces an annual parallax of 1 arcsecond in the sky (about 3.26 light years). Alpha Centauri Proxima is about 1.3 parsecs from earth.

2.4 Constellations

You probably have heard of constellations for most of your life. Exactly what are they and why are they important? Since antiquity, humanity has associated star patterns, now called asterisms, in the sky with stories and myths. Over the years the stories grew and patterns overlapped. Many of the ancient Greek stories and star patterns survived the passage of time and are still used today. Unfortunately, the stories and myths of many other cultures are forgotten or lost to history.

A constellation is an area of the sky that frequently contains an asterism and myth from the past. Constellations and stars were the calendars of ancient mankind. In the northern hemisphere, the appearance of Vega meant warm summer days ahead and its departure told of cooler and harder times. One of the most prominent constellations, Orion, dominates the winter sky. Its arrival in November ushered in cold winter days and its departure in March meant spring was not far away. The opposite was true for the southern hemisphere and different stars and patterns were available. It is not hard to imagine ancient man using the stars and asterisms to know when to plant crops, bring herds of sheep down from high mountain peaks to warmer valleys below, when dry seasons were upon them, when spring floods were on their way and other natural annually reoccurring events.

Until fairly recent times, no "official" list of constellations existed. Publications generally had the same stars in different constellations, different boundaries between constellations, or even constellations not present in other publications. Astronomers and philosophers felt perfectly free to do as they pleased and even make up their own. Chaos ruled. In 1925 the International Astronomical Union decided to make order out of chaos. Eighty-eight Constellations were "officially" designated and boundaries established for each one. The boundaries have no resemblance to the mythical star patterns of old but are simply organized spaces in the sky containing the asterism that gave birth to the constellation's name.

Constellations are useful in several ways in astronomy. If someone says that they saw some event, say a meteor in a certain constellation at a certain time of the night, then anyone who knows their constellations knows where in the sky the event took place. The same is true for astrophotography. If you see a photograph of a deep space object and its constellation is identified, you know when and where the object is available for photographing. The when can be refined not only regarding the time of the year but also the time of night.

Learning the names and boundaries of all 88 constellations is a Herculean task to accomplish. Unless you live near the equator, many are not even visible. Others are obscure and have little need for a visitation. However, as you progress in astronomy, you will slowly become familiar with the night sky including the names and general boundaries of the constellations of interest to you.

2.5 Telescopes

So, what exactly is a telescope? The obvious answer is it's a device that makes distant objects look closer than they really are. Telescopes and their close cousin, binoculars, are used all to time to bring distant events closer, to see elusive wild animals and birds, to watch sports events, etc. The story of their usage really has no end. However, bringing distant objects closer is not all that telescopes do. Another answer is telescopes make faint objects brighter.

While both of these two attributes are important for astronomers, the latter, making faint objects brighter, is the most important. Why? The only close objects in space are located in our solar system with our nearest star, the sun, at its center and planets and other objects in orbit around the sun. The solar system; our sun as well as the objects orbiting it (the planets and their moons, asteroids, and comets) are of primary interest to many astronomers and that's where they spend most of their viewing time. For viewing objects in our solar system, a telescope's ability to magnify—to bring an object closer—as well as its ability to resolve fine details are important.

Once we leave our solar system we are in deep space. This is where most astronomers spend their time viewing distant galaxies, nebulae, star clusters, and other phenomena. Objects in deep space are appropriately called "deep space objects" or DSOs for short. DSOs are far away, some at incredible distances from us. Other than the stars that we can see on a dark night, few DSOs are visible to the human eye. Most DSOs, including most stars in our galaxy by the way, are invisible and will remain so even if we were many times closer. These objects are truly far, far, away and are faint, very faint. For these objects, magnification is not important. To see these objects we must use the ability of a telescope to gather and concentrate light or, to put it another way, the telescope's ability to make faint invisible objects bright enough for us to see them with our eyes.

Consider the human eye. On a dark night the pupil of a human eye dilates to about 7 ± 2 mm in diameter (slightly more than a quarter of an inch). Photons from all that we see must pass through this tiny opening. Now, consider a telescope with a lens 150 mm in diameter (6 in.). The area of this lens is 460 times larger than the area of the typical dilated human eye. The function of a telescope is to collect the light falling on its lens and then concentrate it into a spot having a diameter about the same size as a dilated human eye so all the light the telescope gathers can pass into the eye. The result is a telescope essentially expands the effective diameter of the human eye so that it is equal to the diameter of the telescope's lens or mirror. This attribute of telescopes, the ability to gather and concentrate light, is what allows us humans to see incredibly faint objects in space with a telescope that are invisible to our unaided eye.

The telescope was invented in 1608 by Hans Lippershey. You know it well; it's the refractor telescope like the spyglass the pirates of old used to look for other ships. A refractor telescope looks like a long tube and has a large lens on the front end to gather and concentrate light and an eyepiece and focuser at the other end.

2.5 Telescopes

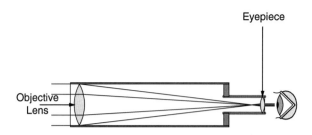

Fig. 2.2 Refractor telescope

This is the kind of telescope Galileo used 400 years ago when he gazed upon the heavens and changed forever how humanity viewed the universe (see Fig. 2.2).

The early refractors used a single lens. Diffraction separated the light into its different colors. Since the wavelength of light varies with color, the early refractors could not bring all wavelengths to focus at the same spot. This meant that images in these telescopes had colored fringes and were not that sharp. This phenomenon is known as chromatic aberration. To combat chromatic aberration, early refractors had long focal lengths, often measured in meters. This worked very well and did greatly mitigate the impact of chromatic aberration. However, these telescopes were unwieldy, difficult to use, and were replaced by other designs as telescope technology progressed.

In the mid 1700s Chester Hall made an objective lens composed of two different types of glass which greatly reduced the amount of chromatic aberration with a refractor and the design came in use again. Later three element lenses were developed that virtually eliminate chromatic aberration. This gives birth to two terms you will hear associated with refractors and not other telescopes. Telescopes with primary lens made of two elements are called achromatic telescopes. Telescopes having a primary lens made of three elements are called apochromatic telescopes.

In 1668, Sir Isaac Newton devised a different way to view the stars and to overcome the difficulties of the first refractors. Instead of a glass lens to gather and concentrate light, he used a parabolic mirror to do the job. Light entered the telescope tube and was reflected off a parabolic mirror mounted at the end of the tube back up the tube to another smaller flat mirror mounted at a 45° angle and then out of the side of the tube through a focuser and eyepiece. Newton's telescope was more complex than the refractors of that time. However, since it reflected light instead of refracting it, Newton's telescope was able to bring light composed of different colors to a sharp focus. This type of telescope is called a Newtonian today and is a very popular type of telescope among amateur astronomers. Large mirrors are easier to make and lighter than large lenses; thus, large and medium size reflecting telescopes are cheaper to manufacture or easier for an amateur astronomer to make than are refractors (see Fig. 2.3).

The next telescope innovation used by modern society was in 1672 by Laurent Cassegrain which bears his name today (see Fig. 2.4). This telescope strongly

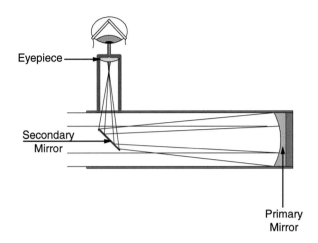

Fig 2.3 Newtonian telescope

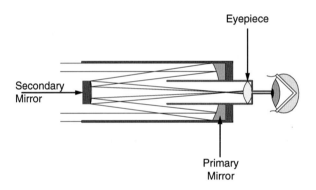

Fig. 2.4 Cassegrain telescope

resembled the Newtonian telescope except instead of a flat diagonal mirror to reflect light out the side of the telescope's tube, the design uses a convex mirror to reflect light back down the tube where it passes through a hole in the center of the primary mirror to the focuser and eyepiece. The Cassegrain telescope was essentially ignored until after the mid 1900s when a method was developed to cheaply manufacture a variation called the Schmidt Cassegrain Telescope. Today, two versions of the Cassegrain telescope, the Schmidt Cassegrain and the Maksutov Cassegrain telescopes are in wide usage among amateur astronomers.

A variation of the Cassegrain was invented by James Gregory in 1663 but the first working model was not made until 5 years after Newton made the first working reflector. A Gregorian Telescope is very similar to the Cassegrain design except the

2.5 Telescopes

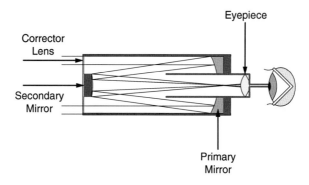

Fig. 2.5 Schmidt Cassegrain telescope

secondary is a concave mirror. Chromatic aberration is not an issue with this design and it, along with the Newtonian design, rapidly became the telescopes of choice by astronomers. The Gregorian remained popular until the late 1700s.

Into the middle of the twentieth century, refractor and Newtonian telescopes were predominately used by astronomers; amateurs and professionals alike. For amateur astronomers, the Cassegrain and other telescope designs remained mostly theoretical curiosities. Since most amateurs had to make their telescopes, they preferred the Newtonian design as grinding a mirror required less expertise and effort than did grinding a lens. For people who could afford to purchase their telescopes, Newtonians again were preferred as they were less expensive.

In 1930, Bernhard Schmidt, who was interested in making a camera for astronomical research, made a modification to the Cassegrain telescope by adding a lens, now called a corrector plate, at the beginning of the light path through the telescope and using a spherical mirror. This plate corrected optical errors of coma and spherical aberration making possible the manufacture of large, wide angled cameras with low focal ratios needed to shorten exposure times in astronomical photography. Since the design has two types of optical surfaces, a lens and a mirror, it is known as a catadioptric telescope or a CAT for short. Schmidt's particular modification became known as a Schmidt Cassegrain Telescope (see Fig. 2.5). It had no impact upon amateur astronomy at the time as its cost was far more than anyone other than large observatories could afford.

In 1964, a new company, Celestron, introduced the Schmidt Cassegrain Telescope on the commercial market at a price affordable by large universities and smaller observatories but out of reach for amateurs. Then in 1970 everything changed. Celestron developed a method to cheaply manufacture the corrector plate needed for the Schmidt Cassegrain Telescope and introduced its now famous Orange Tube to the amateur market at prices that were well within the reach of many amateur astronomers. The Newtonian was rapidly displaced as the telescope of choice by advanced amateur astronomers.

There are other variants of catadioptric telescopes available to amateurs today but the Schmidt Cassegrain telescope dominates. One of the variants that has a

significant use by amateurs is the Maksutov Cassegrain Telescope, simply called a MAK in the astronomy community. A MAK is very similar to the Schmidt Cassegrain Telescope in both appearance and design but uses a different kind of secondary mirror and corrector lens.

In the late twentieth century refractors and Newtonian telescopes staged a comeback with amateur astronomers. Computers became involved in the lens grinding process making reasonably-priced, short, focal-length refractors economically feasible. Also a cheap but highly effective lightweight and sturdy support for a Newtonian telescope, now called a Dobson Mount, made owning and using a large Newtonian telescope practical for viewing the night sky.

Summing up, there are three basic telescope designs on the market today that are of interest to most amateurs. Others designs exist but these three dominate and are useful as a first telescope:

- The refractor
- The Newtonian
- The Schmidt Cassegrain

In addition to the above designs, the Maksutov Cassegrain variant is popular for small aperture telescopes between 3.5 and 5 in. (90–127 mm).

2.6 Telescope Characteristics

Regardless of the type of telescope, the basics governing their performance are often described using the following parameters:

- Aperture: the diameter of a telescope's light collecting surface, its primary mirror or lens
- Focal Length: the distance from the primary mirror or lens where an object in space located at infinity is bought to focus
- Focal Ratio: the ratio between the Focal Length of a telescope and its Aperture (focal length divided by the aperture)
- Back Focus; the distance from the end of the drawtube of a telescope to the telescope's focal plane.
- Chromatic Aberration: The inability to bring all wavelengths of light to a common focus.

The aperture of a telescope, the diameter of its primary lens or mirror, provides the telescope's light gathering capability as well as its ability to resolve details. The focal length provides an indication of image size and field of view while the focal ratio provides information about image brightness. The image size in a telescope is the ratio between the telescope's focal length and the eyepiece's focal length, e.g. a telescope with a focal length of 2,000 mm will produce a magnification of 80 with a 25 mm eyepiece (2,000/25 = 80).

Two telescopes, regardless of design, having the same aperture but having different focal ratios will perform in a predictable way. For any given eyepiece, the

2.6 Telescope Characteristics

telescope having the higher focal ratio will have a larger image because it will have the longer focal length while the telescope with the lower focal ratio will have a smaller but brighter image as well as a larger field of view. For two telescopes having the same focal ratio but different apertures, for any given eyepiece the images in both telescopes will be equally bright but the telescope with the larger aperture will have the longer focal length and the larger image.

For astrophotography, image size is not as important with digital cameras as it was with film cameras. The resolution of digital single lens reflex cameras is such that images can easily be digitally enlarged to a significant extent. However, image brightness is very important to all cameras, including digital ones. A brighter image means more information can be captured by a camera's sensor over any given period of time which can improve the quality of the photograph. For photography, the focal ratio of a telescope indicates the telescope's ability to perform as a camera telescope; the lower the focal ratio, the brighter the image and the shorter the exposure time required. Similar to visual observing, image size is approximately the ratio of a telescope's focal length and the diagonal dimension of the camera's sensor.

Back focus is also an issue. If it is too short, then a focus cannot be achieved with a digital camera and the telescope cannot be used for astrophotography. This issue primarily impacts Newtonian telescopes. Rarely is back focus an issue with a reflector or with either a Schmidt or Maksutov Cassegrain telescope.

Telescopes that use mirrors seldom have issues with chromatic aberration, bringing all wave lengths to a common focus. The same is not true for refractor telescopes. A refractor that uses a single lens for the objective lens acts very similar to a prism and red, green, and blue light comes to focus at different points which has a negative impact upon the image for both viewing and photography. Chromatic aberration in a refractor is substantially mitigated for visual work by using a combination of two lenses made of different types of glass for the objective lens. Such a lens is known as a duplex and the telescope using one is called an achromatic telescope. Achromatic telescopes, often called an ACHRO for short, greatly reduce but do not eliminate chromatic aberration and can require filters. A more expensive variation, the triplex, uses three lenses and different types of glass for the objective lens. A refractor using a triplex primary is also known as an apochromatic telescope or APO for short. The triplex lens essentially eliminates chromatic aberration for both visual work and photography.

A substantial percentage of astrophotographers maintain that a refractor is the telescope design most suited for astrophotography because of the sharp images they can produce. A refractor typically has sufficient back focus to use a large variety of cameras and accessories. It is available in a large range of focal ratios starting as low as f/5 and many can use focal reducers for added versatility. Its optics are typically permanently aligned and do not need adjusting by the astronomer. One attribute of refractor telescopes is that their bulk and weight markedly increases with size of the telescope making a 150 mm aperture telescope about the largest used by amateur astronomers and 102 mm aperture telescopes about the largest that can be handled by a lightweight mount. The major negative attribute of a refractor telescope is chromatic aberration.

The Newtonian telescope design easily supports instruments having low focal ratios around f/4 and slightly lower. These fast telescopes are relatively inexpensive to construct and produce excellent images without any chromatic aberration issues. They also make excellent wide field of view telescopes for observing the night sky. The disadvantages of a Newtonian are that they are large and also must have their optical components aligned (collimated) often, something not difficult to do but an added step in the process each night. Due to the geometry of their design and the design of telescope mounts, the camera or eyepiece on a Newtonian are often difficult to access. Unless a Newtonian telescope is specifically designed for astrophotography it typically will not have sufficient back focus for a camera attached at prime focus. Before acquiring a Newtonian Telescope for astrophotography, its ability to come to focus with a camera should be verified.

Schmidt Cassegrain Telescopes, typically called a SCT, are very popular telescopes because of their versatility. They are excellent telescopes for both viewing and astrophotography due primarily to their compact design and their focusing characteristics. Schmidt Cassegrain Telescopes provide plenty of back focus and can use a large variety of cameras and other accessories. Like Newtonians, they have no chromatic aberration issues. Their disadvantage is that their relatively long focal lengths and high focal ratios produce a large but dim image. An inexpensive lens, called a focal reducer, is easily attached to a SCT that reduces its focal ratio to f/6.3 which is suitable for very short exposure astrophotography. Unlike most refractors, the optical components of a Schmidt Cassegrain telescope must aligned by the user but much less often than that required for a Newtonian.

A Maksutov Cassegrain Telescope, typically called a MAK, has the same characteristics as the Schmidt Cassegrain Telescope except its optics are essentially permanently aligned and its focal ratio is very high, between f/12 and f/15. Even with a focal reducer, the focal ratio of MAKs remains high which negatively impacts their suitability for photographing deep space objects and for using very short exposures. MAKs are excellent telescopes for photographing bright objects that benefit from magnification such as planets and the moon.

2.7 Telescope Mounts

To use a telescope it must be supported by a mount setting on either a pier or a tripod. Some amateur astronomers have home observatories with their telescopes permanently sitting on top of a sturdy pier. However, most amateurs use movable or portable telescopes that have either an azimuth or equatorial mount on top of a tripod or a telescope that has a Dobson mount that sits directly on the ground. While many types of mounts exist, this book is limited to three (see Fig. 2.6):

- A computerized altitude/azimuth mount (also known as an alt-azimuth or azimuth mount),
- A computerized altitude/azimuth mount with a wedge that converts it to an equatorial mount,

2.7 Telescope Mounts

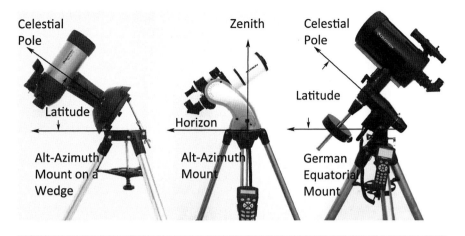

Fig. 2.6 Telescope mounts

- A computerized or motorized German equatorial mount often referred to as a GEM.

What are the issues that make astrophotography with alt-azimuth mounts differ from photography with equatorial mounts? An equatorial mount is aligned with the celestial sphere. This allows the mount to track an object as it crosses the night sky while keeping the object centered and stationary in an eyepiece or in a camera. Since the equatorial mount is aligned with the celestial pole, the rotation of objects in the sky is at a constant rate; 15° per hour. Each object in the sky has its own unique set of celestial coordinates that remain constant regardless of the time of day or location of the observer on the earth. If the equatorial mount is precisely aligned with the Celestial Pole, a motorized mount can keep an object stationary long enough for exposures exceeding several minutes or more with no guidance. Since the movement is constant and in one direction only, no computer is needed to track an object as the earth rotates on its axis.

An alt-azimuth mount is aligned with the plane of the earth. One axis is pointing to a spot in space located directly above an observer called the zenith and the other axis is parallel to the plane of the earth. As with an equatorial mount, each object in the sky has its own set of coordinates but these coordinates change dependent upon the location of the observer on earth and the time of the day. Because an alt-azimuth mount is not aligned to the celestial pole; movements in both azimuth and altitude are required to keep an object centered in view of an eyepiece as the earth rotates. The magnitude of these adjustments constantly change as the earth rotates; thus, a computer is needed to calculate and control the motions of the mount needed to keep an object centered in an eyepiece or camera.

Since an alt-azimuth mount is not aligned with the celestial sphere, objects will rotate in the eyepiece or camera as the Earth rotates. This rotational effect is called

"field rotation." While too slow to be noticeable for visual work, it has two major impacts upon alt-azimuth mount photography. Field rotation limits the duration of exposures that can be made and also limits the areas of the night sky where objects to be photographed can be located. More on field rotation will be discussed later.

The term GOTO refers to motorized, computer-controlled, mounts that can automatically find then track objects in the night sky. The computer used is a small handheld device, about the size of a small portable telephone, with controls for using the mount. You tell the computer what you want to see and the computer will then "go to" the object and then keep it centered in the eyepiece while you view.

Unfortunately, several factors keep a telescope mount from perfectly tracking an object in the night sky. The two significant factors are imperfections in gear construction and mount alignment. These imperfections limit a mount's ability to track an object for more than a few seconds to a few minutes dependent upon the quality of the mount and its alignment.

"Payload and rated payload" are terms you will often hear connected with telescope mounts. Rated payload is the amount of weight that the manufacturer says that a mount can carry and still perform as specified. It does not include mount counterweights, the weight of the mount itself or its tripod, polar scopes, etc. Payload is the total weight of the telescope, camera, adapters, focal reducer, finder, etc. that is carried by the mount's dovetail saddle. The experiences of many are that the rated payloads for alt-azimuth mounts are conservative even when used for astrophotography. However this is not true for equatorial mounts. While the rated payloads for equatorial mounts tend to be accurate for visual work, astrophotographers find they face fewer issues if they limit the weight they put on the dovetail saddle to 50–60 % of the mount's rated payload.

2.8 Manmade Objects in the Sky

Objects in the sky fall into one of three categories; manmade, solar system, or deep space. Manmade objects are the satellites we have orbiting the earth and the space probes we send to other planets, moons, etc. The only manmade object attracting attention at the moment as a photography object is the International Space Station. Many amateurs have successfully made nice images of it. Satellites orbiting the earth create problems for astrophotography when they pass between the camera and the object being photographed leaving a long white streak of light across the image. With rare exception, because of their sizes and distances from earth, space probes do not interfere with astrophotography and are not the subject of photography.

2.9 Solar System Objects

Solar system objects include the sun and objects under the influence of its gravity. This includes the planets with their moons including earth and our moon, asteroids, comets, and objects in the Kuiper Belt and the Oort Cloud.

2.9 Solar System Objects

Table 2.1 Planets in our solar system

Name	Radius Miles	Radius Kilometers	Mean distance to Sun Miles	Mean distance to Sun Kilometers	Day Earth Days	Orbit time Earth Years
Mercury	1,515	2,439	35,969,000	57,910,000	59.00	0.24
Venus	3,762	6,052	67,205,000	108,200,000	225.00	0.62
Earth	3,964	6,378	92,920,000	149,600,000	1.00	1.00
Mars	2,092	3,397	141,580,000	227,940,000	1.02	1.80
Jupiter	44,435	71,492	483,435,000	778,330,000	0.40	11.90
Saturn	37,456	60,268	886,300,000	1,426,940,000	0.43	29.00
Uranus	15,885	25,559	1,783,220,000	2,870,990,000	0.72	84.00
Neptune	15,390	24,764	2,793,210,000	4,497,070,000	0.67	165.00

The sun is the largest object in the solar system with a diameter of 865,000 miles (1,390,000 km). It is a popular subject for photography by amateur astronomers. Specialized filters are needed to protect equipment and human eyes from the sun's intense radiation as well as to provide the contrast to see or to photograph details of sun spots and other solar phenomena. Be aware of cheap glass filters that attach to eyepieces. These filters can crack from the heat of the sun and if you have your eye at the eyepiece you can suffer eye damage or even blindness. Quality filters generally fit over the front of the telescope and filter out most of the sun's light. After all, the sun is very bright and you need only a little light from it to see its wonders.

As shown in Table 2.1 eight planets orbit the sun and all are in the same orbital plane. Mercury and Venus are more of interest as objects to observe rather than to photograph as no surface details are visible. Mars, at opposition with earth, is only 35,000,000 miles (56,000,000 km) distant and has a diameter of 25 arcseconds. At this time, it is of major interest to amateur astronomers for visual work and for photography. Jupiter always puts on a show with its moons and its cloud belts of color when it is visible in the night sky and Saturn with its rings to a lesser extent. Both are objects that attract visual observers and photographers alike. The last two planets, Uranus and Neptune, are some distance from earth and devoid of surface details using amateur telescopes. The earth and its moon occupy a special place as our home in the universe. The moon is the first object that many people see in a telescope. It is also often the subject of that first photograph of an object in space; all that is needed is a steady hand and a camera.

Between the orbits of Mars and Jupiter lies the Asteroid Belt. This is a ring of mostly rocky particles orbiting the sun that vary in size from dust particles to the asteroid Ceres, some 560 miles (950 km) in diameter. Just outside the orbit of Neptune lies the Kuiper Belt. Even further out at the edge of the sun's gravitational influence is the Oort Cloud believed to be a shell of icy particles enclosing the solar system.

Both are thought to be the source of comets. Comets from the very distant Oort Cloud are called long-period comets. They take thousands of years to orbit the sun and are observed only once in recorded history. Comets believed to come from the Kuiper Belt are known as short period comets, have orbits of 200 years or less, and are in the same plane as the planets. Comets, when they approach the sun, are the subjects of intense scrutiny by visual astronomers as well as by photographers.

2.10 Deep Space Objects

Any celestial object not in orbit around the sun is a deep space object; typically called a DSO by astronomers. Many of these objects are visible in telescopes, either with the eye or via a camera, and are viewed and photographed by amateur astronomers. Over the years as astronomy progressed, astronomers developed the following categories of deep space objects:

- Stars
- Open Clusters
- Globular Clusters
- Galaxies
- Nebulae

"Stars" are the most prominent deep space objects in the night sky. They are so distant that they cannot be magnified in our telescopes. However, that does not mean that stars are not the subject of visual observers or photographers. Almost half the stars in the observable parts of the sky are part of a multi-star system often called "double" or "binary" stars. Some, such Albireo, which is an amber/blue-green pair, are like jewels in the night sky and are both viewed and photographed by amateur astronomers. Another attraction for amateur astronomers is the study of "variable stars." These stars vary in magnitude (brightness) over a period of a few hours to years. The change in magnitude is caused by either the actual variance of a star's brightness or by some other object in orbit around the sun that blocks its light. The study of variable stars is one area where amateur astronomers make significant contributions to humanity's knowledge of the universe. Novas and supernovas are stars that have exploded and when they occur they immediately attract the attention of both amateur and professional astronomers around the world.

Open Clusters are stars in close proximity to one another that form irregular but often interesting patterns. No hard-fast rule exists regarding how many stars are in an open star cluster and the number can vary widely. Stars are often born within a common cloud of gas in close proximity in space and time producing clusters of stars with many having similar characteristics. Open star clusters typically have mostly young stars. This is because as the eons pass, the stars in a cluster disperse leaving few clues about the cluster or of the stars it contained. Perhaps the most famous open cluster is Messier Object 45 also known as the Pleiades or the Seven Sisters. This object is easily visible with the naked eye and is well known throughout recorded history.

2.10 Deep Space Objects

Fig. 2.7 Spiral Galaxy NGC 1309. *Credit*: NASA, ESA, the Hubble Heritage Team (STScI/AURA)

"Globular clusters" are tightly packed balls of stars, ranging from tens of thousands to hundreds of thousands of stars. Globular clusters tend to form a halo around galactic centers and contain very old stars approximately 10 billion years old.

Galaxies are the ultimate collection of stars. Galaxies come in various shapes, sizes, and ages but astronomers place them into one of the following four categories:

- "Spiral galaxies" most often come to mind when galaxies are mentioned (see Fig. 2.7). A spiral galaxy has three major components; a spherical bulge of old stars in the galaxy's center, a flattened, spiral-shaped disk of dust, gas, and young stars surrounding the galaxy's center, and a loose, spherical hallo of globular clusters surrounding the galaxy center and part of the disk.
- A variation of a spiral galaxy is a bar galaxy which has an elongated center instead of a tight sphere (see Fig. 2.8). Our Milky Way was originally thought to be a spiral galaxy but current thinking is that it is a bar galaxy.
- "Elliptical galaxies" are spheroid in shape. They can be almost perfect spheres or very elongated like an American football. The light from an elliptical galaxy is uniform with no discontinuities; brightest at galaxy's center and uniformly decreasing toward the galaxy's outer edge (see Fig. 2.9).

Fig. 2.8 Bar Galaxy NGC 1300. *Credit*: NASA, ESA, the Hubble Heritage Team (STScI/AURA)

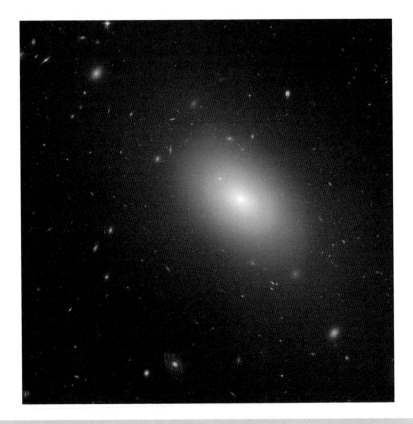

Fig. 2.9 Elliptical Galaxy NGC 1132. *Credit*: NASA, ESA, the Hubble Heritage Team (STScI/AURA)

2.10 Deep Space Objects

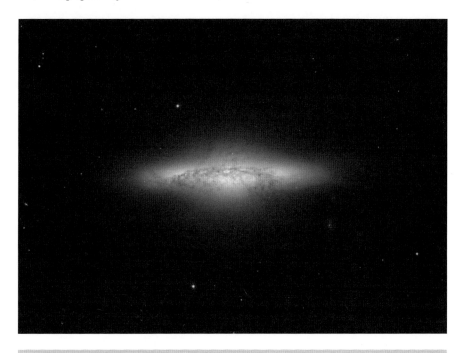

Fig. 2.10 Lenticular Galaxy NGC 5010. *Credit*: ESA/Hubble/NASA

- "Lenticular galaxies" greatly resemble elliptical galaxies but have a central bulge and thin disk of stars with no spiral structure (see Fig. 2.10). Lenticular galaxies are neither a spiral galaxy nor an elliptical galaxy but are a galaxy in transition between the two.
- "Irregular galaxies" are irregular in shape with no symmetry. They tend to fall into two groups; one with large quantities of gas and hot young stars and the other which also has large amounts of dust preventing the observation of its stars (see Fig. 2.11).

Nebulae are large clouds of gas or dust typically having dimensions measured in light-years. Often you will see the terms galactic nebula and diffuse nebula. A galactic nebula is one that is within our galaxy, the Milky Way. A diffuse nebula is extended with no well defined boundaries; a definition that fits most nebulae. Nebulae fall into three basic type regarding their visibility:

- Emission nebulae are gas clouds that become visible when the gas molecules are excited by high energy photons from a nearby bright star causing them to emit visible light.
- Reflection nebulae are dust clouds that are visible by reflecting the light of a nearby bright star.
- Absorption nebulae are clouds of dust so thick that they obscure the light of background stars or nebulae.

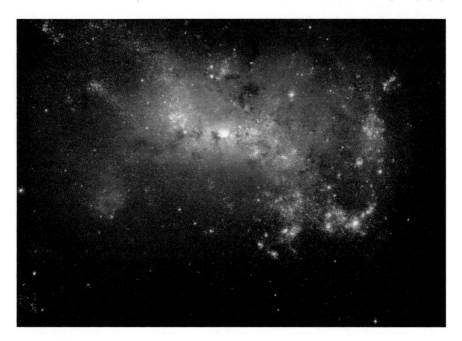

Fig. 2.11 Irregular Galaxy NGC 4449. *Credit*: NASA, ESA, the Hubble Heritage Team (STScI/AURA)

In reality, few nebulae are solely one type but are typically a combination of two or more. The large diffuse, galactic nebula that contains the Horse Head and Flame Nebulae has emission, reflection, and absorption components.

Hydrogen ions dominate most gas clouds. Hydrogen ions are easily excited and radiate visible light in red; thus, red is the dominate color of most emission nebulae. This has an interesting impact upon digital single lens cameras which have filters to attenuate red wavelengths of light in order to more accurately reproduce realistic colors to the human eye. Unfortunately the light from nebulae is too dim for the human eye to see color. Unlike the camera, all we see are shades of gray.

Nebulae are interesting in many ways. Diffuse nebulae are large clouds of gas and dust that often are incubators giving birth to new stars. These star forming nebulae typically make beautiful objects to photograph or to simply observe with a telescope. Perhaps the most famous is the Hubble Space Telescope photograph titled "The Pillars of Creation" of Messier Object M16, the Eagle Nebula. Another type of nebula, called a planetary nebula, is created by dying stars blowing off gasses into space over a period of thousands of years. Planetary nebulae are typically small, multicolored, circular nebulae with blue/green interiors and red exterior surfaces. The Ring Nebula, Messier Object M57, is a good example and easily seen in small telescopes. Occasionally a star will suddenly explode ejecting most of its

mass into space in a matter of minutes and becomes a supernova. The ejected matter is called a supernova remnant. The Crab Nebula, Messier Object M1 is one example of a supernova remnant from a supernova that occurred in the year 1045ca and was visible both day and night.

2.11 Messier Objects and the New General Catalog

Messier objects are much-admired and are often the first objects that are viewed or photographed by amateurs. Charles Messier (France, 1730–1817) is perhaps one of the most widely known astronomers in historic times yet he never wrote a major book or scientific treatise. His career was finding and observing comets. In the course of doing so, he constantly found objects in the sky that looked like comets but later proved otherwise. To prevent others from mistaking these objects for comets, he compiled a list of the objects he observed as well as those observed by others. Unlike many other lists of that time, Messier was meticulous about accuracy and verification. He also was scrupulous about giving credit to others who first discovered an object. His list has survived the test of time and is widely used today by amateurs worldwide. The currently accepted version of Messier's List has 110 objects and consists of 40 galaxies, 29 globular clusters, 28 open clusters, 10 nebulae, and 3 other objects such as the Sagittarius Star Cloud. All of these objects were viewed from France; thus, many are not visible in the southern hemisphere of our planet. Many other lists, both old and new, exist but none are near as famous or widely used as the list made by Charles Messier and another list made by John Dreyer.

Another equally popular and more widely used catalog is the "New General Catalog of Nebulae and Clusters of Stars" compiled by John Dreyer in 1888. This catalog is often simply called the "New General Catalog" or NGC for short. The catalog contains 7,840 deep space objects. Over the years Dreyer published two supplements to the NGC that he called Index Catalogs (IC). The first IC contained 1,520 additional objects and the second IC added another 3,866 objects for a total of 5,386 IC objects.

2.12 Magnitude of Objects in the Night Sky

Star brightness is measured using a scale called "Stellar Magnitude." This is a measure of the apparent brightness of a star as viewed from earth; not its actual brightness. A star having a magnitude of 0.0 is 2.512 times brighter than a star with a magnitude of 1.0; a 1.0 magnitude star is 2.512 times brighter than a star with a magnitude of 2.0; and so forth and so on. Seems simple enough, the larger the number, the dimmer the star. Do the arithmetic and you will see that a difference of 5 magnitudes is a brightness difference of 100. However, there is a complication.

The magnitude scale has negative numbers. The closest star, our sun, has a magnitude of −27, the full moon has a magnitude of −13, and Sirius, the brightest star, has a magnitude of −1.4. The magnitudes of planets vary in relationship to their distance from earth and orbital positions. Planets can also have negative magnitudes. Vega, one of the brightest stars, was selected as the reference 0.0 magnitude star. However, better measurement technology indicated that its actual magnitude was really 0.1; so, rather than adjusting the magnitude of all stars to keep Vega at zero magnitude, the concept of a 0.0 reference star was abandoned.

The process used to express brightness for star clusters, nebulae, and galaxies is different than that for stars. The brightness of a star cluster, nebulae, or galaxy is the object's apparent total visual brightness expressed as a magnitude using the same brightness scale used for stars. However, stars are point sources while star clusters, galaxies, and nebulae have an apparent area that is measurable from earth or else they would appear the same as stars to us. Some objects are quite large and others small. The published magnitude of a star cluster, nebulae, or galaxy is the magnitude the object would have if it were shrunk to a point source like a star.

This presents a problem in that the surface areas of objects vary considerably. When the light is spread over the total visible surface area, the object is much dimmer than the published magnitude. In many cases an object with a large surface area and bright magnitude that may even indicate naked eye visibility is actually too dim to view in a small or medium sized telescope or vice versa, an object with a small surface area and a dim magnitude may be easily seen in a small telescope. For visual observation and photography, another measure of brightness called "surface brightness" is more meaningful.

Galaxies and nebulae are distributed light sources. Their brightness can be represented as a ratio of their total magnitude divided by their surface area. This ratio is called "surface brightness" and is expressed in magnitude per square arcsecond. This provides a more realistic parameter to determine the ability to see or photograph one deep space object in comparison to another or even if the object can be seen or photographed.

2.13 Skyglow

The sky at night is never truly dark but has a faint glow that astronomers call "skyglow." Light to produce this glow comes from three basic sources. One obvious source is light from the stars. The second source is not so obvious. Oxygen in the earth's atmosphere is excited by photons from the sun and has a greenish glow that can be photographed from outer space and, under certain conditions, from here on earth. This glow is not the famous Northern or Southern lights (Aurora Borealis or Australis) as they are another phenomenon which is localized and is not included in basic skyglow calculations. However, when present, they cannot be ignored. The last source of light is artificial skyglow, the light pollution produced by humans.

2.13 Skyglow

Artificial skyglow is the bane of modern day astronomy. However, it is what it is. Get out at night and take what you can get from your location. People successfully observe and photograph from the middle of large metropolitan areas. Either you must cope with our light polluted night sky or remain an arm chair astronomer, reading about the starry universe instead of enjoying the wonders of creation. The choice is yours.

Chapter 3

Astrophotography Basics

3.1 Introduction

Most astronomers will agree that the term "Astrophotography" covers a wide range of photographs from a simple snapshot of the moon to an image of a distant galaxy or nebula. The kinds of images vary greatly dependent upon the subject matter, equipment used for photographing, and the techniques used. However, when we look at the photographs that people make they seem to fall into five distinct categories, each with its own techniques and equipment need. While no official definitions exist for these categories, over the years the following words and phrases have come into general use:

- Lunar
- Nightscapes
- Solar
- Solar System
- Deep Space

These five categories cover the range of photographs made by amateur astronomers. Keep in mind the list as well as the definitions of the categories on it are not absolute and often are vague. You will see other categories and descriptions. For example, Solar System can include solar and lunar photographs; planetary work can be its own category, etc.

Actually a "lunar image" is generally thought of as a daylight photograph. This is because the moon is very bright and is reflected sunlight. A snapshot of the moon

is perhaps the first astrophotograph that many people make, often with a simple point and shoot, hand held, digital or film camera. These wide field of view photographs of the moon against a stark black sky are very majestic. A film or digital camera with a telephoto lens held steady by a tripod or telescope mount can produce lunar images showing details of the moon's craters and mares. Then some people want both, a high resolution and an image of the entire visible lunar surface. This requires a mosaic made of many high definition images that are pieced together into one image of the lunar surface.

"Nightscape" photography is popular and is where many people spend all their time and efforts. Nightscapes cover a very wide range of photography. Spectacular moonrises and sunsets are two popular compositions as are images of the Milky Way with a terrestrial scene such as a distant mountain, lake, or a tree as a backdrop. All that is required to start is a DSLR camera, a suitable lens, a sturdy tripod, and a keen eye for composition. Exposure times vary dependent upon the location in the sky where the camera is pointed and the focal length of the lens used.

One type of nightscape uses the earth's rotation to make "star circles." While not required, a terrestrial object is typically in the foreground of a star circle image to add depth and substance. For star circles, a large number of images are taken over a period of time using a sturdy tripod with no tracking. The result is that the foreground objects are sharp and focused but the earth's rotation makes stars look like arcs or circles of light rotating around a common point.

"Solar" imaging is another popular activity. Amateur photographers produce breathtaking images of solar flares, sun spots, granulation, and other details of the sun's surface. While just about any camera or telescope can be used, special filters are required to protect both the photographer and the equipment from the sun as well as to capture surface details of the sun. The best results are obtained from small aperture telescopes specifically designed for solar viewing and photography. Viewing or photographing the sun also requires more knowledge and skills than beginners typically have. Viewing or photographing the sun are very dangerous activities and are the only areas of amateur astronomy where ignorance or carelessness can definitely result in severe bodily harm; permanent blindness. Do not view or image the sun until you know what you are doing.

Our list of "solar system" objects includes the planets, asteroids, and comets. Images of these objects benefit from telescopes having long focal lengths to produce images large enough to show more than gross details. Inexpensive web cameras can produce images of the planets and the moon equal to and better than images produced from dedicated astrophotography or many DSLR cameras. With a web camera, thousands of very short exposures are made and only the very best used to compose the final image. This process can also be done with a DSLR camera that has a video capability. Because of the high level of magnification used to photograph planets, a computerized tracking mount is essentially required to keep the planet in view of the camera. However, having said that some people are successful manually tracking planets. For asteroids and comets, a precision tracking mount is required for acquisition and tracking. Also these objects are not bright

enough for web cameras and either a dedicated astrophotography camera or a digital single lens reflex camera is needed for imaging.

"Deep space" images cover anything outside our solar system and are the primary thrust of this book. They can be wide field of view images of vast regions of space or detailed photographs of nebulae, galaxies and other objects including double stars, open star clusters, and globular clusters. These objects range from very small covering a few arc seconds of the sky to very large covering several degrees. Photographing deep space often requires images with exposure times measured in hours. To do this, cameras must be sensitive in low light conditions and have low internal noise levels. A mount is needed that can hold the camera motion free and track the object during the duration of the exposure. A camera lens or telescope is needed that has sufficient focal length to produce an acceptable image size of the object and sufficient focal ratio to provide an image bright enough for the camera to capture.

A new type of deep space imaging is currently in its infancy but steadily evolving; video astronomy. Video astronomy essentially uses a television camera at prime focus to view deep space objects real time; typically on a remote television screen. One major attraction of video astronomy is that the camera is much more sensitive than the human eye. This allows the camera not only to show more detail than what the human eye can see but to show it in color. In effect the video camera lets a telescope perform as if it were significantly larger in aperture and do so in color. Some video cameras are capable of photographing deep space objects. The integration time of the commercially available video cameras are as long as 99 min. The video output can be converted to a digital output and then the images stacked the same as done with very short exposures made with a digital camera producing similar results.

3.2 Some Accessories and Terms Related to Astrophotography

The definitions for some terms differ between the astronomy and photography communities. In general, astronomy terminology is used this book. Having different definitions for the same terms is confusing but astronomy is the senior science. References to telescopes are generally made by stating its aperture while references to a camera lens refer to its focal length. For example, a 150 mm telescope has an aperture 150 mm while a 150 mm camera lens has a focal length of 150 mm.

As we discussed in Chap. 2, aperture is the diameter of a lens or mirror and focal ratio is the ratio obtained by dividing the focal length of a lens or mirror by its aperture. Also keep in mind, the aperture and focal length of a telescope lens or mirror are fixed. This means that the focal ratio of a telescope is fixed.

A camera lens is different. Many have a fixed focal length but contain a mechanical iris similar to the iris in the human eye that is used to make changes to the aperture of the lens. Since the focal length is fixed, these changes in aperture

Fig. 3.1 T Ring and T Ring Adapter

change the focal ratio of the lens. So, when photographers talk about changing the aperture of a lens, they mean changing its focal ratio and when they talk about aperture, they mean focal ratio. The iris is designed so that the changes it makes are at predetermined focal ratios. These predetermined focal ratios are called f/stops, a term unique to photography, and are fixed so that a change of one f stop, dependent upon which way you go, either doubles or halves the amount of light entering the camera.

Zoom lenses are very popular with photographers. Recall that the magnification of a telescope provided by an eyepiece is obtained by dividing the telescope's focal length by the focal length of the eyepiece. The image size of a camera is similar and is a function of the ratio between the focal length of the camera's lens and the size of the camera's sensor among other things. One very popular lens is an 18–55 mm zoom lens. The 18–55 mm is the range of the lens's variable focal length. Since the aperture of the lens is fixed, the focal ratio of the lens also varies with its lowest focal ratio at its shortest focal length and its highest focal ratio at its longest focal length. As the focal length is changed to change magnification, the focal ratio also changes.

The DSLR camera is a very popular for astrophotography. Its lens is easily removed and the camera is easily attached to a telescope. One issue with a DSLR camera is the way its removable lens is attached to the camera body. No standards exist and each camera manufacturer has its own specific bayonet fitting for their lenses. Thus, an adapter is needed to attach the camera to a telescope. This adapter is known as a "T Ring." A T ring is simply an adapter that fits a specific camera make and model with the appropriate bayonet fitting on the outside and a standard T2 female thread (M42×0.75) on the inside. This means that a T Ring must be made to fit the make and model camera you are using (see Fig. 3.1).

3.2 Some Accessories and Terms Related to Astrophotography

Fig. 3.2 Focuser with T Threads

A "T Ring Adapter" has T2 male threads on one end and either a nose piece or threaded fitting on the other that attaches to a telescope. Some telescopes have focusers that have T2 male threads; thus, the T ring is attached directly to the telescope without the need of a T ring adapter (see Fig. 3.2). Also, some CCD cameras specifically designed for astrophotography have T2 female threads and only a T ring adapter is required to attach them to a telescope.

The term "back focus" is frequently mentioned when discussing attributes of telescopes for photography. This is the distance from the end of a focuser's drawtube to the point where light converges to form an image. This distance can be quite large, up to 5 in. (130 mm) or so for Schmidt and Maksutov Cassegrain telescopes. The same is true for most refractors. However, for Newtonian telescopes, this distance is very small and can be too short to allow focusing a camera at infinity or using other astronomy accessories.

A "visual back" is used by many catadioptric telescopes to attach diagonals and other accessories (see Fig. 3.3). The visual back screws directly onto the telescope and the diagonal or other accessories are inserted in it and held in place by two thumb screws. It also has male threads at one end for attaching accessories that have the appropriate female threads.

In addition to having different names for the same thing, conventional photographers entering the world of astrophotography will hear many strange terms batted about with abandon. Some of the most frequently heard are:

- Light frame or lights
- Stacking
- Dark frame or darks
- Bias or offset frame
- Flat field frame or flats

Fig. 3.3 Visual back

A "light frame" is one exposure of the object we are photographing that will be digitally combined with other light frames into a final photograph of the object. Plainly stated, it is one picture of the object being photographed.

"Stacking" is the name of the process that digitally combines many light frames of an object into one master image that is equivalent in many ways to the sum of all the light frames. In other words, a stacked image using ten light frames having an exposure time of 60 s each produces a resultant image that is similar in some respects to one image having an exposure time of 600 s. Stacking is done by aligning each light frame and then calculating the average, mean, or total value of each pixel in the image.

A "dark frame" is an exposure taken with no light allowed to reach the sensor of the camera using the same exposure time and ISO setting as used for a light frame and at the same temperature. The purpose of a dark frame is to eliminate the impact of hot pixels (defective cells in the camera's sensor) as well as electronic noise and thermal noise from the camera.

A "bias or offset frame" is similar to a dark frame except the exposure is taken at the same ISO and temperature as the light frames using the camera's fastest shutter speed. Bias/offset frames are used to remove a type of noise known as chip readout from the sub frames.

A "flat field frame" is an exposure of a blank white surface taken through the same telescope as the light frames with the same camera at the same ISO setting and at the same occasion. The purpose of the flat field is to correct for dust particles on the camera sensor, vignetting, and unequal light sensitivity of the sensor pixels.

3.3 Digital Camera Basics

Consider some basic attributes of digital camera sensors. Essentially each pixel making up a camera sensor collects photons and transforms them into electrons. The more photons it captures the more electrons produced. The capability to change photons into electrons is called the quantum efficiency (QE) of the sensor. The thing to keep in mind is the quantum efficiency of a sensor is fixed and not dependent upon camera settings. In other words number of photons collected by a sensor thus the number of electrons produced remains the same regardless of a camera's ISO setting.

The next attribute of a sensor to consider is its Full Well Capacity (FWC); the maximum number of electrons a pixel can hold which is also a measure of how many photons it can capture. Exceeding the full well capacity can produce blooming as the excess electrons produced by one pixel impact the surrounding pixels; thus, the photons collected are essentially wasted. Full well capacity of a pixel is dependent upon many factors including pixel area, electronic design, temperature, etc.

The last part of sensor design to consider is the actual conversion of the number of electrons collected (the analog signal) by a sensor during an exposure into a digital number. The analog to digital converter (ADC) used by many modern DSLR camera sensors are typically 12 or 14 bit designs that provide a output values ranging from 0 to 4,095 or 16,383 respectively. These output values are often referred to as ADUs (Analog Digital Units).

If the number of photons captured is independent of the ISO setting of a camera, how does increasing the ISO setting improve the quality of the image? The answer is that it may or may not improve the image. Recall the quantum efficiency and the full well capacity of a pixel. These attributes determine the sensor's sensitivity as well as the camera's lowest ISO setting. Cameras are designed to prevent spill over (over exposures) at their lowest ISO setting. This is done so the camera can be used outdoors in very bright conditions without over exposing the image. To do this, the camera compresses the data from the ADC. Instead of one electron representing one ADU from the analog to digital converter, many electrons are used to produce one ADU. There is a price to pay for this data compression as it sacrifices details in shadows to prevent overexposures. On the other hand, it produces a very wide dynamic range for the sensor.

As the intensity of light entering the camera decreases, such as happens outdoors as the sun sets and night approaches, the number of photons striking a pixel will decrease. This reduces the number of electrons produced by each pixel so the value of the digital output signal will also decrease. Since our data is compressed, details are absorbed by darkness.

If we counter the decrease in light by increasing the camera's ISO setting the number of photons entering the camera remain the same as well as the number of electrons produced by each pixel. All that happens is the analog to digital converter (ADC) amplifies the analog signal before converting it. This will increase the

output value from the ADC even though there was no corresponding increase in the number of electrons produced by the pixel. In other words fewer photons are needed for one ADU.

However, there is no free ride. At some ISO setting the point is reached where pixels near their full well capacity will lose information because the multiplied signal will exceed the range of the analog to digital converter; in other words, the white point is lowered. In astrophotography this means bright stars will bloom and stars in general will lose color and visual appeal due to the resultant stark contrast between stars and the black background. Cores of galaxies will bloom. The contrast in the image is also reduced. However, the positive benefit is that details of faint objects are amplified. This allows the imaging of objects with a surface brightness too low to otherwise be captured with the equipment and exposure times being used, especially for very short exposures of 30 s or less.

A related theory advocated by some photographers expands upon this concept somewhat. Their hypothesis is that as the ISO setting is increased there is a point where the one electron produced by one pixel will equal one ADU. This point is called the unity point and the gain produced by the amplifier at the unity point is called the unity gain. The contention is that exposures made with an ISO setting exceeding the unity point will be degraded because data is discarded; in other words, the white point is lowered. The unity point varies among camera manufacturers as well as among different camera models produced by the same manufacturer. Digital camera manufactures do not publish data related to unity point or utility gain; thus, followers of this theory must guess the unity point of their camera by experimenting with different ISO settings.

3.4 Digital Cameras Used for Astrophotography

Astrophotography is a digital world. Before the digital camera revolution, astrophotography was the providence of a very small number of very dedicated people using film cameras. Due to the digital revolution in photography, film has all but disappeared from the scene for general public usage as well as for astrophotography. Digital cameras changed the playing field. Today, just about anyone can invest as little as $1,000 to buy a camera, telescope, and mount that can produce images rivaling some of the best taken during the film era.

Point and shoot digital cameras cover the earth in our tablets, cell phones, and small dedicated pocket sized cameras. These cameras are often used to capture very nice lunar and landscape shots. Many amateurs hold one up to the eyepiece of their telescope and capture presentable images of planets, the moon, and a few the brightest of the very bright deep space objects like the Great Nebula in Orion. Holding a camera still over an eyepiece is difficult to do and special brackets are sold for that purpose. However, despite their popularity, these cameras have a very limited utility for astrophotography and none at all for the vast majority of images typically thought of as astrophotography.

3.4 Digital Cameras Used for Astrophotography

Not long in the not so distant past some amateur astronomers started modifying inexpensive "web cameras" designed for home computers and using them to image the moon and planets. The results were astounding and in most respects were better than what the professional observatories were capable of producing from earth at the time. The theory behind the success of web camera was simple. Take several thousand exposures of an object in a short period of time then select the best of the best and digitally stack them into one image. This works very well for bright objects such as the moon, sun, and planets. The camera is inserted into a telescope in lieu of an eyepiece and then connected to a computer which controls the photographic process. Shutter speeds of about 1/30th a second are used and as a minimum 2,000–3,000 images are taken. The computer controls the photographic process and stores the images taken. Other software is used to digitally combine the images and to process the image afterwards. Web camera performance is variable and based upon the quality of the camera used as well as the skills of the person modifying it. Several sites on the internet exist where people discuss web camera conversions, performance, photographic techniques, etc. Experimentation with small inexpensive video cameras, especially low light security cameras, continues as some amateurs try to push the concept into deep space. Keep in mind, the use of a computer with the camera adds considerable logistical requirements (power supplies, computer tables, etc.)

Today, the practice of converting web cameras is not as common as it once was. Several manufactures of amateur astronomy equipment have copied the concept and sell "planetary imagers;" cameras designed specifically for the task of imaging the moon and planets. Several planetary imagers are available on the market with prices ranging from $125 to about $400. These commercial cameras come bundled with the necessary software needed to photograph and to process the images. One advantage a planetary imager has over a modified web camera is that the planetary imager is a turn-key item usable out of the box while someone must perform the modifications required for a web camera. Which is better? Many modified web cameras outclass the commercial cameras. However, the commercial planetary imagers are known quantities. Also many people do not have the knowledge, skills, or desire to physically modify a web camera. For them a planetary imager is a better choice. Like the web camera, a computer is required to control the photographic process and to store and process images.

Astronomical CCD (charged couple device) digital monochrome cameras are designed specifically to photograph very dim deep space objects. CCD cells are very sensitive to low light conditions; an attribute required for photographing very dim deep space objects. Light hitting a CCD cell (called a pixel on a camera sensor) releases an electrical charge that can be measured. The amount of the electrical charge is dependent upon the intensity of light hitting the pixel. A large matrix of these pixels make up a camera sensor and their output is used to form a monochrome image (no color). Color images can be made from a monochrome CCD camera by simply taking four exposures; one using a red filter, one using a blue filter, one using a green filter, and one with no filter. These images are combined into a color image that has the resolution of a monochrome image taken with the same camera.

Heat and electrical noise are the enemies of digital cameras and CCD cameras are no exception. Most have a built-in cooling system, generally a solid state, Peltier Effect cooler, that keeps the temperature of the sensor cold enough so that infrared and electrical noise are at very low levels. Like a planetary imager or a web camera, an astronomical CCD camera must be connected to a computer that controls the photographic process and that stores and processes images. This requires that the photographer have a computer in the field while the images are being made as well as the supporting logistics (electrical power, computer table, etc.).

Color astronomical CCD digital cameras are also available; some at the lower end of the price scale. As we mentioned earlier, CCDs are monochrome. To make a color CCD camera, the pixels on a camera sensor are grouped in a matrix made of four pixels each. A color filter placed on each of the pixels in each matrix; one red filter on one pixel, one blue filer on one pixel, and a green filter on two pixels. This is known as a Bayer mask. Two green filters are used to duplicate the sensitively of the human eye to the color green. This allows the CCD sensor to collect the data needed to produce color images. Note that four pixels are required to present what one pixel can present in a monochrome sensor. The impact upon resolution is obvious. Given an identical number of equal sized pixels on a camera sensor, the resolution of an image made with a color CCD camera is less than the image made with a monochrome camera. The advantage of a color CCD camera is time. A monochrome CCD camera using color filters to produce a color image takes about four times longer than a color CCD camera. Most color CCD cameras have a built-in cooling system, generally a Peltier Effect cooler, that keeps the temperature of the sensor cold enough so that infrared and electrical noise are at very low levels. Like a monochrome CCD digital camera, a color CCD astronomical camera must be connected to a computer that controls the photographic process and that stores and processes images. This requires that the photographer have a computer in the field while the images are being made and the attending supporting logistics (electrical power, computer table, etc.).

In the first decade of the twenty-first century Digital Single Lens Reflex (DSLR) cameras became available that were affordable by the general public and had sufficient low light sensitivity and low noise characteristics that made them very suited for photographing deep space objects. As with a film single lens reflex camera, the lens on a DSLR camera is removable and the camera is easily attached to a telescope. Unlike a CCD camera, planetary imager, or web camera, a DSLR camera is self-contained. It has its own internal power supply, microprocessor, and memory; thus, it does not need an external computer to control the photographic process or to store images although one can be used if the photographer so desires. This makes a DSLR far more portable than a dedicated astronomical camera. As a side benefit, a DSLR can also be used as the family camera. This dual usage aspect often helps in justifying the expenditure of several hundred dollars for a camera. A DSLR camera is a color camera and uses the same Bayer mask used for color CCD cameras. The major negative aspects associated with a DSLR camera is they contain an infrared filter that attenuates their responsiveness in the red wavelengths of light and they have no way to keep their sensor cooled producing electronic noise, espe-

3.4 Digital Cameras Used for Astrophotography

cially in hot summer weather. This has the impact of subduing reds in astronomical photographs, some of which can be adjusted during post processing. The internal filters can be removed but doing so alters or eliminates the usage of the DSLR as a family camera.

At the end of the first decade of the twenty-first century, the micro 4/3 format camera with interchangeable lenses and no mirrors were introduced to the camera market. These cameras offer many of the same advantages as a DSLR camera. Like DSLR cameras, their lenses are removable. They are easily attached to a telescope and are self-contained; no computer in the field is required. While none currently have the low light sensitivity and low noise characteristics of a DSLR camera the gap is narrowing. Micro 4/3 format cameras are usable for imaging deep space; especially the brighter objects. They are attractive for applications requiring a very compact sized camera or a very light weight one. At the moment, micro 4/3 format cameras are a bit pricy compared to a DSLR camera but since they have fewer parts they should be cheaper to produce in volume. Last but not least, the body thickness of a mirrorless camera is less than that of a DSLR camera. Many Newtonian telescopes that cannot come to focus with a DSLR camera can achieve focus with a mirrorless camera. Being new and with little exposure to astrophotography, astrophotography related software support for these cameras is problematic.

Which type camera is the best to use, an astronomical CCD or a DSLR? The answer to this question is "it depends" mostly upon which technology you prefer. One major advantage associated with an astronomical CCD camera with their Peltier effect coolers is low thermal noise. One issue with an astronomical CCD camera is that it is not self contained and must be connected to a computer to work. The self-contained nature of a DSLR is much more compatible with the portability offered by lightweight mounts for astrophotography. These aspects tend to favor using a DSLR camera when portability is required, but no reasons exist why an astronomical CCD camera cannot be used. Just keep in mind, with an astronomical CCD camera you will also need to have a computer with its logistics needs to control the camera and to store the images taken.

Which DSLR is the best to use? One answer you often hear is use the one the one you have if you already have a DSLR or maybe a micro 4/3 format camera if you have one. Any DSLR camera will work but, and there is always a but, the king and queen in the world of DSLR camera astrophotography is Canon. Canon is by far the most popular brand of DSLR camera used to photograph deep space. Nikon is a distant second even though many of its DSLR cameras are excellent for astrophotography. This is basically because only Canon has designed cameras specifically for astrophotography and in the earlier days of DSLR technology produced RAW images that were almost truly RAW. This gave Canon a lot of momentum. The result is that many astrophotography software developers only support Canon products with a few also supporting Nikon. For the concept of Astrophotography on the Go with its highly portable astrophotography kits and unguided exposures, this is not an issue. Computers are not used in the field at night; thus, computer support is not relevant. Technical issues like thermal noise, sensor sensitivity, mirror lock, live view, weight, shutter settings, etc. are what is important, not computer

support. If you have a lot of money invested in lenses, sticking to the brand you have may be the most prudent path to take.

Are the advantages of a Canon or Nikon worth buying a new camera if you already have a DSLR or a micro 4/3 format camera? That depends upon several factors. If your existing camera is a late model and its noise characteristics are satisfactory to you, then use it until your abilities exceed its capabilities. If your DSLR camera is an older one dating before the around 2008 or so; maybe yes as the noise characteristics and sensitivity of the older DSLRs are not as good in comparison to current cameras.

What are some of the major attributes of a DSLR Camera that make it suitable for very short exposure astrophotography?

- Low light sensitivity
- Manual operation
- Exposure times of 30 s
- A bulb setting
- ISO settings of 3200 with low noise levels
- Usable with a remote shutter switch or interval timer
- Live view
- RAW files
- Mirror lockup; not required but a valued asset
- Light in weight; around one pound (0.5 kg)
- Articulated review screen

3.5 How Cameras Are Attached to Telescopes

Several methods are available to connect a camera to a telescope. The simplest method is to bolt the camera to the exterior of a telescope with the camera lens pointing to the same area of the sky as the telescope and take photographs with the camera through its lens (see Fig. 3.4). This method is called "Piggyback." It is an ideal place to start learning how to photograph the night sky as well as a place where many advanced astrophotographers do all of their work. All that is needed to connect the camera to the telescope is a bracket that bolts to the telescope. The camera is attached to the bracket using its tripod mounting socket. Many refractors and Newtonian telescopes have a piggyback bracket built-in the tube rings that are used to attach the telescope to its mount. This method is very versatile and with the possible exception of solar photography can be used for any category of astrophotography. Piggybacking is done with cameras that have a lens. Here a DSLR camera or micro 4/3 format cameras are ideal. Bridge cameras can also be used but may have issues with internal noise as well as focal ratios. Dedicated CCD cameras, planetary imagers, and web cameras cannot use this method as they have no internal lens to focus light.

Prime focus, also known as direct coupling, is perhaps the most used method to attach a camera to a telescope (see Fig. 3.5). Prime focus uses a telescope without

3.5 How Cameras Are Attached to Telescopes

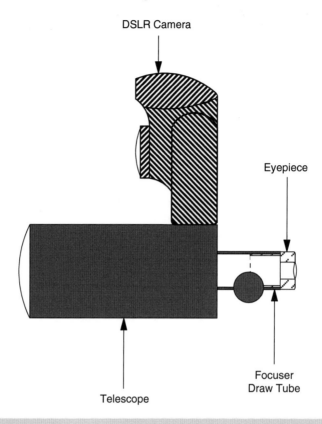

Fig. 3.4 Piggyback camera

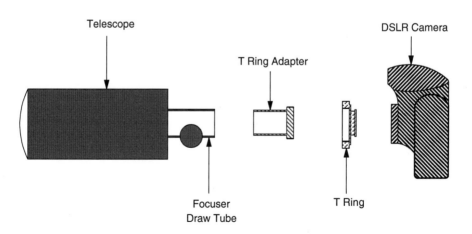

Fig. 3.5 Camera at prime focus

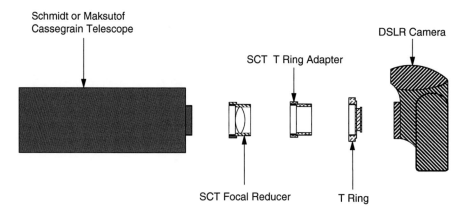

Fig. 3.6 Compression or focal reducer camera connection

its eyepiece as the camera's lens. It is not suited for cameras that do not have a removable lens. Prime focus photography is suited for planetary, lunar, solar, and deep space. Due to the image size produced other methods are generally preferred for nightscapes and star trails.

A third method to connect a camera to a telescope is called "Compression," (see Fig. 3.6). This method is very much like "Prime Focus" except that a focal reducer is placed between the telescope and the camera. Compression is used in circumstances where a brighter image or larger field of view is required; two attributes often most helpful for photographing deep space objects, especially for many relatively slow refractors and catadioptric telescopes. A 0.63 focal reducer is particularly useful for Schmidt Cassegrain Telescopes to reduce their focal ratio from f/10 to f/6.3. As with prime focus, compression is suitable only for cameras with removable lenses like a DSLR or a micro 4/3 format camera and cameras that have no lenses like astronomical CCD cameras, planetary imagers, and modified web cameras. Focal reducers reduce a telescope's focal length which in turn reduces the amount of back focus available. For this reason they are not used with Newtonians.

One very easy method to use a camera with a telescope is to simply hold the camera over the eyepiece of a telescope and snap a photograph. This method is called "Afocal Coupling" see (Fig. 3.7). Point and shoot cameras as well as telephone and tablet cameras work very well for "Afocal Coupling" and can produce some very acceptable photographs of bright objects like the moon. Brackets are available to hold the camera in place and make the task easier.

"Eyepiece Projection, sometimes called Positive Projection," is used when a large image size is important" (see Figs. 3.8 and 3.9). The two terms are used interchangeably. Eyepiece projection is used when the size of an image needs to be increased making it particularly useful for planetary, solar, and lunar imaging. Eyepiece Projection is suitable for cameras with removable lenses like a DSLR or a micro 4/3 format camera and cameras that have no lenses like astronomical CCD

3.5 How Cameras Are Attached to Telescopes

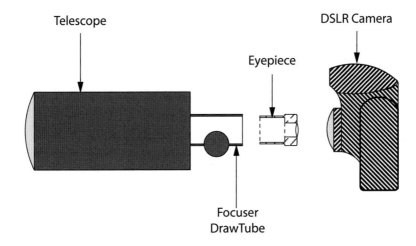

Fig. 3.7 Afocal camera coupling

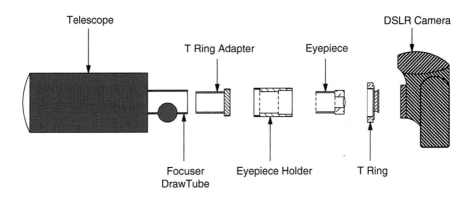

Fig. 3.8 Positive projection or eyepiece projection

cameras, planetary imagers, and modified web cameras. It is also useful to increase back focus.

The last method discussed in this chapter used to connect a camera to a telescope is called "Negative Projection." This method is very similar to "Eyepiece Projection" except a Barlow lens is used instead of an eyepiece. Like eyepiece projection, negative projection is used when the size of an image needs to be increased and is suitable for cameras with removable lenses like a DSLR or a micro 4/3 format camera and cameras that have no lenses like astronomical CCD cameras, planetary imagers, and modified web cameras. Negative projection, like eyepiece projection, is also useful for increasing the back focus of a telescope.

Fig. 3.9 Eyepiece holder

3.6 Mounts

Chapter 2 discussed the mounts typically used by amateur astronomers to visually view the night sky. Except for the manually operated alt-azimuth mounts, including the Dobsonian Mount, these same mounts are useful for astrophotography albeit some are far more useful than others. By far the most capable mount for astrophotography is a computerized German equatorial GOTO mount followed by a computerized alt-azimuth GOTO mount on a wedge. A computerized alt-azimuth GOTO mount is a distant third. A motorized German equatorial mount without a GOTO capability can be used for deep space photography. However, using one requires that the photographer have sufficient astronomy knowledge and skills needed to locate objects in the night sky and to do precise polar alignments without the benefit of a goto mount and its microprocessor.

For PiggyBack Photography, just about any mount is useful including a photographic tripod but unless it is an equatorial mount with motorized tracking, the earth's rotation limits exposure times to very short exposures. Solar, lunar, and planetary imaging are at high magnification and benefit greatly from computerized tracking; however, many people take excellent images on manually operated mounts using web camera or a planetary imager.

Deep space places severe demands upon a mount and its support (tripod or pier). This is the realm of computerized equatorial and alt-azimuth mounts that can not only find very dim, often invisible, deep space objects but can then can keep them stationary in the camera's field of view, preferable for long periods of time. Unfortunately, several factors keep a telescope mount from perfectly tracking an object in the night sky. The two significant factors are imperfections in gear construction and mount alignment. These imperfections limit a mount's ability to track an object for more than a few seconds to a few minutes dependent upon the quality of the mount and its alignment.

Two enemies of astrophotography are vibration and tracking movement. For lightweight mounts and tripods, wind is a major source of vibration. Wind driven vibration is often enhanced by swinging camera straps, power cables, and wobbly tripods.

3.6 Mounts

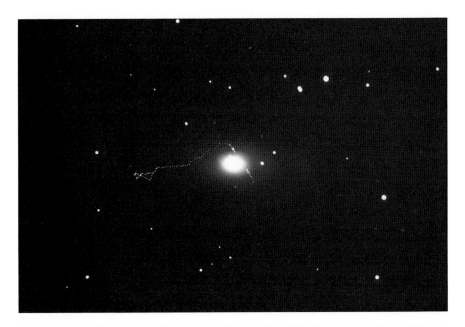

Fig. 3.10 Hot pixel tracking motion

Needless to say, securing all hanging objects is of prime importance as is having a sturdy tripod. Unfortunately, for many lightweight mounts, their tripods are vibration prone. These tripods must be either replaced or modified for the tripods used by Celestron, SkyWatcher, and iOptron for their lightweight mounts.

Mount tracking movement is often a factor that limits exposure times for photography with lightweight mounts and must be measured for each specific mount. Tracking movements originate from two sources. An alt-azimuth mount constantly makes corrections in both azimuth and altitude to keep an object centered in the eyepiece. While to the eye an object may appear stationary in an eyepiece, the camera sees a different reality as the mount moves in small zigzag movements in both azimuth and altitude to correct for the earth's rotation (see Fig. 3.10). The magnitude of this movement must be small to use the mount for photography. On the other hand, an equatorial mount that is properly polar aligned need only to move one axis to keep an object centered and is less constrained by tracking movements.

Figure 3.10 is a photograph that shows the motion of a SkyWatcher SynScan AZ GOTO Mount over a 2 h period using 20 s exposures. In the photograph you will see the core of galaxy M81 with a white dotted track made from a hot pixel on the camera's sensor. Actually in the photo the hot pixel is stationary and the image is moving due to the motion of the mount tracking M81 and field rotation cause by the rotation of the earth. Keep in mind, if you were viewing with your eye, M81 would appear stationary in the eyepiece.

The gearing of the mount is another source of mount movement. Nothing is perfect and gears do not mesh perfectly. This produces a movement that has a repeatable pattern and is called periodic error. Since most azimuth mounts are designed for visual observation only, periodic error is generally more significant than with an equatorial mount. Fortunately while periodic error can be a significant error for long exposure photography, the duration of very short exposures is too short for it to be of major concern.

Another characteristic of alt-azimuth mount movement is associated with the period of time after a goto is completed. The alt-azimuth mounts used by entry level telescopes seem to slowly refine their tracking movements after a GOTO is completed and an object can move in the field of view before appearing to be stationary. This "refinement period" can last a couple of minutes before the mount steadies down. Afterwards, the object actually never is stationary but its movement is such that it is not visible to the eye or sufficient to cause star trails with the camera using very short exposures of 30 s or less. Needless to say, photographing during the time immediately following a GOTO is seldom productive.

Many, lightweight GOTO mounts are capable of significant periods free of motion before an event (tracking movement, vibration, etc.) moves the mount. It is during these periods when exposures can be made. Since we have no way to know when such a period will start or stop, many of our light frames will have star tracking and cannot be used so we make more lights than we actually need. A typical alt-azimuth mount will have a 30–40 % rejection rate due to mount movements. How long can these periods with no motion last? Some alt-azimuth mounts when put on a wedge and polar aligned can achieve exposures of 120 s or more with no star trailing or other movements.

Unguided exposures can have a duration of a few minutes if the mount is precisely polar aligned. If exposures are wanted longer than a couple of minutes, a self-guider is used, either as a standalone device with a built-in microprocessor or by connecting a lap top or personal computer to the telescope. Either method uses a small camera and telescope that is focused on a star near the object being photographed. This star is called the guide star and the small telescope is known as a guide telescope. The self guider detects any apparent movement by the guide star and instantly corrects the mount's movement. Other variations exist that do not require a guide scope but using a guide scope is the most popular method. Before the digital revolution hit astrophotography, guiding was manually done by the astronomer; a very tedious and mind numbing task seldom practiced today.

3.7 Field Rotation

Let's take a look at the Great Nebula in Orion on a December night. Early in the night, the nebula is rising in the east. In the middle of the night it is due south high in the sky, and before sunrise it is setting in the west (Fig. 3.11). Notice also how the nebula seems to point downward when it is in the east and upward when it is in

3.7 Field Rotation

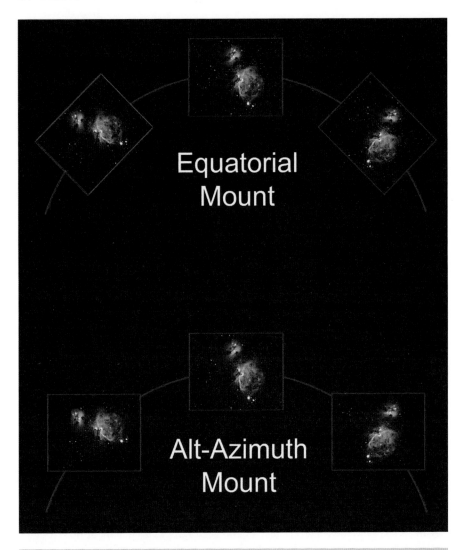

Fig. 3.11 Field rotation and an alt-azimuth mount

the west. Also notice how it stays fixed relative to the arc its path makes through the night sky. Actually the orientation the Orion Nebula is fixed as this apparent motion is caused by the rotation of the earth.

Now let's put two telescopes side by side; one with an equatorial mount and the other with an alt-azimuth mount. Next, let us take three photographs of the Orion Nebula with each telescope; one photograph early in the evening as the nebula is rising, one in the middle of the night when the nebula is high in the night sky, and the other as it is setting to the west as shown in Fig. 3.11. During the photographic

Fig. 3.12 M25 with 2° of field rotation

process, the alt-azimuth mount keeps the telescope orientated to the plane of the earth while the equatorial telescope keeps the telescope orientated to the rotation of the earth.

Now compare the photographs taken with the two mounts. The nebula in the photograph taken with the telescope on the alt-azimuth mount seems to rotate in the photographs as the nebula travels from east to west while the nebula in the photograph taken with the equatorial mount keeps the same orientation in all three photographs. This effect is known as field rotation.

With an alt-azimuth mount field rotation results in stars and other objects moving in arcs around the center of the camera (see Fig. 3.12). The rate of field rotation is dependent upon the latitude of the observer on the earth's surface with a maximum for an observer located on the earth's equator and a minimum, zero, for an observer located at the earth's poles where the zenith and celestial poles are one in the same. In addition, the rate of field rotation is also dependent upon the location of an object in the night sky with the maximum rate occurring at the zenith and the minimum rate toward the eastern and western horizons. Since the location of an object in the sky is constantly changing, the rate of field rotation associated with an object's position is also constantly changing.

With an alt-azimuth mount field rotation will cause objects in a photograph to appear to rotate around the photograph's center. This produces star trails instead of stars and distorts other objects. If an assumption is made that 0.125° of field rotation is not objectionable in a photograph, the time for an object to move 0.125° can

3.7 Field Rotation

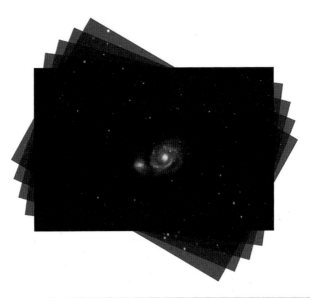

Fig. 3.13 Fanned stack

be calculated for any given latitude on earth if an object's altitude and azimuth are known. This time can then be used as the maximum allowable exposure time to photograph an object from that specific geographic location on earth without having star trails due to field rotation. If the maximum exposure time is calculated for objects at all positions in the sky, these calculations define the area of the sky available for photography using an alt-azimuth mount.

However, even though we can mitigate the impact of field rotation in an image by using a very short exposure, we do not eliminate field rotation. Since the exposure is typically 30 s or less, multiple images are taken and stacked to obtain the final image. Each exposure is slightly rotated from the previous one. Stacking programs adjust for this by rotating the frames until they are aligned then combining them in one final image (see Fig. 3.13). As shown in Fig. 3.12, this rotating produces a fanning effect that causes information to be lost.

Stacked images taken with an alt-azimuth mount typically look soft in comparison to similar images made with an equatorial mount. This is the impact of field rotation. Even though we limit exposure times so that star trailing is not noticeable, field rotation is still present and due to the earth's rotation the image moves slightly while it is taken. This ever so slight movement slightly blurs the image making it not as sharp as images obtainable with and equatorial mount. Exposures taken with a polar aligned equatorial mount do not have these characteristic; thus, there is no fanning during the stacking process and loss of information. For the final image, the stacked image is cropped, either during the stacking process or afterwards during the photo processing phase.

3.8 Telescopes and Exposure Time

Consider any distant deep space object. Except for variable stars, etc., the number of photons an object sends our way statistically remains relatively fixed over time. The total number of these photons that enter into a telescope in any given period of time is constant per unit area of a telescope's light collection area (its primary mirror or lens). Thus, the larger the aperture of a telescope, the greater the total number of photons it can collect. This would seem to indicate that the larger the aperture of a telescope, the better it is for photography. This, however, as we shall soon see is not altogether true. For photographers making the transition to astronomy, please note that in astronomy the term aperture is the diameter of the primary mirror or lens of a telescope.

Recall, one parameter that describes a telescope's optical train is its focal ratio; a measure of image brightness. This has a direct impact upon photography as the brighter the image the more photons that are concentrated on the camera's sensor over any given time; thus, the higher the signal (the picture part) to noise (static) ratio or the shorter the resultant exposure time. In other words, the lower the focal ratio of a telescope, the higher its exposure efficiency for photography.

Typically for astrophotography the exposure efficiency of a telescope is not that important because individual exposure times can be changed to match the telescope. All that happens is the total amount of time needed to obtain an image changes. With lightweight alt-azimuth and equatorial mounts, limits exist for the length of exposure times due to field rotation, mount stability, and, for equatorial mounts, periodic error and the preciseness of the polar alignment. A very short exposure of 30 s or less does not have time to collect many photons so the signal to noise ratio is low. Fortunately, for bright deep space objects like most of the Messier and Caldwell Objects, sufficient photons can be captured by a telescope on a lightweight alt-azimuth or equatorial mount to produce nice images by stacking many frames. As objects become dimmer, the number of photons captured by the telescope and camera decreases and the signal to noise ratio of each frame decreases. A point is reached where the signal strength is too weak and the signal is buried in noise.

With very short exposure astrophotography and its fixed exposure times, the objective is to gather as much information (photons) as possible in the 20–30 s that are available. For example; consider two telescopes of equal aperture; one with a focal ratio of f/5 and the other with a focal ratio of f/10. The telescope with a focal ratio of f/5 will have a smaller but brighter image than the telescope with a focal ratio of f/10. The photons gathered per unit of time are the same for both telescopes. However, the f/10 telescope produces an image that is twice the size of the image produced by the f/5 telescope. Since the number of photons gathered per unit time by either telescope is the same, this implies that the photon density of the image made by the f/10 telescope is one fourth the photon density of the image

3.8 Telescopes and Exposure Time

made by the f/5 telescope. Thus, over any given period of time the f/5 telescope will concentrate four times as many photons per unit area of the camera's sensor than a telescope with a focal ratio of f/10. Adding a 0.63 focal reducer to the f/10 telescope improves its exposure efficiency. However, the f/5 telescope will still be almost twice as efficient; collecting 1.6 times as many photons per unit area of the camera's sensor than the f/10 telescope with a 0.63 focal reducer.

Newtonian telescopes used for photography today can have focal ratios as low as f/4 while nearly all Schmidt Cassegrain Telescopes sold today have a focal ratio of f/10 and the focal ratios of Maksutov Cassegrain telescopes range from f/12 to f/15. Typical focal ratios for refractors are between f/5 and f/8. The high focal ratios of Maksutov and Schmidt Cassegrain telescopes require long overall exposure times. With very short exposure astrophotography, their exposure efficiency is low which has a negative impact upon the quality of the final image. Because telescopes with high focal ratios need longer exposure times they are often referred to as slow telescopes and telescopes with low focal ratios are referred to as fast telescopes. In other words, telescopes are categorized for photography as fast, medium, and slow based upon their focal ratio. A fast telescope has a focal ratio of f/6 or lower, while medium speed telescopes have a focal ratio between f/6 and f/8 and the focal ratio of a slow telescope is higher than f/8.

The performance of both Schmidt Cassegrain telescopes and Maksutov Cassegrain telescopes can be enhanced by attaching a focal reducer to the telescope. The typical focal reducer available today for Schmidt and Maksutov Cassegrain Telescopes theoretically reduces their effective focal length to 63 % of the original length. In reality, the actual result may differ a little. Regardless, the resultant impact upon exposure times is significant as shown by Table 3.1.

Table 3.1 The impact of focal ratio upon equivalent exposure times

Focal ratio	Exposure time (s)	Remarks
f/4.0	20	Baseline
f/5.0	31	
f/6.3	50	f/10 telescope with a 0.63 focal reducer
f/7.6	72	f/12 telescope with a 0.63 focal reducer
f/8.1	82	f/13 telescope with a 0.63 focal reducer
f/8.8	97	f/14 telescope with a 0.63 focal reducer
f/9.5	113	f/15 telescope with a 0.63 focal reducer
f/10	125	
f/12	180	
f/13	211	
f/14	245	
f/15	281	

For the mathematically inclined, here is the equation for calculating exposure times related to changes in focal ratio:

$$En = Eo \left(\frac{fn}{fo}\right)^2$$

where

En is the new exposure time
Eo is the old exposure time
fn is the new focal ratio
fo is the old focal ratio

For example; an image needing an overall exposure time of 45 min with a f/5 telescope will require 28 min with a f/4 telescope, 180 min with a f/10 telescope, 258 min with a f/12 telescope, or 405 min with a f/15 telescope. Add a 6.3 focal reducer and the time needed for exposure drops significantly; from 180 to 72 min for a f/10 telescope and similar reductions for telescopes with higher focal ratios.

Although Schmidt and some Maksutov Cassegrain Telescopes do not require a focal reducer for very short exposure astrophotography work, the quality of the images and the breath of objects photographable are greatly enhanced by using one. In reality, with very short exposures, a 0.63 focal reducer is required to photograph all but the very brightest objects using a DSLR camera with a Schmidt or Maksutov Cassegrain telescope if the photographer wants images having a quality commensurate with the effort required to obtain them.

3.9 Noise Reduction

When we look at the data in a digital image we see two components; signal and noise. The signal is the image we wish to capture and noise is everything else that obscures the signal. Our goal in photography is to capture a photograph that has a very high signal component and a low noise component; in other words, we want an image with a high signal to noise ratio.

To increase the signal to noise ratio of an image we can either increase the signal component of an image or decrease the noise component or both. To increase the signal component of an image we can:

- increase the exposure time
- use a focal reducer to lower the focal ratio of a telescope
- use a faster telescope, one with a lower focal ratio
- use a better camera

To reduce the noise component of an image we can:

- take measures to mitigate artificial skyglow
- decrease camera noise
- use digital processing techniques

3.9 Noise Reduction

There are few options available to astrophotographers that increase the signal component of an image's signal to noise ratio and all must be done before or during the imaging process. One option, obtaining a "better" camera is obvious but typically has financial constraints. The same is generally true for obtaining a faster telescope.

The option to increase exposure time is dependent upon the mount and tripod used for to capture the image as well as skyglow. If the mount is capable of making long exposures (guided or unguided) and skyglow is not excessive, then exposure time can be increased. This allows the gathering of more photons from the object, thus, improving the image's signal component.

Increasing signal strength has a linear relationship with exposure time; doubling the exposure time doubles the signal strength. However, longer exposures also collect more noise. Fortunately noise increases as the square root of exposure time; thus, doubling the exposure time has a net impact of increasing the signal to noise ratio by a factor 1.41 (the square root of 2).

As discussed earlier, a focal reducer can improve image brightness, thus, reduce exposure times. If exposure time is held constant, then adding a focal reducer to a telescope changes the signal to noise ratio proportional to the change in focal ratio; e.g.

$$SNRn = SNRo \times \left(\frac{fo}{fn}\right),$$

where

$$SNRn = new\ signal\ to\ noise\ ratio$$

$$SNRo = old\ signal\ to\ noise\ ratio$$

$$fo = old\ focal\ ratio$$

$$fn = new\ focal\ ratio$$

A 0.63 focal reducer is often used with Schmidt Cassegrain telescopes to reduce their focal ratio of f/10 to f/6.3. For equal exposure times, this improves the signal to noise ratio for the Schmidt Cassegrain telescope by a factor of 1.59. The same relationship exists for telescopes having different focal ratios. If the f/10 Schmidt Cassegrain telescope is replaced with a f/5 short tube refractor, for equal exposure times, the signal to noise ratio produced by the f/5 short tube refractor will be twice that of the f/10 Schmidt Cassegrain telescope.

Decreasing the noise component of the signal to noise ratio is where much effort is spent. As with increasing signal strength, decreasing noise levels starts in the imaging process. Noise has three major sources:

- Camera read noise
- Dark noise
- Shot noise

Camera read noise is electronic noise introduced when the camera converts the analog signal from the sensor to a digital signal for processing. Read noise is independent upon exposure time. Dark noise is noise produced by temperature, defective

pixels, and other sources. It is dependent upon sensor temperature and exposure time; the longer the exposure, the greater the noise. Dark noise can produce patterns in the background due to variances in pixel performance. Shot noise is the variation in signal. In an ideal world, the photon flow from an object would be uniform. In reality, it varies and this variance produces uncertainty as the signal strength randomly varies. Shot noise is also called Poisson noise, photon noise, or statistical noise.

Digital cameras are a major source of noise. Researching digital camera noise can make one wonder how any images are ever made using a digital camera, especially using a DSLR camera. Essentially there are four basic components of noise related to digital cameras:

- noise generated reading, converting, and storing the information captured by the camera's sensor
- thermal noise
- noise caused by sensor defects
- uneven sensor illumination

A digital camera introduces noise each time it reads its sensor. This means that read noise is dependent upon the number, not the duration, of exposures; so, the fewer exposures made; the lower the camera read noise component of the signal to noise ratio. One benefit of longer exposures is that fewer exposures are needed to produce the final image; thus, the impact of read noise is reduced accordingly. With modern digital cameras, read noise is very small and its impact is no longer near as significant as it once was.

Dark noise is caused by the sensor of the camera itself. Some pixels in just about every sensor manufactured do not function properly. This produces colored or white spots that detract from the quality of the image. As the camera is used the sensor becomes very warm and creates patterns of electronic noise that also detract from image quality. Fortunately, a solution, known as dark frame subtraction, exists to mitigate, not eliminate, sensor and thermal generated noise. Another tactic to reduce thermal related noise is to cool the camera's sensor. Most astronomical CCD cameras have built-in solid-state, coolers that keep the sensor cool and relatively noise free. Unfortunately, this is not the case for a DSLR camera.

Uneven illumination of the camera sensor can cause gradients in the images or vignetting. Dust particles (dust motes) on the camera sensor can also create uneven field illumination. These defects are remedied with a process known as "Flat Frame Subtraction."

"Dark frames." Recall, a dark frame is obtained by simply covering the telescope so no light can enter and then making exposures having the same exposure time and ISO setting as the light frames and preferable at the same temperature. Since the telescope is covered and no light can enter, the image produced is the image of the noise produced by flaws in the camera's sensor and thermal impacts. We can then use the dark frame and subtract it from our light frame, thus, remove the noise generated by the camera. This is usually done by the computer program used for the stacking process. Many cameras can also automatically do dark frame subtraction but this feature doubles the amount of time per exposure and its attendant battery

3.9 Noise Reduction

power consumption; neither of which we have an abundance of to waste. The easiest way to make dark frames at the same temperature as the light frames is to simply take the dark frames as you make your exposures. One way is to make ten dark frames per each ISO/shutter speed used for imaging at the beginning of the photographic session, ten in the middle of the session, and the final ten at the end of the session. If temperature variations are small, one simple method to make dark frames is to remove the camera from the telescope, cap the camera body, and let the camera click away as there is no need for it to be mounted on the telescope. How many dark frames should you take? This is controversial but at least 25–30 dark frames for each common ISO setting and exposure time are sufficient so that the dark frames do not inject noise into the light frames; but, more is better. Note: The number of dark frames needed is independent upon the number of light frames.

"Flat Field Frames." Flat field frames are also known as "flat frames." As defined earlier, a flat frame is an image made through a telescope of a uniform white source using the same ISO settings and telescope focus used during the photographic session. One simple method used by many people is to put a white T shirt in front of the telescope, smooth the wrinkles, and use a bright artificial light to illuminate the front of the telescope. Put the camera in the AV mode and let it determine the exposure time. Make at least 25–30 flat frames for each ISO setting used for the light frames. Many photographers who set up before dusk use the western sky before darkness as a light source; conversely, the eastern sky can be used at dawn for a light source. Keep in mind that good flat frames depend upon an uniform light source. If dust particles are a problem, the telescope should be in the same position and focus as used for the imaging session. Flats are not needed if dust motes, vignetting, and gradients are not a problem or if you wish to correct them using photo processing software. If flat frames are not used, then flat dark frames or bias/offset frames are not needed. As with the dark frames, as a minimum 25–30 flat frames are needed to insure that noise is not added to the image; again, more is better.

"Bias/Offset Frames." These frames are the easiest to make. The camera need not be on the telescope or have a lens. Put the camera cap on the body and then set the shutter speed to the fastest speed the camera has and the ISO to the setting used for the light frames. Make at least 25–30 bias/offset frames for each ISO setting. Note: if you use flat dark frames, do not use bias/offset frames.

"Flat Dark Frames." To make a flat dark frame cover the telescope as was done for dark frames and take at least 25–30 exposures for each ISO setting and shutter speed combination used to make the flat frames. Note: If you use bias/offset frames, do not use flat dark frames.

Shot noise is the statistical variance in signal strength over time that is indistinguishable between signal and random noise. Technically skyglow is signal but it is an unwanted signal. Unfortunately, the camera cannot differentiate between photons from skyglow or photons from the object being photographed. Thus, shot noise has two components, uncertainty produced by photons from the object being photographed and uncertainty produced by photons from skyglow. This is especially true for the artificial component of skyglow (light pollution) which can have sufficient intensity to be the major contributor to shot noise.

Table 3.2 The relationship between the number of frames stacked and the improvement in the signal to noise ratio of the image

Signal to noise ratio increase	Number of images stacked
2	4
3	9
4	16
5	25
6	36
7	49
8	64
9	81
10	100

With digital images, several very short exposures can be digitally combined into one final image or to use commonly accepted terminology, several "light frames" can be "stacked" to produce a final image that is the sum of its components. Stacking increases the signal to noise ratio by reducing noise, not by increasing the signal. This is an important attribute to always keep in mind. Stacking will not improve the quality of the signal part of an image. If the signal is not there, no amount of stacking can bring it out.

When we stack two light frames or more, we reduce the noise, thus, increase the signal to noise ratio and improve the quality of an image. This increase in the signal to noise ratio is directly proportional to the square root of the number of frames stacked. If two images are stacked the signal to noise ratio improves by a factor of 1.4. Stacking four images improves the signal to noise ratio by a factor of 2 and nine images are required to gain an improvement of a factor of 3, etc. As shown by Table 3.2 the increase in signal to noise ratio is linear while the increase in the number of light frames required is quadratic.

Keep in mind that each deep space object emits photons that we capture with our camera sensor to produce an image. The rate of photons emitted varies with the brightness of the object. Some objects simply do not emit sufficient photons for a camera to capture much information (signal) with a very short exposure time and many light frames will have a very weak or no signal. If a signal is not present in the majority of the light frames stacked, it is considered noise and rejected. The longer the exposure time of each light frame, the more information is collected and the higher the probability that a majority of the light frames will have a strong signal. In other words, you can get a signal only if your exposure time is long enough to capture it.

Dark frame subtraction, flats, bias frames, stacking, light frames, etc.; all of that sounds complicated and it is. However, most stacking programs perform these corrections automatically if the data is entered into the programs.

3.10 Signal to Noise Considerations

Now, take a look at a few scenarios regarding stacking, exposure time, and noise. Specifically look at impact on noise that comes about by:

- increasing exposure time
- stacking an equal number of light frames having different exposure times
- stacking an unequal number of light frames having different exposure times but the same integrated exposure time

Exposure time has a direct impact upon the signal to noise ratio of an image. Excluding camera noises, the signal component of an individual exposure increases linearly with time while the noise component increases as the square root of the signal. Consider the signal to noise ratio of a short exposure; say 15 s as an example. Let's normalize the example and say the signal and the noise components of the 15 s exposure both equal to one. If the exposure time is increased to 45 s, the signal component of the 45 s exposure will be three times higher than that of the 15 s exposure but its noise component will only increase by a factor of 1.7 (square root of 3). Thus the signal of the 45 s exposure is 3 and the noise component is 1.7 making the signal to noise ratio equal to 1.7. The signal to noise ratio of the 45 s exposure is 1.7 times higher than that of the 15 s exposure. This will remain true no matter what the signal to noise ratio is for the 15 s exposure all else remaining constant.

Keep in mind, stacking reduces noise by a factor equal to the square root of the number of light frames that are stacked. Stacking only reduces noise. The signal component remains constant.

Consider the images from two stacks that are identical except for the exposure time of the light frames. Say, for example, that one image is from a stack of 100 light frames having an exposure of 45 s each (which we can write as 100×45 s light frames) and the other image is from a stack of 100×15 s light frames. Just to normalize the example, assume that the signal to noise components of one 15 s light frame are both equal to one. Since both stacks have the same number of light frames, 100, both will have their noise reduced by the same amount, a factor of 10 (the square root of 100, the number of light frames that were stacked). This does not mean that both will have the same signal to noise ratio however. Recall from our previous example, the signal to noise ratio of a 45 s exposure is 1.7 times higher than that of a 15 s exposure. Since both stacks reduced noise by a factor of 10, the signal to noise ratio of the stack of 45 s exposure is increased ten times from 1.7 to 17 while that of the stack of 15 s light frames is also increased ten times from 1 to 10.

Now look at what happens if we stack two sets of light frames having different exposure times but the same integrated exposure time. In our example of 15 and 45 s light frames, one stack contained 100×45 s exposures and had a signal to noise ratio of 17. The integrated exposure time of this stack is 4,500 s (75 min). To have the same integrated exposure time of 75 min, a stack of 15 s exposures needs 300

light frames. A stack of 300 light frames lowers the signal to noise ratio by a factor of 17; the same signal to noise ratio as the stack of 100×45 s light frames. All other things equal, this holds true for any set of light frames; images for stacks of light frames having the same integrated exposure time have the same signal to noise ratio.

There is one interesting aspect to consider. Recall that stacking only reduces noise, it does not improve signal. Thus, in our example for equal integration time, the signal of the image made from a stack of 45 s light frames is three times higher than the signal of the image made from the stack of 15 s light frames. However, both have a signal to noise ratio of 17. This implies that the noise component of the signal to noise ratio of the image made from the 45 s light frames is three times higher than the noise component of the image made from the 15 s light frames. So, even though the two images have the same signal to noise ratio, they are not equal.

The image made from stacking the 45 s light frames will be brighter with better contrast and definition albeit, a bit noisier than the image from the 15 s light frames. The brighter image also provides more flexibility regarding camera ISO settings.

For our last example, consider our 300×15 s light frame stack with an integrated exposure time of 4,500 s (75 min) and compare it with a stack of 3×25 min light frames. Here again our integrated exposure time is equal, 75 min and our signal to noise ratio is 17. The difference between the two images is the signal level of the 3×25 min stack of light frames. The signal component of a 25 min light frame is 100 times higher than the signal component of a 15 s light frame while its noise component is only ten times higher. A stack of three light frames decreases the noise level by a factor of 1.7 giving an overall noise component of 17, the same as the 300×15 s stack. The difference between the two images is the signal of the 25 min light frame stack is 100 times higher than that of the 15 s light frame stack. The two images definitely are not equal. This is why many astrophotographers spend the money they spend for heavy duty, precise tracking, German equatorial mounts.

Frequently you will hear people maintain that stacking more than 25 light frames does not produce a meaningful improvement. This is probably true for long exposures that are measured in several tens of minutes or hours. However it is not true for very short exposures. Consider two images of the same object with one made from 25 light frames having a 5 min exposure time and another made using light frames having an exposure time of 30 s. All else equal, a stack of 250 light frames having a 30 s exposure time is needed to obtain the same signal to noise ratio provided by a stack of 25 light frames having a 5 min exposure times.

The question is where is this all leading? The point is the signal component of an image. Stacking cannot increase it. If the photons from an object are not sufficiently numerous enough to be seen as a signal, no amount of stacking will produce a usable image. While stacking will not improve the signal, it will lower noise to acceptable levels and excellent images are produced.

Like exposure time, the focal ratio of a telescope also has a significant impact upon very short exposure astrophotography. Consider two images, each having identical exposure times; one taken using a telescope with a focal ratio of f/5 and the other taken using a telescope with a focal ratio of f/6.3. All other things being

equal, the signal to noise ratio of the image made with the f/5 telescope will be 1.26 times greater than the signal to noise ratio of the image made with the f/6.3 telescope. Again, all other things being equal including exposure time, a stack of 100 lights made with a telescope having a focal ratio of f/5 will have the same signal to noise ratio as a stack of 126 lights made with a telescope having a focal ratio of f/6.3 or 200 lights made with a telescope having a focal ratio of f/10. (Note: f/6.3 is typical of a f/10 Schmidt Cassegrain telescope with a focal reducer).

Images of deep space objects made with very short exposures are underexposed due to their short exposure times. Exposure time and telescope focal ratio have a major impact upon the signal to noise ratio, thus, the quality of images produced. A small variance in either or both can produce a significant change in the signal strength and the signal to noise ratio of images taken using very short exposures.

3.11 Histograms

A histogram is a graphical presentation, typically in the form of a bar graph, of a distribution of data based upon the frequency of occurrence (see Fig. 3.14). The vertical axis of the graph represents the frequency of occurrence and the horizontal

Fig. 3.14 Histogram

axis represents the value of the variable being analyzed. The width of the bar graph represents the breadth of the variable plotted. For photography, the horizontal axis measures the tone of an image with black at the left end and white at the right end. The vertical axis measures how many pixels have a particular tonal value. The width of the histogram represents the breath of values between black and white contained by an image. The histogram of an under exposed image will be toward the left side (black) of the tonal scale while that of an over exposed image is to the right side (white) of the tonal scale. A histogram that has poor contrast is tall and narrow.

The histogram of a typical 30 s exposure of a nebula or galaxy will be very tall and extremely narrow; typically all the way to the left border (black) as they are chronically underexposed and have poor contrast. A 60 s exposure will be somewhat better and may have a very small gap between the histogram and the left border (black). It will remain tall but will be slightly wider. Sometimes the histogram of a very short exposure seems as if it is only one very thin vertical line directly adjacent to the left border of the histogram.

3.12 Image Size and Field of View

You will often hear the term "field of view." Basically this is the size of the area you can see in a telescope or photograph with a camera. In optics, the field of view is typically expressed as an angular measurement and is calculated using the following formula:

$$a = 2\tan^{-1}(d/2f)$$

where

a is the angle of the field of view in degrees
d is the diameter of the field of view in millimeters
f is the focal length of the optical device in millimeters

Note that this describes a circle such as is seen when viewing through a telescope. For photography, film and digital sensors are typically rectangular. For a digital sensor to be fully exposed to the image, its rectangular foot print must fall within the circular field of view. If not, vignetting will occur. If we substitute the dimensions of a camera sensor or film frame in the above formula, we can calculate the resulting rectangular field of view as follows:

$$Ax = 2\tan^{-1}(x/2f)$$

where:

Ax is the angle of the field of view in the x dimension in arc degrees
x is the x dimension (length) of the digital sensor or film frame in millimeters
f is the focal length of the telescope in millimeters

3.12 Image Size and Field of View

and

$$Ay = 2\tan^{-1}(y/2f)$$

where:

Ay is the angle of the field of view in the x dimension in arc degrees
y is the x dimension (length) of the digital sensor or film frame in millimeters
f is the focal length of the telescope in millimeters

As with camera lens fittings, no standardization regarding digital sensor sizes exist among the camera manufactures. However, for a DSLR the variation is not great. Two similarly sized sensors are used; a full frame sensor or a smaller APS-C size sensor. A full frame sensor is approximately the same size as 35 mm film frame while the smaller APS-C sensor is about 60 % the size of a full frame. Full frame sensors are approximately 36×24 mm and the smaller size sensors are approximately 22×15 mm. The smaller sensors are called APS-C sensors (Advanced Photo System-Classic) which is a term borrowed from the days of film cameras that had film frames of similar size.

From the two equations above, notice that the angle of the field of view in either dimension is dependent upon the telescope's focal length and the width or length of the sensor. Table 3.3 provides the dimensional angular field of views for a full frame and a typical APS-C camera attached to telescopes with different focal lengths.

A relationship exists between focal ratio and image brightness. Recall that the focal ratio is obtained by dividing the focal length of a telescope by its aperture and that the lower the focal ratio the smaller but brighter the image. This implies that a small aperture telescope with a low focal ratio, say f/5 is better for astrophotography than a large aperture telescope with a higher focal ratio, say f/10. For any given sensor, the longer the focal length of a telescope, the larger the image. Tying this to the field of view, we see that the shorter the focal length of a telescope, the larger the field of view. Thus, a short focal length telescope will have a small image size

Table 3.3 Field of view in angular degrees

Telescope focal length (mm)	Full frame sensor (35.8 mm × 23.9 mm)		APS-C sensor (22.2 mm × 14.8 mm)	
	Width	Height	Width	Height
400	5.12	3.42	3.18	2.12
600	3.42	2.28	2.12	1.41
800	2.56	1.71	1.59	1.06
1,000	2.05	1.37	1.27	0.85
1,250	1.64	1.10	1.02	0.68
1,500	1.37	0.91	0.85	0.57
2,000	1.03	0.69	0.64	0.43

and a large field of view. Conversely, a telescope with a long focal length will have a larger image and smaller field of view. Which is better? Neither; the answer depends upon what you want to photograph. The long focal length telescope is better suited for small objects benefiting from magnification while the short focal length telescope is better for large objects that cover a wide area of the night sky.

Now consider two telescopes with a focal ratio of f/5 but with one telescope having an aperture of 100 mm and the other having an aperture of 200 mm. The focal length of the 100 mm f/5 telescope will be 500 mm and the focal length of the 200 mm f/5 telescope will be 1,000 mm. The images in both telescopes will be equally bright and require the same exposure time. However since the focal length of the 200 mm telescope is twice the focal length of the 100 mm telescope, the image made with the 200 mm telescope will be twice the size of the image produced by the 100 mm telescope but the field of view will be half that of the smaller telescope.

What does this mean in practical terms? Both of the two f/5 telescopes are equally well suited for imaging most deep space objects. However some deep space objects have a very large apparent size that exceeds the field of view provided by a fast, large-aperture telescope. A fast, small-aperture telescope with its larger field of view is better suited to image these objects. On the other side of the coin, many objects have a small apparent size. Here a fast, large-aperture telescope is advantageous.

Regardless of whether a camera has a full frame or APS-C sized sensor, the field of view of either has a proportion of 1–1.5 which corresponds to a 5×7.5 in. or an 8×12 in. image. How does this relate to the size images we can print and have good resolution? Modern DSLRs will have sensor sizes of 12,000,000 pixels or more. But for this discussion let us assume that we are using an older Canon Rebel EOS XS(1000D) camera that has a sensor with 10.0 megapixels. Publishing companies typically require an image resolution of 300 dots per inch (12 pixels per mm) and the lowest resolution for printing acceptable photographs is about 150 dots per inch.

Table 3.4 provides the maximum image print size at 150 and 300 dots per inch for several popular DSLR camera sensor resolutions. At 300 dpi the largest image size for a 10.0 megapixel sensor is 8.6×12.9 in. The equation used to calculate the maximum image print size versus sensor resolution is as follows:

$$x = \frac{\sqrt{S/R}}{D} \text{ and } y = Rx$$

where

x is the image height in inches
y is the image width in inches
D is the image resolution in dots per inch
S is the sensor size in pixels; note: megapixels times 1,000,000
R is the ratio of the camera sensor's width and height

Table 3.4 Maximum print size versus sensor and printer resolution

Camera sensor resolution (megapixels)	Print resolution (150 dots per inch) (6 pixels/mm)				Print resolution (300 dots per inch) (12 pixels/mm)			
	Inches		Centimeters		Inches		Centimeters	
	Height	Width	Height	Width	Height	Width	Height	Width
10.0	17.2	25.8	43.6	65.6	8.6	12.9	21.8	32.8
12.0	18.8	28.2	47.8	71.6	9.4	14.1	23.9	35.8
14.0	20.4	30.6	51.8	77.6	10.2	15.3	25.9	38.8
16.0	21.8	32.6	55.4	82.8	10.9	16.3	27.7	41.4
18.0	23.0	34.6	58.4	87.6	11.5	17.3	29.2	43.8
20.0	24.4	36.6	62.0	92.8	12.2	18.3	31.0	46.4

3.13 Focusing a Digital Single Lens Reflex Camera on a Telescope

A good focus is the foundation of an astrophotograph regardless of the camera used or the object photographed. It is also challenging to obtain requiring both knowledge and skill, especially skill. Two basic ways exist to focus cameras; "trial and error" imaging or "live view." Regardless of the method used, spend time focusing until you are confident you have achieved the best possible focus attainable with the equipment and conditions present. Also don't forget to install any filters you plan to use before you focus.

Trial and error is seldom used today. Broadly speaking, trial and error is exactly that, trial and error. The photographer takes an image and then uses either the camera's review screen or a computer display to see if the image is focused. If the image is not focused, the focus is blindly adjusted and another image is made and reviewed to see the results. This process is repeated until a sharp focus is obtained. Needless to say, it is as tedious and time consuming as it appears. There are "tricks of the trade" that simplify the process somewhat but none make it easy. Fortunately with modern cameras or software, trial and error is mostly a thing of the past.

Modern cameras have a live view capability that greatly simplifies the focusing process. Dedicated astronomy cameras; whether they are web cameras for planets, video cameras for video astronomy, or astronomical CCD cameras for deep space; display the image they see real time on a computer display or, for video cameras, a television screen. This allows the photographer to see in real time the object being focused on a screen and instantly observe any changes made by adjusting the telescope's focus. Modern DSLR cameras also have a live view capability and use the camera's review screen to display the image. This eliminates the need for a computer to display the image although one can be used if the photographer so desires.

Focusing a modern DSLR camera with live view is relatively easy to do. The first step is to find a star bright enough to see on the live view screen; typically this will be a magnitude 1 or brighter star. The star must be first focused through the

Fig. 3.15 Bahtinov mask

camera's view finder else it most likely will not be visible on the live view screen. Once the star is acquired on the live view screen, the display magnification is increased to the maximum the camera is capable of doing; usually 10×. The telescope focuser is then adjusted until the finest focus is attained.

This last step, fine focus, is dependent to a large extent upon the skill of the photographer and the quality of the equipment used. It is also dependent upon seeing conditions and the location of the star used as the focusing star. A little patience is golden when focusing. If you must wear eyeglasses wear them. Fiddle around going in and out of focus until in your mind you record the smallest star image obtainable with the given seeing conditions and star location. This lets you know where the focus spot is located and what it looks like. After that, focus the scope. Don't hesitate to repeat the effort if you think you missed the focus spot. Try to focus with the focuser tube or mirror moving inward. This lets gravity deal with any backlash in the focuser mechanism. After achieving focus, lock the focuser in place if your telescope has that feature.

Some photographers like to use a Bahtinov mask when they focus (see Fig. 3.15). The mask allows the photographer to know exactly when the telescope reaches focus. A Bahtinov mask produces a diffraction pattern around the star used for focus. This diffraction pattern is composed of one set of diffraction spikes that are stationary and another set that moves when the telescope focus is changed. The telescope is focused when the moving diffraction spikes are centered in the stationary pattern of diffraction spikes. An internet search "Bahtinov mask" will turn up sites that manufacture and sell the mask, sites that have free software you can download that will design a mask specifically for your telescope so you can make the mask if you are handy with an EXACTO knife, and sites that describe in detail how to use the mask. The mask is fairly easy to use with medium and large aperture telescopes but can be tedious with smaller apertures, especially when filters are used. With a small aperture telescope, especially if a filter is used, the diffraction

spikes may not be visible. If this is the case, focus the best as possible with live view and then make and review an image of the star. This can make the diffraction spikes visible. At this point, revert to "trial and error" focusing until you center the moving diffraction spikes in the stationary ones.

Achieving a fine focus is difficult if the focuser is stiff which is typical of the focusers of many lower priced telescopes. Two speed crayford focusers are preferred by many astrophotographers because of the smooth movements and the ability to make minute adjustments in focuser movements. A shaky tripod adds to the difficulty as well.

The process, including using a Bahtinov mask, used to focus a DSLR camera using its live view feature is also applicable to web cameras, video cameras, and astronomical CCD cameras as well. Since these cameras require a computer in the field, computer programs are available to assist the focusing process.

3.14 Planning to Insure a Successful Imaging Session

One way to photograph an object in the night sky is to look at the effort required as a project and plan accordingly. Photographs of deep space objects require a considerable time obtaining the actual images and then processing them later. Planning helps prevent some nasty surprises such as too small or too large an image size, excessive noise, running out of camera memory in the middle of the photographic session, etc.

A plan to insure a successful imaging session has two major components; logistics and execution. Logistics covers all the activities that need doing prior to the imaging session while execution covers the actual imaging of the object. Execution is dependent upon the equipment used and is addressed in later chapters. Here, the logistic aspects are addressed by asking the following questions:

- What object will be photographed?
- What is needed to photograph the object?
- Is your equipment suitable to photograph the object?
- What are the characteristics of the location where you will make the photograph?
- When, date and time, is the object best situated in the night sky for your equipment and observing site?
- Are all the components of your astrophotography kit present and in good working order?
- Are all batteries charged?

The above questions are self-explanatory but the answers are not always simple. Don't worry if they are not clear at the moment. The issues involved are discussed further on. While astrophotography can be intimidating at first, none of it is rocket science, so to speak.

The obvious first step is to determine what object to photograph. Two ways exist to approach this question. One approach is to identify some object that is of particular

interest to you and then determine the best date to photograph it. Another approach is the case that some particular date in the future is available and you need to find an object to photograph.

The next two questions; what equipment is needed and is your equipment suited; are related. Each deep space object has its own characteristics. Three, of particular importance for astrophotography, are:

- the amount of light an object emits
- the kind of light an object emits
- the apparent size of an object as seen from earth

Is the image bright enough for our particular telescope, camera, and mount to capture an image of it? Will the use of a filter enhance the photograph? Is the image size produced by our camera and telescope too large or too small to produce an interesting photograph? The answers to these questions determine if the image is a suitable object to photograph with the available equipment.

Not all locations are created equal. Some are nice and dark, others are within the glare of bright artificial lighting, some have trees, hills, or buildings blocking the view of parts of the night sky, and the story continues. These site dependent factors also impact what can be photographed the best date and time for the imaging session.

The last two questions are obvious. Is all the equipment needed present and accounted for, is it all in good working order, and are all the batteries charged. Forgetting something seeming as unimportant as a visual back ruins the entire night. The only options are to pack up and go home or to pull out the trusty binoculars and scan the night sky.

These simple steps are not that difficult or time consuming to do and will help prevent a major disappointment. Appendix A is an example you can use for planning a photographic session. Some people may think that the approach is overkill and perhaps it is. You are free to alter the planning phase as it suits you and your situation. However, keep in mind that astrophotography pushes the limit of photography and that very short exposures using lightweight kits pushes the envelope regarding astrophotography.

3.15 Light Pollution

Today many, perhaps most, amateur astronomers, live in urban areas with light polluted skies. The contribution from artificial lighting greatly increases the amount of skyglow. Unfortunately, we cannot discriminate between skyglow and the signal part of an exposure as the two look the same to our cameras; thus, skyglow is treated as if it were part of a signal. This effectively establishes a limit to what can be photographed. Does this mean that astrophotography cannot be done in urban areas? No, but it does mean that urban photographs will have less details and contrast than photographs taken from a dark spot and, dependent upon the object's

3.15 Light Pollution

luminance, may not be obtainable at all. While natural or fabricated light screens can mitigate the impact of direct lighting, they have no impact upon the natural or artificial components of skyglow. This leaves three basic options to combat skyglow:

- travel to a dark location
- decrease exposure time
- use a narrow or broad band light pollution filter

For most urban astronomers traveling to a dark location is not possible leaving them the option of learning to co-exist with our light polluted skies. Reducing exposure times and increasing the number of exposures made is one tactic employed by urban astronomers. Another that is effective, especially for emission nebulae, is the use of light pollution filters. These interventions are the subject of Chap. 8.

Chapter 4

Very Short Exposure Astrophotography

4.1 Introduction

What is very short exposure astrophotography? Ask this question to a group of astrophotographers and you will get a variety of answers as there is no definitive definition. Answers range from as long as a minute down as short as 1 s with 20 to 30 s being a frequent answer. For this book and the concept of "Astrophotography on the Go," the term "very short exposure astrophotography" is defined as photographs of deep space objects made by stacking light frames having exposure durations of 60 s or less. This definition is not entirely arbitrary. Sixty seconds represents the duration of unguided exposures consistently obtainable with light weight equatorial mounts currently available while mount characteristics and field rotation limit alt-azimuth mounts to between 10 and 30 s. There is no lower boundary to the exposure time but images below 10 to 15 s typically have very poor signal to noise ratios.

This raises an additional question. What is a lightweight and portable mount? Again, there is no real definition. For the purposes of this book, a lightweight and portable mount is a computerized goto mount with tripod that:

- weighs no more than 7.5 kg (16.5 lbs) including the tripod and counter weight, if applicable
- is easily separated into two or more components
- has a standard dovetail saddle (Vixen dovetail)
- has a collapsible tripod with extendable legs

In comparison, the weight of a traditional computerized German equatorial goto mount and tripod typically used by amateurs varies from a low of about 40 pounds (18 kg) to well over 100 pounds (45 kg). Advanced level alt-azimuth mounts are also heavy and bulky. In addition to the weight and bulk, many alt-azimuth mounts are specifically designed for one particular telescope and the OTA cannot be easily separated for packing and transport.

Lightweight mounts that meet the compactness and portability needs of "Astrophotography on the Go" are thoroughly discussed in Chaps. 12 and 13. All that is needed at the moment is to understand that lightweight and portable equatorial and alt-azimuth mounts cannot track objects for long periods of time. Typical maximum exposure times are between 45 and 75 s for an equatorial mount and 10 to 30 s for an alt-azimuth mount. To work around these restrictions astrophotographers use very short exposure techniques that are discussed in this chapter.

4.2 Telescope Characteristics for Very Short Exposures

Often in books and on the internet forums we read that the telescope is the least important part of the astrophotography triad, last after the camera and mount. For very short exposure astrophotography this analogy does not hold true; the telescope is as important as the mount; perhaps even more so.

As previously discussed, the camera is operating at its edge of capabilities with very short exposures. The signal to noise ratio is low and mount limitations preclude increasing exposure time to increase signal strength. Mount limitations also place limits upon the total weight of the telescope and camera used.

For this scenario the focal ratio of a telescope is of major importance as is its size and weight. Given the very short exposure times allowed, a telescope with a fast focal ratio of f/5 or less produces images having a higher signal to noise ratio than obtainable from telescopes having a medium focal ratio between f/6 and f/8. The signal to noise ratio of images produced by slow telescopes (a focal ratio higher than f/8) limit these telescopes to the very brightest deep space objects.

Weight is another important attribute. Ten pounds is the maximum weight for an OTA used with a lightweight alt-azimuth mount and tripod and 6 pounds for an OTA used with a lightweight equatorial mount. Refractor telescopes, especially apochromatic telescopes can be heavy. The same is true of Maksutov Cassegrain telescopes with their thick corrector lens.

The Maksutov Cassegrain telescope is a popular telescope and available on today's market with apertures ranging from 90 to 190 mm. However, it is not particularly suited for very short exposure astrophotography. While many very bright deep space objects, particularly double stars and star clusters, can be photographed with a Maksutov Cassegrain telescope, images of nebulae and galaxies made using very short exposures are often disappointing. This is because the focal ratio of these telescopes is high varying from f/11.8 to f/15.

As was shown in Chap. 3, Table 3.1; while a focal reducer can greatly improve the situation for a Maksutov, the resultant focal ratio is still slow for very short

4.2 Telescope Characteristics for Very Short Exposures

exposure work. The images produced even with a focal reducer will not have the quality of images produced with telescopes having significantly lower focal ratios. On the plus side, Maksutov Cassegrain telescopes do not have issues with chromatic aberration and keep their collimation. Because of the long focal length associated with the Maksutov Cassegrain telescope design, they are useful for imaging small but bright deep space objects and as well as solar system objects.

Schmidt Cassegrain telescopes typically have a focal ratio of f/10. Again, this is slow for very short exposure photography but it is sufficient to produce images comparable to images made using a Maksutov Cassegrain telescope with a focal reducer. The addition of a 0.63 SCT focal reducer reduces the focal ratio of a Schmidt Cassegrain telescope to f/6.3 which is well suited for very short exposure astrophotography for a wide range of deep space objects. Like the Maksutov Cassegrain telescope, chromatic aberration is not an issue with the Schmidt Cassegrain telescope.

In today's market, the selection of Schmidt Cassegrain telescopes that can fit on a lightweight mount is rather limited. Meade has one 6 in. Schmidt Cassegrain telescope available that comes bundled on its Light Switch mount. Celestron has a 5 in. and a 6 in. Schmidt Cassegrain telescope available either as an OTA or bundled with one of its VX, SE, or Prodigy mounts. The 5 and 6 in. Schmidt Cassegrain telescopes currently available have ample back focus with plenty of room for accessories including a focal reducer.

At one time Meade produced a 4 in. (102 mm) Schmidt Cassegrain telescope, the Meade 2045/2045/LX3, which shows up on the used telescope markets from time to time. This telescope does not have the back focus associated with larger SCTs but is able to achieve focus with a DSLR camera at prime focus and with a 0.63 focal reducer. It is very light weight and an ideal OTA for light weight mounts and tripods. All but the last model, the 2045 D, have a tripod mount fitting as a standard feature; thus, attaching a camera dovetail to it is easily done.

A fast Newtonian telescope is ideal for very short exposure astrophotography. Like the Schmidt and Maksutov Cassegrain telescopes, Newtonian Telescopes do not exhibit chromatic aberration. Unfortunately many Newtonians do not have sufficient back focus to allow a DSLR to come to focus when used at prime focus. This is especially true for Newtonians that are small and light enough to be carried by a light weight mount and tripod. Currently, one 130 mm, f/5 Newtonian designed for astrophotography is available in Europe as an OTA only and none are available in the United States. This is the SkyWatcher Explorer 130P DS.

In the United States, Newtonian telescopes have little application for very short exposure work using a lightweight mount, not because of any design deficiencies but because of how telescope manufacturers make and sell them. Essentially, someone in the United States who wants to use a Newtonian telescope on a lightweight mount for very short exposure astrophotography has four options:

- Design and build an OTA specifically for astrophotography
- Modify an existing OTA by moving the primary mirror a short distance to decrease the distance between the primary and secondary mirrors

- Use a micro 4/3 format camera
- Order a SkyWatcher from Germany The shipping charges from Germany are quite reasonable even crossing the Atlantic to the USA.

In the world of very short exposure astrophotography, refractor telescopes are very attractive; especially short tube refractors with focal ratios around f/5. However, refractors tend to be heavy for their size in comparison to other types of telescopes and can have problems with chromatic aberration. Refractor options are plentiful ranging inexpensive short tube achromatic refractors that cost a little more than $100 to apochromatic refractors costing several thousand dollars or euros. When selecting a refractor, the first consideration is to decide if you want to tolerate chromatic aberration or not as this will determine if you purchase an apochromatic or an achromatic telescope. Keep in mind that while apochromatic refractors do not have chromatic aberration, they cost much more that an achromatic refractor and typically weigh significantly more. Also keep in mind that, for visual work with an achromatic refractor, a "fringe" filter works very well to reduce chromatic aberration; however, these filters are not effective when used for imaging.

Perhaps one of the most difficult aspects associated in selecting a telescope for astrophotography is "what size aperture to choose?" Telescopes with apertures as small as 55 mm are used for imaging deep space. Small aperture telescopes typically have short focal lengths, thus, small images. Even though their images can be digitally expanded, there is a limit and telescopes with short focal lengths have difficulty producing medium to large size images of objects having a small apparent size such as the Cone Nebula. On the other hand, they do very well for objects that have a large apparent size such as the Rosetta Nebula. Telescopes with large apertures are heavy but have longer focal lengths and produce larger images. They do very well for objects that have a small apparent size and less so for objects covering a large area of the sky. Regardless of aperture or focal length, for very short exposure astrophotography, a telescope's focal ratio is the important attribute; the lower the better.

Here are three telescopes suitable for very short exposure astrophotography with either a light weight alt-azimuth or an equatorial mount that are excellent ones to consider:

- the Synta 80 mm f/5 short tube achromatic refractor (Orion ST-80A or SkyWatcher StarTravel 80)
- the Celestron C5 125 mm f/10 Schmidt Cassegrain telescope with a 0.63 focal reducer
- SkyWatcher Explorer 130P-DS 130 mm f/5 Newtonian telescope

The Synta 80 mm f/5 short tube refractor with tube rings and a dovetail and finder weighs just over 4 pounds (1.9 kg). Its price is about $200 with tube rings, dovetail, finder, diagonal, and eyepieces but is often on sale for $160. This short tube refractor has surprisingly low levels of chromatic aberration for visual work but will exhibit blue fringes on bright white stars in photographs. The Celestron C5 Schmidt Cassegrain telescope weighs 6 pounds (2.7 kg) with a 0.63 focal reducer,

dovetail, and finder. The C5 produces images free of chromatic aberration, and is a viable alternative to an expensive apochromatic refractor. The price of the C5 is around $600 (including a focal reducer, finder, diagonal, visual back, dovetail, and eyepiece). The SkyWatcher Explorer 130P-DS is sold as an OTA for 200 euros complete with a 2 in. dual speed Crayford focuser, guide scope, tube rings, and dovetail. It weighs 8.8 pounds (4 kg). The 130P-DS is designed specifically for prime focus astrophotography with either a DSLR or CCD camera. Being a Newtonian telescope, chromatic aberration is not a factor. A coma corrector is available for 130 Euros. The 130P-DS is not available in the United States but can be imported from Germany.

4.3 Mount and Tripod Issues with Very Short Exposure Astrophotography

Very short exposures allow astrophotographers to obtain images of deep space objects using very basic, entry level, lightweight mounts and tripods. Using such equipment presents several issues that must be addressed before attempting to photograph deep space. Unless these issues are addressed, mount movements and vibration will render most light frames useless and make the photographic process very frustrating. Our objective is produce light frames of sufficient quality to be able to stack at least 60 % of them. While this percentage may seem low, given the short exposure times involved, it does not represent a huge loss in overall time of an imaging session.

The tripod is the weakest link associated with lightweight mounts and tripods. All the tripods on lightweight mounts, except the Celestron SE series tripods and the SkyWatcher EQ3 tripod, have essentially the same weakness; droop and vibration. Some simple modifications greatly improve the performance of these tripods. These modifications are easy, inexpensive to do, and do not require any special tools or skills. While the modified tripods are not rock solid, they are sufficient for astrophotography and very satisfactory for visual work. Details of the required tripod modifications are provided in Appendix B.

Lightweight alt-azimuth goto mounts including the Celestron and iOptron alt-azimuth/equatorial mounts do not have the precision gearing associated with mounts designed for astrophotography. This creates two issues; periodic error and tracking accuracy. There really is no fix for these two issues; however, some mitigation measures are available to reduce their impact such as:

- carefully level the mount with the plane of the earth
- use a reticle eyepiece to precisely center alignment stars
- balance the OTA and camera on the mount
- enter the observing site's coordinates as accurate as possible
- enter the time synchronized with Universal Time with no more than a 5 s error

- Do not use alignment stars low on the horizon, near Polaris for equatorial mounts, or near the zenith for alt-azimuth mounts.
- Do not use solar system objects for mount alignments.

The objective of the above actions is to obtain an accurate as possible mount alignment in order to reduce the rate that the object drifts during the exposure and to reduce the magnitude of corrections made by the drive motors. The impact of any one of the above is admittedly very small but the aggregate of all, while still small, makes them worth the doing.

4.4 DSLR Camera Considerations

Very short exposure astrophotography operates on the edge of the capabilities of modern DSLR cameras. A 15 to 30 s exposure of a faint deep space object is under exposed; often almost buried in noise. Needless to say, a camera with excellent low light sensitivity and very low internal noise characteristics is needed. Of secondary importance is weight. While weight is always a consideration in astrophotography, it is especially relevant when using lightweight mounts that have very limited payload capacities.

Most DSLR cameras provide a histogram of each image obtained. This histogram is easily reviewed on the camera's view screen. Ideally, photographers can adjust the exposure time so that the histogram of the image is separated from the left border where noise (unwanted signal) is located. With very short exposures, very few objects have sufficient brightness to separate the image from the noise; especially images made using an alt-azimuth mount. Often, all the histogram shows is a thin vertical band at the very edge of the left border. This indicates that the signal is nearly buried by noise or, in other words, has a very low signal to noise ratio.

Unlike traditional astrophotography, this very low signal to noise ratio cannot be remedied by increasing exposure times. The limitations of lightweight alt-azimuth mounts do not allow this option as exposure times are essentially fixed by the mount's characteristics and by field rotation. With a lightweight equatorial mount, some leeway in exposure time may exist dependent upon the mount's tracking abilities and the accuracy of the polar alignment; however, it will not be substantial. This leaves but one alternative for most situations; adjust the camera's ISO setting. Keep in mind that increasing the ISO setting will amplify the signal but will also amplify noise.

What ISO setting should you use? The typical answer to this question is use a low ISO setting. This may be true for traditional astrophotography but is rarely true for very short exposure photography. The answer is dependent upon the camera, the exposure time, and the apparent magnitude of the object being photographed. The proper setting requires some experimentation and will come with experience. Too high an ISO setting and data can be discarded. This discarded data removes color from stars making them appear stark against a dark background, blows out centers of galaxies, etc. Too low an ISO setting can bury details and produce banding and

4.4 DSLR Camera Considerations

other artifacts in dark areas of the image such as the night sky. With exposures of 30 s or less, the probability of a signal being sufficient to discard data at a high ISO setting is low for all but the brightest deep space objects while the probability of buried details and banding from too low an ISO setting is fairly high.

Fifteen to thirty seconds is not a long time to collect a lot of photons. With a low ISO setting, the darker areas of an image will lack contrast and can exhibit banding and other read noises. Stars will be very dim. These issues are normally addressed during processing; however, the dim stars create an issue that processing cannot address. At a low ISO setting, stars can be too dim for a stacking program to recognize and the program will not stack the light frames. In other words, a night's work is down the tubes. Sometimes, converting each light frame into a "TIF" file and then stretching each one a little will salvage the night's work. Many DLSR camera come bundled with a program that will do the conversion and stretching as a batch process.

The other argument against using a high ISO setting is that high ISO settings amplify random noise. For traditional astrophotography where a stack of 20 light frames is considered a large stack, the increased noise is a valid issue. A stack of 25 light frames will reduce random noise by a factor of 5; thus, may not be sufficient to handle the additional noise added by a high ISO setting. However for very short exposures astrophotography, stacks typically vary between 100 and 400 or more light frames. Such large stacks reduce random noise by a factor of 10–20 negating the increased noise issue at high ISO settings to a great extent. Thus, for very short exposures, the increase in noise associated with a higher ISO setting is not near as significant as it is for longer exposures.

Look at it this way. The major differences are the higher ISO image will have more random noise and can be over exposed while the darker areas of an image made at the lower ISO setting will lack contrast and can exhibit banding and other read noises. Keep in mind that details can be recovered from an underexposed image but not from an over exposed one. On the other hand, having light frames that will not stack cannot be worked around. Also a very short exposure of a deep space object is not likely to collect sufficient photons to exceed the full well capacity of the sensor in a modern DSLR camera.

A good starting point is an ISO setting of 800 or 1600. If you are experiencing difficulty with stars or the light areas in your images are blooming, then perhaps you should use a lower ISO setting. If your images of deep space objects are acceptable but dark areas such the black night sky are noisy, with or without bands, or if you are having difficulty stacking because the stacking program cannot detect a sufficient number of stars, use a higher ISO setting. In a short time, you will know what ISO setting does best for your equipment and imaging techniques.

The sensors in digital cameras generate significant amounts of heat when they are in use. Unlike most astronomical CCD cameras that have built-in solid state coolers, DSLR camera chips are not cooled. One area of debate related to DSLR cameras is whether or not to allow the sensor and its internal power supply to cool between exposures. While this debate is less relevant for modern DSLR cameras, especially for Canon cameras with their low thermal noise characteristics, it

remains an issue. One side of the debate contends that allowing 30 to 60 s or so between exposures lets the camera chip cool and reduces thermal noise.

The other side maintains that since the sensor and its power supply are enclosed the amount of cooling over a short period of time is not significant and only increases the amount of time needed for the imaging session. They further maintain that the sensor temperature reaches a steady state point and then stabilizes; thus, it can be removed by dark frame subtraction if the dark frames are made while the camera's sensor is still hot.

For very short exposure astrophotography, allowing an extended cool down period between exposures is not that practical. Consider that upward of 100–400 light frames are needed to obtain a sufficient number to produce an acceptable image. Typically a 5 s pause is used between exposures to let the camera do its internal processing. This means that 2–3 h are needed for imaging. A 30 s cool down period between exposures extends the imaging time to as much as 5 h.

Very short exposures are taken with a DLSR in the manual mode. Camera settings in the manual mode are camera specific as are terms used to name functions. However, the principle remains the same regardless of the make and model of the camera. Here are some typical settings that may be useful for making very short exposures:

- Image quality: raw
- Redeye: off
- Review time: off
- Auto image rotate: off
- Auto power off: disable
- Live view: on
- Live view shoot: off
- Grid display: on
- Metering timer: inoperative in manual mode
- Flash firing: disable
- Exposure time:
- Bulb with an interval timer or computer
- Desired exposure time with a remote shutter
- Long exposure noise reduction: off
- High ISO speed noise reduction: off for raw images, on for JPG images (note: may decrease image sharpness somewhat)
- Auto lighting optimizer: disable
- Assist beam firing: disable
- AF during Live View shooting: disable
- Mirror lockup: disable
- Set button when shooting: Menu display or disable
- LCD display when power on: display
- Add original decision data: disable

4.5 Total Integrated Exposure Time

The quality of the final image produced by stacking two or more light frames is dependent upon how many light frames are stacked and the exposure time of the light frames, all other things being equal. These two variables define the total integrated exposure time for the stacked image which is the summation of the exposure times of all the light frames used in the stacking process. Essentially, the longer the total integrated exposure time the better the final image will be.

What is the total integrated exposure time needed to produce an optimal image? This is a question asked frequently on the internet forums. In an attempt to answer this question I did a case study of 25 images of galaxies and nebulae that were posted on an internet forum where astrophotographers show-off their work. The 25 images were selected based upon their visual appeal (focus, sharpness, contrast, color, details, etc.). The study's objectives were to determine the average number and exposure duration of light frames used by skilled photographers to image galaxies and nebulae using guided exposures longer than 5 min. The findings of the case study are as follows:

- average total integrated exposure time per image: 112 min
- average exposure time per light frame: 8 min
- average number of light frames stacked per image: 14
- average signal to noise improvement by stacking: 3.74
- average telescope focal ratio f/5.4

While admittedly a case study, this one included, is limited in scope and is not rigorous; a case study can provide some useful information. For this case study, we see how a group of skilled astrophotographers using guided long exposures made 25 images they deemed suitable for display in a public setting. Even though the study's findings are for guided long exposures, they have some relevance for very short exposure astrophotography.

Based upon the study's findings, consider what happens with images produced by stacking when exposure times and the number of light frames vary. Looking at the study's findings, the average light frame exposure time used by the group of skilled photographers was 8 min. This is very long in comparison to the exposure times used for very short exposures which are typically 45 to 75 s for an equatorial mount and 30 s or less for alt-azimuth mounts. This time difference has a large impact upon the strength and quality of the signal component of an image.

Compare the signal and the signal to noise ratio of one 8 min light frame to a very short exposure; say one 30 s light frame. Recall that signal strength of an image increases linearly with time while its noise increases as the square root of time. Assume that the 30 s light frame has a signal to noise ratio of 1 (signal=1; noise=1). An increase the exposure time from 30 s to 8 min (480 s) increases the signal component by a factor of 16 and the noise component by a factor of 4. This means that the 8 min light frame will have a signal component 16 times that of a 30 s light frame and a signal to noise ratio that is four times greater.

The average number of light frames used per image by the group of skilled photographers was 14 light frames per image. The average exposure time was 8 min. This produces a total integrated exposure time of 112 min (6,720 s). Continuing the comparison to a 30 s exposure, the image resulting from a stack of 14×8 min light frames will have a signal component of 16 since stacking only reduces noise and does not impact the signal. However, the noise component decreases by a factor of 3.74 (the square root of 14) from 4 to 1.07 making the signal to noise ratio of the stack of 14×8 min light frames equal to 15. A signal to noise ratio of 15 is excellent.

A stack of 224×30 s light frames will have the same integrated exposure time as the stack of 14×8 min light frames; 112 min. The signal component of the stack of 30 s light frames will remain at 1 but the noise component of the stack will decrease by the square root of 224 (15) from 1 to 0.067. Thus, the signal to noise ratio of the 224×30 s stack is equal to 15, which is identical to the signal to noise ratio of the stack of 14×8 min light frames.

This does not mean that the image produced by a stack of 224×30 s light frames is the equivalent to a stack of 14×8 min light frames as the signal component of the stack of 8 min light frames remains 16 times greater than the stack of 30 s light frames. By the way, this works out for other combinations of the number and exposure time of stacked frames; two stacks having the same total integrated exposure time will have the same signal to noise ratio but not the same signal strength all else equal.

Now look at what happens if the number of 8 min light frames is doubled from 14 to 28. A stack of 28×8 min light frames will have a total integrated exposure time of 224 min and the signal to noise ratio is increased from 15 to 21. However, now a stack of 448×30 s light frames are needed to have the same signal to noise ratio. This is a large quantity of light frames to make. If we triple the number of 8 min exposures from 14 to 42, the signal to noise ratio increases from 21 to 25 but now a stack of 672×30 s light frames is required. Clearly, increasing the number of frames stacked past that needed for a total integrated exposure time of 112 min, say 120 min to round it off at the nearest hour, is a case of diminishing returns.

This analysis implies if we use an integrated exposure time of 120 min (7,200 s) for very short, unguided, exposures; the signal to noise ratio of the resultant image is the same as that associated with photographs made skilled photographers using traditional, long-exposure, astrophotography equipment and techniques. This is indeed the case. However, the signal level of a stacked image remains the same as that of one of its light frames. Also keep in mind that, if the exposure time is too short in relation to the photon flux from the object being photographed, stacking programs will treat the signal as noise and no image produced.

To answer the questions of how many light frames are needed, simply divide 7,200 s by the light frame's exposure time in seconds. This will give an image having the same signal to noise ratio typically used by a group of skilled photographers. In the case of 30 s light frames, 240 are required. This is a lot of light frames. Is it possible to shorten the overall exposure time? Yes but if the number of light frames is say reduced to 120, the total integrated exposure time is halved.

While the signal strength of the image produced remains the same, its signal to noise ratio decreases to from 15 to 10.6. The resultant image's signal to noise ratio is approximately 30 % lower but most likely still high enough to present an acceptable image. This remains true for light frames having exposure times other than 30 s.

The conclusions from the above analysis for very short exposure astrophotography are:

- A total integrated exposure time of 120 min is optimal for producing images of galaxies and nebulae.
- A minimum total integrated exposure time of 60 min will produce acceptable images for most galaxies and nebulae.
- A total integrated exposure time exceeding 120 min will produce little improvement in image quality in relationship to the number of light frames required for stacked.

4.6 Very Short Exposure Astrophotography Techniques

Recall from Chap. 3 the need for planning the imaging session was briefly discussed and that Appendix A is a comprehensive example of that process. This planning process covered activities up to the imaging session. The actual imaging session is dependent upon whether or not an alt-azimuth or an equatorial mount is used. Chapters 5 and 6 discuss the imaging session in detail for an alt-azimuth and equatorial mount respectively. However, there are some common aspects that are independent of the mount to consider.

First we need to address the memory card in the DSLR camera. For very short exposures, an 8 gigabyte memory card is the smallest that provides sufficient memory needed for one photographic session. Eight gigabytes will provide the capacity needed for approximately 700 exposures in the RAW format. Note that this capacity for the number of images that the card can hold is independent of exposure time. After subtracting the memory needed for dark, flat, and offset frames; enough memory remains for approximately 550 light frames, the actual photographs of the object. This is more than sufficient even for the worst case scenario of say 15 s exposures and a 60 % retention rate.

The next aspect to consider related to a DSLR camera is battery life. Since battery life varies based upon make and model as well as the ambient temperature, run a test to see how long your battery will last at night. All you need do is attach an interval timer and let the camera automatically expose until the battery dies. Start with a fully charged battery, of course. From the frame numbers you can easily calculate how long the battery took to discharge. An imaging session that only captures the minimum number of light frames, flats, darks, etc. needed to obtain a total integrated exposure time of 60 min will have approximately 400 exposures of different duration and take around 3 h. Don't forget that cold temperatures shorten battery life.

With either a lightweight alt-azimuth or an equatorial mount and tripod, exposure times do not vary considerable. One major constraint for exposure time associated with an alt-azimuth mount is the impact of field rotation which places an upper limit of around 30 s with a few exceptions. This will be discussed in depth in Chap. 5. For now, just be aware that the impact of field rotation is dependent upon the latitude of the observer's location and the position that an object occupies in the sky. Allowable exposure times vary from a couple of seconds to minutes or more.

The impact of field rotation can be negated with an equatorial mount and theoretically unguided exposure times measured in hours are possible, this never happens and self-guiders are used. Unguided exposure times vary dependent upon the accuracy of the mount's polar alignment and its RA and DEC drives, the quality of construction among other considerations. Unguided exposure times for 5 min or so are often made with high quality German equatorial mounts. However, for light weight and portable equatorial mounts with their lower quality drives and tripods, unguided exposures of 45 to 75 s are more realistic expectations.

Regardless of whether or not an alt-azimuth or equatorial mount is used, the basic process used to photograph a deep space object using very short exposures is very similar. The major activities are as follows and are appropriate for prime focus or piggy back astrophotography:

- Kit assembly and OTA cool down
- GOTO mount alignment
- Precise polar alignment (equatorial mount)
- Mount synchronization with the target object you want to photograph
- GOTO to a bright star near the target object
- Attach the camera to the telescope and focus
- GOTO and center target object in the camera's field of view
- Determine the maximum attainable exposure time
- Program the interval timer (intervalometer)
- Acquire images
- Acquire dark, flat, and bias frames
- Secure equipment

Assembling your kit is very specific to the equipment being used but the steps are similar for most mounts. Set up your tripod, geographically orientated as required for your mount's alignment process. For tripods that support equatorial mounts this typically means that one leg is pointing due north. For many alt-azimuth mounts, the geographic orientation of the tripod is not a factor. Adjust the extension legs for the height you want. With most lightweight tripods, not extending the extension legs greatly improves stability and is the better option to take. Carefully level the tripod with the plane of the earth making tripod's vertical axis orthogonal to the plane of the earth. Attach your telescope to your mount and verify that your finder is aligned. If not, align the finder.

At dusk, if you set up in the late afternoon, power up the telescope, enter your date, time, and location as required and as accurately as possible. If your hand controller has a date time capacity, check the time to be sure it is synchronized with

4.6 Very Short Exposure Astrophotography Techniques

universal time. With a little practice, you should be able to enter the time with an accuracy of 5 s or less. Determining the coordinates of your location and synchronizing your watch to Universal Time should be done prior to departing to the location where you intend to photograph. The internet has many sites that provide accurate time and Google Earth is a good source to obtain the precise coordinates of your observing site.

When the night sky has darkened sufficiently to see alignment stars, start the alignment process for your mount. Do not use the moon or planets for alignment objects. Their locations are not as precise as the location of stars and this can induce error in the alignment. If possible, select one alignment star near the object you will photograph. Use a reticle eyepiece to center alignment stars as precisely as possible; the higher the magnification used in the alignment, the better. If you do not have a reticle eyepiece, buy one.

Once you have aligned the mount, do a precise polar alignment if you are using an equatorial mount. Which method to use is dependent upon your skills and the features of the mount that you are using. If required by your mount, repeat the mount's GOTO alignment process. Add calibration stars or replace alignment stars as applicable after a computerized polar alignment. Check the mount's offsets from a precise polar alignment and repeat the polar alignment if off by a significant amount. With a light weight mount like the 4SE, achieving an alignment with offsets less than 10' is doable but generally takes a few tries.

While you wait for the night sky to darken or the telescope to thermally equalize, take a trip in the night sky. Planets are nice if the telescope has sufficiently thermally equalized, else a few brighter Messier Objects. Once the sky has darkened sufficiently, do a GOTO to the object you want to photograph. Synchronize your mount to the object if your mount has that feature. Study the object looking for any bright star groups or stars that could be useful for composing the image later. For example, the Rosetta Nebula NGC 2237 is faint and a very difficult to see at a dark site and essentially not visible at an urban setting. However, a star cluster, NGC 2244, is at the center of the nebula and is visible, even with a small telescope.

Next, do a GOTO to the nearest bright star to the object you want to photograph and center it in your eyepiece. Install any filters you are using and then attach your DSLR camera. Secure all dangling cables and camera straps. Black electricians tape is handy for this task. If you are doing piggy back photography, use the bright star to align the camera with the telescope. Focus the camera using the method you like best. Take your time here and get a very sharp focus. If you are piggy backing you may want to tape your lens so it will not drift from focus during the night. After you have focused the camera, do a calibrate goto if you have a Celestron SE mount. The Calibrate GOTO command is in the Utility Menu. It lets the mount measure and adjust for the change in weight caused by attaching the camera. Once you are satisfied with your focus, do a GOTO to the object you want to photograph.

Once the telescope is at object you want to photograph, the first step is to make sure that the object is centered in the camera's field of view. This is because in the course of the imaging session the telescope can drift considerably. Starting with the object centered is usually sufficient to keep it properly framed for an hour or two;

long enough to complete photographing it. If the object, star, or a star grouping that you recognize is visible in the camera's view finder or review screen if the camera has live view; use it to center the object in the field of view. However, most likely neither the object nor a recognizable star pattern will be visible. Set the camera to a high ISO setting, make a 60 to 90 s exposure, and then review the image to see where the object is located. If the object is not centered in the field of view, use the mount's hand controller and center the object. To do this, set the slew rate to a slow speed, say around 4, and move the telescope in very short increments, one in RA and the other in DEC, of no more than 5 s each. Make another 60 to 90 s image and check the results. Repeat this trial and error process until you center the object. At first this is rather cumbersome but after a few times, it becomes fairly easy to do. If you mess up and lose the object, simply do another GOTO and start the process anew. Also look at the star trails in the image, if any. This will give you an idea of how long you can make an exposure if you are using an equatorial mount.

Once you are satisfied with the composition of your photograph, determine what exposure time you can use. To do this, simply make five exposures of the object and examine each exposure for star trails. Ideally all of the five images will be free of star trails but three out of five will do. Also important; do not confuse vibration or tracking movement with field rotation. With field rotation, star trails become longer away from the center of the image. Vibration and tracking movements tend to be more uniform.

When determining the optimum exposure time start with 30 s exposures with an alt-azimuth mount and 60 s exposures with an equatorial mount. If the exposures are acceptable increase the exposure time by 5 and 15 s respectively for the alt-azimuth and equatorial mounts and repeat until you no longer can achieve three out of five with no star trails. If the exposures are not acceptable then decrease the exposure time by 5 and 15 s respectively until three out of five exposures are acceptable. If you have sufficient time, you can increment the final iterations by 1 s to maximize the length of the exposure. An increase of only 1 s will increase the signal to noise ratio of the image and improve its quality.

The next step after determining the exposure time for the photographic session is to program the interval timer or GOTO mount if the mount has a camera control feature. With very short exposure astrophotography a total integrated exposure time of 120 min is desired. This requires a stack of 360 light frames with 20 s exposures or 240 light frames with a 30 s exposure. Approximately 40 % of the light frames taken will not be usable for a variety of reasons but primarily for vibration and tracking movements. Thus, you will need to take 600 light frames at 20 s or 400 light frames at 30 s. Dark frames, flat frames, and bias frames will add another 150 exposures. In all, about 3 h are needed to obtain an integrated exposure time of 120 min. In the event, more than 60 % of the light frames are usable; they are not wasted. You can use them as they will increase the quality of the resultant image. See Table 4.1 to determine the number of exposures versus retention rate and total integrated exposure time.

For a variety of reasons objects often drift in the field of view, especially with very lightweight alt-azimuth mounts. The 4SE mount in the equatorial mode also

4.6 Very Short Exposure Astrophotography Techniques

Table 4.1 Number of exposures versus retention rate required for a total integrated exposure time of 120 min (for a total integrated exposure time of 60 min divide the table values by two)

% Retention rate	100	90	80	70	60
Exposure time (s)	Number of exposures				
10	720	800	900	1,028	1,200
15	480	534	600	686	800
20	360	400	450	514	600
25	288	320	360	412	480
30	240	266	300	342	400
35	106	228	258	294	342
40	180	200	226	258	300
45	160	178	200	228	266
50	144	160	180	206	240
55	130	146	164	188	218
60	120	134	150	172	200
70	102	114	128	146	172
80	90	100	112	128	150
90	80	88	100	114	134
100	72	80	90	102	120
110	66	72	82	94	110
120	60	66	76	86	100

has a short period of significant drift if the telescope crosses the meridian while imaging as the weight of the telescope shifts. Drift is easily mitigated by periodically stopping the imaging process and examining the location of the object being photographed in the camera's view screen. If the object is drifting substantially off center, then use the hand controller to position it back to the center of the camera's view screen using the same technique used to center the object before starting the imaging process. This process will add about 15 min to the total time required to obtain the images regardless of the exposure time used. It is 15 min well spent.

A large number of light frames required do not allow the luxury of an extended cool down period between shots. Many DSLR cameras need about 5 s between shots to do their internal processing; thus, 5 s is the minimum interval between exposures. Unless a prolonged interval is used between shots of a minute or so, a significant cool down of the camera's electronic components is not likely; thus, for very short exposure work, a 5 s interval between exposures is used. The camera's electronics will heat up but will rapidly stabilize. Dark frames for the image should be obtained before the camera's electronics have an opportunity to cool.

How many dark frames, flat frames, and dark bias frames should you make? The answer is "as many as possible." There is no upper limit. However, there is a lower limit. Too few dark frames, flat frames, or bias frames can actually increase noise in your light frames. If you only use one image each to make your dark frame, flat frame, or bias frame, when you subtract one of these frames, say a dark frame from

a light frame, you add the noise in the dark frame to the light frame. However, if you create a master dark frame by stacking several dark frames, the noise level of the master dark frame declines by the square root of the number of frames in the stack. A master dark frame made from a stack of 25 dark frames reduces then noise of the master dark frame by a factor of 5. This is adequate for longer exposures but not for very short exposures that will be stacking 100 or more lights thus reducing noise by a factor of 10. A stack of 25 darks will add noise. Ideally, a stack of 100 darks, flats, and bias frames is needed to not inject noise. However, this doubles the amount of the time to acquire your images. A stack of 49 dark, flat, and bias frames is perhaps the minimum for very short exposure astrophotography. Stacks of more than 100 frames have diminishing returns.

Now we have the object we want to photograph centered in the camera's field of view and we have our interval timer programmed. Our telescope is focused and we are tracking the object. Take a good look at the telescope. Check again to be sure no hanging wires, camera straps, hand controller cables, etc. are dangling loose. Make sure the hand controller is secure. This will reduce the possibility of vibration. Plastic electrician's tape is ideal for securing dangling straps, hand controller cord, power cable, and even the interval timer cord. The tape is easy to remove later and leaves no residue. Velcro is also a great friend.

Trip the interval timer and start taking your exposures. Keep in mind that most all lightweight mounts and tripods are designed for visual work, not astrophotography. Every 30 min interrupt the photographic process and examine some of the light frames you have made. Check to insure that you do not have star trails and that the image remains centered in the field of view of the camera. If it has drifted, move it back to center. This will reset the exposure count of most interval timers, so record the number of light frames you have made then resume the photographic process. When you have the number of light frames you want, take your dark frames. You will need, as a minimum, 49 dark frames for each combination of exposure time and ISO setting that you used to obtain your light frames. Once you have your dark frames, take your flat frames and bias frames and then secure your equipment.

Chapter 5

Alt-Azimuth Mount Astrophotography

5.1 Introduction

Alt-azimuth mounts are very popular for their lightweight, compact, designs and ease of use. Their popularity surged in recent years as more and more amateurs embraced the versatility of the computerized alt-azimuth GOTO mount or the simplicity and efficiency of the Dobson Mount. Today, alt-azimuth GOTO mounts are found across the entire spectrum of amateur astronomy on telescopes for beginners as well as the most advanced observer. In spite of their popularity, alt-azimuth mounts are typically used only for visual observation as everyone knows the truth of an astronomy myth, "you can't use an alt-azimuth mount for astrophotography."

Like many myths, this one was born in the cradle of truth. Alt-azimuth mounts are aligned with the earth's plane and not to the celestial sphere. Tracking an object in space with an alt-azimuth mount requires movements in both azimuth and altitude. These movements are variable in speed and magnitude and are dependent upon the position of the object in the sky, which, in turn, is dependent upon the time of the day as well as the location of the observer on earth. Automating this movement was not practical with amateur telescopes until the introduction of the computerized alt-azimuth mount in the 1990s.

With computerized tracking, an alt-azimuth mount can keep an object in view of an eyepiece and the object will appear stationary to the human eye. However, a camera at the same eyepiece will not see a stationary object but a view that rotates slowly with the earth's rotation. With the long exposures required in the days of film, images made using an alt-azimuth mount were blurred and stars were streaks of light. The statement "you can't use an alt-azimuth mount for astrophotography" was true; at least for amateur astronomers.

Time and technology march on. In the world of astrophotography digital technology replaced film cameras and eliminated the need for long exposures. With today's digital cameras, images with usable signal to noise ratios are obtainable with alt-azimuth mounts by using exposure times too short to show movement by the earth. These very short exposures are then stacked producing a final image that is in some ways equal to the sum of the exposure times. The astronomy truth from the days of film, "you can't use an alt-azimuth mount for astrophotography," is now an astronomy myth.

This is not to say that parity in astrophotography exists between an alt-azimuth and an equatorial mount. The very short exposure times associated with an alt-azimuth mount do impact signal strength. This limits photography with an alt-azimuth mount to the brighter objects in the night sky. How bright? That is a difficult question to answer as it depends upon the level of artificial skyglow from light pollution, the camera used, the focal ratio of the telescope or camera lens used, the number of exposures stacked, the duration of exposures, and the total integrated exposure time of the stacked images. If you can see an object in the telescope, you definitely can photograph it using an alt-azimuth mount and have an image with a workable signal to noise ratio. Elusive visual objects such as the Veil Nebula (NGC 6960), the California Nebula (NGC 1499), or the famous Horsehead Nebula (Barnard 33) are well within the capabilities of a modern DSLR cameras using a very short exposure of 30 s from a suburban location where artificial skyglow renders these objects invisible to the observer.

5.2 Equipment

"Astrophotography on the Go" is astrophotography using ultra-lightweight telescopes, mounts, and tripods. The lowest cost configuration is the Orion or SkyWatcher short tube, 80 mm, f/5 refractor on either a Celestron SLT or a SkyWatcher SynScan AZ goto mount (see Fig. 5.1). With the exception of not using a self-guider, the components used for astrophotography with an alt-azimuth mount are pretty much the same as used for an equatorial mount. The following components are typical:

- Digital single lens reflex camera. Live view is a feature that will greatly simplify both focusing and composing an image. Other desirable features are an articulated view screen, a video capability, and a weight of approximately 1 pound (around 0.5 kg). An entry level DSLR will do nicely as astrophotography is done in the manual mode and the many extra features on advanced DSLRs are not needed or used. While a dedicated astronomical CCD camera can be used, doing so requires a computer to process and store the images made by the camera. One major reason for using an alt-azimuth mount for astrophotography is portability. A computer and its associated logistics tail run counter to this requirement.
- T ring and T ring adapter. Many T rings and T ring adapters are on the market today. All are not equal. The T ring manufacturing tolerances should provide a

5.2 Equipment

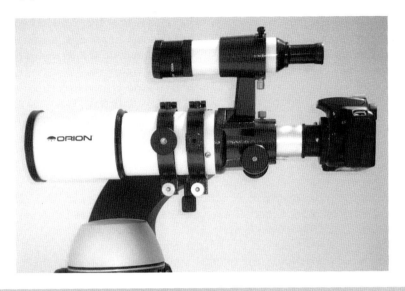

Fig. 5.1 Alt-azimuth astrophotography kit

tight fit on the camera with essentially no movement. A T ring adapter may or may not be needed as some telescope focusers, like the ST-80A in Fig. 5.1 have built-in "T" threads. If you are using a Schmidt or Maksutov Cassegrain telescope, then a SCT T ring adapter that screws directly onto the telescope or a focal reducer if used is preferable over a universal T ring adapter that is inserted into the telescope's visual back and secured with two thumb screws.

- Telescope OTA with finder. The telescope must have sufficient back focus to allow the image to be focused on the camera's sensor and it should have a low focal ratio. Unlike an equatorial astrophotography system, an alt-azimuth system cannot maintain a good signal to noise ratio by increasing exposure time to compensate for a telescope with a high focal ratio. The signal to noise ratio of an image obtained with an alt-azimuth mount is inversely proportional to the focal ratio of the telescope; the higher the focal ratio, the lower the signal to noise ratio. A short tube 80 mm f/5 refractor similar to the one shown in Fig. 5.1 is an excellent telescope for alt-azimuth mount astrophotography and is available for under $200 in both North America and Europe. An inexpensive red dot finder is all that is needed for aligning the mount.
- Alt-azimuth GOTO mount with hand controller. The mount must be able to acquire and track deep space objects for at least 30 s with no apparent tracking movement of the object in the eyepiece. Celestron, SkyWatcher, and iOptron offer several relatively inexpensive azimuth mounts that meet this requirement which are not bundled with telescopes.
- Tripod. The tripod must be able to support the camera, telescope, and mount with no vibration resulting from wind forces or mount tracking movements. This does

not mean that it must be vibration free. The tripod is the weak link in most lightweight mounts and tripods. Most tripods must be modified to provide the stability required. These modifications are simple to do and discussed later in Appendix B.
- An interval timer (intervalometer). An interval timer is used to control the photographic process. It is connected directly to the camera and controls the number of images made, the exposure duration of each image, and the time (interval) between each image. With an interval timer and a DSLR, no computers are needed for the alt-azimuth mount astrophotography process. A remote shutter can be used instead of an interval timer and the imaging process done manually; a lot of work but definitely doable.
- Portable computer (optional). As stated earlier, a computer is optional. No need at all exists for using a computer or a tablet in the field when a DSLR camera is used with a GOTO mount. However, there is nothing wrong including a computer if you want to use one. Keep in mind that it is another piece of equipment to carry and setup. While this may be fairly simple in your backyard, setting up and powering a computer in a park, parking lot, or a remote location is a different story. A tablet, on the other hand is highly portable (shirt pocket) and can facilitate focusing a DSLR, composing the image, and controlling the photographic process. Computers and tablets are discussed in Chap. 9.
- Power supply. A 12vdc power supply is needed to power the computerized alt-azimuth goto mount. An ac to dc power converter is not recommended for a portable system as few power outlets exists in the field away from home. Power supplies are discussed in Chap. 13.

As stated earlier, missing from the list is a self-guider. A self-guider has no function with an alt-azimuth mount because of the very short exposure times associated with these mounts.

5.3 Equipment Issues

Can an alt-azimuth mount compete with an equatorial mount for use in astrophotography? The answer here is yes and no. The strengths of an alt-azimuth mount are its ability to handle heavier weights than a similarly sized equatorial mount and its simplicity means fewer things can go wrong during an imaging session. An alt-azimuth mount cannot match the flexibility or capabilities provided by an equatorial mount or the range of objects that can be photographed. Even so, an alt-azimuth mount can be used to produce excellent results for the brighter deep space objects and makes an excellent mount for piggybacking a camera. In addition, an alt-azimuth GOTO mount is perfect for the urban astronomer who must observe away from home and can make the difference between being an "armed chair" observer or an active one.

5.3 Equipment Issues

Do issues exist using an alt-azimuth mount for astrophotography? The answer to this question is yes, several issues exist. The major ones are:

- field rotation
- mount stability
- mount tracking
- signal to noise ratio
- mount payloads

Fortunately, these issues have solutions or a way to work around them.

"Field rotation" is an issue that must be resolved in order to photograph the night sky and is the major issue associated with using an alt-azimuth mount. Field rotation governs when an object can be photographed, where in the sky an object must be to photograph it, and the exposure time used. Measures to mitigate field rotation exist and are discussed in the next section of this chapter.

"Mount stability" is another major issue with lightweight mounts and tripods; specifically with the tripods. The tripods typically have a metal tripod head with stainless steel legs held together with soft plastic components and rivets or bolts. The soft plastic components and cheap fasteners allow movement at all connections. This movement has two impacts. The tripod can actually lean as the mount rotates in azimuth. This prevents accurate mount alignments and the object can rapidly move out of the field of view during a photographic session. The other impact is vibration. The fasteners and soft plastic components tend to amplify rotational movements creating excessively long periods of vibration. Fortunately, these stability issues are easily resolved using a screwdriver, a wrench, and a little bit of epoxy or super glue. Appendix B provides a detailed description of how to improve the stability of these lightweight tripods.

"Mount tracking" is another issue that can be problematic. Lightweight alt-azimuth goto mounts are designed for viewing with the eye, not for photography. While an object may appear stationary to the human eye, the camera often shows a different picture. Another aspect associated with these mounts is that precision gearing is not used which also introduces tracking movements. Fortunately, for very short exposures of 30 s or less, tracking movements are typically too small to be noticeable in a photograph. Tracking movements can be mitigated to some extent by:

- Stiffening the mount's tripod
- Leveling the mount with the plain of the earth
- Precisely entering the location and time in the mount's hand controller,
- Using a reticle eyepiece to precisely center alignment stars when aligning the mount

The "signal to noise ratio" of a very short exposure is low. Field rotation and tracking movements will typically limit exposure times using an alt-azimuth mount to 30 s or so. This is a very short amount of time to capture an image of a distant, faint deep space object. The result is that the images captured with very short exposures have a low signal to noise ratio. This attribute of alt-azimuth astrophotography

makes the telescope used a very critical component; perhaps more important than the mount or camera. A fast telescope is required; ideally f/5 or lower. Having said that, acceptable images of bright objects such as found on the Messier and Caldwell lists are obtainable using a f/10 Schmidt Cassegrain telescope with a 0.63 focal reducer. Slower telescopes will work but noise levels will be higher and signal levels lower. The noise can be mitigated by stacking a large number of light frames but the signal will remain low.

"Mount payload" is always an issue. Lightweight alt-azimuth mounts, especially the mounts manufactured by iOptron and Synta (Celestron and SkyWatcher), are rugged and dependable. In comparison to similarly sized equatorial mounts, these alt-azimuth mounts are not near as sensitive to overload conditions provided the load is balanced on the mount. Alt-azimuth mounts typically have little difficulty operating in overload conditions as high as 50 % providing their tripods are stiffened as discussed earlier. For example, the payload for the SkyWatcher SynScan AZ goto mount is 8 pounds (3.6 kg) with a maximum telescope aperture of 130 mm. It easily handles a 12 pound (5.5 kg) payload consisting of a 150 mm SCT with a focal reducer and a DSLR camera. This attribute has one significant aspect. The size and weight of OTAs, cameras, etc. used with an alt-azimuth mount can be larger than that of a similarly sized equatorial mount. This greatly increases the selection of equipment available for these mounts to use for astrophotography in comparison to their equatorial mount counterparts.

5.4 Field Rotation Mitigation

Field rotation is the dominant issue associated with using an alt-azimuth goto mount for astrophotography. As discussed earlier, with an alt-azimuth mount field rotation will cause objects in a photograph to appear to rotate around the photograph's center. This produces star streaks instead of stars and distorts other objects. If an assumption is made that 0.125° of field rotation is not noticeable in a photograph, the time for an object to move 0.125° can be calculated for any given latitude on earth if an object's altitude and alt-azimuth angles are known.

The time that is needed for 0.125° of field rotation is the maximum allowable exposure time for photographing an object from a specific geographic location on earth without having star trails due to field rotation. If the maximum allowable exposure time, is calculated for all positions in the sky and observer locations on earth, these calculations will define the area of the sky available for photography using an alt-azimuth mount. Table 5.1 is a compilation of these calculations and provides the time needed for 0.125° of field rotation, thus maximum allowable exposure times with an alt-azimuth goto mount, based upon:

- the geographic location of the observer (degrees latitude to the nearest 10°),
- the altitude of an object (degrees above the horizon to the nearest 10°), and
- the azimuth angle of an object to the nearest 10° (0° true North, 90° due East and 180° due South; 270° due West).

5.4 Field Rotation Mitigation

Table 5.1 Maximum exposure time based upon 0.125° of field rotation

(a) Maximum exposure time in seconds for an observer at 0° latitude

Object's azimuth angle (degrees)				Object's altitude angle (degrees)								
				10	20	30	40	50	60	70	80	90
				Maximum exposure time in seconds								
0	180		360	30	28	26	23	19	15	10	5	0
10	170	190	350	30	29	26	23	20	15	10	5	0
20	160	200	340	31	30	28	24	21	16	11	6	0
30	150	210	330	34	33	30	27	22	17	12	6	0
40	140	220	320	39	37	34	30	25	20	13	7	0
50	130	230	310	46	44	40	36	30	23	16	8	0
60	120	240	300	59	56	52	46	39	30	21	10	0
70	110	250	290	86	82	76	67	56	44	30	15	0
80	100	260	280	170	162	150	132	111	86	59	30	0
90		270		339	323	298	264	221	172	118	60	0

(b) Maximum exposure time in seconds for an observer at 10° latitude

Object's azimuth angle (degrees)				Object's altitude angle (degrees)								
				10	20	30	40	50	60	70	80	90
				Maximum exposure time in seconds								
0	180		360	30	29	26	23	20	15	10	5	0
10	170	190	350	30	29	27	24	20	15	11	5	0
20	160	200	340	32	30	28	25	21	16	11	6	0
30	150	210	330	35	33	30	27	23	18	12	6	0
40	140	220	320	39	37	34	30	26	20	14	7	0
50	130	230	310	47	45	41	36	30	24	16	8	0
60	120	240	300	60	57	53	47	39	30	21	11	0
70	110	250	290	88	84	77	68	57	45	30	15	0
80	100	260	280	173	165	152	134	113	88	60	30	0
90		270		344	328	303	268	225	175	120	61	0

(c) Maximum exposure time in seconds for an observer at 20° latitude

Object's azimuth angle (degrees)				Object's altitude angle (degrees)								
				10	20	30	40	50	60	70	80	90
				Maximum exposure time in seconds								
0	180		360	31	30	28	24	21	16	11	6	0
10	170	190	350	32	30	28	25	21	16	11	6	0
20	160	200	340	33	32	29	26	22	17	12	6	0
30	150	210	330	36	35	32	28	24	18	13	6	0
40	140	220	320	41	39	36	32	27	21	14	7	0
50	130	230	310	49	47	43	38	32	25	17	9	0
60	120	240	300	63	60	55	49	41	32	22	11	0
70	110	250	290	92	88	81	72	60	47	32	16	0
80	100	260	280	181	173	159	141	118	92	63	32	0
90		270		361	344	317	281	235	183	125	64	0

(continued)

Table 5.1 (continued)

(d) Maximum exposure time in seconds for an observer at 30° latitude

Object's azimuth angle (degrees)			Object's altitude angle (degrees)									
			10	20	30	40	50	60	70	80	90	
			Maximum exposure time in seconds									
0	180	360	34	33	30	27	22	17	12	6	0	
10	170	190	350	35	33	30	27	23	18	12	6	0
20	160	200	340	36	35	32	28	24	18	13	6	0
30	150	210	330	39	38	35	31	26	20	14	7	0
40	140	220	320	45	42	39	35	29	23	15	8	0
50	130	230	310	53	51	47	41	35	27	18	9	0
60	120	240	300	68	65	60	53	45	35	24	12	0
70	110	250	290	100	95	88	78	65	51	35	18	0
80	100	260	280	196	187	173	153	128	100	68	35	0
90		270		391	373	344	304	255	199	136	69	0



Azimuth (deg)			10	20	30	40	50	60	70	80	90
0	180	360	34	33	30	27	22	17	12	6	0
10 / 170 / 190 / 350			35	33	30	27	23	18	12	6	0
20 / 160 / 200 / 340			36	35	32	28	24	18	13	6	0
30 / 150 / 210 / 330			39	38	35	31	26	20	14	7	0
40 / 140 / 220 / 320			45	42	39	35	29	23	15	8	0
50 / 130 / 230 / 310			53	51	47	41	35	27	18	9	0
60 / 120 / 240 / 300			68	65	60	53	45	35	24	12	0
70 / 110 / 250 / 290			100	95	88	78	65	51	35	18	0
80 / 100 / 260 / 280			196	187	173	153	128	100	68	35	0
90 / 270			391	373	344	304	255	199	136	69	0

(e) Maximum exposure time in seconds for an observer at 40° latitude

Azimuth (deg)	10	20	30	40	50	60	70	80	90
0 / 180 / 360	39	37	34	30	25	20	13	7	0
10 / 170 / 190 / 350	39	37	34	30	26	20	14	7	0
20 / 160 / 200 / 340	41	39	36	32	27	21	14	7	0
30 / 150 / 210 / 330	45	42	39	35	29	23	15	8	0
40 / 140 / 220 / 320	50	48	44	39	33	26	17	9	0
50 / 130 / 230 / 310	60	57	53	47	39	30	21	11	0
60 / 120 / 240 / 300	77	74	68	60	50	39	27	14	0
70 / 110 / 250 / 290	113	108	99	88	74	57	39	20	0
80 / 100 / 260 / 280	222	212	195	173	145	113	77	39	0
90 / 270	442	422	389	344	289	225	154	78	0

(f) Maximum exposure time in seconds for an observer at 50° latitude

Azimuth (deg)	10	20	30	40	50	60	70	80	90
0 / 180 / 360	46	44	40	36	30	23	16	8	0
10 / 170 / 190 / 350	47	45	41	36	30	24	16	8	0
20 / 160 / 200 / 340	49	47	43	38	32	25	17	9	0
30 / 150 / 210 / 330	53	51	47	41	35	27	18	9	0
40 / 140 / 220 / 320	60	57	53	47	39	30	21	11	0
50 / 130 / 230 / 310	72	68	63	56	47	36	25	13	0
60 / 120 / 240 / 300	92	88	81	72	60	47	32	16	0
70 / 110 / 250 / 290	134	128	118	105	88	68	47	24	0
80 / 100 / 260 / 280	265	253	233	206	173	134	92	47	0
90 / 270	527	503	464	410	344	268	183	93	0

(continued)

5.4 Field Rotation Mitigation

Table 5.1 (continued)

(g) Maximum exposure time in seconds for an observer at 60° latitude

Object's azimuth angle (degrees)				Object's altitude angle (degrees)								
				10	20	30	40	50	60	70	80	90
				Maximum exposure time in seconds								
0	180		360	59	56	52	46	39	30	21	10	0
10	170	190	350	60	57	53	47	39	30	21	11	0
20	160	200	340	63	60	55	49	41	32	22	11	0
30	150	210	330	68	65	60	53	45	35	24	12	0
40	140	220	320	77	74	68	60	50	39	27	14	0
50	130	230	310	92	88	81	72	60	47	32	16	0
60	120	240	300	118	113	104	92	77	60	41	21	0
70	110	250	290	173	165	152	134	113	88	60	30	0
80	100	260	280	340	325	299	265	222	173	118	60	0
90		270		678	647	596	527	442	344	235	120	0

(h) Maximum exposure time in seconds for an observer at 70° latitude

Object's azimuth angle (degrees)				Object's altitude angle (degrees)								
				10	20	30	40	50	60	70	80	90
				Maximum exposure time in seconds								
0	180		360	86	82	76	67	56	44	30	15	0
10	170	190	350	88	84	77	68	57	45	30	15	0
20	160	200	340	92	88	81	72	60	47	32	16	0
30	150	210	330	100	95	88	78	65	51	35	18	0
40	140	220	320	113	108	99	88	74	57	39	20	0
50	130	230	310	134	128	118	105	88	68	47	24	0
60	120	240	300	173	165	152	134	113	88	60	30	0
70	110	250	290	253	241	222	196	165	128	88	45	0
80	100	260	280	497	475	437	387	325	253	173	88	0
90		270		991	945	871	771	647	503	344	175	0

Table 5.1 presents exposure times in 10° increments (observer's location and the object's altitude and azimuth). For the greatest accuracy you can interpolate values but simply rounding to the nearest 10° increment is close enough for planning. The values provided in Table 5.1 for 90° and 270° azimuth are actually the values calculated at 85° and 265° since the mathematical solutions at 90° and 270° are a singularity, thus, a meaningless number. What is important to note is that field rotation limits the maximum allowable exposure times from a few seconds to several minutes dependent upon where the object is located in the night sky and where the observer is located on earth. Also keep in mind that these exposure times are for an alt-azimuth mount that is tracking an object in the sky. The table is not valid for a stationary mount.

Several trends regarding maximum exposure times and alt-azimuth goto mounts are readily observable in Table 5.1:

- The closer an observer is to the equator, the shorter the allowable exposure time.
- The higher an object is in altitude, the shorter the allowable exposure time.
- The closer an object is to the meridian, the shorter the allowable exposure time.
- Regardless of where an observer is located, an exposure time of at least 15 s is possible for any object having an altitude angle of 60° or less.

All of this sounds complicated and in a way it is. Fortunately two ways to work around the problem of field rotation are available. The first work around is to use a device known as a field de-rotator. This device is used by some advanced photographers but is not recommended for someone who is just beginning astrophotography or is it suited for a lightweight mount and tripod. Also, it is not inexpensive. A field de-rotator, when attached to a telescope, will rotate the camera at the same rate as field rotation is rotating the image. In theory, this will produce the same results as obtained with an equatorial mount. Overall the results with a de-rotator are mixed. In practice, synchronization of rotator speed with field rotation is often difficult and the movement can be another source of vibration or movement that destroys images. Also, de-rotators do not alter the problem alt-azimuth mounts have tracking near the zenith.

The second work around is a simple rule of thumb; the 30/15 rule. Regardless of the location of the observer, any object can be photographed to within 30° of the zenith using an exposure time of 15 s. Fifteen seconds is not sufficient for all deep space objects but it is a good starting point. However, this is the worst case. For most observers on earth much longer exposure times are possible with an alt-azimuth goto mount.

5.5 Planning Your Photographic Session

Taking an image of a faint deep space object requires some planning before going out at night. This is especially true for photography using an alt-azimuth mount since the best part of the night sky, the area around the zenith, is not available. A large variety of tools are available on the internet and with computer programs to assist your planning efforts. These tools are discussed in Chap. 9.

The first step for alt-azimuth photography is the same as for any other mount; select the object that you want to photograph and then determine if you can photograph it. Keep in mind that with an alt-azimuth mount you are constrained by field rotation and cannot image objects near the zenith. You can image objects at a low altitude angle but, the lower the altitude the greater the impact of the atmosphere. Also consider your site characteristics and obstructions like trees, neighboring structures, etc. that can block your view of the object.

If the object is rising, make sure that you have sufficient time for the exposure session before the object passes within 30° of your zenith. Conversely, if the object

5.5 Planning Your Photographic Session

is setting, make sure that you can complete your exposure session before it sets or disappears behind some object like a tree. Some objects may need sessions spread over more than one night. If you do this, keep your start and stop times as well as your camera orientation to the telescope constant as possible between the sessions. This will increase the commonality between the exposures and greatly enhance the viability of the stacking process. The major difficulty of expanding an imaging session over two nights or more is keeping the composition of the light frames as close to identical as possible. Having the image centered in one set of light frames then rotated many degrees or off-centered in the light frames obtained the next night can degrade the final image or even prevent the stacking program from stacking the lights.

You need to determine the possible exposure times for your photographic session. This will vary dependent upon the location of an object as it travels across the night sky, the start and finish times you want for your photographic session, and your geographic location on earth. For this, consult Table 5.1. A good rule of thumb for people located at latitudes of 30° or higher is 20–30 s exposures. You will notice in Table 5.1 that the lower the object is in altitude the longer you can have an exposure without field rotation creating star trails.

For example; consider an observer located at 40° latitude who wants to photograph an object that will move from 20° altitude (at 110° azimuth) to 60° altitude (at 180° azimuth). The maximum exposure time starts at 108 s and decreases to 20 s. A constant exposure time of 20 s can be used for the entire session or, if the mount is capable of supporting long exposures, the session can be segmented, starting with 80 s for the first third of the session, 40 s for the middle of the session, and 20 s for the last third of the session. All this assumes the mount can stay steady enough for 40 and 80 s exposures. After you decide upon your exposure times, you need to calculate the number of light frames you will take using the process we described earlier in Chap. 4; see Table 4.1.

Light pollution is present for most urban observers. The amount of light pollution sets the lower limit regarding the brightness of an object that you can photograph. For photography, keep in mind that it is the surface brightness that is important not the absolute brightness. If the surface brightness of an object is less than the brightness of the skyglow in your area, its contrast and details will be greatly diminished and perhaps washed out completely. As discussed in Chap. 8 Light Pollution, surprisingly enough you can still make very acceptable images in areas having high levels of light pollution. As you gain experience you will get a "feel" regarding what objects you can photograph at your observing location.

One last factor to consider in your planning is our closest neighbor in space, the moon. Light from the moon is a killer for photographing many faint deep space objects and detracts for the details attainable from brighter objects. Plan your sessions for the nights of the month when the moon is not visible during the time you want to photograph.

As an example of the planning needed, let's say that you want to photograph Messier Object M45, also known as the Pleiades or as the Seven Sisters. In this example, assume that you are located at latitude 40° north, the date is 1 December

and the moon will not rise until 3 a.m. A quick look at a planisphere tells us that the Constellation Taurus which contains the Pleiades is visible in the night sky until early morning.

Next, we need to determine when M45 is best positioned in the night for us to photograph it. For this task, Table 5.1 is very helpful and provides maximum exposure times in 10° increments of altitude, azimuth and observer location. Table 5.1e presents data calculated for an observer located at 40° for this example. Table 5.1e shows that about 75 % of the night sky can support exposures of 20 s or more and that most of the night sky supports exposures of 30 s or more. We decide to use an exposure time of 30 s instead of 20 s in order to increase the signal component of our image.

Use a program like Stellarium, the SkyX, or a website like Tonight's Sky to determine the altitude and azimuth angles versus time for M45 for the night of 1 December. For this example, assume that the program Stellarium was used to obtain the azimuth and altitude readings versus time. Record the azimuth and altitude angles of M45 starting about an hour after sundown, 7 p.m. in our example, and every hour until 5 a.m. or the time you want to quit for the night. Some of the altitude readings will be greater than 60°. For these altitudes, record the azimuth and altitude angles every half hour. Now look at Table 5.1e for an observer at 40 latitude. North or South? It makes no difference nor does the longitude of the observer. Keep in mind that even though Table 5.1 may indicate that exposure times of several minutes are possible, for most lightweight alt-azimuth GOTO telescopes mount tracking movements and vibration limit exposures to around 30–45 s.

The table lists maximum exposure times based upon an object's azimuth and altitude angles in 10° increments. When using the table, use the altitude and azimuth angles nearest the ones you have looked up for an object. From the hourly and half hourly azimuth and altitude readings obtained from Stellarium and the data in Table 5.1e; 30 s exposures are possible until 10:30 p.m. From 10:30 p.m. until 1:00 a.m. the object is too close to the zenith to allow exposures of 30 s. A second window of opportunity for 30 s exposures exists from 1:00 a.m. until dawn.

For our example to have sufficient light frames at a 60 % retention rate to statistically have enough for a total integrated exposure time of 120 min, 400 are needed. This will take a little over 4 h after factoring in a 5 s delay between exposures and another 15 min checking to insure that tracking remains steady. If imaging starts at 7:30 p.m. it will be completed by 11:30 p.m.; 1 h after our window of opportunity expires at 10:30 p.m. We have a choice to shorten our integrated exposure time or suspend imaging at 10:30 and then start again at 1:00 a.m. or the next night.

You also need to plan when and how you will prepare your dark, flat, and bias frames. For the dark frames you need a minimum of 49 frames at each ISO and shutter speed combination used for your light frames with the camera at the same temperature. The optimal time to do this is immediately after you complete obtaining the light frames before the camera has time to cool down. Place a cover over the telescope tube to seal the light and make your dark frames and your dark bias frames. You need a set of 49 or more dark frames for each ISO and exposure time used for your light frames. Next take your dark bias frames while you still have

your telescope sealed to keep out light. A minimum of 49 dark bias frames are needed for each ISO setting used for your light frames. Set your camera to its fastest shutter speed for the dark bias frames. Finally, if you are alone and have a light source, take your flat frames and then pack up and call it a night. Make at least 49 flat frames for each ISO setting used for your light frames. Set the camera on Av and let it automatically determine the exposure time. If others are nearby, take your flats frames after the sun rises. If you cannot do your flat frames on site; mark the orientation of your camera to the telescope and the position of the focuser. When you get home, setup again using the camera and focuser marks and then do your flat frames. This will not be ideal but try to orientate your telescope and your camera on your telescope to match as close as possible that used during the imaging configuration.

Table 5.1 provides data at 10° increments of latitude. Most people are located at a latitude in between, thus, will need to interpolate the exposure times. Don't get too involved in accuracy, round down or up to the nearest 10° increment or split the difference if you are near a latitude divisible by 5. This does have some error but provides data more than suitable for planning purposes.

5.6 Setting Up

Lightweight alt-azimuth mounts are designed for visual observing not for astrophotography. However, this does not preclude using them for photography as long as any particular mount's abilities are known and the photographic process is kept within the mount's capabilities. The gearing used on lightweight alt-azimuth mounts is not designed or manufactured with the precision really necessary for astrophotography. Add to this the variance between manufacturers as well as among product lines by the same manufacturer and a situation exists that precludes any blanket statements concerning any particular mount's capabilities. While in general a lightweight mount can support 30 s exposure times, some mounts can go longer and others not as long. Fortunately some simple tests can document the performance capabilities of a mount. Knowing these performance characteristics is important so that you can use the mount to its fullest capabilities and do not try to push the mount into doing something that is beyond its capabilities.

Alt-azimuth mounts can operate in an off balance condition, some like the 4SE mount can be considerably off balance. However, a balanced load is preferable. Unlike an equatorial mount, an OTA cannot be attached to the mount and adjusted back and forth letting gravity tell us where the balance point is located. One simple way to balance the load on an alt-azimuth mount is to remove the OTA from the mount. Attach the camera and, if used, the focal reducer to the OTA. If you are using a refractor, have the focuser racked out the approximate distance needed to focus the camera. Place the OTA on a flat level surface like a table with the OTA resting on its dovetail. Place a pencil underneath and at a right angle to the dovetail. Use the pencil as a fulcrum like for a child's seesaw to find the balance point of the

OTA with the camera attached. Mark that spot on the dovetail; white or some other light colored fingernail polish works very well for the mark and is easily seen in the dark. Attach the OTA back on the mount with the balance mark centered on the mount's dove tail saddle. This activity should be done as soon as you have assembled your photographic kit and definitely before going out at night. Here again, don't get too wrapped up with absolute accuracy. Close is generally good enough.

Some alt-azimuth goto mounts have an internal clock chip and others don't. If the mount has an internal clock chip (will keep the correct time even when the mount is not powered), set it to the local time synchronized to Greenwich Mean Time, also known as Universal Time. The more accurate you set the time, the better; ±5 s is easily done with a little practice. An internet search "current universal time" will provide many Websites that will not only give you the correct Universal Time but also the correct time for a large city near you.

Do a long term test to determine the accuracy of the hand controller's internal clock chip. Synchronize the hand controller's time to Universal Time and monitor it weekly to determine if it loses or gains time. This will let you know how often you must make time corrections. The more accurate the time, the more accurate your tracking and gotos will be.

If the mount does not have an internal clock chip, then synchronize your watch to universal time. Also, look up the longitude and latitude of the observing site and enter this data in the mount's hand controller. Again, the Internet is a good resource for finding the latitude and longitude of your location. The geographic data is entered in degrees, minutes, and, for some mounts, seconds. It is not entered as a decimal number. The mount must also be told if the local time entered is or is not daylight savings time.

Lightweight alt-azimuth mounts in general can tolerate considerably sloppiness regarding the correct time and location and still provide acceptable service for visual observing. However, this is not true for astrophotography. Anything that you can do to improve accuracy will enhance the photographic process. Balancing the load on a mount, leveling the mount, and entering the proper time and location are simple ways to enhance a mount's tracking abilities. Don't ignore the tripod. Lightweight mounts typically have weak tripods that need stiffening, see Appendix B for details. Do not extend the extension legs unless you have a sturdy tripod like the 4SE and even then, do not extend the legs more than about 33 %.

5.7 Measuring the Maximum Exposure Time for a Mount

This exercise is optional but it can help you improve the quality of your images, especially for people located 50° or more north or south of the equator where the impact of field rotation is less. Thirty seconds is often mentioned as the longest exposure time attainable with an alt-azimuth mount. This is an over simplification. What is true is that with a 30 s exposure statistically 60–70 % of the light frames taken will not exhibit signs of mount vibration, tracking movements or other arti-

5.7 Measuring the Maximum Exposure Time for a Mount

facts that make using them not beneficial. This statistic also changes with the mount used. For example the widely used Celestron SLT/SkyWatcher SynScan AZ goto mounts have a 70 % light frame retention rate with a 20 s exposure and a 60 % light frame retention rate with a 30 s exposure. The 4/5SE mount has a 70 % light frame retention rate with a 30 s exposure.

Take a look at Table 5.1. A very large portion of the sky supports exposures longer than 30 s. The size of this area increases the further away the observer is located from the equator. In our discussion of image quality, increasing signal strength was an attractive option to pursue. A change in exposure time from 30 to 40 s will increase the signal component of a light frame by 33 % and 45 s provides a 50 % improvement. Either case is significant. A simple test can let you know how reliably your mount can support exposure times greater than 30 s. For this exercise, a night with no wind is important.

As soon as the sun set sets or is no longer visible at your photographic location, take your telescope outside and let it start thermally equalizing. Setup your telescope as accurately as possible. When sufficient stars are visible, align the telescope. If you have to enter the time, take particular care to enter the time as correctly as possible. Use a long focal length eyepiece to go to alignment stars and a medium to high power reticle eyepiece to center an alignment star in the eyepiece. If you do not have a reticle eyepiece, you should really consider getting one. To center without a reticle eyepiece, defocus the telescope so that stars look like a large circle. This will help judging when a star is centered in the eyepiece.

For alignment stars; use bright stars 60° or more apart and not near the zenith. Also do not use a star near the horizon, say within about 30°, as diffraction by the earth's atmosphere introduces error. Regardless of what your telescope manual may say, do not use planets or the moon for an alignment object as the locations of these objects are not as precisely calculated as are the locations of stars. For an alt-azimuth mount in the northern hemisphere, Polaris is always a good choice for the first alignment star. A good second choice when photographing a deep space object is a bright star near the object you want to image. For this exercise, any bright star not near the zenith will do; however, one due east or west, if it exists, is best.

After aligning the telescope mount, leave it on the second alignment star. Remove the eyepiece and diagonal and then install the camera and a remote shutter switch or an interval timer. Focus the camera using its live view function or a Bahtinov Focusing Mask as discussed in Chap. 3, Sect. 3.13. Now the setup for the exposure duration test is complete.

One factor to consider when doing the exposure duration test or any other similar trial; while one data point is infinitely better than none, it does not tell the story. That's like flipping a coin one time, having heads show, and announcing that if you flip a coin heads will show every time. To have a valid result, we need sufficient data to take care of the statistical abnormalities. For our test we want to have good confidence level in the results, so we will repeat the test several times.

Once the camera is focused, the maximum attainable exposure time needs to be established or, in other words, we want to determine the length of time the mount can track an object with no mount movement or periodic error ruining the exposure.

This will define the longest possible exposure time attainable with the mount and tripod. Here we are not talking about field rotation but the movement of the mount caused by vibration and tracking motion.

From Table 5.1 we note that for objects 50° or less in altitude and 20° either side of due east or due west, exposures of 60 s are possible without field rotation. Use the hand controller and aim the telescope due east or west at some stars preferably having a magnitude of around 2 or 3. Any stars having an altitude between 30° and 50° and an azimuth within 20° of due east or west will do. Brighter stars can bloom and not give as good results. Give the mount about 5 min to settle down after you center the star(s) in the camera. Now make a 60 s exposure of the star(s) and examine the image on the camera's view screen at the highest magnification the camera allows. If the star(s) is a bright dot with no star trail, you have one data point that the mount can make a 60 s exposure. If a star trail is present, you have one data point saying otherwise. Neither finding is significant. Repeat this test at least nine more times to establish some statistical significance for the test. If after doing the test ten times, you have say six exposures with no star trails and four with star trails, you can say with a fair degree of confidence that for 60 s exposures, 60 % will be good enough for keeping and using with a stacking program. In other words, your retention rate for 60 s exposures is 60 %. If you repeat the test 20 times, then your level of confidence in the results is far greater.

If after completing the test using 60 s exposures, you have a retention rate of 60 %, or higher then, if you wish, you can go to 75 s exposures and see what happens there. However, due to field rotation, there will be little opportunity for using exposures of 60 s or longer. If after completing the test using 60 s exposures, your retention rate was less than 60 %, repeat the test using 45 s exposures.

If the mount cannot support 30 s exposures with a 50 % retention rate, check the following possible faults:

- Unlevel mount; eyeball level is not good enough, use a level
- Weak tripod, check to insure the tripod is stiffened as much as possible, see Appendix B
- OTA balance; double check the OTA's balance
- Dangling cables, wires, camera straps, etc.
- Insure that the surface where you have set-up your telescope is solid and vibration free (roof tops and balconies are generally poor platforms)
- Check to insure that vibration from mirror lift is not a problem
- Last, but not least, don't do the test if you have wind.

5.8 Imaging with an Alt-Azimuth Mount

To prevent vibration a remote shutter cable is required. Since 100–200 or more light frames are frequently taken, a remote shutter with a programmable switch, called an interval timer or intervalometer, is preferable. They are available on eBay from China for very low prices; less than $25. An interval timer also keeps the exposure

5.8 Imaging with an Alt-Azimuth Mount

time constant which facilitates the stacking process. The 4/5SE telescope mount and the SkyWatcher EQ3PRO have a built-in interval timer. This is not true for other mounts including the larger 6/8SE mount.

If possible use a star near the object selected to be photographed as one alignment star. Once the alignment process is completed, do a goto to the selected object and synchronize the mount to the object. Synchronizing the mount varies among manufactures as well as the type of mount. The process can vary also from simply centering the object in the eyepiece and having the mount adjust its alignment settings to processes involving nearby bright stars.

Now go to the closest star near the object to be photographed that is sufficiently bright enough to use to focus the camera. Then do a goto back to the object to verify that it remains centered in view followed by going back to the star selected for focusing. Remove the eyepiece, install the camera, and focus on the star being very careful not to move the telescope, mount, or tripod. Focusing through the camera viewfinder is very difficult and seldom produces good results. Some cameras have a "live view" feature that provides real time viewing of a bright star on the camera LCD screen at 10× magnification. Live view greatly facilitates focusing the camera and is one of the most accurate methods to focus. A 3× angle finder also helps but is not as precise as live view. Other methods such as using a Hartman Mask, diffraction spikes, Bahtinov Mask, etc. also exist. Use the method most comfortable to you; but take the time to achieve the sharpest focus possible.

If an interval timer is used, configure it to take the number of light frames at the exposure time you calculated you needed during the planning process. Program a 5 s pause between light frames to allow the camera to process the image. If a non-programmable remote is used, set the camera's exposure time to the desired time for exposure times of 30 s or less. If your exposures are longer than 30 s, you will need a watch you can read in the dark or some sort of timer you can set in the dark. Make sure a comfortable chair is available for you as you manually trip your camera shutter. Some soft background music will help pass the time. When the sky is sufficiently dark, begin the photography process. If you are using an interval timer, then some stargazing with binoculars is fun to do to pass the time.

Periodically during the exposure process, stop and examine a few of the light frames. Review them at as high magnification as is possible with the camera and look for evidence of star streaks. If more than approximately 40 % have star streaks, check for dangling cables or other sources of vibration. Decreasing the camera's shutter speed by 5 s often helps. Note: Star streaks can be caused by field rotation, mount vibration, mount tracking motion, wind, etc. Also check the composition of the photograph to make sure the object being photographed has not drifted too far from center. If it has, use your hand controller to make adjustments. This requires very small corrections.

Once the object approaches the zenith or the photographic session comes to an end, place a lens cap on the telescope. Take a series of photographs with the lens cap installed, called darks, using the same exposure times and ISO settings as were used to photograph the object. You will need at least 49 darks for each ISO shutter speed combination you used. After that, take your dark bias frames and your flat frames.

Chapter 6

Astrophotography with Lightweight, Portable, Equatorial Mounts

6.1 Introduction

Why use an equatorial mount if an alt-azimuth mount is capable of photographing deep space objects? This is a good question especially given the added complexity of setting up and using an equatorial mount. To answer the question, an equatorial mount has three major advantages over an alt-azimuth mount. These are:

- Exposure time
- Sharper images
- Unrestricted sky access

However, an alt-azimuth mount has one huge advantage over an equatorial mount for observers in urban locations. It does not have to be precisely polar aligned. As you leave the suburbs and head in toward the city center, the levels of artificial skyglow increase making finding suitable alignment stars difficult. Also in many cities, the height and number of buildings and other obstructions increase toward the city center limiting the amount of sky that is visible. An alt-azimuth mount often can make the difference from being able to view or photograph the night sky or staying at home practicing armchair astronomy.

Very short exposures have very low signal to noise ratios. Keep in mind, when we stack these images, the signal part remains constant; we only reduce the noise component. Since an equatorial mount counters the earth's rotation, exposure time is no longer limited by field rotation. This means that exposure times with an equatorial mount can be longer than times with an alt-azimuth mount with the time limited by either the mount's tracking characteristics or by skyglow.

Since the signal part of an image increases linearly with the duration of an exposure, the longer exposures available from an equatorial mount will have a higher signal and will provide more details and contrast than the shorter exposures from an alt-azimuth mount. This will also allow photographing objects with a surface brightness lower than can be captured with an alt-azimuth mount. Even a small increase in exposure time is significant. Take for example increasing a 30 s exposure 15 s. The resultant 45s exposure will have a signal component 50 % greater than the 30 s image.

An image made with an alt-azimuth mount has movement in it resulting from field rotation. Although the impact of field rotation is greatly reduced by using very short exposures, it is not eliminated. While field rotation may not be visible to the eye in a very short exposure, it is there nevertheless. The object does rotate slightly during the exposure. That makes the images appear a little soft; especially at the edge of the field of view where the impact of field rotation is the greatest. By softness, we mean the image while focused is not razor sharp. Because an equatorial mount counters the earth's rotation, the object is stationary during the exposure with no movement. This produces a slightly sharper image than does an alt-azimuth mount.

Unlike an alt-azimuth mount where imaging must stop if an object nears the zenith; an equatorial mount can photograph objects at and near the zenith where the impact of the earth's atmosphere and light pollution are at a minimum. Less atmospheric impact increases the sharpness of an image and less light pollution increases an image's details and contrast. The capability to photograph the night sky surrounding the zenith also significantly increases the length of time many objects are available for photographing.

The list of equipment needed to use an equatorial mount for astrophotography is the same as listed in Chap. 5 for using an alt-azimuth mount with two exceptions. While a self-guider is not used for alt-azimuth mounts, it may be used to increase exposure times with an equatorial mount. If used, this adds a guide telescope and a self-guider to the list of equipment.

6.2 Lightweight Equatorial Mount Characteristics

Recall from Chap. 4, for the concept of "Astrophotography on the Go" our definition of "lightweight and portable" means a complete astrophotography kit that can be carried by one person in a case or a backpack on public transport such as a subway, up and down several flights of stairs, walking or riding a bicycle, or as carry-on baggage aboard commercial airlines. Currently four equatorial mounts are available that meet this criteria that are also capable for photographing a multitude of deep space objects. These mounts are the:

- iOptron SmartEQ PRO
- iOptron SmartEQ
- iOptron Cube A
- Celestron 4/5 SE

6.2 Lightweight Equatorial Mount Characteristics

The Celestron 4SE and 5SE use the same identical mount and tripod. The 4/5SE mount is a single arm alt-azimuth mount with a built-in wedge that allows its use as an equatorial mount. The iOptron Cube A mount is also a single arm alt-azimuth mount with a built-in wedge. However, the design of the Cube A mount is such that when the wedge is used, the mount becomes a German equatorial mount, not an alt-azimuth mount on a wedge. The iOptron SmartEQ and SmartEQ PRO are German equatorial mounts. Although externally they appear identical to the eye, internally they are two different mounts with significant differences in capabilities.

The most capable lightweight equatorial mount currently available meeting our definition of portability is the iOptron SmartEQ PRO. This mount is a German equatorial mount that was specifically designed as a very portable, lightweight, mount capable of astrophotography. It differs from the less expensive SmartEQ mount in that it has precision metal gearing instead of nylon gears, a ST-4 auto guider port, and an illuminated polar scope. The SmartEQ PRO is capable of up to 30 min guided exposures while periodic gear error of the SmartEQ and the lack of an auto guider port limit its exposures times to approximately 45 s.

Like most goto equatorial mounts today, the SmartEQ hand controller has a routine to allow a precise polar alignment without the need to see the celestial pole. The rated payload for both SmartEQ mount versions is 11 pounds (5 kg). Guided exposures of 30 min duration have been obtained with the SmartEQ Pro carrying a payload of 8 pounds (3.6 kg). The total weight of the mount, tripod, and counterweight is 14.1 pounds (6.4 kg).

The iOptron Cube A alt-azimuth mount is actually a German equatorial mount designed for operation at 90° latitude where an alt-azimuth and equatorial mount are the same. This means when it is located at other areas on earth, it functions as an alt-azimuth mount. However, if placed on a wedge it reverts to a German equatorial mount that can have its load balanced. Thus, the iOptron Cube A mount does not have the balance issues in the equatorial mode as does a single arm mount like the Celestron 4/5SE mount.

The iOptron Cube A has a built-in wedge on its tripod very similar to the Celestron 4/5SE. The latitude adjustment bar of the iOptron Cube A is designed to provide the small adjustments required for a precise polar alignment. However, the Cube A does not have a way to make adjustments in azimuth. The tripod must be physically moved in azimuth. This is a tedious process making obtaining a precise polar alignment very difficult to obtain especially since the Cube A does not have a computer assisted precise polar alignment routine. The iOptron Cube A also has a built-in GPS that provides a precise location and time but is not automated to self-align the mount. Its published payload in the alt-azimuth mode is 7 pounds (3.2 kg) with a payload of around 5 pounds (2.5 kg) in the equatorial mode. Reported exposure times with the Cube A using its wedge as an equatorial mount are on the order of 45 s.

The 4/5 SE tripod provides a very stable platform, the best of all the lightweight mounts mentioned in this book. Like the iOptron SmartEQ, the 4/5SE mount and tripod is lightweight and portable weighing a total of 16.4 pounds (7.44 kg). The tripod has a built-in wedge that allows using the mount in the equatorial mode.

The 4/5SE hand controller programming is loaded with features to facilitate astrophotography of deep space objects including the capability to obtain a precise polar alignment and to control a DSLR camera for the entire photographic process. The rated payload for the 4/5 SE mount is 10 pounds (4.5 kg) in the alt-azimuth mode. Its payload in the equatorial mode is around 6 pounds (2.7 kg). The OTAs bundled with either the 4 or 5 SE mounts are on the heavy side for photography in the equatorial mode.

Unfortunately the latitude adjustment bar on the wedge of the 4/5SE mount cannot provide the small adjustments in latitude needed to obtain a precise polar alignment and no capability exists for azimuth adjustments other than actually moving the tripod. While the latitude adjustment bar is easily modified (see Appendix C) to allow the precision movements required for a polar alignment; no such option exists for azimuth adjustments. With practice, you can become fairly proficient moving the tripod in azimuth by the small distances required for a precise alignment if the tripod is located on a smooth, level surface. This eliminates grassy lawns, rough pavements, etc. Also note; the larger mount made for the 6/8 SE does not have a built-in wedge or the capability to control the photographic process.

The Celestron SE series telescopes use a single-fork alt-azimuth mount sometimes referred to as a single-tine or a single-arm alt-azimuth mount. A telescope is easy to balance on this type of mount so that the major loads on the drive motors are overcoming inertia when starting or stopping. However, when a single arm fork mount is placed on a wedge, the dynamics change completely; now the drive motors and gearing must handle both the weight that the mount is moving plus the inertia of starting and stopping. As the mount moves in RA, this unbalanced condition also causes the center of gravity of the mount and its load to change. This has a significant impact when the mount tracks an object that crosses the meridian. On one side of the meridian, the RA drive motor is lifting the weight of the mount and its load while on the other side the motor is acting as a break countering the force of gravity. Significant drift can occur as an object approaches, crosses, and then leaves the meridian.

Equatorial mounts in general are sensitive to payload weight. The payload weights typically published by mount manufacturers are the weight the mount can support when it is used for visual observing. For astrophotography as weight is added to a mount issues such as tracking movements, gear error, vibration, etc. become larger until a point is reached that corrections are difficult to do. This generally occurs when the payload reaches around 50–60 % of the rated payload weight for a German equatorial mount. These issues are also present when the mount is used for visual work but are not visible since the human eye does not integrate an image over time like a camera does.

Lightweight alt-azimuth mounts are not as sensitive to payload weight as are their equatorial mount counterparts. They can also carry heavier loads. This makes a wider selection of telescope OTAs, cameras, and other equipment available for use with a lightweight alt-azimuth mount than with a lightweight equatorial mount. For an example, the 5SE mount in the alt-azimuth mode can easily support the weight of the 5SE OTA, finder scope, focal reducer, t ring adapter, t ring, and a DSLR; however, this load is about 2 pounds more than it can handle using its wedge in the equatorial mode.

6.3 Precise Polar Alignment

Recall from the discussion on equatorial mounts in Chap. 2 that if an equatorial mount is precisely aligned with a celestial pole only movements in RA are needed to keep an object centered in an eyepiece or camera. For visual work, the alignment need not be that precise. However, for astrophotography, the more precise the polar alignment the longer the exposure time can be without needing guidance. Until recently, obtaining a precise polar alignment was a tedious job.

For astrophotography, a precise alignment with the celestial pole is required. If not, the mount cannot counter the effects of the earth's rotation and the nemeses of the alt-azimuth mount, field rotation, will also be present. A very precisely aligned equatorial telescope can keep an object stationary for long lengths of time allowing very long exposures without the need to make any guidance adjustments. Such perfection is difficult to obtain but sufficient precision is possible for unguided exposures of 5 min and longer.

Today, most equatorial mounts with a GOTO drive have routines programmed into their hand controllers that greatly facilitate obtaining a precise polar alignment even when the celestial pole is not visible. This is also the case for the four equatorial mounts we are discussing in this chapter. The SmartEQ, SmartEQ PRO, and the 4/5SE mounts have computerized routines to dial in a precise polar alignment. The Cube A is less rigorous and only provides the offsets from a precise polar alignment. None of these routines require that you actually see the pole star. While the computerized precise alignments are not as accurate as some of the older manual methods can be, far less skill and time are required to do an alignment and the precision obtained is excellent. The time saving from a computerized alignment is often a significant factor for people who must travel to a location away from their homes or are limited by their personal lives from participating in late night photographic marathons.

Regardless of whether you are using a computerized alignment process or a manual method, all polar alignments require that the mount be moved in azimuth and latitude. Here we are talking about moving the actual mount to change its orientation in space, not using a hand controller to slew the telescope in azimuth or altitude. German equatorial mounts and most wedges for converting an alt-azimuth mount into an equatorial mount have hand operated controls that allow the very small adjustments in both latitude and azimuth needed to obtain a precise polar alignment. Unfortunately this is not the case for wedge built into the 4/5SE mount's tripod or tripod for the iOptron Cube A.

One very popular polar alignment process is called "drift alignment." The first step is to obtain a rough alignment with the North Celestial Pole if you are in the northern hemisphere of our planet or the South Celestial Pole if you are in the southern hemisphere. For people in the northern hemisphere, a fairly bright star, Polaris, is less than 1° from the North Celestial Pole. For southern hemisphere, Sigma Octantis is 59 arcminutes from the South Celestial Pole but the star is very dim and difficult to see with the unaided eye.

A rough alignment with the celestial pole is not difficult. If you are located in the northern hemisphere and are using a German equatorial mount:

- set up your telescope mount so it is level and its polar axis is pointing North
- release the mount's DEC clutch and move the telescope until its tube is parallel to the mount's polar axis
- use the mount's altitude and azimuth adjustment screws to center Polaris, first in the finder then in the telescope. Note: here we are moving the mount using its adjustment screws; we are not moving the telescope.
- If you are in the southern hemisphere the alignment is the same except use Sigma Octanis. This alignment is good enough to for doing a star alignment with a GOTO telescope mount and for visual observations.
- Some German equatorial mounts have a hollow shaft for the mount's polar axis. A small telescope, called a polar scope, is inserted in the shaft and can be used to obtain an alignment with the pole star as well as with the celestial pole. For visual viewing people in the northern hemisphere can forego the polar scope and simply align Polaris in the hollow shaft.

If you are using an alt-azimuth mount on a wedge the process for a rough polar alignment is similar. The process varies slightly among the different manufacturers but here are the basics that are used. You will need to refer to your manual for specifics:

- Setup your scope so that the hinge side of the wedge is pointing North
- The angle the wedge makes to the plane of the earth is equal to 90° minus your latitude. (Note: Some wedges are calibrated for this and you must enter your latitude. See your manual.) Your mount's azimuth axis is now the RA axis and the altitude axis is now the DEC axis.
- The fork arm(s) of the mount should be pointing directly towards Polaris. Rotate the mount in RA until the DEC axis parallel to the plane of the earth.
- Rotate telescope in its DEC axis (former altitude axis) until it is parallel to the fork arm of your mount and pointed directly at Polaris. Adjust the altitude and azimuth adjustment screws on the wedge until Polaris is centered in view of the telescope. Some wedges do not have an azimuth adjustment so the mount and tripod must be physically moved. This is tedious and takes some practice to become skillful at doing it. Here as with the German equatorial mount, we are moving the mount, not the telescope.

Whether you have a German equatorial mount or an alt-azimuth mount on a wedge, the above alignments are more than sufficient for visual work and for doing an equatorial star align with a GOTO telescope. However, for astrophotography a more precise polar alignment is needed. One method very popular with photographers is known as a drift alignment. This method can be time consuming at first and requires some developed skills. With practice and development of your skills, the time required will become shorter.

6.3 Precise Polar Alignment

Two stars near the celestial equator (0° DEC) are needed to perform a drift alignment; one star due south near or on the meridian and the other star on the eastern horizon. An illuminated reticle eyepiece is also required.

- First choose a star where the meridian and celestial equator meet. The star should be within 0.5 h RA of the meridian and within 5° DEC of the celestial equator. If no stars meet these criteria, select the nearest star that is closest to the meridian and within 20° of the equator.
- Center the star in the telescope using a reticle eyepiece then watch how the star drifts in declination; north (up) or south (down). Ignore any drift left or right.
- If the star drifts south, the polar axis of the mount is adjusted too far east; if the star drifts north, the polar axis is too far west. Adjust the azimuth adjustment screws for the mount or wedge until the star no longer drifts north or south. Note: For the Celestron 4SE or the iOptron Cube A wedge you will need to physically move the mount and tripod in azimuth as the wedge has no azimuth adjustment screws. This can be very tedious as over-shoots are easy to do.
- Once you have no drift in north or south, move to a star near the eastern horizon. This star should about 20° above the horizon and within 5° DEC of the celestial equator. If the eastern horizon is blocked or you cannot find a suitable star, use one to the west but reverse the process. If no stars meet these criteria, select the nearest star that is close.
- Center the star in the telescope using a reticle eyepiece and, as before, watch how the star drifts in declination.
- If the star drifts south, then the polar axis is too low. If the star drifts north, then the polar axis is too high. Adjust the latitude adjustment screws until the star no longer drifts north or south.
- If you are in the southern hemisphere, reverse "North" and "South." Since we cannot choose the perfect alignment stars, mount movements in one axis will impact the other axis. Three or more iterations are often needed to obtain the precision needed for astrophotography. Also using the reticle at high magnification will also improve the accuracy of the alignment. For telescopes that do not use a diagonal such as a Newtonian, reverse the adjustment in azimuth.

Now for some good news; an easier way exists to obtain a precise polar alignment if you have an equatorial mount with a GOTO drive made by Celestron, iOptron, or SkyWatcher. These manufacturers include in their hand controller programming a routine that greatly simplifies obtaining a precise polar alignment. While not as accurate as a drift alignment can be, these programs are precise enough to align within 10 arcminutes of the celestial pole for a mount like the 4SE and reportedly within a couple of arcseconds for a mounts having ways to make small adjustments in azimuth and altitude like the SmartEQ. The process used by each telescope manufacturer is different but similar and also can vary slightly within each produce line. Celestron and SkyWatcher use one star for the alignment; iOptron uses two.

The process used by Celestron is called "All Star Polar Align." It is not exactly "all star" in that stars near the celestial pole as well as due east or due west cannot

be used. The All Star Polar Alignment process varies slightly across Celestron's product lines due to variances in equipment design but is essentially identical regardless of the telescope and mount. SkyWatcher has a very similar process. Here is the Celestron All Star Polar Alignment Process as done with the 4SE mount; the iOptron process is different but follows the same general model:

- The telescope must be set up level in the polar position and a successful equatorial alignment made. Until this is done, the All Star Polar Alignment feature is not accessible on the hand controller.
- Next, a goto is made to the star selected for the precise polar alignment. An alternative is to slew a fairly bright star selected for the alignment and use the hand controller's "identify" command. In either case the mount must know which star is in the telescope's field of view or it will use the last star used for the equatorial alignment. While just about any star will do, one near the intersection of the meridian and celestial equator seem to be easier to use for the alignment, at least with the 4SE.
- After selecting the alignment star, toggle the undo button on the hand controller until the word NexStar appears on the hand controller's screen.
- Push the alignment button and then select polar align. The hand controller will provide explicit directions to help you with the process.
- Once you start the polar alignment process, the mount will slew to where the star you selected should be located if your mount were precisely polar aligned.
- Using only the mount's azimuth and altitude adjustment screws (NOT THE HAND CONTROLLER), center the star in the finder scope then in the telescope. For this process, a reticle eyepiece is required and the greater the magnification the greater the potential accuracy of the alignment. Note: Since the 4SE mount has no azimuth adjustment screws, the mount and tripod must be moved in azimuth. This takes some practice but can be done at moderate levels of magnification and on smooth surfaces.
- Centered means centered, not being just within the small square box created by the dual cross hairs in many reticle eyepieces. This is very difficult to do with the 4SE mount.
- Once the star is centered in the telescope, press the enter key on the hand controller. This completes the precise polar alignment.

Goto accuracy can be negatively impacted by the polar alignment process with the magnitude of the possible error dependent upon the accuracy of the mount's rough polar alignment. With Celestron's All Star Polar Align, restarting the mount and doing another equatorial alignment is not required. To improve accuracy with the 4SE mount do a goto to the first alignment star you used for the equatorial alignment, and then go back to the alignment menu and then select replace alignment star. Replace the alignment star with itself. Next do the same for the second equatorial alignment star you used. For other mounts, this issue is addressed by adding calibration stars.

After restoring the mount's goto accuracy, if you go back to the Polar alignment and select "Alignment Stars" in the polar menu, the mount will provide the error in the precise polar alignment. If you have not replaced an alignment star or added

a calibration star after doing the precise polar alignment, the mount has insufficient information to calculate the error and the alignment error will be displayed as 0°. This is not a true reading. You must replace an alignment star, add calibration stars, or repeat the equatorial alignment to obtain an accurate polar alignment error reading. If the error is more than you can tolerate, repeat the polar alignment process.

6.4 Planning Your Photographic Session

Like the alt-azimuth mount, planning is an integral part of the imaging process with an equatorial mount. The two processes are very similar. One major difference is that an equatorial mount can support photographing objects as they pass through the zenith. This makes the best part of the night sky available for imaging and also increases the amount of time available for imaging many objects. The second major difference is that exposure times are not limited by field rotation; thus, longer exposures are attainable with the corresponding increase in signal to noise ratio.

As with the alt-azimuth mount, the first step for imaging with an equatorial mount is selecting the object that you want to photograph and then determining when you can photograph it. Don't forget to consider your site characteristics and obstructions like trees, neighboring structures, etc. that can block your view of the object.

If the object is rising early in the evening, you will have plenty of time to obtain your light frames. However, if the object is past the meridian early in the evening, then you will need to make sure that you have sufficient time for the imaging session before the object gets too low on the horizon.

As previously mentioned, light pollution is present for urban observers. It impacts equatorial mounts in the same manner as it does alt-azimuth mounts; the contrast and details of images are diminished and perhaps washed out completely. As discussed in Chap. 8 Light Pollution, surprisingly enough you can still make very acceptable images in areas having high levels of light pollution. Again, as with an alt-azimuth mount, as you gain experience you will get a "feel" regarding what objects you can photograph at your observing location.

The moon impacts photography with an equatorial mount pretty much the same as it does with an Alt-azimuth mount. Plan your sessions for the nights of the month when the moon is not visible when you want to photograph.

As an example of the planning needed, let's use the same example that was used for an alt-azimuth mount in Chap. 5; Messier Object M45. In this example, assume that you are still located at latitude 40° north, the date is 1 December, and the moon will not rise until 3 a.m. A quick look at a planisphere shows that the Constellation Taurus which contains the Pleiades is visible in the night sky until early morning.

Next, determine when M45 is best positioned in the night sky to photograph it. Unlike for the alt-azimuth mount, the zenith is no longer off limits; however, imaging an object as it passes through the meridian can create some issues for lightweight equatorial mounts. A quick look using a planning program tells us that M45 passes the meridian at 11:30 p.m. on 1 December. At 7:00 p.m. it is only 32° high in the sky while by 9:00 p.m. it has an altitude angle of 75°.

A total integrated exposure time of 120 min will bring out the nebulosity in M45's open cluster. Table 4.1 indicates that 228 light frames are required for a 120 min integrated exposure time assuming 45 s exposures with a 70 % retention rate. This will take 3 h and 10 min including a 5 s pause between each light frame. Doing the arithmetic, in order to complete taking all the light frames before the object passes the meridian at 11:30 p.m.; imaging must start no later than 8:20 p.m. If the telescope is setup and ready to start an equatorial alignment by 7:00 p.m., almost one and a half hours are available to do an equatorial alignment of the mount and then a precise polar alignment. These two processes normally take between 30 and 45 min altogether leaving a cushion of 35–50 min. This time cushion is more than adequate to take care of any unforeseen problems and to determine if the polar alignment is sufficient to support exposures longer than 45 s. The process for taking the dark frames, dark bias frames, and flat frames is the same as it was for the alt-altitude example in Chap. 5.

"Exposure time" With a polar aligned equatorial mount exposures longer than the 20–30 s associated with alt-azimuth mounts are obtainable. For planning purposes an exposure time of 45 s is a good start as statistically it is generally obtainable with a lightweight equatorial mount. However, at the start of the imaging session, this time must be verified and should be increased if the mount's polar alignment and characteristics allow doing so.

"ISO Setting" Each camera has its sweet spot. A good starting point is an ISO setting of 1600 if exposure times are less than 60 s and 800 ISO if exposure times are 60 s or longer.

"Dark frames, flat frames, and bias frames" This is another area of debate. As a minimum, 49 flat and dark bias frames or needed for each ISO setting used and 49 dark frames for each ISO/exposure time setting. However, the more you have the better. Keep in mind that the improvement is proportional to the square root of the number of frames you make. While only 25 frames are needed to reduce noise by a factor of 5, 100 are needed to reduce noise by a factor of 10. 49 frames will lower noise by a factor of 7 and is a good starting point when very short exposures are used for the light frames.

"Imaging Session Process" The imaging session has the following four phases:

- equipment setup and cool down
- equatorial and polar alignments
- imaging
- equipment teardown and storage

The setup and alignment process, from starting the equatorial alignment to erasing the memory card, will take about 30–45 min. Here is a synopsis of the process using a 4SE mount in the equatorial mode for someone located in the northern hemisphere of our planet:

- Setup the telescope at the observing location as soon as possible without the equipment being directly exposed to the sun. This will provide more than ample time for the telescope to thermally equalize with ambient conditions.

6.4 Planning Your Photographic Session

- Use a compass and contractor's protractor/angle finder to do a rough polar alignment while waiting on darkness to come. This is done with the 4SE mount by pointing the hinged side of the wedge toward north and setting the angle of the wedge for the latitude of the observation site. The angle of the wedge to the tripod head is 90° minus the latitude. A cheap $10 plastic magnetic protractor angle locator works very well (see Appendix C).
- As soon as the first stars are visible, power up the telescope, enter the correct date, location if required, and time. Take care to make the time entry as accurate as possible. With a little practice you should be able to set the time to within 5 s of universal time.
- As soon as Polaris is visible rotate the tripod to have the hinged side of the wedge pointing directly toward the star. If a pole star is not visible, use the compass alignment with the pole.
- In the alignment menu on the hand controller, select North Equatorial Alignment and do an equatorial alignment using at least two alignment stars. Do not use a planet or the moon for an alignment object.
- Upon completion of the equatorial alignment do a precise polar alignment. For the 4SE mount, do a goto to a star that you want to use for your precise polar alignment and then do the alignment using Celestron's All Star Polar Align.
- Upon completion of the polar alignment, replace the alignment stars with themselves
- Enter the alignment menu, select polar align and then select alignment star. This will give the azimuth and altitude off-sets from a true polar alignment, in other words, the error. If the error is less than 5–10 arcminutes, you have about an accurate polar alignment as is possible with the 4SE mount. If the error is more than 15 arcminutes, you may want to repeat the All Star Polar alignment.
- Do a goto to the object you want to photograph.
- Enter the Alignment Menu and select the "Sync" command and sync the mount to the object.
- Use the hand controller and slew the telescope to a bright star near the object that is bright enough to see in the view finder of a camera.
- Remove the diagonal and eyepiece from the telescope and install the camera t ring then the camera. Be very careful not to move the mount, tripod, or telescope. (Note: If you inadvertently move the telescope, mount, or tripod you will need to repeat the polar alignment. The best option is to power down the mount, start at the beginning of the equatorial alignment process, and repeat the entire process. With the 4SE mount you can take a chance and use the "Set Mount Position" command in the Utility Menu. This command is designed to restore goto accuracy after a small bump. After finishing the "Set Mount Position" go to the Alignment Menu, do an "Undo Syn" command, and then repeat the above process starting with a precise polar alignment.)
- Focus the camera using whatever method you prefer. Cameras with the live view feature make focusing relatively easy to do. A Bahtinov focusing mask can also produce a sharp focus. Which method is best is debatable. Use the one you like the best.

- Once the telescope is focused, go to the Utility Menu and do a "Calibrate GOTO" command. This will let the 4SE mount measure the impact of change in weight on the mount caused by attaching the camera. The telescope will be pointing to some random spot in space when the calibrate goto is completed.
- Do a GOTO to the object you want to photograph.
- Now do a 60 s test exposure to determine if the object is in view of the camera and that the camera can make a 60 s exposure with no star trails. If you have star trails at 60 s, do another test exposure a 45 s exposure, then down to 30 s if you are not successful at 45 s. If you cannot get 30 s exposures something is amiss with either your alignment or your equipment. If you have no star trails at 60 s, increase the exposure time to 90 s and see if star trails are present. If not, go to 120 s.
- Once the available exposure times are verified, find that the object being photographed in the test exposure. If the object is not centered, use the hand controller to move the scope slightly in the appropriate directions and center the object. Do another test exposure to see the results. Repeat this until you are satisfied with the composition of the image.
- If you had to center the object, go to the Alignment Menu, do an "Undo Sync" command followed immediately by a "Sync" command; this syncs the new location of the object being photographed.
- If you are using the 4SE camera control feature, enter the object into the hand controller's data base and program the mount for the imaging session. If you are using an interval timer, program it.
- Now erase all the test images to have an empty memory card available for the night's work.
- You are now ready to start the imaging session as soon as the sky is dark enough.

The above process is for a 4SE mount using its wedge to put the mount in the equatorial mode. The process for a German equatorial mount like the iOptron SmartEQ will be very similar. Some differences are:

- The iOptron polar alignment process uses two stars
- The iOptron programming does not have an equivalent to Celestron's "Calibrate GOTO" command or its "Set Mount Position."
- The iOptron cannot control a DSLR camera

Our camera tells us that the 8 GB memory card in our camera can hold approximately 730 RAW images. However, we know from experience that the actual number with the camera we are using is slightly less and we assume that we have memory for 700 images. This capacity is dependent upon the number of exposures not the duration of an exposure. If we make a total of 150 dark, flat, and bias frames, enough memory remains for approximately 550 light frames. Camera memory is not a factor for the imaging session. A total integrated exposure time of 120 min is ideal for most nebulae and galaxies and 60 min for double stars and star clusters. With a 60 s exposure, 120 light frames are needed for an integrated exposure time of 120 min. Often about 30 % of the light frames made with a lightweight

6.4 Planning Your Photographic Session

alt-azimuth or equatorial mount are not usable due to clouds, mount vibration, etc. so making 170 light frames is prudent. Add the additional time for 49 dark frames, 49 flat frames, and 49 bias frames, and an imaging session of approximately 5 h is needed to setup, polar align, acquire imaging data, and pack up.

No reasons exist why two objects cannot be imaged on the same night. A larger or a second memory card can easily be obtained for the camera, if needed, as well as spare batteries. A battery suitable of 8 h operation can be obtained for the telescope mount and an extra thermos of hot coffee included in your kit.

Chapter 7

Piggyback Astrophotography and NightScapes

7.1 Introduction

As we discussed in Chap. 3, Piggyback photography is nothing more than attaching a camera with its own lens to a telescope with the camera's lens pointing to the same spot in the sky as the telescope. The camera with its lens is then used to photograph objects in the sky (see Fig. 7.1). A variation of piggyback photography is attaching a camera directly to a telescope mount or to a mount designed specifically for a DSLR camera with no telescope used (see Fig. 7.2). Piggyback photography is very flexible due to the large variety of camera lenses that are available.

Nightscapes are another category of astrophotography with a camera and its lens. Here a camera is used with a fixed camera tripod to photograph both terrestrial and celestial scenes at the same time. Some nightscapes have both the terrestrial and celestial objects stationary while others keep the terrestrial object stationary but have stars moving making circles in the sky. In some ways nightscapes are the most challenging form of astrophotography as finding the right composition is more than the mechanics of making a shot but also requires an artistic eye.

Piggyback astrophotography or nightscapes are excellent ways to start developing your knowledge and skills related to astrophotography. If you already have a suitable camera and a telescope with a tracking mount or a camera tripod, all you need do is to go out at night and start photographing.

While piggyback and nightscape photography may sound sophomoric, this definitely is not the case. For many accomplished photographers, piggybacking or

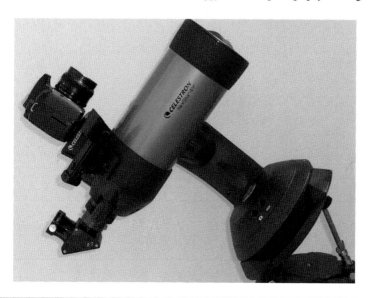

Fig. 7.1 Piggyback camera

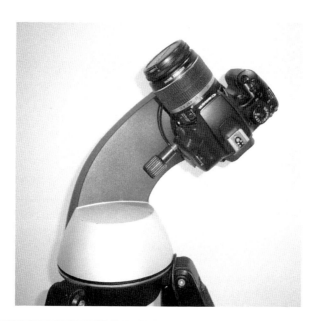

Fig. 7.2 Camera on a telescope mount

nightscapes are where they spend all their time under the stars at night. Either is a great way to enjoy astrophotography, especially if you do not want to invest a large amount of money.

7.2 Cameras and Lenses

What Camera Should You Use?

If you already have a DSLR CAMERA, use it to get started. You can purchase a new camera later if you decide you need to upgrade. Keep in mind that older DLSRs do not have the low noise and low light sensitivity attributes of recent models and are often heavier.

If you must purchase a camera, either a new or late model Canon DSLR CAMERA that has the "live view" feature and an articulated review screen is difficult to beat. While the other manufacturers make excellent cameras, the astrophotography related software and support available for Canon as well as Canon's excellent low noise characteristics make it the camera of choice among astrophotographers.

Four thirds, mirrorless, interchangeable lens cameras are excellent for daytime photography; however, their noise characteristics are not up to the standards exhibited by modern DSLR Cameras. Hopefully this will not be the case for long as the second generation of these cameras is definitely better than the first. This does not mean that you cannot use one, just that your results may not be as good as they could be.

Bridge cameras are now very sophisticated. A bridge camera like the Canon PowerShot SX50HS appears to have the features needed for either piggyback or nightscape photography. It has the capability for remote and manual operation including manual focus, can do JPG, RAW, or JPG and RAW files, and has an articulated view screen. Its weaknesses are that it is limited to exposures of 15 s or less, does not have live view, and is noisy in low light conditions. If you have a bridge camera, trying it out is definitely worthwhile but be prepared for some noisy images.

Point and shoot cameras simply do not have the capabilities needed for photographing deep space through their small lenses.

What lenses do you need for piggyback photography? Most modern cameras come bundled with a zoom lens. Since a zoom lens works by changing the focal length of the lens, the focal ratio will vary with changes in focal length. One very popular lens bundled with many Canons is its EFS 18–55 mm zoom lens. This lens has a focal ratio of f/3.5 at a focal length of 18 mm and a focal ratio of f/5.6 at a focal length of 55 mm. Similar lenses are bundled with other cameras. If a zoom lens is what you have, use it. You can buy better lenses later if you wish to pursue piggyback photography further.

One nice attribute of the Canon EOS camera line is that they can use older lenses with a Pentax M42 screw thread mounting. These lenses are plentiful in the used

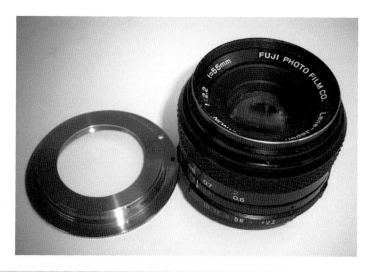

Fig. 7.3 M42 lens adapter

market and inexpensive. To use one you will need an adapter similar to a "T" ring to change the M42 threads to the EOS lens fitting (see Fig. 7.3). None of these older lenses will support the automation of today's cameras but you will be using your camera in the manual mode anyway. Also, in comparison to a telescope, these lenses have relatively short focal lengths and are more forgiving of mount vibration and tracking errors.

Older 35 mm film cameras typically came bundled with a 50 mm, f/1.8 or a 55 mm f/2.8 fixed lens. These lenses are excellent for rich field photography as well as for nightscapes. A popular telephoto lens was a 200 mm f/3.5 fixed lens. It is very useful for photographing large objects such as the Rosetta Nebula, North American Nebula, The Sagittarius Star Field, etc. For nightscapes and star trails, a fast wide angle lens with a focal length of around 18 mm is desirable but higher focal lengths such as a 55 mm lens will also work.

Used lenses, especially vintage SLR lenses, are easily obtained and generally at low prices. Buying a used lens from a local used camera store is advantageous, especially if you can make a deal where you can exchange the lens if it does not work for astrophotography. If you buy a vintage lens, here are some things to look for:

- fungus growth between the lens elements
- obvious signs of abuse
- tightness of the focus and f/stop adjustment
- lens quality

The first three items on this list are obvious. However, to determine lens quality you will need to take the lens out at night and photograph a bright open star cluster

that has a lot of stars and covers a large area of the night sky. M45, if visible, is a good one. Start with the fastest setting for the lens and then repeat the test with the second and third fastest settings. Take several exposures at each setting. With a bright star cluster a 20 s exposure should be good enough. Look carefully at the star images. Stars in the center of the field of view should be sharp pinpoints of light. They will most likely slowly become distorted as you view toward the outer edge of the field of view; the less the distortion, the better but don't expect perfection.

Other things to look for are chromatic aberration, excessive vignetting, focus, focus shift, and internal reflections. Colored halos around bright white stars are an indication of chromatic aberration. Vignetting, a circular image of the stars with dark corners, will exist so look for severe vignetting. Images where you cannot achieve a focus or are not focused uniformly indicate a problem lens and the lens should be rejected. Images that have changes in focus over a series of exposures indicate that the focusing mechanism may be too loose (may be remedied with tape and is a trait of some zoom lenses). Arcs of light are indicative of internal reflections but before rejecting the lens, make sure that stray light is not entering your light train.

Lenses, especially very fast lenses, sometimes perform poorly at their fastest settings. If the lens does not do well at its fastest setting but does do well backed off one or two f/stops you may want to consider keeping it if it is a fast lens. After all, a f/1.8 lens at f/2.8 is still very fast. Also, keep in mind that not all lenses use full f/stops and that, backing off f/stops is not feasible with a slow lens as there is no room to spare.

7.3 Piggy Back Astrophotography; Telescopes and Mounts

Which telescopes and mounts are suitable for piggyback astrophotography? In many respects, any telescope will do. While the telescope is not used in the actual photographic process it can have a substantial supporting role. Equatorial mounts are capable of exposures of several minutes if they are precisely polar aligned. The precision of a polar alignment is greatly enhanced when a telescope is used for star alignments or drift measurements. Nearly all deep space objects including most stars are simply too dim to see through a camera's viewfinder. The photographer can use a telescope to locate and center the targeted object. If the cone error (misalignment) between the telescope and camera is not too great, the object will also be visible to the camera. Another task performed by the telescope is that of a guide scope. For long exposure imaging, the telescope can be used as a manually operated guide scope and eliminate the need for having a computer in the field at night. Guide scopes are also needed with a goto alt-azimuth mount but in a different role. Since goto alt-azimuth mounts are designed for visual work, especially the entry level and intermediate mounts, objects often drift in their field of view. This drift is monitored with the telescope and corrected if the drift becomes substantial.

The mount and its tripod are a different story. Unlike the telescope, they are not optional. Just about any equatorial mount with a motorized or computerized tracking capability will work as well as nearly all computerized alt-azimuth mounts. Here again, an equatorial mount offers greater capabilities than an alt-azimuth mount and a computerized mount greatly facilitates the photographic process.

One thing to consider; if you are not using a computerized GOTO mount, you will have to find the object you want to photograph on your own. This requires both knowledge of the night sky and the skills related to locating faint objects that are often invisible to the unaided eye and sometimes not visible with a telescope. If this description fits you, don't despair, try nightscapes instead until you learn the night sky.

Most German equatorial mounts used for piggyback photography are large and heavy mounts designed specifically for astrophotography. While movable, these mounts do not fit the definition for lightweight and portable mounts used in this book. Having said that, there are some relatively lightweight, German equatorial mounts that are popular for piggyback photography such as:

- Celestron CG4 (manual, single or dual axes drive motors)
- iOptron SmartEQ/EQ PRO (GOTO drive)
- Orion AstroView Equatorial Mount (manual, single or dual axes drive motors)
- SkyWatcher EQ3 (manual, single or dual axes drive motors, GOTO drive)
- Vixen GP2 Photo Guider (single axis drive motor).

Regardless, the telescope can be used as a guide scope if very long guided exposures are wanted. Tracking can either be manually done or computer controlled if a GOTO drive is used. Dependent upon the alignment, camera lens focal length, and atmospheric conditions; unguided exposures of several minutes are attainable. While not heavy or bulky from a German equatorial mount perspective, other than the iOptron SmartEQ/PRO, none of the mounts on the list fit our definition of lightweight and portable.

Alt-azimuth mounts are also suitable for piggyback photography. Their neminis, field rotation, remains and must be worked around by using very short exposures. This makes them not as popular for piggyback photography as are equatorial mounts. Since tracking with an alt-azimuth mount requires constant corrections in both altitude and azimuth, a computerized GOTO is required to calculate and control the required movements. However, as said earlier, an alt-azimuth mount does not require a precise polar alignment which in an urban setting can make the difference between being able to photograph or staying at home.

Both computerized tracking and GOTO alt-azimuth mounts are available but the GOTO mounts are by far the most popular and plentiful. Beginner and intermediate level alt-azimuth mounts are designed for visual work and do not have the precise tracking ability found in alt-azimuth GOTO mounts designed for advanced level work and for astrophotography using a wedge. Advanced level alt-azimuth mounts, like their German equatorial mount counterparts, are heavy and bulky and do not fit our definition of lightweight and portable mounts. Of the beginner and intermediate

alt-azimuth mounts, the following are suitable as a lightweight, portable mount for piggyback photography:

- Celestron SLT, Prodigy, and SE Mounts
- iOptron Cube and mini Cube series mounts
- SkyWatcher SynScan AZ GOTO mount
- Meade LS and LT mounts

Mounts designed specifically for using a camera with its lens for astrophotography are also available. Some camera mounts currently popular among photographiers are:

- Astro Trac TT320X AG Astrophotography Mount
- iOptron SkyTracker
- iOptron Sky Guider
- SkyWatcher AllView Multifunction Computerized Mount
- Vixen Polarie Star Tracker
- Vixen GP2 Photo Guider

For people who want to keep cost down to the minimum, a homemade mount called a "Barn Door Mount" is easily constructed using simple hand tools for less than $20. Detailed plans and directions for building your own Barn Door Tracker are easily obtained for free; simply do an internet search "barn door tracker astrophotography" and take your pick. Construction is simple using hand tools (hand saw, drill, screwdriver, ruler, and a hammer). The materials needed are piece of wood, a piano hinge, camera ball mount, and a few nuts and bolts. The mount can be either motorized or hand driven.

One popular, inexpensive, entry level telescope offered by several telescope makers is a 130 mm Newtonian on a motorized German equatorial mount. Unfortunately, the telescope does not have sufficient back focus for a DSLR CAMERA and the mount is noted for its vibration. Using it as a piggyback platform to photograph bright deep space objects is tedious and filled with issues but it can be done using a very fast (~f/2.8), short focal length lens (~55 mm or shorter) and 10–15 s exposures. The mount can also be used to photograph nightscapes. Being fair to the manufacturers, this telescope is designed and sold for viewing, not for photographing, deep space. If this is the telescope you have, use it but stay within its limitations. While you will have many issues and at times may get frustrated, don't let them discourage you. You will learn a lot about astrophotography and in the process make some very beautiful photographs.

7.4 Deep Space Photography with a Piggyback Camera

The first step is obvious but also can be difficult; decide what you want to photograph. This area is where learning the basics of astronomy before starting astrophotography pays-off so you know what is out there, where it is located, and when it is visible. Also, If you do not have a GOTO telescope, you will need to be very skilled at finding objects on your own in the night sky in order to photograph them.

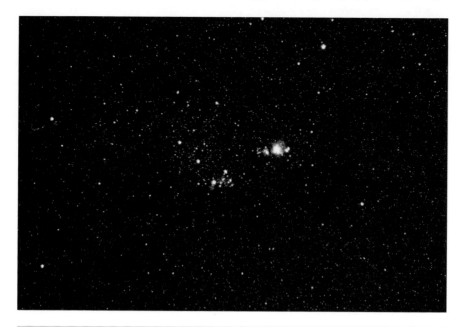

Fig. 7.4 Richfield Orion constellation

For newcomers to astronomy, a good starting place is the Caldwell and the Messier lists. These objects are well known and details of their size, visibility, etc. are readily available on the internet, computer programs, etc. Internet astronomy forums are another excellent source to use. All the popular astronomy forums have sub forums where members post the images they make. These sub forums are particularly helpful as the members generally include the details of the image such as:

- exposure time
- number of subs taken
- the camera used as well as its settings
- the lens or telescope used along with the focal ratio
- the mount used
- computer programs used
- date and time the image was made

For piggyback photography look for objects that cover a large area of the night sky. The Cone Nebula is an excellent object to photograph with a Schmidt Cassegrain telescope with its long focal length, but not with a camera lens as its physical size is far too small. With a camera lens, all you will get is a dot. On the other hand the Rosetta nebula with a 200 mm lens makes a very nice composition. M24, the Sagittarius Star Field is a good subject for a 55 mm lens or a 200 mm lens. Wide field of view photographs are also possible such as a photograph of the Constellation of Orion (see Fig. 7.4).

7.4 Deep Space Photography with a Piggyback Camera

Table 7.1 Approximate field of view vs. lens focal length

Lens focal length (mm)	Degrees long axis	Degrees short axis
20	58	41
50	25	17
100	13	9
150	9	6
200	6	4
300	4	3
400	3	2

That's all well and good but how do you know what lens is needed? Astronomers measure distance in the night sky in degrees. One degree is broken into 60 arcminutes and 1 arcminute is subdivided into 60 arcseconds; very similar to the way we measure time. To give you a perspective of size, the full moon is about 30 arcminutes in diameter while the apparent size of M42, the Orion Nebula is 85 by 60 arcminutes and the apparent size of the M57, the Ring Nebula, 86 by 62 arcseconds.

The field of view provided by a camera lens is dependent upon the focal length of the lens as well as attributes of the particular camera being used. Table 7.1 provides a gross estimate of the field of view provided by a camera lens and a typical DSLR CAMERA. While the Orion Nebula is suited for capture with a 300 mm camera lens the Ring Nebula needs a longer focal length typical of telescopes. Fortunately the night sky has many objects suitable for camera lenses. Here is a sample of a few of them; there are many more:

- the Large and Small Magellanic Clouds
- Barnard's Loop
- Andromeda Galaxy
- Veil Nebula
- North American Nebula
- Sagittarius Star Cloud
- Rosetta Nebula

Setting up for a piggy back session is very similar to setting up for a session with either an equatorial or alt-azimuth mount. The only difference is the camera must be adjusted so that it is pointing in the same direction as the telescope. This can be done during the afternoon before sunset using the same process used to align a telescope with its finder scope. In fact, the two can be done together. Another approach is to center a bright star in the eyepiece of a telescope then center the same star in the camera's view finder or live view screen. If you are using an equatorial mount, then you need to precisely polar align the mount using the same procedures used when photographing with a camera at prime focus as described in Chap. 6.

The actual photographic process is the same as with a telescope at prime focus as described in Chap. 5 for an alt-azimuth mount or Chap. 6 for an equatorial

mount. Go to a bright star, focus the camera, go to the object, make a 60 s exposure to ensure the object is in the center of the field of view of the camera, adjust if necessary, take your images, take your darks frames, flat frames, and bias frames and then process the data.

7.5 Nightscape Photography

Exactly what is a nightscape? For the sake of having a definition, a nightscape is a photograph of a terrestrial object taken outdoors at night using the light from the moon or stars that may or may not include a heavenly object and may or may not include artificial lighting (see Fig. 7.5). This definition is very broad but so is

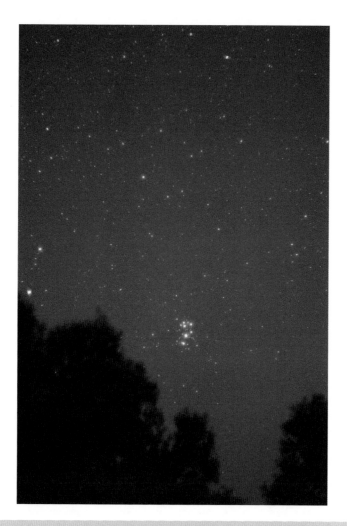

Fig. 7.5 Pleiades rising

7.5 Nightscape Photography

human imagination. The human imagination is an important part of a nightscape as it is human imagination that makes a nightscape either just a photograph done by a photographer or a piece of art that amazes people. Unfortunately, not all of us have the talent needed to bridge the gap between photographer and artist.

Nightscape photography offers one particularly interesting challenge; photographing both a stationary and a moving object simultaneously under extreme low light conditions. The earth rotates 15° per hour. This gives an apparent motion of the stars and other celestial objects moving in the sky. If an image contains a terrestrial object then tracking a celestial object will blur the terrestrial image. With no tracking, the terrestrial object in the image is sharp but stars can be curved streaks of light that are called star trails. Images with star trails can be interesting and many people produce them on purpose in their photographs. Not surprising, photographs featuring them are often called "star circles" and that is the term used to describe them. However, for a nightscape sharp well defined stars are wanted against a sharp background.

With the proper camera lens and settings, sharp images are obtainable for both celestial and terrestrial objects. This popular imaging technique is typically what people have in mind when they use the term nightscape and is the term used in this book for such images. Notice that no tracking is needed for either a nightscape image or a star trail image. This is one major difference between nightscape and piggyback photography. For nightscape or star trail images, a sturdy camera tripod and a DSLR CAMERA with the appropriate lens are all that the photographer needs.

Nightscape photography is no different to other forms of astrophotography in that you must plan your imaging session. Planning includes determining what you want to photograph, how you want to compose the image, when you can capture the image, and where you should locate your camera. Here computer programs are most valuable. They can help you know what is visible in the night sky as well as where objects are located and when they are visible.

Perhaps the most difficult part of a nightscape is the composition; the art part. A boring background will make a boring nightscape. Taking a photograph during the day of the terrestrial background you want in your image is very helpful. If the daytime photograph is uninteresting, the nightscape is not likely to be any better. Reflections of celestial objects are often part of a nightscape. Water surfaces are popular but other surfaces can be used such as a car's windshield or the windows of a house.

The Milky Way and its reflection on the still waters of a mountain lake is a popular nightscape theme. Then there are the unusual themes such as an image of the moon rising over the Acropolis in Athens. These compositions require considerable planning to know when, both the date and the time, to capture the image and where the camera should be positioned.

Fortunately, we have many notable celestial objects such as star clusters like the Pleiades, constellations with conspicuous star patterns such as the Orion Constellation, the Magellanic Clouds, a bright planet, or a bright star just to name a few. These celestial objects are relatively bright and are noticeable features of the

night sky. Then there is the perpetual favorite of many photographers, the Milky Way. Having said all that, the plain, old ordinary, night sky properly framed with a terrestrial object can also produce excellent images.

7.6 Capturing a Nightscape

The setup for either a nightscape or a star trail photograph is similar. Look for a suitable terrestrial setting to include in your image, either in the foreground or background. This terrestrial object and how you frame it against the starry night sky will be the art part of your image and is what will make it a spectacular photograph. Look out for power lines, power poles, TV antennas and other things such as a nearby light source that can detract from your image.

Setup your tripod and camera where you can capture the celestial object or scene you want and also the terrestrial object you have selected. Make sure the tripod is orthogonal to the earth to help prevent the image from being tilted. Now move the camera until the terrestrial object is framed to your satisfaction. If you are doing your setup after the sun sets, you may need to do some exposures of several minutes with the camera lens at its lowest f/stop and at your camera's highest ISO setting to be able to frame the terrestrial object. Painting the object if it is nearby for a few seconds with a small flashlight can help. Don't hesitate to move your entire setup if need be.

For a nightscape we need an exposure sufficient to show both stars and terrestrial objects. A fast camera lens with a short focal length makes this possible. The faster the camera's lens the brighter the image produced. The shorter the focal length, the longer the exposure that can be obtained with stars remaining stars, not star trails.

The first item is to determine the longest exposure time that you can use. The exposure time is estimated using what many call the 600 or 500 rule dependent upon if your DSLR CAMERA has a full frame or an APC-S sensor. To calculate your longest exposure time, if you have a full frame sensor divide 600 by the focal length of the lens you are using (substitute 500 if you have an APC-S sensor or 400 if you are using a bridge camera). The resultant number is your estimated longest exposure time in seconds before stars start to become streaks instead of round dots. The arithmetic here is simple, the shorter the focal length, the longer the allowed exposure thus, the more defined objects, terrestrial and stellar, will be in your photograph.

For a typical DSLR CAMERA with an APC-S sensor the maximum exposure time is around 28 s with an 18 mm lens, 10 s with a 50 mm lens, and only 2.5 s with a 200 mm lens. Note, the accuracy of this rule of thumb is not that good but good enough to provide a starting point. You will need to do some test shots with your camera and lens setup to determine the exact length of time you can make an exposure while keeping stars as points of light and not streaks. Select your camera's highest ISO setting for these test shots. Use your camera's review screen and examine the stars in your image. Magnify as much as your camera will allow. If your

stars are dots, repeat using a slightly longer exposure time, until you start getting star streaks then back down. If your initial shot had star streaks instead of dots, then shorten the exposure time until you obtain satisfactory stars. In examining your images for star trails, magnify the image to the maximum extent possible with your camera's review screen.

After you have determined your allowable exposure time, set your camera's ISO to its highest setting and its lens to its fastest f/stop. Use a remote shutter switch to first lift the camera's mirror if it has the mirror lock feature then take the exposure. If you do not have a remote shutter switch or your camera cannot use one, use the camera's self-timer to trip the shutter. Repeat several times to be sure you get a good exposure then change to the next highest ISO setting and repeat the process. When this is completed, repeat the process again using the next lowest ISO setting from the one you started with. Until you get a good feel for your camera and its abilities, making some exposures at 3200 and 6400 ISO will cost you nothing but a few minutes time. Later, when you are processing your night's work, select the exposure that provides the most pleasing image to you.

Another school of thought and method used by some people is to set their camera to its highest ISO setting and their lens to its fastest f/stop. Again, this is really camera specific but worth trying if you cannot get satisfactory results otherwise. After all, a noisy photograph is better than no photograph.

Shoot using RAW or JPG? RAW files will give you the greatest flexibility in the image processing phase. However, if you do not have the capability to process RAW files, shoot JPG files at the highest resolution your camera allows. With RAW files, the curve and levels controls coupled with masking can also be used to darken or lighten portions of the image. Colors can be adjusted, skyglow removed, airplane and satellite tracks eliminated, etc. Use your camera's noise reduction features if it has dark frame subtraction or JPG noise reduction.

7.7 Star Trail Photography

If you are doing a star trail image, setup your tripod and camera so that the celestial pole is the center of the camera's viewfinder or live view screen and the terrestrial object is in the background. Move the camera until you have the terrestrial object framed like you want. As with a nightscape, to frame the object you most likely will need to make several exposures at a low focal ratio and high ISO setting. Framing may move the celestial pole from the center of the field of view but that is OK. Just keep in mind as you compose your image that star trails will make the celestial pole the focal point of the photograph; the spot that draws the eye when someone first sees the image. To give you an idea of how the final image will look, make a 5 min exposure to produce some star trailing. Spend some time on the composition. This is the "art" part of the process and can make the difference between just another photograph or an image that commands "WOWs" when people see it.

Star trails of 30° or more are needed to make interesting photographs if enough bright stars are in the image. Since the earth rotates at a rate of 15° per hour, 2 h are

needed to produce a star arc of 30° and 3 h for 45°. Trying to save time by having star trails less than 30° degrades the effect and generally does not make for a pleasing photograph.

Some aspects to consider when you compose your image are the length, curvature, and apparent center of the arcs of light caused by the star trails. Other aspects are:

- The apparent center of the star trails will be the North Celestial Pole for people located in the northern hemisphere of our planet or the South Celestial Pole for people living in the southern hemisphere.
- The celestial pole is located either due North or due South from the photographer and is at an angle above the ground equal to latitude of the photographer's location.
- For any given exposure time, the further a star is located from a celestial pole, the longer its star trail will be and the less curvature its arc will have.
- For stars that rise either due East or due West of the photographer, the star trails will be straight lines and will make an angle to the horizon equal to 90° minus the latitude of the photographer's location.

The final issue is exposure time; how long to make the exposure. In the days of film, the camera shutter was left open for the time needed to obtain the desired star arc. This option is available for a DSLR CAMERA in areas of low light pollution. However there are some issues with this approach such as passing airplanes, satellite tracks, etc. that can ruin the shot. With digital photography, another option is available; many short exposures can be combined into one final image in a process similar to stacking; except instead of reducing noise, a composite of all the images is made. Unlike stacking programs that rotate to match the movement of the stars, in the process to stack star trails, the camera is stationary to both the sky and terrestrial objects. Since the sky is moving relative to the terrestrial object, this makes stars appear to be curved streaks of light.

Going back to the 500 rule we can define a minimum exposure time for a particular lens which is equal to the longest exposure time allowable for nightscapes. For star circles our objective is to have star trails, so our exposure needs to be long enough for them to be evident. If not, we will have a dotted pattern of stars circling the earth instead of solid lines. We also want bright stars, not faint ones. As always, local light pollution must also be considered.

Selecting an exposure time is not an exact science. The time must be sufficient to show some star trailing and produce a bright star trail yet be short enough that artificial skyglow is not evident. Also, we will need to take images for 2–3 h. Over a 3 h period, a 15 s exposure will have 720 images, a 30 s exposure time will produce 360 images, and a 60 s exposure will have 180 images. Seven hundred and twenty images resulting from 15 s exposures needs a lot of camera memory, especially if RAW files are used.

In any case, an exposure time between 30 and 60 s is a good starting place, especially if you are in a rural or suburban setting and north is not looking directly into the city proper. Use the fastest lens setting and an ISO setting around 1600.

7.7 Star Trail Photography

Table 7.2 Star circle programs

Program	Price	Platform	Source
Photo Shop CC	$120/year	Win OSX	http://www.adobe.com/products/photoshop
Image Stacker	$17	Win	http://www.tawbaware.com/imgstack.htm
StarStaX	Free Ware	Win OSX Linux	http://www.markus-enzweiler.de/software/software.html
StarTrails	Free Ware	Win	http://www.startrails.de/
Star Trails Action and Layer Opacity Adjustments	Free open source script for PS CS5 and CS6	PhotoShop CS5 and CS6 Extended	http://russellbrown.com/scripts.html

Make a test shot then adjust your camera settings as appropriate. For example, if skyglow is evident you have the options of lowering the ISO setting, lowering the f/stop of the lens if it is adjustable, or decreasing the exposure time.

Now that you have several hundred images of stars you need to combine them into one image. Here you have two basic options. You can manually combine or use a PhotoShop plug-in to combine them in a program like PhotoShop or you can use one of several programs designed especially to combine star circle images. An internet search, "Star Circle Photography Programs," will turn-up several programs as well as personal experiences of people who use them. Table 7.2 is a listing of the programs currently popular.

If you are using PhotoShop CS4 or higher, you have all the tools needed to process a start trail image. What we want to do is to open each image in its own layer, remove any flaws such as an airplane track in a particular image, and then combine the images into one final image. Here is the process for CS4. CS5 and CS6 should be very similar.

- With PSCS4 or higher, open Adobe Bridge.
- Upper left side of the screen you have a choice "Inspector, Favorites, Folders;" select "Folders."
- Go to the folder where you have stored your Star Trail images and select all the images. To do this hold down the shift key and click on the first and the last image you want to use.
- This is an optional step. If you want to adjust some attribute of all your images such as the white point saturation, etc.; go to the File Menu and click on "Open in Camera Raw" and then click the "Select All" box at the top left of your screen. If you do not want to make any adjustments skip this step and go to the next one.
- On the Menu Bar select "Tools." Under Tools select "PhotoShop." Under PhotoShop select "Load files into PhotoShop Layers." PhotoShop will now load the files with each one in its own layer. The layer name will be the file name. Dependent upon how many files you have, this may take some time.

- Now, go through each layer and erase any airplane or satellite trails or any other flaws you think will detract from the final image. On the lower right side in the "Layers" box select "Lighten" to combine the images.
- Go to the upper menu bar and select "Layers" and then "Flatten Layers" to combine all the layers into one image. All that is left to do is to use your other Photoshop tools to adjust color, contrast, etc. as you think is needed.

One weakness of the above method is that it can be very memory hungry. One DSLR CAMERA RAW file is large; 200–300 of them are humongous. As a matter of fact, if you have a lot of files, you may want to break the job into segments called "mini stacks" dependent upon how much memory your computer has. Combine the images in each mini stack using the process described above and then combine the mini stacks into a final image. For an example; let's say you have 300 images to combine. You can break this down into smaller segments (mini stacks); say 15 mini stacks having 20 images each. Process each mini stack of 20 images to the point to where you have flattened the layers. After you finish the 15 mini stacks, you will have 15 images. Load each of these 15 images into a layer and process them like you did the mini stacks. After you flatten the resultant image you can process it for color, contrast, etc. to suit your personal preferences. The PhotoShop scrips mentioned in Table 7.2 automate the above process providing some simplification and "hand holding."

Instead of PhotoShop which is financially outside the reach of many people, a far less costly option is to use a program specifically designed for making star trails such as Image Stacker, StarStaX or StarTrails. These three programs are very similar. StarStaX and StarTrails are freeware while there is a nominal charge for ImageStacker and its companion program StarTracer. These programs are 8 bit and limited to jpg, png, tiff, and tif files; none can handle RAW files. The three basically work in the same manner:

- Load the files into the program
- Select from a very limited list of stacking options such as image brightness, closing gaps in star trails, blending mode, etc.
- Push the process button and shortly your final image appears.
- Save as an 8 bit jpg, tif, tiff, bmp, or png file.
- Load into an 8 bit photo processing program and adjust colors, contrast, etc. to your desires.

If you elect to use one of these programs, you need to remove the blemishes (airplane lights, satellite trails, etc.) before stacking the images. Most 8 bit photo processing programs can do this.

Finally, the use of the noise reduction features of a DSLR camera are problematic with star circles. An 1 min exposure will have a 1 min gap between frames if you use dark frame subtraction. This will produce star dashes, not star circles.

Chapter 8

Astrophotography in Light Polluted Areas

8.1 Introduction

Based upon statistics published by the World Health Organization, at the beginning of the previous century, only 20 % of the world's population lived in an urban setting. That has changed considerable and today, slightly over half of the world's population resides in urban areas. This percentage is less for underdeveloped countries but higher, around 80 %, in developed countries like the United States and the United Kingdom. By the year 2050, the percentage of urban dwellers is projected at 70 % worldwide. Most of this growth will occur in today's developing countries. Developed countries, especially those in North America and Europe will see a leveling of their populations with little growth due to declining birth rates that are offset by immigration. This bodes ill for astronomy as the increasing urban sprawl will continue to spread its signature; a light polluted night sky around the globe. The only positive aspect is that the destruction of the night sky may stabilize in Europe and North America.

Whether or not the percentage of amateur astronomers who live in urban areas is the same as the general population is unknown. It could be the same, less, or more. In any case, since most sources of livelihood are in urban areas, it is probably safe to say that the percentage of amateur astronomers living in urban areas is close to that of the population in general for any particular country. Based upon astronomy magazine and book sales, most amateur astronomers live in developed countries. Assuming that most developed countries are similar to the United States and the United Kingdom regarding the percentage of people living in urban areas, then the argument can be made that approximately 70–80 % of amateur astronomers today

live in an urban area and must contend with significant amounts of artificial skyglow, also known as light pollution.

The major sources of artificial skyglow come from street lights, security lighting, advertising signs, and automotive headlights. External factors such as humidity, clouds and airborne aerosols (particulate matter such as smoke, haze, dust, particulate air pollutants, etc.) also play a major role in the impact these light sources have upon the night sky. Economics regarding outdoor lighting seem to have taken a holiday; replaced by humanity's primordial fear of the dark, commercial greed, and expediency. Some movement in the developed world is apparent toward more efficient outdoor lighting. This will reduce the light we waste to outer space and lower artificial skyglow. However, any significant impact upon urban light pollution levels will be years in the making.

In addition to artificial skyglow, astrophotographers must content with the earth's natural skyglow. Oxygen in the earth's sky is excited by our sun and produces a green glow that covers the entire earth. This skyglow is easily seen from outer space and can be photographed here on earth. Since it is produced by excited oxygen, it produces light at distinct spectra lines and can be filtered. For this reason, light pollution reduction filters are useful even at dark sky locations. For people located at fairly northern or southern latitudes, a second form of natural skyglow are the auroras that provide dazzling displays of beautiful colored light in the night sky. Two other components of natural skyglow are broadband light from stars and our moon that cannot be filtered out.

Light pollution leaves the urban dweller interested in astronomy with two alternatives:

- Remain an arm chair astronomer dreaming about the stars while reading books and surfing the internet forums
- Become an urban astronomer enjoying what the heavens above will surrender through an artificially illuminated night sky

Some urban astronomers will have the luxury of viewing from private observatories or a dark spot in their back yards. Unfortunately for many this is not an option, especially for people who live in apartment complexes, condominiums, amongst tall buildings, and other high density housing. They must travel away from their homes to either a nearby location such as a park or out of the city to darker suburban or rural skies. Transporting a large telescope kit requiring multiple trips to and from the car is often intimidating or not practical at all. In this case, "Astrophotography on the Go" and one of its portable observatories can be the difference between photographing the night sky or joining the ranks of armchair astronomers.

Making the decision to get out of the arm chair and start observing or photographing is the first step many must take to combat our light polluted night sky. For the folks that do, a surprise is in store. The stars are still in the sky and with a telescope you can see them along with many deep space objects. And, there is another surprise; you can photograph the night sky as well. A digital camera can take you deeper into space than you may believe possible.

8.2 Light Pollution Is Not a Friend

Light pollution robs humanity of the magnificence of the universe. This is particularly true for people who want to see the heavens with their own eyes whether unaided, with binoculars, or with a telescope. If we want to see more than a pale gray night sky we must learn to cope with our nemesis.

Light pollution comes in two forms; direct and indirect. Each form has its special characteristics and each requires different interventions to mitigate its impact.

Direct pollution is light spilling into an area where it is not wanted, like a streetlight or neighbor's security light shinning into your backyard. This is generally called stray light or light trespass. Direct pollution is often accompanied with glare.

Indirect pollution is skyglow from natural sources and artificial sources (manmade light that is either reflected or directed into the night sky). The magnitude of artificial skyglow depends upon the actual amount of light directed into the sky, the area over which the light is spread, and the transparency of the air through which the light passes. High levels of humidity and airborne aerosols scatter a significant percentage of the light reflected up into the sky back toward the earth. This brightens the night sky to the point that only the moon, a few planets, and the very brightest stars are all that may be visible with the unaided eye.

Skyglow is particularly bothersome for astronomy. Unlike stray light it cannot be combated by altering, shielding, or simply turning off the offending light source. In some respects stray light is more of an annoyance than a problem for astrophotography. However, this is not true for visual work. Stray light, even when shielded, degrades night vision, thus, reduces what is seeable in a telescope.

8.3 How to Combat Stray Light?

Stray light is the easier of the two categories of light pollution to combat; at least for astrophotography. For the case of a neighbor's security lighting, often a simple request that it be turned off will work. But, on the other hand, often it does not. Streetlights are a different story. A call to the city to see if they will install a switch for you is worth the try but success probably isn't that high. The same is true for a nearby parking lot, sports complex, shopping center, etc. It never hurts to ask and sometimes it works. However, in all likelihood, you will need to take your own measures to mitigate the problem.

If you cannot find an observing location on your property that offers a good window to the night sky that is free from stray light, then light screens are one effective way to shield unwanted light. The image of the North American Nebula shown in Chap. 14 was made 10 m from a street light in the shade of a parked van. Light screens can range from permanent structures to nothing more than an old blanket thrown over rope stretched between two supports of some kind. Portable free standing frames can be made from wood or plastic pipe and covered with fabric or plastic vinyl sheeting. The frames need not be that high, 5 or 6 ft is usually more

than enough but sometimes higher screens are needed. A wheeled garment rack similar to the kind used in hotels with an old blanket thrown over it works very well on flat ground if you need to move around. If your local building codes or neighborhood covenants allow, permanent light shields can be made disguised as a trellis for your garden landscaping, etc. Then there is the ideal light shield; a backyard observatory. The point here is if you have a location on your property that is open to the night sky, with a little imagination and ingenuity, you can generally shield stray light and make the spot into a usable observing or photography site.

Stray light and glare can play havoc with night vision. Light screens work only while you stay in the shade they provide and even then they offer no protection from light reflected from nearby structures. While adapted night vision is not needed for photography, it is helpful for aligning the mount, composing the image, and especially for focusing. During the cooler months, an oversized hood works well to further shield stray light and also helps keep you warm. During the warm part of the year, a lightweight piece of fabric works well such as dark colored beach towel draped over your head while you are at the eyepiece. For moving around your yard away from the light shields, red goggles or an eye patch will help retain night vision.

Stray light can enter a telescope at an angle creating halos on images. Darkening edges of lenses on refractors and flocking the interior of telescopes can reduce the impact of stray light. Dew shields are also very effective stray light shields. If you don't have a light shield or dew shield on your telescope, make one. All that is needed is cardboard and tape if your telescope is not too big. A good length for a light shield is equal to the diameter of the telescope tube. A light shield is particularly helpful for Newtonians to prevent stray light from striking the secondary mirror or entering through the focuser drawtube.

Also, let us not forget the camera at the other end of the telescope. With a DSLR camera stray light can enter through the camera's viewfinder. Most Canons and many other brands have a small rubber cap to seal the view finder opening. Canon has theirs attached to the camera's strap. If you don't have a cap to seal the view finder, a temporary cover made using black plastic electrical tape works very well and, if you promptly remove it when you finish your photographic session, does not leave any tape residue. Another way stray light can enter Newtonian and refractor telescopes is through the gap between the focuser and the focuser draw tube. This is truer for a Newtonian than a refractor because of the location of the focuser. Again, this is a problem that a little black electricians tape easily handles; fortunately it rarely occurs.

If you do not have an observing location at your home or one that you can shield from stray light, you will want to find a nearby location where stray light is not a problem or, the ultimate escape, drive to a remote dark location outside the urban area if you can afford to spend several hours driving. To do this, requires that you pack up your kit and transport it to the observing location. It also creates a new set of issues related to the logistics of transporting your kit to and from the observing location, obtaining permission to use the location, and security issues in many urban and rural areas. Don't overlook your local astronomy club if one is nearby. Clubs often have a secure observing location available for their members. In any case, if you must travel away from home to observe or photograph the night

sky, one of the portable observatories described in Chap. 13 makes life much easier and also increases the probability that you will go out frequently. This is especially true if the security or logistics considerations require that the entire kit be moved in one trip whether aboard public transportation, walking, or via a private vehicle such as an automobile, motor cycle, or even a bicycle.

8.4 Artificial Skyglow

Artificial skyglow is created by light sources made by humans. It is the glowing light dome seen over populated areas with the magnitude of the glow proportional to the size of the metropolitan area. Components of artificial skyglow are light directed into the sky and light reflected from the ground. This light is scattered by particulates and aerosols in the air sending a good portion back toward the ground that can drown out all but the moon and the brightest of stars and planets.

Artificial light is composed of light from the following major light sources:

- Incandescent light
- Florescent light
- Mercury vapor light
- Low pressure sodium light
- High pressure sodium light
- LED lighting
- Colored advertising (argon, neon, led, etc.)
- Halogen automotive light
- Xenon automotive light

While sources using all the above types of lighting contribute to artificial skyglow, the biggest contributors are street and security lighting, advertisement lighting, and automobile headlights. The dominate lighting technology currently used for street and security lighting are Mercury vapor and sodium lights; however, LED lights are slowly making inroads as cities seek to find ways to cut operating costs and reduce carbon emissions. Automobile headlights are a major contributor in the early to mid evening hours. Halogen headlights currently dominate automotive lighting followed by Xenon headlights with LED headlights entering the market.

White LED lighting is a sword that cuts two ways for astronomy. On one side it is very efficient and should lower artificial skyglow while on the other side it is broadband and cannot be removed with light pollution filters. Street and security light fixtures using LED lights direct light downward and not into space. This greatly reduces the amount of light directed skyward but does not eliminate it as light is still reflected from the earth's surface. White LED lights are increasingly being used for automotive headlights but their future impact is unknown at the present. If LED technology is widely implemented, artificial skyglow in the future should be less than that of today but will have a significant component produced by white LED lights that cannot be removed with light pollution filters. How this will impact astronomy related activities is an unknown at the moment.

8.5 Why the Concern About Skyglow?

Skyglow has the following two major impacts upon astrophotography:

- The brightness of the night sky is increased reducing contrast and details.
- The color of the night sky is altered.

The traditional methods to combat artificial skyglow are:

- Reduce exposure times and increase the number of light frames
- Use a light pollution reduction filter

Recall from Sects. 2.12 and 2.13 in Chap. 2 the magnitude scale used to denote the brightness of stars. Also recall how the surface brightness of objects like nebulae and galaxies is measured using the same magnitude scale used for stars but spread over the surface area of the object. Unlike magnitude, surface brightness is expressed in units of magnitude per square arcsecond.

Skyglow too is measureable and is also expressed as a surface brightness using the same scale used for the surface brightness of nebula and galaxies; magnitude per square arcsecond. This provides a way for astronomers to determine if a particular galaxy or nebula that they wish to observe is seeable. For an object to be seeable with details by the eye in a telescope, its surface brightness must be brighter than the local skyglow. Astronomers can either measure the local skyglow using an inexpensive skyglow meter or estimate it based upon some general criteria:

- Very remote area, as dark as it gets, no moon or artificial skyglow: 22 mag/arcsecond squared
- Rural area; widely scattered small towns: 21 mag/arcsecond squared
- Outer suburbia: 20 mag/arcsecond squared
- Half moon: 20.5 mag/arcsecond squared
- Suburban area: 19 mag/arcsecond squared
- Urban area: 18 mag/arcsecond squared
- Full moon: 18 mag/arcsecond squared
- Metropolitan area: 17 mag/arcsecond squared

The brightness of natural skyglow with a full moon is 18 per square arcsecond. In comparison, the skyglow in the middle of one of earth's mega cities like New York or London typically has a magnitude of 17 per square arcsecond. A large urban area is a little darker with a magnitude of approximately 18 per square arcsecond. A true dark location with no artificial light glow has a magnitude of 22 per square arcsecond.

To a digital camera, skyglow is a signal just the same as the photons from some distant object. While it may be an unwanted signal, it is signal never the less. At first glance one might conclude that an object with a surface brightness equal to or less than skyglow is not visible and cannot be photographed. However this is not necessarily the case.

The apparent brightness of an object is the magnitude of the light it emits concentrated into a point source like a star. The surface brightness of an object is an

average value obtained by spreading the light from an object evenly over its visible surface. In reality, the object's magnitude varies across its surface with the brighter areas of the object having a magnitude higher than the average value and dimmer areas having a lower than the average value. Thus, when an object's surface brightness equals the that of skyglow, some areas of the object such as the bright core of a galaxy are brighter than skyglow and remain visible while the rest of the object, such as a galaxy's spiral arms, cannot be seen with the human eye because the contrast may be too low or that part of the image is simply buried in skyglow or noise. However, a digital camera is different from the human eye and can integrate an exposure over time. This capability can produce images having details not visible to the human eye.

8.6 How Are Photographs Made of Objects That Have a Surface Brightness That Is Less Than the Brightness of Skyglow?

Let's look at how skyglow impacts imaging an object; say an emissions nebula, for an example. Assume that we are downtown in a major city having a skyglow brightness of 17 magnitude per square arcsecond. Also assume that the light flux for the skyglow is 1,500 photons per second and we want to image a hypothetical nebula having the following parameters:

- Average light flux: 250 photons per second
- Maximum light flux: 500 photons per second
- Minimum light flux: 10 photons per second

Please note that while the photon flux values used in this and following examples are hypothetical, they do demonstrate the process that is occurring. The actual values are different but the principle and results are the same.

Note that in this hypothetical example that the photon flux of the skyglow of 1,500 photons per second is six times greater than the average photon flux from the object. Recall that a difference of one magnitude in brightness is a change of 2.5 times and a two magnitude difference in brightness is a change of approximately 6 times. This implies that the brightness of the hypothetical nebula in this example has a surface brightness of approximately 19 magnitude per square arcsecond; in other words, the average brightness of the nebula is two magnitudes dimmer than the magnitude of skyglow at our downtown observing area.

Now let's make a 60 s image of our hypothetical nebula from the middle of the city. Recall that signal increases linearly with time and noise increases as the square root. Also, keep in mind that the camera cannot differentiate between photons emitted by skyglow or the nebula. This produces an interesting problem as we now have two sources for signals, skyglow and the nebula.

Let's take the light flux from the skyglow first. This flux is 1,500 photons per second and is essentially uniform. Thus, each and every pixel of a camera's sensor records 1,500 photon per second for a total of 90,000 photons for a 60 s exposure.

Now, consider the photons coming from our distant nebula. They too enter the telescope, strike the sensor of our camera, and are added to the photon count of each pixel. Light from the brightest part of the nebula, the maximum light flux in our example, will add another 30,000 photons over a period of 60 s in addition to the 90,000 photons recorded from skyglow. Thus, the pixels recording the brightest part of the nebula will collect a total of 120,000 photons during the 60 s exposure (30,000 photons from the nebula and 90,000 photons from skyglow). The areas of the nebula having an average brightness will contribute 15,000 photons and the pixels recording them will collect a total of 105,000 photons over the 60 s exposure. The dimmest part of the nebula only contributes 600 photons over the 60 s exposure, thus, the pixels recording them will detect a total of 90,600 photons.

Photon noise increases as the square root of the signal. The average signal in our example is 105,000 photons. Thus, the value of photon noise in this image is approximately 325 photons per pixel. Summing all this up, the 60 s image will have the following characteristics:

- Skyglow = 90,000 photons per pixel
- Nebula Image, minimum value = 600 photons per pixel
- Nebula Image, average value = 15,000 photons per pixel
- Nebula Image, maximum value = 30,000 photons per pixel
- Photon Noise = 325 photons per pixel
- Noise + Skyglow = 90,325 photons per pixel
- Image + Skyglow, minimum value = 90,600 photons per pixel
- Image + Skyglow, average value = 105,000 photons per pixel
- Image + Skyglow, maximum value = 120,000 photons per pixel

What does this all mean? Look at the minimum, maximum and average values for the image + skyglow of our hypothetical nebula:

- The highest value any one pixel will record is 120,000 photons.
- The lowest value any one pixel will record is 90,600 photons.
- The average value of all photons recorded is 105,000 photons.

Next, look at the value for the photon noise + skyglow which is 90,325 photons per pixel. For any part of the nebula's image to be visible, a pixel must record a value greater than 90,325 photons in order to stand out above skyglow and noise. In this example, all components of the signal (image + skyglow) exceed 90,325 photons per pixel; thus, the nebula will be visible in a 60 s exposure.

How good is this image? To determine this, look at the ratio of the image brightness to that of the skyglow brightness. Values exceeding around 10 % should have sufficient contrast to see in an image.

$$\%Contrast \propto 100 \times \left((I - N) \div (SG + N) \right),$$

where

I = photons from the object being imaged
SG = photons from skyglow
N = photon noise

8.6 How Are Photographs Made of Objects That Have a Surface Brightness…

Doing the calculations, we see that the maximum signal from the hypothetical nebula is 33 % greater than the value of skyglow plus photon noise; thus, it will show in an image and with sufficient contrast to show significant details. The average value is 16 % greater than skyglow plus noise. It too should be seeable in the image but with less detail and contrast than the maximum values. However, this is not the case for the dimmer parts of the nebula. Even though their values are greater than noise plus skyglow; they are insufficient to produce the contrast needed to be detectable over the skyglow component.

So how good is the image? It will show good contrast and details for the brighter parts of the nebula but the dimmer parts will be lost to skyglow and noise. The results produced for our hypothetical nebula are not really that bad; especially considering the average brightness of the signal from the nebula was two magnitudes less than the skyglow signal. This tells us that some meaningful astrophotography is possible in the worst of skies provided stray light and glare are controlled.

Is there a way to improve the image? One method often used to improve the signal to noise ratio of an image is to reduce noise by stacking a lot of images. This applies to images made with skyglow present too. Stacking will reduce noise but the signal level will remain the same. Since skyglow is a signal stacking has no impact on it or its impact upon the image of the object.

Another way to reduce noise is to increase exposure times. Here again, the potential improvement is iffy. This is because the camera cannot differentiate between skyglow and the object's signals. Thus both, skyglow and object's signal, are increased proportionally by the same amount.

To demonstrate this, let's make a 120 s image of our hypothetical nebula from the middle of the large city. Recall that signal increases linearly with time and noise as the square root. Also, keep in mind that the camera cannot differentiate between photons emitted by the nebula or skyglow. We get the following results:

- Skyglow = 180,000 photons per pixel
- Nebula Image, minimum value = 1,200 photons per pixel
- Nebula Image, average value = 30,000 photons per pixel
- Nebula Image, maximum value = 60,000 photons per pixel
- Photon Noise = 490 photons per pixel
- Noise + Skyglow = 180,490 photons per pixel
- Image + Skyglow, minimum value = 181,200 photons per pixel
- Image + Skyglow, average value = 120,000 photons per pixel
- Image + Skyglow, maximum value = 240,000 photons per pixel

Now let's take a look at Table 8.1 that compares the 120 s image to the 60 s image. Both the skyglow contribution and the signal from our hypothetical nebula doubled as expected. Photon noise increased a little but not significant in comparison to the increase in signal.

The image's signal levels are twice as much as the 60 s exposure. Normally this results in a significant increase in contrast and details. However, the skyglow level also doubled increasing the lightness of the sky background in the image as well as adding to the discoloration. The contrast levels of both images remained essentially the same.

Table 8.1 Comparison between a 60 and a 120 s exposure

Photons per pixel	60 s exposure	120 s exposure
Skyglow	90,000	180,000
Image (minimum)	600	1,200
Image (average)	15,000	30,000
Image (maximum)	30,000	60,000
Photon noise	325	490
Noise + Skyglow	90,325	180,490
Image (min) + Skyglow	90,600	181,200
Image (avg) + Skyglow	105,000	210,000
Image (max) + Skyglow	120,000	240,000
% Contrast (min)	0	0
% Contrast (avg)	16	16
% Contrast (max)	33	33

As with the 60 s image, the 120 s image has contrast and details for the light and midrange portions of the nebula but the dimmer areas of the nebula are washed out by skyglow and photon noise.

Now let's look at what happens if the average photon flux for the nebula is equal to skyglow. Let's keep the same hypothetical nebula but move the imaging location from the middle of the city to an outlying suburban neighborhood with magnitude 19 skies. This means that the brightness of skyglow in our example is reduced by a factor of approximately 6 from 1,500 photons per second to 250 photons per second. A 60 s image of our hypothetical nebula from the suburbs will have the following characteristics:

- Skyglow = 15,000 photons per pixel
- Nebula Image, minimum value = 600 photons per pixel
- Nebula Image, average value = 15,000 photons per pixel
- Nebula Image, maximum value = 30,000 photons per pixel
- Photon Noise = 170 photons per pixel
- Noise + Skyglow = 15,170 photons per pixel
- Image + Skyglow, minimum value = 15,600 photons per pixel
- Image + Skyglow, average value = 30,000 photons per pixel
- Image + Skyglow, maximum value = 45,000 photons per pixel
- Contrast, minimum = 3 %
- Contrast, average flux = 100 %
- Contrast, maximum flux = 200 %

The 60 s image of the hypothetical nebula made at a suburban location has far greater levels of contrast than the image made from the city's center. In addition, the amount of the image buried by skyglow is much smaller than the image made from the city center. Note that the signal strength of the image made from the suburban site is the same as the signal strength of the nebula's image made from the center of a large city. The differences between the two images are the magnitude of the skyglow contribution and, to a far lesser extent, the magnitude of photon noise.

So what have these three examples shown? The first example shows how a digital camera can make images of objects that are dimmer than skyglow. The second example shows that increasing exposure time does have the benefit of increasing signal strength; however, it does nothing to decrease the impact that skyglow makes on contrast and details of the image. The third example shows the significant gain in contrast and details obtained from decreasing the magnitude of skyglow by moving to a darker location.

8.7 Light Pollution Reduction Filters

A light pollution reduction filter, also known as a nebula filter, is a major tool used by astronomers to combat light pollution for both visual work and for astrophotography. These filters work by attenuating or blocking light at wavelengths emitted by artificial lighting and passing wavelengths of light emitted by objects we wish to see or photograph. This only works when the light spectrum of the unwanted light is emitted at frequencies that do not coincide with the light spectrum emitted by objects we wish to see or photograph; see Table 8.2. Filtering will not work if the artificial light source is broad band covering a wide range of the light spectrum such as automotive headlights, white LED lights, incandescent lighting, etc.

The effectiveness of a filter is not the same for all objects we see in deep space. Filters are far more effective for emission nebulae than for broadband objects like reflection nebulae, stars, star clusters, and galaxies. Because filters block or attenuate light, they make objects dimmer; however, contrast is improved giving the perception that brightness is increased.

Three basic types of nebula filters are available; broadband, narrowband, and line filters:

- A broadband nebula filter passes blue and green light through an 80–90 nm wide band centered at approximately 485 nm and red light through a second band about 40 nm wide centered at approximately 660 nm.
- A narrowband nebula filter is similar to a broadband filter except the lower bandwidth in blue/green is around 25 nm from 480 to 505 nm.

Table 8.2 Light pollution and emission nebulae spectra

Major light emission lines			Major nebulae emission lines			Broad band Nebula filter
Mercury vapor (nm)	HP sodium (nm)	Natural skyglow (nm)	Emission line	Wavelength (nm)	Color	Pass band wavelength (nm)
435.8	589.0	557.7	H-β	486.1	Blue green	450–540
546.1	589.6		OIII	495.9	Green	
577.0	615.4		OIII	500.7	Green	
578.1	616.1		H-α	656.3	Red	640–680

- A nebula line filter is the most precise with a 10 nm band in green that includes 495.9 nm and 500.7 or 9 nm band in blue that is centered at 486 nm; there is no red pass band.

These frequencies and bandwidths vary somewhat among the different filter manufacturers as does the optical quality and light transmission efficiency.

The terminology used for filters is confusing at best. All of these filters are light pollution reduction filters and all are called nebula filters. Often narrowband filters are called UHC filters (ultra high contrast). As you probably already have concluded, a line filter is the most effective filter for blocking skyglow from natural or artificial sources followed by the narrow band filter with the broad band filter being the least effective.

For the very short exposure astrophotography techniques used for "Astrophotography on the Go," you will find that a broadband nebula filter like the Astronomik CLS filter provides excellent results for combating light pollution and natural skyglow. Narrow band and line filters simply attenuate too much light for very short exposure photography. With a traditional heavy duty equatorial kit, this issue of light reduction is countered by using guided long exposures; an option that does not exist for portable, lightweight kits or, for that matter, for traditional kits that do not have a self-guider.

If you have a mount that is capable of guided exposures of say 40 min or more and are using an astronomical CCD camera, a line filter is excellent for overcoming light pollution when imaging nebulae. With this concept you use several line filters that pass different frequencies of light and make long monochrome exposures with each filter using a color wheel. You will need four images for each filter used; lightness, red, blue, and green. In a process much like stacking, all the images are combined into one final image. This process produces images of great depth and detail even in heavy light pollution. However, it is time consuming and typically requires several nights work to obtain all the lights required.

Most people who have a mount with a self guider use a narrowband nebula filter. The reduction in skyglow allows guided exposures of 5 min and longer which increases signal strength, contrast, and details.

If your mount is not capable of guided exposures needed for line filters or narrowband filters, then you can use a broadband nebula filter. The 90 nm pass band centered at 485 nm of a broadband nebula filter passes most of the blue, cyan, and green portions of the visible light spectrum while the 40 nm band passes reds. Violet, yellow, and orange are blocked. This filters out the major emission lines from natural air glow, Mercury vapor street lights, and Sodium street lights but passes light from emission nebulae as well as a significant amount of light from stars, galaxies, and reflection nebula without a drastic decrease in image brightness. The overall result is that skyglow from natural and artificial sources is reduced much more than the signal from the object being photographed, providing an overall increase in contrast, details, and color for emission nebulae and, to a lesser extent, for reflection nebulae. Stars and galaxies are much less benefited by a filter as they emit light across the entire visible spectrum including the wavelengths attenuated by filters.

8.8 How Does This All Impact "Astrophotography on the Go?"

Most of the lightweight kits and the very short exposure techniques associated with "Astrophotography on the Go" do not have the capabilities to take advantage of the longer exposure times provided by a light pollution reduction filter. From the perspective of light weight and portable astrophotography kits, the important attribute of using a broad band nebulae filter is that the reduction in the level of skyglow and photon noise is significantly more than the reduction in the brightness of the object. The lower level of skyglow widens the dynamic range of the object we are photographing allowing us to capture features with greater detail, contrast, and color.

To demonstrate the value of using a light pollution filter, let's use the broad band filter described by Table 8.2 and take a look at our hypothetical nebula in the middle of a large city that we used earlier to examine how skyglow impacted images. Recall the nebula had a maximum light flux of 500 photons per second, a minimum light flux of 10 photons per second, and an average light flux of 250 photons per second per square arcsec. Skyglow was 1,500 photons per second per square arcsec. Let's assume that the filter removes 90 % of the skyglow in the frequencies it attenuates and passes 90 % of the light flux from the emissions nebula in our example. The results for a 30 s exposure with and without a broadband filter are shown in Table 8.3

The 30 s exposure produces an image that is very similar regarding contrast and details to the images produced by 60 and 120 s exposures looked at earlier in this chapter. However, the addition of a filter produces a significant improvement. Contrast is improved to 3, 145, and 290 % respectively for the minimum, average, and maximum photon fluxes emitted by our hypothetical nebula. This is a drastic improvement in contrast and image quality. The filter has changed a washed-out

Table 8.3 Comparison; 30 s exposure with and without a filter

Photons per pixel	No filter	Broadband LPRF
Skyglow	45,000	4,500
Image (minimum)	300	270
Image (average)	7,500	6,750
Image (maximum)	15,000	13,500
Photon noise	245	135
Noise + Skyglow	45,245	4,635
Image (min) + Skyglow	45,300	4,770
Image (avg) + Skyglow	52,500	11,250
Image (max) + Skyglow	60,000	18,000
% Contrast (min)	0 %	3 %
% Contrast (avg)	16 %	143 %
% Contrast (max)	33 %	288 %

image with little contrast showing only the bright and midtone areas of the nebula into one that shows almost the entire nebula in excellent contrast and details. This also implies that the light pollution filter will allow imaging nebulae dimmer than the one in our example.

Again, the values in this example are hypothetical and represent the best possible case as no broadband component of skyglow was included. However the results presented are indicative of how a light pollution filter can improve the contrast and details of an image made in light polluted skies.

What are the major issues associated with using a light pollution reduction filter? The first noticeable attributes looking through an eyepiece are that stars are both dimmer and smaller and the night sky is black. With some filters, stars have a greenish tinge to them. A side benefit is that focusing using a camera's "live view" feature is easier as flaring is greatly reduced. The dimmer stars make using a focusing mask difficult or not possible for some small aperture telescopes. The smaller and dimmer stars can be an issue when you attach your DSLR camera and attempt to focus it as the number of stars available that are bright enough to see in the camera's view finder or live view screen is less than without a filter.

Very short exposure astrophotography can produce very acceptable images in a suburban night sky even without a filter. The images in Chap. 14 were taken using very short exposures in a suburban area of a large city having a population of three million people. With the exception of Messier Objects 42 and 45 that were made with a light pollution filter, no interventions were made to counter skyglow during the imaging part of photographic process. Skyglow was addressed during image processing. Skyglow at the location where the images were made overwhelms all but the brightest stars and planets in the sky to the west of the meridian. To the east of the meridian is the open sea and relatively dark skies. Airborne aerosols and other particulate matter are often very high restricting horizontal visibility to 25 miles (40 km) or less. Even on the darkest of nights with no moon the sidewalks typically remain visible as well as critters of the night that sometimes crawl or slitter on them.

Chapter 9

Computers and Computer Programs

9.1 Introduction

Computers are an integral part of astrophotography and perform a wide range of tasks. Anyone with poor computer skills soon learns either to develop them or find a hobby other than astrophotography. While computers are required for processing our digital images, they also can greatly facilitate the other aspects of astrophotography from identifying objects to photograph to printing out beautiful images to frame and hang on a wall for all to enjoy. All in all, the role of the computer is extensive. Some of the tasks they do for us are:

- Research to identify objects to photograph
- Planning an imaging session
- Stacking images
- Enhancement of images
- Cataloging and storing digital images
- Displaying digital images
- Printing paper photographs
- Communications with other astrophotographers

"Astrophotography on the Go" is about portability using a DSLR camera and very short exposure techniques to photograph the night sky. A DSLR camera has its own internal microprocessor and needs no computer to help it capture and store images of the night sky. The same is true for the goto mounts used to locate and track the objects being photographed. They too have their own internal microprocessor

and need no help from an external computer to do their job. The computer with its logistics tail is not needed to photograph the deep sky and can be left at home.

This is not to say that a computer is not needed. Quite the opposite is true. The viability of the entire concept of "Astrophotography on the Go" depends upon the computer to transform the noisy images produced by very short exposures into acceptable photographs of deep space objects. A computer is needed to stack the several hundred light frames that will make the final image whether it is done the old fashion way, one frame at a time, or automated under the control of a computer program. After stacking comes the processing of the image; the digital equivalent of developing film. Here again, this task must be done by a computer. However these tasks are best done at home, not outside in the dark of the night.

9.2 Research, Identifying Objects to Photograph

Often beginners attempting to learn astronomy and astrophotography on a parallel course ask the question on the internet forums "what can I photograph tonight?" Initially, the Messier and Caldwell lists provide an easy answer to that question, but after that, what? Books help some but there really is no silver bullet. Unless you are very knowledgeable of the night sky, identifying objects to photograph takes some research on your part. Here, a computer or a tablet and the internet provide a valuable resource available at your finger tips to identify objects you may want to photograph.

A little surfing the web provides wealth of ideas. One good starting point is an internet search using the word "astrophotography" or the phrase "objects in tonight's sky." Such searches indentify a wide variety of sites worth visiting such as:

- Astronomy magazine sites; some have galleries where amateurs post their images.
- Astronomy internet forums; most allow their members to show off their photographs
- Astronomy association and club sites
- Astrophotography tutorial sites
- Personal sites of amateur astronomers

As you visit these web sites, you will soon realize that amateur astronomy, including amateur astrophotography, is far more than the Messier or Caldwell lists. As you surf you will see photographs of objects that catch your eye. Note their catalog number as well as the details of how the image was made. Many will be made with expensive, high precision, equipment using self guiders and long duration exposures. These images are frequently breathtaking. Pay special attention to images made using a DSLR camera and light frames of 5 min or less. While some of the objects you will find are a challenge for very short exposure work, others aren't.

9.2 Research, Identifying Objects to Photograph

If an object is interesting to you, do an internet search using its catalog number as the search parameter. With very few exceptions the search will produce a number of sites that give information and images of the object. This will help you determine if photographing the object is feasible from your location and with your equipment. Some aspects about potential objects to photograph to consider while surfing are:

- Object accessibility (Is the object visible from your imaging site and if so, when?)
- Image size (Is the object too large or small for your camera and telescope combination?)
- Image brightness (Is the image brightness sufficient for a very short exposure from your site?)

One web site that will be high on the list of an internet search is "Tonight's Sky" (http://www.tonightssky.com). This is an unique web site currently on the internet that has been around for years. It is designed specifically to identify objects to photograph or to view. "Tonight's Sky" is a privately owned and operated site and is available free of charge. It is also simple and intuitive to use. The observer's location as well as the time and date of the proposed observation or photography session are entered. Next, the user identifies the level of difficulty and type of objects desired to see or photograph. The list of objects generated is generally fairly long as the data base used is extensive. The user can then select the items of interest and obtain a print out sorted by difficulty, rise time, or constellation. The RA and DEC of the objects are provided as well as the magnitudes and sizes of the objects. An option exists to print out the altitude and azimuth angles of the object versus time.

Another interesting internet site is SKY-MAP (www.sky-map.org). SKY-MAP is an interesting site to visit as its database of the deep sky is very comprehensive as is its collection of images of deep space objects. The site is an on-line sky map using data from the following sources:

- Palomar and AAO Digitized Sky Survey
- Sloan Digital Sky Survey
- Infrared Sky Survey (IRAS)
- H-Alpha All Sky Survey
- Xray All Sky Survey (RASS)
- Ultraviolet Sky Survey (GALEX)
- Astro Photo Survey

While not a computer program or an interactive internet web site, "Deep Sky Watch" is another must stop for any astrophotographers (www.deepskywatch.com). The site has several interesting features. Two of particular interest for astrophotography are the "Deep Sky Illustrated Observing Guide" and the "Deep Sky Hunter Star Atlas;" both available as a free download in the form of printable PDF files.

The "Deep-Sky Illustrated Observing Guide" is a 162 page document that contains basic information on 7,000 deep sky objects to magnitude 14 from the Saguaro Astronomy Club's SAC Catalog version 7.7 (www.saguaroastro.org).

Almost 700 of the objects are singled out and additional information provided including thumbnail images. This selection of featured objects includes:

- all Herschell 400 objects
- all Messier objects
- all Caldwell objects
- all SAC's best of NGC objects
- over 100 various objects of interest selected by the author of the guide

Needless to say, enough objects are identified in the "Deep-Sky Illustrated Observing Guide" to keep anyone busy for a lifetime.

The "Deep Sky Hunter Star Atlas" supplements the "Deep-Sky Illustrated Observing Guide." Five hundred of the featured objects in the observing guide are also specially featured in the star atlas. The "Deep Sky Hunter Star Atlas" contains stars to 10.2 magnitude and deep space objects to 14.0 magnitude. The atlas has 116 pages (101 charts, 2 index maps, and 8 pages of detailed zoom charts). The two documents together provide all the information necessary to identify and locate candidates for deep sky imaging.

9.3 Planning and Planetary Programs

A quick search on the internet reveals a multitude of planetarium and star atlas programs designed for amateur astronomy. These programs are very helpful for planning an imaging session. Unlike internet sites like "Tonight's Sky" or programs like Deep-Sky Planer that use a data base interface, planetarium programs use interactive graphics that provide a visual presentation of the night sky. A glance at a computer screen shows a picture of the night sky for whatever date and time desired by the astronomer.

Planetary programs are more than simple start-charts. Most provide an interactive interface that lets a user explore the depths of the current night sky as well as that of the future or past. Screen displays are provided to present the night sky, constellations, and objects in the sky at a glance. Most of the popular programs can also control computerized telescopes and some can even control observatories (dome movement, etc.). Typical information provided by planetarium programs include the location and catalog number of deep space objects; names, magnitude, and location of stars; rise, transit, and set times of stars and deep space objects; etc. The list of planetarium programs is very long and programs are available for Mac, Windows, and Linux operating systems as well as apps for Android and Apple tablets and smartphones.

"Astrophotography on the Go" is about using very portable astrophotography kits that are easily transportable in one trip from its storage location to the observing location whether it is by foot, bicycle, public transportation, or automobile. This pretty much eliminates the lap top computer from the equation due to size, power and other logistics considerations. However, smart phones and small tablets easily

9.3 Planning and Planetary Programs

Table 9.1 Planning and planetary programs

Program	Platform	Web site
RedShift	Windows, Mac OS X, Mac iOS	www.redshift-live.com
SkySafari	Mac OS X, Mac iOS, and Android 2.2 or higher	www.southernstars.com
StarMap	Mac iOS	www.star-map.fr
Stellarium	Linux, Windows, Mac OS X, Mac iOS and Android	www.stellarium.org
The SkyX	Windows, Mac OS X, and Mac iOS	www.bisque.com

fit in a pocket, have little logistics support requirements, and reflect the essence of "Astrophotography on the Go." Table 9.1 provides a listing in alphabetical order, of some popular planning and planetary programs available on either the Android or iOS platform. The list is in no way complete but does give an idea of some programs that are available.

"Redshift" is a moderately priced, fully featured, planetarium program that some European astronomy stores bundle with a telescope purchase. It is offered in three editions for the Windows platform and one edition for the Mac OS X platform as well as iOS for iPhone, iPad, and iPod APPS. The current prices are $12 for APPs and from $20 to $80 for computer programs. Redshift can control GOTO telescopes. The program has an extensive data base of up to 2,500,000 stars, 1,000,000 deep space objects, and 125,000 planetary system objects. The familiar Windows menu interface is used which facilities learning to use the program. The RedShift APPs for the iPhone, iPad, and i Pod do not have the capability of actually controlling a GOTO telescope but can provide the distance, type, luminosity, size, rise times and set times for 500 deep space objects as well as other functions needed to plan an observing or imaging session.

"SkySafari" is a fully featured planetarium and telescope control APP designed for smart phones and tablets running Android 2.2 and Mac iOS. For optimum performance the smart phone or tablet should have a 1 GHZ or faster processor as well as a built-in compass and accelerometer. Images as well as encyclopedic descriptions of constellations, stars, and planets are displayed. Telescope control is available via Wifi or Bluetooth using the appropriate Skyfi wireless or Bluetooth serial adapter; both available from the software developer. A version for Mac OS X is also available.

The SkySafari Basic APP costs $2.99. It has a catalog of 46,000 stars and the 220 best known star clusters, nebulae, and galaxies as well as the 150 best known asteroids, comets, and satellites. The solar system's major planets and moons as well as the sun can be displayed. The APP has a night vision mode. It shows the sky from anywhere on earth at any time up to 100 years in past or in the future. Objects are identified by pointing the phone or tablet at the area of the sky where the object is located. The basic version does not have the ability to control telescope movements or to provide guidance to specific targets.

The Plus version of SkySafari costs $14.00. It has all the features of SkySafari Basic. In addition, it has an expanded data base, wireless telescope control, and the

ability to project night skies away from earth. The catalog of SkySafari Plus contains 2,500,000 stars and 31,000 deep space objects including the entire NGC/IC catalog as well as updateable orbits for nearly 18,000 asteroids, comets, and satellites. Telescope control is provided using the built-in Wifi or Bluetooth capability of the smart phone or tablet used for control. Recently the developer added the capability to control telescopes with an USB interface like the Meade ETX LS or iOptron mounts. Serial or USB, the telescope must have an adapter compatible with SkySafari to allow control of the telescope. This adds an additional $80–150 to the total cost dependent upon which adapter and interface is used. See the developer's site for details.

SkySafari Pro cost $39.99. In addition to all the features of Safari Plus, it has 15,300,000 million stars from the Hubble Guide Star Catalog, 740,000 galaxies down to 18th magnitude, 640,000 solar system objects, including every comet and asteroid ever discovered, a moon map based upon 2009 Lunar Reconnaissance Orbiter data with eight times the resolution provided by other versions of SkySafari. The APP shows sky with sub arcsecond precision from any point on or off the earth up to 100 million years in the future or in the past.

SkySafari for Mac OS X is also available in the Basic, Plus, and Pro versions at the same prices as the APPs. The Mac OS X and iOS applications are pretty much the same. The major differences between the SkySafari OS X and iOS programs are:

- SkySafari for the Mac OS X has a user interface within the Mac OS X framework. It has the look and feel of a proper Mac OS X program and the advantages of a full size monitor, keyboard and mouse while SkySafari for iOS has the look and feel of an iPhone application.
- SkySafari for Mac OS X cannot provide the live view simulation features provided by the iOS version that require a built-in compass and accelerometer to function.
- SkySafari for Mac OS X can provide printed copies of sky charts while the iOS version can not.

"StarMap" is available in three versions; StarMap Standard ($5.00), StarMap Pro ($17.00), and StarMap HD for iPad ($17.00). StarMap Standard is an abbreviated version of the APP having only 350,000 stars, 50 asteroids, and 110 deep space objects. StarMap Pro and HD are essentially the same except that HD is optimized for the Mac iPad graphics. Both have a database of 2,500,000 stars (250 named), 14,000 deep space objects (Messier, Caldwell, NGC/IC, and Abbel clusters), 470,000 asteroids, and 1,500 satellites. Twenty-five thousand objects are referenced objects; objects with detailed information on their physical parameters, position, and ephemeris. Typical functions include tonight's sky, catalog search, night vision, telrad view, visibility, etc. StarMap can identify objects in the night sky. The Pro and HD versions can control GOTO telescopes via a Wifi serial bridge.

"Stellarium" is a free planetarium program for Mac OS X, Windows 64 bit, Windows 32 bit, Linux, and Ubuntu. iOS and Android versions are also available but, unlike the computer programs, do not have the ability to control GOTO telescopes.

Stellarium shows a realistic 3D sky depicting the view of the unaided eye, binoculars or a telescope. Instead of a typical Window's menu, Stellarium uses an interactive graphics interface of the night sky. Control is intuitive through symbols and pop-ups. This feature makes using the program in the field at night easy to do especially in the night vision mode and is one of the reasons for the program's popularity. Another reason for Stellarium's popularity is that it is available in many languages. Stellarium uses "plug-ins" developed by others for artificial satellites, ocular simulation, telescope configuration, telescope control, etc.

Stellarium, as downloaded, has a catalog of 600,000 stars that is expandable to 210,000,000 stars. In addition to stars, Stellarium displays solar system bodies, deep sky objects (galaxies, nebulae and star clusters). Artificial satellites are displayed using a "satellite plug-in." Asterisms and illustrations of the constellations along with a realistic reproduction of the atmosphere, light pollution, sunrise and sunset are also contained in the program. A "telescope plug-in" allows control of most GOTO telescopes using the ASCOM protocol.

The iOS and Android versions of Stellarium are almost identical to the computer versions. Their star catalog is limited to 600,000 stars. Unfortunately neither the iOS nor the Android Apps have the ability to use plug-ins, thus, cannot control telescopes, display artificial satellites, etc. The Stellarium APPS do have the ability to use GPS and accelerometers to identify objects in the sky.

"TheSkyX" is perhaps the most comprehensive planetarium program available for amateur astronomers. Like many of the other planetarium programs it has several variations. TheSkyX Student Edition ($50), unlike typical student and beginner programs, is fully featured with only telescope and camera control being the major missing components. An abbreviated version of the student addition is available as an iOS APP, TheSky HD ($5.00). Two other Windows and Mac OS X versions are available; the SkyX Serious Astronomer Edition ($170) and TheSkyX Pro ($350). The Serious Astronomer Edition adds telescope control and a larger database of stars and objects. Add-ons are available that increase telescope pointing accuracy, add dome control, or allow control of both dedicated astronomical cameras or digital single lens reflex cameras. The prices of the add-ons range from $200 to $250 each. TheSkyX Pro version increases the automation of the program and its ability to automate the photography process. It too has add-ons ($200–250) for cameras, domes, larger data base of objects and stars, and telescope pointing accuracy.

9.4 DSLR Camera Control

The control of the imaging process is one area where tablets, while not necessary, are a convenient accessory to have for "Astrophotography on the Go." The nicest thing about using a tablet is the ability to sit comfortably in your observing chair with your tablet in hand while you use the camera's live view function to focus the camera or to compose the image. No longer will you need to get down on hands and knees to see your camera's display screen. The touch screen of a tablet is very convenient and setting parameters for the photography session is a simple task to do.

Several Apps for Android devices are available that allow complete control of a DSLR camera via a WiFi, Bluetooth, or an USB cable connection. None of the DSLR camera control Apps are specifically designed for astrophotography. Two features, live view support and time lapse capability, are needed to make the APP usable for astrophotography. The selection is much more limited for iOS devices.

Four issues exist at the current time related to using smart phones and tablets to control the photographic process for a DSLR. These are:

- USB cable connections tend to be problematic due to the large variance in hardware used by different tablet manufacturers. About the only way to be sure that an USB cable connection will work is to simply buy an application and try it out. USB offers the fastest data transfer rate at the present time.
- Another issue related to using smart phones or tablets is that these devices do not have a night vision mode. While nearly all of the planetarium applications discussed earlier have a night vision mode, none of the DSLR Control applications do. This leaves the option of either ruining your night vision or fitting a rubylith screen on your Android or Mac iOS device.
- The third issue is the turnover in the DSLR Control Apps sold on the iTunes or Google Play Stores is rather volatile. For this reason a listing of DSLR Control applications is not included as it would be obsolete before this book is published.
- The final issue is battery life. This varies considerable. Make sure that your Android or iOS device can operate for around 4 h or so if you want to control the imaging process.

If you wish to try your smart phone or tablet to control your DSLR, do an applications search "DSLR control" or "DSLR controller." Either will bring up the current available programs and you can see which one, if any, fits your needs and equipment. As you evaluate the selection of applications available, keep in mind that two functions are absolutely required, live view and time lapse. Also keep in mind that not all DSLR cameras have an infrared interface.

9.5 Image Processing Programs

So far in this chapter, all the applications discussed for computers, smart phones, and tablets are optional. You can certainly plan and image deep space objects without them. All that is needed a good book for planning, a DSLR to capture and store images, and an interval timer to control the imaging process. This is not true for the imaging processing aspects of "Astrophotography on the Go." Here, a computer is not optional. It is required to transform the very short exposure images stored in a DSLR's memory card into the final digital or paper photograph that we can proudly share with family, friends, and others.

The programs used for image processing are fairly complex and some effort is required to learn how to use them. There are no "silver bullets." These programs are

9.5 Image Processing Programs

too complex and memory intensive to operate on tablets or smartphones. A computer must be used; the faster the processor and the more memory the better.

Image processing has two phases. The first phase, stacking, is concerned with combining the exposures taken during the imaging session into one image to reduce noise. The second phase, publishing, is concerned with enhancing the image to bring out contrast, details, and color. A list of both types of programs is extensive. Table 9.2 lists some of the more popular ones. None of these programs are available for smart phones and tablets as the computing power needed to do their functions is very extensive.

"DeepSky Stacker" is one of the more popular image calibration and stacking programs used today for amateur astrophotography. It is freeware and available in 12 languages. The program is widely used by beginners and advanced photographers alike because of its relative ease of use and broad range of capabilities. Chapter 11 of this book is dedicated solely to DeepSky Stacker and explores most facets of the program including detailed information on its use.

Table 9.2 Some popular image processing programs

Program	Platform	Price	Function
DeepSky Stacker www.deepskystacker.free.fr/english/index.html	WIN	Freeware	Calibration and stacking
GIMP www.gimp.org	WIN, OS X, Linux	Freeware	Photo processing
IRIS http://www.astrosurf.com/buil/index.htm	WIN	Freeware	Camera control, calibration and stacking, photo processing, telescope control
Maxim DSLR http://cyanogen.com/index.php	WIN	$400	Camera control, calibration and stacking, photo processing, telescope control, observatory control
Nebulosity http://www.stark-labs.com/index.html	WIN, OS X	$80	Camera control, calibration and stacking, photo processing
PaintShop Pro X6 Ultimate http://www.paintshoppro.com/en/	WIN	$80	Photo processing
PhotoShop CC http://www.adobe.com/products/photoshop/tech-specs.html	WIN, OS X	$240/year	Photo processing
PhotoShop Elements http://www.adobe.com/products/photoshop/tech-specs.html	WIN, OS X	$100	Photo processing
PixInsight http://pixinsight.com/	WIN, OS X, Linux, FreeBSD	$250	Calibration and stacking, photo processing
StarTools http://startools.org/drupal/	WIN, OS X, Linux	$60	Photo processing

"GIMP" is an open source, freeware clone of Adobe PhotoShop. While a very popular program, GIMP is not that suited for enhancing images made from very short exposures. Its curves and level commands do not provide the range needed to stretch 16 bit images without producing color banding. However, if an image is stretched prior to porting over to GIMP, then its architecture has much less of an impact.

"IRIS" is a fully featured program capable of controlling a DSLR camera as well as a telescope; calibrating, aligning, and stacking light frames; and providing the image enhancements needed to produce a finalized image. Its extensive features and a mixture of pull down menus and command lines make it an intimidating program to many people and is probably why its popularity lags behind far less capable programs. Never the less, it is a very robust and full featured program with many advanced image enhancement features.

"Maxim DSLR" is a program that does it all and is priced accordingly. It can control the entire imaging session from focusing the camera to controlling telescope and observatory dome movements. Image processing includes calibrating and stacking images then enhancing them. The magnitude of these capabilities can overwhelm a newcomer to the program at first.

"Nebulosity" is a popular, moderately priced, program, especially for people using dedicated Astronomical CCD cameras. The program supports a wide range of CCD cameras but its support for DSLR cameras is limited to the later Canon EOS models. Nebulosity has two major functions, camera control and image processing (calibration, stacking, and enhancement). While the camera control features of the program are not needed for "Astrophotography on the Go," the image processing features are extensive and well suited for processing very short exposures taken using an alt-azimuth mount. Stark Labs, the program developer, understands how astronomical programs are used. The licensing agreement is very liberal. It allows the license holder to have the program simultaneously loaded on more than one computer as well as on computers having different operating platforms.

"PaintShop Pro X6 Ultimate" from Corel has a 64 bit architecture and is fully capable of doing 16 bit stretches in both levels and curves. The program's extensive variety of enhancements make it a viable alternative to the more expensive PhotoShop CC and far more capable than PhotoShop Elements or GIMP.

"Adobe PhotoShop CC" is the latest version of this famous photo enhancement program. The program is only available as a yearly lease starting at $240 per year for the basic service. This pricing structure may be beneficial to commercial establishments but over the long term is a heavy price for most amateur photographers. Programs like PixInsight and StarTools are specifically designed to process astrophotographs and are definitely lower costs alternatives to Photoshop CC as is PaintShop Pro X6 Ultimate.

"Adobe PhotoShop Elements 12" is a scaled down version of PhotoShop. It has a mixture of 8 bit and 16 bit features. The image from a stacking program must be first stretched using levels in a 16 bit format before using other 8 bit features of the program.

"PixInsight" is a fully featured calibration, stacking, and enhancement program designed especially for astrophotography. The stated philosophy on the developer's

website is that features and capabilities are more important than user friendliness. PixInsight has a steep learning curve but, like IRIS, once mastered, the program offers a vast array of features and tools required to process astrophotographs.

"StarTools" is another very powerful photo enhancement program designed especially for astrophotography. Its users say it is as capable as PixInsight and IRIS for enhancing images but has no capability for actually stacking images. StarTools uses a simple tool menu with slider adjustments for fine tuning parameters of the program. This approach produces a user friendly interface providing a short learning curve for the program. At $60, the program is a great bargain and an excellent complement to DeepSky Stacker.

9.6 Which Programs Should You Use?

DeepSky Stacker is one of the more capable calibration and stacking programs and is perhaps the easiest to learn to use. The program is well supported by its developer. Best of all, it costs nothing. As the old saying goes, "it's a no brainer;" especially for people on a budget.

The choice for image enhancement is not so simple. Image enhancement is where the rubber meets the road and what makes or breaks an image. No matter how good your camera work is, the final image is no better than the enhancements you make. Two kinds of image enhancement programs are available; programs designed especially for astrophotography and programs developed for traditional photography that can be used for astrophotography. Which of these two types of programs is better? Both types produce excellent results. In the end, the results obtained are more dependent upon the photo processing skills of the person enhancing the image than the computer program used.

StarTools is designed especially for astrophotography. From both an economical and technical perspective, StarTools is difficult to beat because of its graphics capabilities, moderate learning curve, easy to use user interface, user support, and reasonable price. Both 64 and 32 bit versions are available.

Adobe PhotoShop CC and older versions are programs designed for traditional photography and are the programs of choice by a very large percentage of astrophotographers. The knowledge base related to astrophotography on the internet for PhotoShop is extensive; far exceeding that available for any other program. However, PhotoShop is expensive, especially the latest version that is available only as an annual lease starting at $240 a year. Corel PaintShop Pro X6 and later versions are similar to PhotoShop. PaintShop Pro X6 is a viable 16 bit substitute for people who want to use a traditional photo processing program and who cannot afford Adobe PhotoShop.

Chapters 10 and 11 go deeper into DeepSky Stacker, PhotoShop type programs, and StarTools. However, the other programs in Table 9.2 are all capable programs. Should your personal preference be for one, by all means use it.

Chapter 10

Mastering DeepSky Stacker

10.1 DeepSky Stacker Overview

DeepSky Stacker is a very popular and capable stacking program widely used by astrophotographers around the world. Best of all it is freeware and available in 12 languages thanks to the generosity of its author. DeepSkyStacker is actually very simple to use but can be daunting at first if you are not familiar with the terms and phraseology used by stacking programs. The many options available with the program can also confuse new users as often which option to use and which one to ignore is not that apparent. However, once the terms and phraseology used with stacking are understood, the program becomes quite simple to use.

10.2 Getting Started

The best way to master DeepSky Stacker is to start using it. After a couple of successful runs the mystery evaporates and you will find that DeepSky Stacker is a very powerful and easy to use tool for processing your astrophotographs. The program is capable of stacking images that have considerable drift between each light frame as well as rotating light frames to adjust for field rotation, changes in camera orientation, or multiple imaging sessions over several nights, weeks, etc. As a bonus, DeepSky Stacker has some photo processing capabilities that can help you stretch your image if you do not have a 16 bit photo processing program; however, these features are limited.

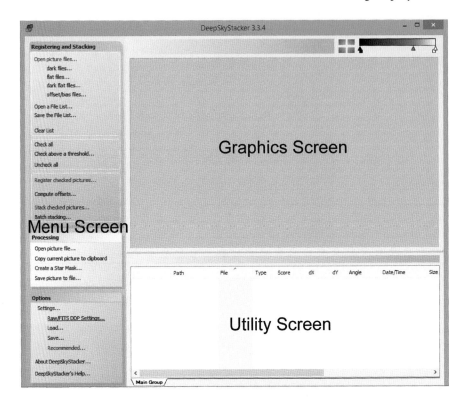

Fig. 10.1 DeepSky Stacker User Interface

When you run DeepSky Stacker, it starts with the DeepSky Stacker "User Interface" on your computer display. The User Interface presents a consistent view for the user throughout the stacking process (see Fig. 10.1). A "Menu Screen" takes about 20 % of the left side of the User Interface. This Menu Screen is where the commands and features for DeepSky Stacker are located. The remaining 80 % of the User Interface is divided horizontally into two parts with a "Graphics Screen" taking the upper two thirds and an "Utility Screen" taking the lower third.

While the User Interface remains the same, the contents of the Graphics and Utility Screens change after an image is successfully stacked. Before stacking the Graphics Screen has an image of one of the light frames being stacked and the Utility Screen will list each file (light, dark, flat, bias) that is loaded in the program along with each file's characteristics (see Fig. 10.2). After stacking an image, the Graphics Screen displays the image produced by the stacking process and the Utility Screen contains the controls for the limited processing features of the program (see Fig. 10.3). As shown in Figs. 10.2 and 10.3, the User Interface keeps its design and nature throughout the process.

10.2 Getting Started

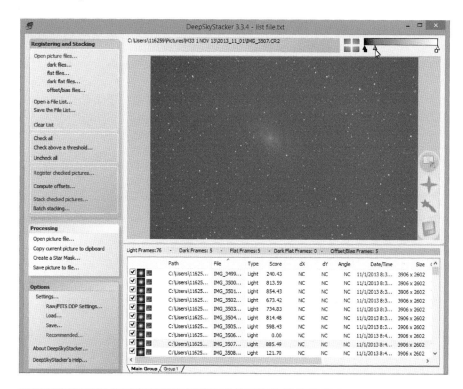

Fig. 10.2 Utility screen with files loaded

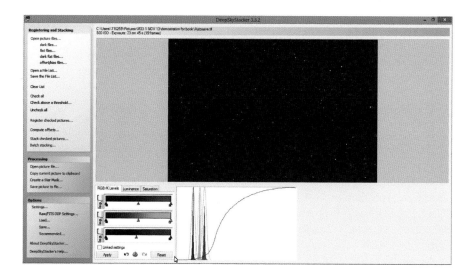

Fig. 10.3 DeepSky Stacker User Interface after Stacking

The basic flow of DeepSky Stacker is as follows:

- Load the light frames (picture files)
- Load the dark frames, flat frames, bias frames, if any
- Select the files you want to stack
- Register the selected light frames
- Compute the offsets needed to align each light frame
- Stack the selected light frames
- Process the stacked image (optional)
- Save the image for processing with an image processing program

At first this may appear a bit complex, but keep in mind that the program, not you, will be doing most of the work. However, there is one thing that you can do when you are out at night acquiring your images that will make life easier for you when you stack; keep a log of the file names so you know which files are light frames, dark frames, flat frames, or bias frames. If you fail to do this, then before you start loading files into DeepSky Stacker, you will have to look at each one and identify which files are which. DeepSkyStacker can not automatically review a file and determine what kind of file it is. You have to identify it.

10.3 Stacking Parameters Box

Before DeepSky Stacker is able to stack your light frames, you must tell the program how you want it to perform the stacking process that it will use. To do this, you will need to define the following parameters:

- The composition of the stacked image
- The process used to stack light frames
- The process used to make master flat, dark, or bias frames
- The process used to align light frames
- The disposition of intermediate files
- The cosmetic effects, if any
- The disposition of output files

At first glance all the above may seem a bit complex but you will soon see that it really is very simple. Once you set these parameters, the program can take over and you can go have a cup of coffee while it cranks away.

On the Menu Screen look at the bottom box titled "Options." Left click on "Settings." Another box will pop-up with two options, "Register Settings" and "Stacking Settings." Left click on "Stacking Settings." Yet another box will pop-up, this one titled "Stacking Parameters" with the "Results Tab" selected (see Fig. 10.4).

As shown in Fig. 10.4 the Stacking Parameters box has ten tabs across the top If less than ten tabs are displayed, look at the upper right hand corner of the Stacking Parameters box. There you will see two small arrows, one pointing to the left and

10.4 Results Tab

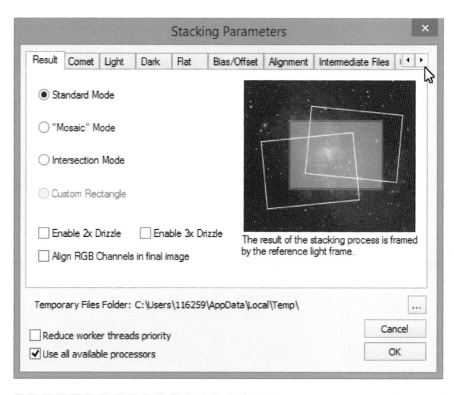

Fig. 10.4 Stacking Parameters

the other to the right. Click on the left arrow and the other tabs will scroll into view. These ten tabs are used to define the parameters listed above that are required to run DeepSky Stacker.

10.4 Results Tab

The "Results Tab" is where you tell DeepSky Stacker how you want your stacked image composed (see Fig. 10.4). The tab has four composition options:

- standard mode
- mosaic mode
- intersection mode
- custom rectangle

The "Standard Mode" uses a reference light frame to define the size, orientation, and composition, of the final stacked image. The stacked file will be the same size as the referenced light frame. Only data from each light frame that coincides with

the reference light frame are used. The remaining data are discarded. This option is problematic if you have a lot of rotation with your light frames resulting from field rotation, imaging over two or more nights, rotating your camera during the imaging session, etc. The reference frame is automatically selected by DeepSky Stacker and is the light frame it calculates has the highest quality. If you don't like the composition provided by the reference light frame, review your light frames until you find one having the composition you want. To review a light frame, click on the file you want as a reference frame listed in the utility window and it will load into the graphics window. If you wish to take some action on the file, right click on the file name and a popup appears that lists 12 self-explanatory options. One option on the list is "use as reference frame." If you left click on the option "use as reference frame" then the frame you left clicked on becomes the reference frame.

The "Mosaic Mode" produces a final image that is the composite of all the light frames that are stacked. This mode uses all the data from the stacked light frames; no data are discarded. The final stacked image is physically larger than the light frames and, dependent upon its physical size, can be a very large file. The stacked image size is dependent upon the amount of rotation and movement between the frames; the greater the movement, the larger the file.

The "Intersection Mode" only uses data common to all light frames in the final image. This mode discards a lot of information but produces the highest quality image file. The resultant image is smaller than a light frame. Like the mosaic mode, the amount of movement between each frame determines the size of the final stacked image; the greater the movement, the smaller the size of the image and corresponding file. If part of the object you are imaging is not common to all your light frames, then that part will not be in the final image. Dependent upon the movement between light frames, this option can produce an oddly dimensioned final image that has a large difference between the height and width of the image.

The "Custom Rectangle Mode" lets you determine the exact composition and size you want the final stacked image to have. To activate this mode, you first have to define the composition you want. To do this, go to the "Utility Screen" and click on a light frame to load it into the "Graphics Screen." At the upper right hand corner of the graphics screen is a slider that adjusts image brightness. Slide the middle arrow tick to the left until you can see some details of the object you photographed. Located in the lower half of the right side border of the graphics screen is a menu with the following options (see Fig. 10.2):

- custom rectangle mode (denoted by a red rectangle with an arrow)
- edit stars mode (denoted by a red star)
- edit comet mode (denoted by a green star with a tail)
- save changes (denoted by a floppy disk)

Click on the red rectangle then use your mouse to drag a rectangle on the image on your graphics screen to define the size and composition of the final stacked image. Next, go back to the "results tab" and select "custom rectangle." This option can produce the smallest sized final stacked image and the smallest file size. It also lets you, not a computer, compose the final image.

Two drizzle options are also available on the results tab; "2× drizzle" and "3× drizzle." Drizzle is an image enhancement process developed by NASA to enhance resolution. It is useful for images of small objects taken using a telescope with a short focal length. 2× drizzle doubles the image size while 3× drizzle triples the image size. Keep in mind that while 2× drizzle doubles the size of an image, it increases the size of the image file by four times and 3× drizzle increases the size of an image file by nine times. 2× drizzle is probably as big as you wish to use with a DSLR and its large image files. 3× drizzle is useful for older astronomical CCD cameras that had small image files. Using this feature with the "custom rectangle mode" reduces the size of the image and decreases the demands this option places on your computer's memory size and processor speed. If used with the mosaic mode, file sizes exceeding 500 MB are possible. Also, the drizzle option needs a large number of light frames, say 25 but preferably more.

10.5 Comet Tab

The "Comet Tab" is pretty much self explanatory (see Fig. 10.5). DeepSky Stacker provides the following three options for stacking an image of a comet:

- Standard: The "standard option" stacks based upon the stars in the image. This produces a final image that has sharp stars but the image of the comet will be soft (fuzzy).
- Comet: The "comet option" stacks on the comet producing a sharp image of the comet but stars have trailing.
- Stars plus Comet: The "stars plus comet" option does two iterations and produces a sharp image of the comet as well as a sharp image of the stars.

Choose the option that best satisfies your needs. However, before the comet tab will appear as part of the stacking process, you must identify the comet to the program. To do this:

- In the utility screen, click on the name of the first light frame that you will stack.
- After the light frame loads onto the graphics screen adjust the image brightness using the slider control at the upper right hand corner of the User Interface (Fig. 10.2) then enter the "Edit Comet Mode" by clicking on the Green Comet Symbol on the menu located on right side of the Graphics Screen. A circular cursor will appear on the Graphics Screen.
- Move the circular cursor to the center of the comet's head and left click your mouse button (note: If the cursor refuses to center on the comet, hold the shift key down when you left click on the mouse.)
- Now save the information by clicking on the "save changes button" (the black floppy disk symbol) beneath the comet symbol in the menu.
- Once the comet position is set a +(C) appears next to the star count for the frame
- Repeat the above for each light frame you are stacking

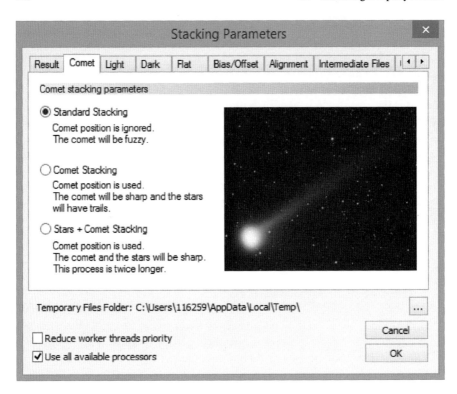

Fig. 10.5 Comet Tab

The above is a lot of work, especially if you have a lot of light frames. Fortunately the following shortcut exists if your camera includes time/date information in its images (most DSLR cameras and many astronomical CCD cameras do):

- The file listing in the utility window has one column titled date/time; left click on the date/time column heading. This will sort the light frames by the date and time they were obtained.
- Using the same process just described, set the position of the comet only for the first light frame, the last light frame, and the reference light frame.

DeepSky Stacker will calculate the position of the comet for the remaining light frames using an interpolative process based upon the time between exposures.

10.6 Light Tab

The "light Tab" sets the stacking mode used for stacking the light frames (see Fig. 10.6). You need to select one of the following seven options:

- Average (This is the default mode. The average value for all the pixels in the stack is calculated and used for each pixel.)

10.6 Light Tab

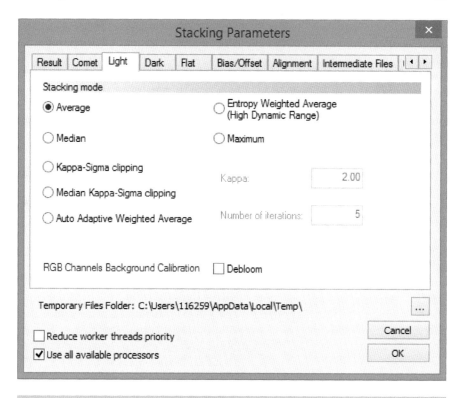

Fig. 10.6 Light Tab

- Median (This is the preferred mode for very short exposures. The median value for all the pixels in the stack is calculated and used for each pixel.)
- Kappa-Sigma Clipping (DeepSky Stacker calculates the mean and the standard deviation, sigma, for all the pixels in the stack and rejects any values outside a predefined multiple of the standard deviation. This is repeated for the number of iterations selected. The multiple, Kappa, and the number of iterations are designated in the boxes at the right of this option.)
- Median Kappa-Sigma Clipping (This is very similar to Kappa-Sigma Clipping except instead of rejecting pixels with values outside Kappa x Sigma, they are replaced with the median value of the stack.)
- Auto Adaptive Weighted Average (A weighted value is calculated for each pixel based upon the deviation from the mean in relationship to the standard deviation.)
- Entropy Weighted Average (Combines images obtained under different exposure and lighting conditions into a single image that provides the best possible composite view.)
- Maximum (The maximum value for all the pixels in the stack is calculated and used for each pixel.)

Note: The difference between an average value and a median value is often misunderstood. They two are different things. Take the following set of seven numbers (9, 4, 3, 7, 1, 3, 9) as an example. The sum of these 7 numbers is 36 and the average value is 5.14 (36/7). The median value for this set of 7 numbers is 4. To obtain the median value, rearrange the set of numbers in the example in either ascending or descending order. For a set of numbers with an odd number of values, the median value is the value exactly in the middle. The number set in the example, rearranged in descending order, looks like this (9, 9, 7, 4, 3, 3, 1). The value in the exact center is the number 4.

Say that we have a set of numbers that has an even number of values like (9, 8, 8, 4, 3, 2, 2, 1). A set having an even number of values has no value in the middle but does have two numbers, one on each side of the middle. In this case the median value is 3.5, the average of the two middle numbers 4 and 3. The sum of the set is 37 and the average value is 4.625 (37/8). Now let us take this set and replace the 9 with a 24 and one of the 8s with 21 as an example. The number set now becomes (24, 21, 8, 4, 3, 2, 2, 1). The median value remains 3.5 as the numbers 4 and 3 remain in the center but the average value is now 8.125.

The "Average" stacking method is mathematically the simplest of the seven methods offered by DeepSky Stacker. The values of the pixels are summed then divided by the number of pixels. Pixels out of range, such as hot pixels, airplane lights, satellite trails, etc. are included in the average and are often visible in the final image. This is the best option for stacks having a small number of light frames; no more than around 8–10.

"Median" stacking requires at least three frames but really is not that statistically significant for stacks have less than around 8–10 light frames. The median mode uses the median value (not the average value) of a stack of pixels; thus, pixels out of range such as airplane lights, satellite trails, etc. are not used. For very short exposure astrophotography with light weight mounts, Median Stacking is the preferred stacking process.

The "Kappa-Sigma Clipping" and "Median Kappa-Sigma Clipping" methods are very similar in many respects. Both methods require that the user define the value of Kappa and the number of iterations used in the calculations. Sigma is the term used in statistics to express one standard deviation in a set of data. Typically in statistical analyses data outside two standard deviations, 2 sigma, is considered outside the normal and not used. In the expression "2 sigma," the number 2 is the Kappa value. Unless you are well versed in statistical analysis, use 2 for the value of Kappa. Another consideration is the number of iterations to run. Choosing ten iterations for a stack of 10 or less light frames makes little sense. A good rule of thumb is to set the number of iterations equal to 10 % of the number of light frames stacked with a maximum number of iterations not exceeding ten. As with median stacking, these methods eliminate airplane lights, satellite tracks, etc.

The "Auto Adaptive Weighted Average" is a more robust version of Average Stacking that gives additional weight to values near the mean value of set of pixel values. It is an iterative process and the number of iterations must be defined. The criterion for the number of iterations to select is the same as for the sigma clipping methods.

Select "Entropy Weighted Average" when the exposure times or ISO settings vary for your light frames. This option can often provide more depth to an image and is worth trying if you are not satisfied with the results obtained with one of the other stacking methods. Pixels out of range, such as hot pixels, airplane lights, satellite trails, etc. are often visible in the final image.

"Maximum" stacking uses the maximum value of a set of pixel values. This is useful for diagnostic work as it displays all the defects of the stacked light frames.

10.7 Dark, Flat, and Bias/Offset Tabs

These three tabs are identical except for the type of file (dark, Flat, Bias/Offset) except the dark tab has the following four additional options that are not applicable for flat, bias/offset, or light frames (see Fig. 10.7):

- hot pixel detection and removal (After dark frame subtraction, pixels with a value greater than the median plus 16 times the standard deviation are replaced with the a value interpolated from neighboring pixels.)

Fig. 10.7 Dark, flat, and bias/offset tabs

- dark optimization (Adjusts for dark frames not obtained under optimal conditions such as temperature variances, etc.)
- bad columns detection and removal (This option automatically detects and removes columns that are dead or saturated for some astronomical CCD cameras with monochrome sensors.)
- dark multiplication factor

Select the same stacking mode that was selected for stacking your light frames.

10.8 Alignment Tab

Five alignment options are offered based upon three different mathematical models along with parameters for using each one (see Fig. 10.8). These options are as follows:

- Automatic (DeepSky Stacker will select the alignment option for stacking the light frames dependent upon the number of stars detected. This option is the default option and recommended for very short exposures.)
- Bilinear (Sets the alignment mode to bilinear regardless of the number of stars detected.)

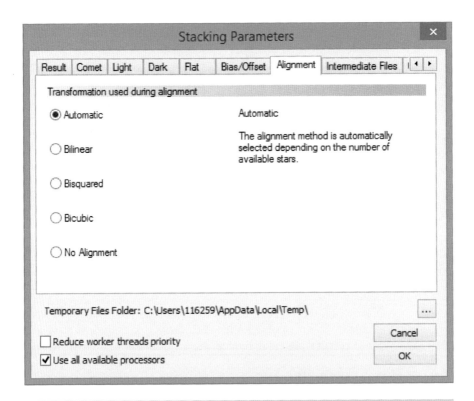

Fig. 10.8 Alignment Tab

10.9 Intermediate Files Tab

- Bisquared (The bisquared alignment mode is used when 25 or more stars are detected, else the bilinear mode is used.)
- Bicubic (The bicubic alignment mode is used when 40 or more stars are detected, the bilinear mode for less than 25 stars, and the bisquared mode used if 25–39 are detected.)
- No Alignment (The images are aligned based upon the xy coordinates of the camera sensor instead of stars.)

10.9 Intermediate Files Tab

The Intermediate Files Tab has the following two options (see Fig. 10.9):

- create a calibrated file for each light frame
- create a registered/calibrated file for each light frame

The default is none of these two options are selected. The remaining option available is to designate whether intermediate and final files are saved as TIFF or FITS files.

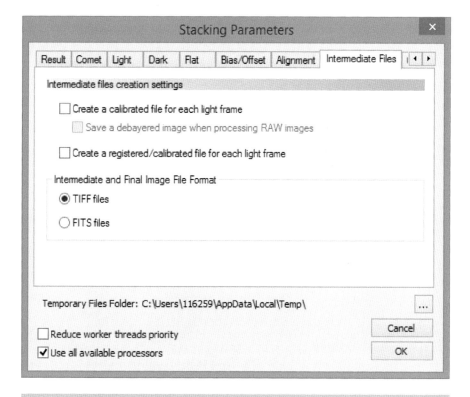

Fig. 10.9 Intermediate Files Tab

10.10 Cosmetic Tab

Two post calibration settings are available (see Fig. 10.10):

- detect and clean remaining hot pixels
- detect and clean any remaining cold pixel

The default settings are neither of these two options are selected. These settings can produce undesirable results; deviate from the default settings with care.

10.11 Output Tab

This tab is self explanatory (see Fig. 10.11). The options are:

- create an output file
- designate the output file naming convention or name
- designate the location to save the output file

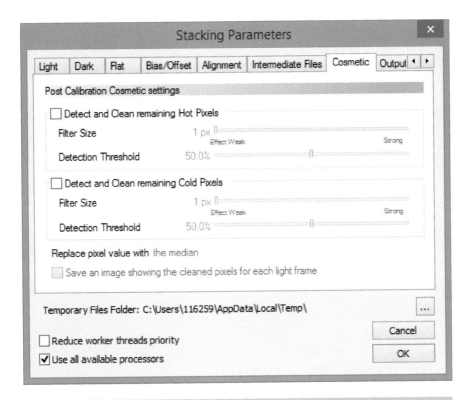

Fig. 10.10 Cosmetic Tab

10.12 Raw Digital Development Process

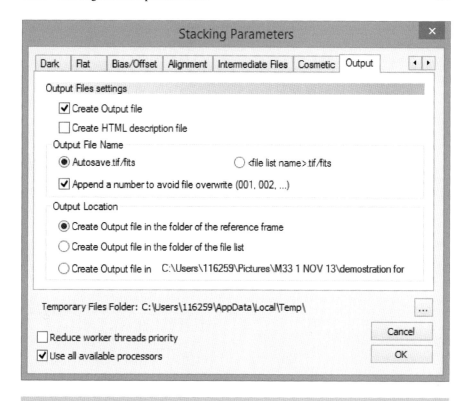

Fig. 10.11 Output Tab

The default is to create an output file using the name "Autosave." Note: If you are stacking more than one image, the addresses where you save files will not be automatically changed. You must bring up the Output Tab and type in the addresses where you wish to save your files.

10.12 Raw Digital Development Process

The last parameter needing definition is how you want DeepSky Stacker to handle RAW files. If you look at the Menu Screen in under the box titled "Options," there is an option titled "RAW/FITS DDP Settings." Clicking on that setting brings up a box titled "RAW/FITS Digital Development Process Settings," (see Fig. 10.12). This is where we tell the program how to process RAW Files. The box has two tabs, one titled "RAW Files" and the other titled "FITS Files" Choose the "Raw Files" tab. The default settings for this tab are:

- Color Adjustment; 1.0000 for brightness, red scale, and blue scale
- White Balance; no selection
- Bayer Matrix Transformation; bilinear interpolation

Fig. 10.12 Raw digital development process settings

Settings for a Canon EOS camera are as follows:

- Red scale = 1.25; blue scale = 1.00; brightness = 1.0000
- White balance: auto white balance or camera white balance; your preference

The Bayer Matrix Transformation has the following four options:

- Bayer interpolation (default value)
- adaptive homogeneity directed interpolation

- use Bayer drizzle algorithm
- create super pixels from the raw Bayer matrix

All the images in Chap. 14 were made with an unmodified Canon EOS Rebel XS (1000D) Digital Single Lens Reflex Camera using the following settings:

- red scale: 1.25
- blue scale: 1.0000
- brightness: 1.0000
- white balance: auto
- Bayer interpolation

10.13 Loading Files into DeepSky Stacker

The last area to explore before you can use the program is how to load light, flat, dark, bias files into DeepSky Stacker. Look at the Menu Screen on the left side of the DeepSky Stacker User Interface (Fig. 10.1). The Menu Screen has three sections that are titled as follows:

- Registering and Stacking
- Processing
- Options

Under the Registering and Stacking Section, click on "Open Picture Files." This will bring up the typical box Windows uses for loading files into a program. The box is titled "Open Light Frames." Make sure the box titled "open as read only" is not selected. Go to the directory that contains your light frame files. Left click your mouse on the first light frame file your want to open and then, while holding down the shift key, left click on the last light frame file you want to open. This highlights all the image files from the first one to the last one. At the lower right corner of the "Open Light Frames" Window's box, left click on the button titled "Open." Your light frames are now loaded into DeepSky Stacker. If you have light frames located in different directories, repeat the process for each directory. The Utility Screen now contains all the files you loaded into the program (see Fig. 10.2).

Next, if you have dark frames, under the Registering and Stacking section of the Menu Screen click on "Dark Files." As with the "Open Picture Files," this opens up a typical Window's box for selecting and opening files. This box is titled "Open Dark Files." Select the dark files you want to open and open them the same way you opened your light frames. If you have flat files, dark flat files, or bias files; load them into DeepSky Stacker using the same process by clicking on "Flat Files" and "Offset/Bias Files" respectively. You now have all your files loaded in the program. Note: If you do not have any dark, flat, dark flat, or offset/bias files; the program will run just the same.

"How many dark, flat, or bias frames are required?" A minimum of 25 is recommended by the developer of DeepSky Stacker but more is better. Forty-nine reduces noise by a factor of 7 and is a good starting place for very short exposures. Too few darks, flats, or bias/offset frames add noise to the final image.

10.14 Running Deep Sky Stacker

Recall the basic flow of DeepSky Stacker:

- Load the light frames, dark frames, flat frames, and bias frames, if any
- Select all the files you want to stack
- Register the selected light frames
- Compute the offsets needed to align each light frame
- Stack the selected light frames
- Process the stacked image (optional)
- Save the image for processing with an image processing program

After loading all your light frames, dark frames, etc. you must define the stacking parameters for the program. Look at the bottom box titled "Options" on the Menu Screen. The first choice offered is "Settings." Left click your mouse on "Settings" then left click on "Stacking Parameters." This brings up the "Stacking Parameters" box where you must select the composition you want for the stacked image, the stacking process you want to use, and where you can identify the directories where you want your stacked image stored (see Fig. 10.4). Set the parameters as you want them. If you do not have darks, flats, etc. simply ignore their settings as DeepSky Stacker will detect that you are not using them and adjust accordingly.

On the Menu Screen, look at "Registering and Stacking" group. In the group there is a menu box with the following options:

- Check All
- Check Above a Threshold
- Uncheck All.

Click on "Check All."

Now all the files you have loaded into DeepSky Stacker are selected for stacking and you are ready to start the actual stacking process. The next step is to register all the image files. This is where DeepSky Stacker processes the darks, flats, and bias frames; determines number, location, and luminance of stars in each image; etc.

Again go to "Registering and Stacking" menu box on the Menu Screen of the User Interface. Immediately below the area where you just ticked off "Check All" is a box having the following options:

- Register Checked Pictures
- Compute Offsets
- Stack Checked Pictures
- Batch Stacking

10.14 Running Deep Sky Stacker

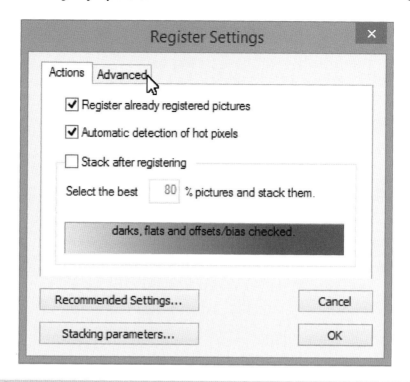

Fig. 10.13 Actions Tab

Notice the order of the above option as they are the order of the program's flow. First the light frames are registered, second the offsets needed to align the light frames are calculated and finally the light frames are stacked.

Select "Register Checked Pictures."

This brings up another box titled "Register Settings" that has two tabs, "Actions" and "Advanced." The "Actions" tab has the following options (see Fig. 10.13):

- register already registered picture (do not select)
- automatic detection of hot pixels (select)
- stack after registering (do not select)
- select the best ___ % of pictures and stack them (leave blank)

Click on the "Advanced Tab." This bring up a box with a slider selector titled "Star Detection Threshold" (see Fig. 10.14). Underneath the slide is a button titled "Compute the Number of Detected Stars."

Left click on this button.

The program will then count the number of stars it can detect in the first light frame checked in the list of light frames located in the utility window. If the number of stars detected is very high, several hundred for example, increase the percentage

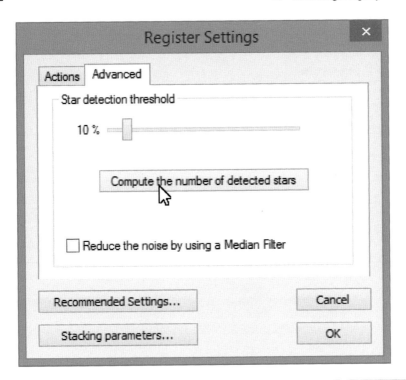

Fig. 10.14 Star detection threshold

by moving the slider to the right and then calculate the number of stars again. Repeat this until the number of stars is no more than around 300–500 or so. If the number of stars is less than around 20, move the slider to the left two or three percentage points and recalculate the number of stars. Repeat this until you obtain at least 15–20 stars. Note: DeepSky Stacker must detect at least eight stars common to all light frames that it stacks. This generally means that it needs to detect about 15–20 stars in order to have eight common to all.

If you cannot detect around 15–20 stars by the time the slider is lowered to 4 %, there is a problem with your light frame. Uncheck the light frame. This will remove the frame from the stacking calculations. Repeat the above process using another light frame. Note. You may have to physically remove the defective light frame from the list. Right click on the file and select "Remove from List." If you cannot detect 15–20 stars after trying three or four light frames, you can try lowering the slider to 3 %. However, generally a slider setting of 2 or 3 starts counting noise as stars. If you cannot detect more than around ten stars with the slider set at 3 %, you can attempt to stack the light frames but the probability of success is low.

10.14 Running Deep Sky Stacker

At the bottom of the "Advanced Tab" there are four menu buttons:

- recommended settings
- stacking parameters
- cancel
- OK

Selecting the "Recommended Settings" button provides a list of recommended options. If the text color of the recommended option is green, this means that the option is already selected. If the text color is blue, then the program is recommending an option. The "Stacking Parameters" button brings up the "Stacking Parameters Box" so you change any of the parameters you previously defined but with one exception; only the relevant tabs are displayed (The Comet Tab is missing if you are not doing a comet, the Bias Tab is missing if you have no bias frames, etc.).

Click on the OK button to start the registering process. If you have loaded dark, flat, or bias frames, they are automatically processed. Part of the registering process does the following for each light frame:

- detects the number, location, and luminance of stars
- calculates the average "full width half maximum" (FWHM) value in pixels for stars in each light frame
- calculates a score based upon the number and quality of stars detected

When the program finishes registering the light frames, it will add the following data to each light file in the file list:

- score
- average FWHM value
- number of stars detected

The light frame that has the highest score is designated as the reference frame and identified by an asterisk placed next to the frame's score. The reference frame is used for aligning the frames with one another.

The next step is to calculate the offsets needed to align each light frame to the reference frame and to remove the light frames not suitable for stacking. Go back to the group where you told the program to register the light frames and select "Compute Offsets." Remember that was in a box the bottom of the "Registering and Stacking" menu and had the following options:

- Register checked pictures
- Compute offsets
- Stack checked pictures
- Batch stacking

Select "Compute Offsets." The program will then calculate the xy offset and rotation angle needed to align each light frame with the reference frame. This process is rapid and will not take long; about 1 s per light frame.

Now comes a very subjective process; culling light frames not suited for stacking. DeepSky Stacker does some of the work. Light frames that do not have at least eight stars in common with all the other light frames are rejected and no offsets calculated. While the program can stack the remaining light frames; this may not be the best thing to do. Keep in mind that the purpose of stacking is to reduce noise; not to stack as many light frames as possible. Light frames of poor quality can actually increase noise.

Look at the score assigned to each light frame. It is a factor of the number of stars and the FWHM value. However, the number of stars detected is dependent upon the exposure time and ISO setting used for the light frame. If all the light frames have the same ISO setting and exposure times, then their scores are an excellent indicator of relative image quality. Frames with vibration or star trails will have fewer detected stars and higher FWHM values; thus, lower scores.

If all your light frames have the same exposure time and ISO setting a good culling strategy is to keep only the frames having scores equal to or greater than 70 % of the reference frame. For example; if the score of the reference frame is 750, only select frames having a score of 525 or higher for stacking ($0.70 \times 750 = 525$). This does not mean that 30 % of the frames are rejected as statistically it is possible that all the light frames are of decent quality will have a score equal to or greater than 70 % of the maximum score. This is a subjective process. If you find you are rejecting more than around 40 % of your light frames this probably means that the reference light frame is not representative of the other light frames. A maximum rejection of about 40 % of the light frames is a good limit. Don't forget to include the light frames that DeepSky Stacker rejected because of inadequate stars in your rejection percentage.

If your light frames are composed of images having different exposure times and ISO settings, culling the poorer images is even more subjective. Since the exposure time and ISO have an impact upon the number of stars detected, exposures with higher ISO settings or longer exposure times will have higher scores than exposures with lower ISO settings or shorter exposure times.

First sort the file listing in the utility screen by the parameter (ISO or exposure time) that varies with your light frames. For example, if you have different ISO settings, simply put the cursor on the heading "ISO" at the top of the ISO column and left click your mouse. This will sort the files based upon the ISO setting. Take a look at the scores for the light frames having the same ISO setting and reject all the light frames that have scores significantly lower than the rest. If exposure time is the variance, do the same for it. If both ISO and exposure times vary, first sort and reject based upon one parameter then the other. In any case, don't reject more than about 40 % of the total number of light frames.

Regardless of how you evaluate your light frames; remember, you only want to get rid of light frames that are of poor quality. If the variance between the lower and higher scores is small, you may only end up rejecting a few frames or even none at all. In any case, after you identify the light frames that you do not want to include in the stacking process, go to the file listing in the utility screen and "un-check" the unwanted frames.

10.14 Running Deep Sky Stacker

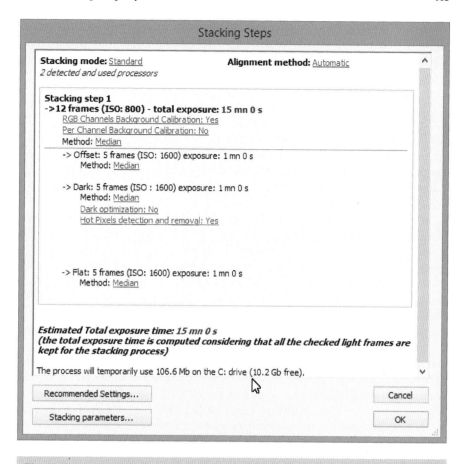

Fig. 10.15 Stacking Steps

Now you are ready to stack your light frames. Go to the "Registering and Stacking" menu box on the left side of the User Interface and to the sub menu box with the following options:

- Register checked pictures
- Compute offsets
- Stack checked pictures
- Batch stacking

Select "Stack Checked Pictures."

Another box titled "Stacking Steps," will pop up providing information about the upcoming stack (see Fig. 10.15). If your computer has insufficient memory to run the program, a warning statement will appear at the top of the box telling you that you need xxxx MB but only yyyy MB are available. One reason for an insufficient memory condition is dithering; check and make sure dithering is not

selected. If the program is ready to run, the following sentence will be at the bottom of the pop up box: "The process will temporarily use xxxx MB on drive C: (yyyy GB is free)." At the bottom of the box are four menu buttons:

- recommended settings
- stacking parameters
- cancel
- OK

Click on the "OK" button and then go have a cup of coffee. The stacking process will start and will take some time to complete dependent upon how many light frames are stacked, how much memory your computer has as well as the number and the speed of its processors.

When DeepSky Stacker completes the stacking process it stores the stacked image in a file named "Autosave" located in the same folder where your light frames are located unless you designated a different directory during the program setup. It then loads the stacked image into the graphics screen of the User Interface. This image may be a black screen with no stars or it may have some details. In any case, it will not be a very good looking image (see Fig. 10.3). If you have previously used DeepSky Stacker and do not designate where to save the autosave file, the program will save it in the directory designated the last time you ran the program.

If you wish to preview details of your image or do not have a 16 bit photo processing program, you can use DeepSky Stacker to stretch your image to bring out some details and color (see Fig. 10.16). The tools needed to do this task are located in the utility screen at the bottom of the graphics screen.

The utility screen is split in half. The right side contains a window having three histograms (red, green, and blue) and a levels curve for the image. The left side is opened in the RGB Levels mode has three sliders for adjusting the histogram of each color with controls for applying changes or reverting to default values at the bottom and three tabs at the top (RGB Levels, Luminance, and Saturation). Adjust the Luminance controls until you get a levels curve similar to that shown in Fig. 10.16 and adjust saturation and levels until you are satisfied with the image produced.

Adjust in small steps. The final curve and histograms should be similar to that shown in Fig. 10.16. As stated earlier, you only really need to use DeepSky Stacker's limited processing capabilities if your photo processing program cannot stretch 16 bit images without producing banding. Dependent upon your computer and the program you are using, you may be able to open DeepSky Stacker's "autosave.TIF" file that has your stacked image. However, some computer/software combinations cannot load the "autosave.TIF" file and need the file saved in a 32 or 16 bit format. Until you determine how the DeepSky Stacker files react to your particular photo processing program, it's a good idea to save the autosave file in a 32 bit and a 16 bit format. If you do not have a 16 bit or higher photo processing program then process the image using DeepSky Stacker and save the image as a 16 bit file.

10.14 Running Deep Sky Stacker

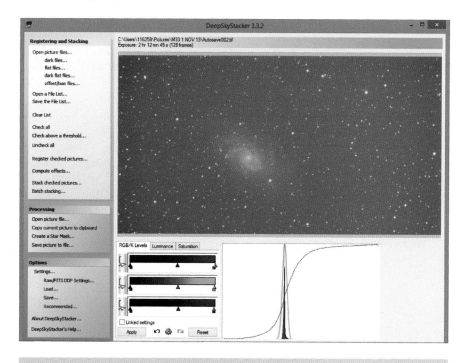

Fig. 10.16 Stretched Image in DeepSky Stacker

To save your stacked image file, make sure that it is in the graphic screen. Look at the box titled "processing" located at the lower middle of the left side screen on DeepSky Stacker's User Interface. Click on "save picture to file." A typical windows box pops up. Select the directory where you want to save the picture and enter a name for the file. For the box titled "Save as Type;" you have six choices:

- TIFF Image (16 bit/ch)
- TIFF Image (32 bit/ch integer)
- TIFF Image (32 bit/ch rational)
- FITS Image (16 bit/ch)
- FITS Image (32 bit/ch integer)
- FITS Image (32 bit/ch rational)

At the bottom of the box are two options:

- apply adjustments to the saved image
- embed adjustments in the saved image but do not apply them

If you have a photo processing program that can not stretch 16 bit images and are saving the image you processed with DeepSky Stacker, select:

- TIFF Image (16 bit/ch)
- apply adjustments to the saved image

If your photo processing program can stretch 16 bits images, select:

- TIFF Image (32 bit/ch rational)
- embed adjustments in the saved image but do not apply them

Notes:

- If you have the ability to work with FITS files, then you can select them instead of TIFF files, including the autosave file.
- Photoshop cannot load the 32 bit (integer) TIFF files created by DeepSky Stacker. You must save the file in a 32 bit (rational) TIFF file format to open them later in Photoshop.
- If you save an image with the option "apply adjustments to the saved image" all the adjustments made using the DeepSky Stacker photo processing tools are saved in the image and the image parameters are fixed. This means that only limited photo processing is possible. Only use this option for photo processing programs that cannot stretch 16 bit images. For all other cases select the option "embed adjustments in the saved image but do not apply them." None of the image's parameters are fixed and the full range of photo processing tools is usable. Also use this option if you have to power down your computer for some reason before you complete stretch your image in DeepSky Stacker. When you load your image to resume stretching in DeepSky Stacker, the file will load with the changes you made and will also allow further changes to be made.

Now, look at the Menu Screen of the User Interface immediately under where the commands for loading files into the program are located. There you will see three choices:

- Open a list file
- Save the list file
- Clear list

Click on "Save the list file." This will open up the typical Window's save box. Designate where you want to save the list file and the name you want the file to have then click on save. This will save a list of the files you have loaded in DeepSkyStacker as well as the results of registering and calculating offsets. If you want to load the same files into DeepSky Stacker again, use the "Open a list file" command, enter the name and location of the list file you want to load, and click open. The program will then load all the light frames, darks, flats, bias frames as well as the results of registering, etc. If you need to terminate the DeepSky Stacker before you finish stacking, you can use this list file feature to save your work before you exit. When you are able to resume work, then load the list file and continue with the stacking process. This feature is a big time saver if you wish to stack the image a second time using a different stacking method.

If the program does not stack your light frames the problem could be caused by one or more of the following issues:

- Insufficient stars (to stack, at least eight stars common to all light frames are required; try using the mosaic composition mode)

10.14 Running Deep Sky Stacker

- Egg shaped or star trails instead of round stars
- Poorly focused stars
- Inconsistent pixel sizes (all frames must have the same dimensions and pixel size)
- Too low signal to noise ratio (changing the RAW files to TIFF or JPG files sometimes works)
- Excessive movement between frames

Chapter 11

Processing Very Short Exposures

11.1 Introduction

Very short exposures are the foundation of "Astrophotography on the Go." They make possible the use of lightweight and portable alt-azimuth and equatorial mounts. However, very short exposures have a dark side; they are typically under exposed and have a low signal to noise ratio. Frequently a histogram of a very short exposure is merged with background noise. Coaxing a final image that has pleasing details with color is often an iterative process involving some trial and error. As always, noise is the enemy and care is needed to not introduce more. Just as important, care must be taken not to discard signal. A light hand using small incremental steps generally produces the best overall results.

The low signal to noise ratio associated with very short exposure astrophotography has a major impact upon the programs used for photo processing. An 8 bit program has 256 values between black and white with 0 being black and 255 being white. A 16 bit program has 65,536 values; 0 being black and 65,535 being white. Typical modern DSLR and astro CCD cameras are 12–16 bit devices. Using 8 bit programs to process their data negates much of the capabilities of modern cameras.

The under exposed image produced by very short exposure uses only a relatively few of these 65,536 values to represent the entire image; all located at the low end near black. This produces an image that appears very dark, often black, with few or no details. One action that must be done to see the image and its detail is to expand (stretch) the image so that it uses the values from 0 for black to 65,535 for white and the appropriate values for the levels in between. Since an 8 bit program only has 256 values between black and white, it cannot assign an unique level to each of

the 65,536 levels of a 16 bit image. This produces discontinuities called banding and data being lost in a dark background.

Two very popular programs used for processing astrophotographs are PixInsight by Pleiades Astrophoto and Adobe PhotoShop. These programs are expensive and are outside the reach of many astrophotographers. The latest version PhotoShop CC is only available as an annual lease starting at $240 per year. The popular PhotoShop CS6 version is priced at $700. PixInsight at $270 is less expensive but still pricy. Other programs are available, some of which can manage the entire imaging process from acquiring an image, stacking, and then doing the final processing. Two such programs are Nebulosity and Maxim DL. These programs are designed for long exposure work and require a computer in the field and not in keeping with the portability concept of Astrophotography on the Go.

Two excellent, moderately-priced (under $100) processing programs are available that are fully capable of stretching and processing the under exposed images produced by very short exposures. These are:

- Corel Paint Shop Pro (version X6 and higher); a PhotoShop look alike that produces excellent results ($80).
- StarTools; an inexpensive but very robust, fully featured, 64/32 bit program designed specifically for processing astrophotographs that produces outstanding results ($60).

In addition three other moderately priced (under $100) programs are available that have issues stretching images produced by very short exposures but for which a viable "work around" exists. These programs can produce very good results but not as good as the programs previously mentioned. These are:

- GIMP (version 2.8.10 and higher); a PhotoShop clone (freeware).
- Adobe PhotoShop Elements (version 8 and higher); an abbreviated version of PhotoShop CS6 ($99).
- Serif's PhotoPlus X6; a Photoshop clone ($80)

The recent released 16 bit version of GIMP (version 2.8.10) unfortunately did not fully address the issue of stretching 16 bit images. The same is true of Serif's PhotoPlus X6 and the recent 32 and 64 bit releases of Corel's PhotoPaint. To use these programs with very short exposures, the images must first be stretched. This is a task that most stacking programs, including DeepSky Stacker, can do. PhotoShop Elements also lacks a true 16 bit curve tool but can stretch images using its levels tool. With Elements, you must use the program's 16 bit processing tools first then finish off with its 8 bit tools. While these programs can produce very pleasing results, they do not compete with the more robust, fully-featured programs like PhotoShop CS2 and later, StarTools, PixInsight, Paint Shop Pro X6, etc. On the other hand, the cost of using two freeware programs like GIMP with DeepSky Stacker cannot be beat.

The first step taken to enhance a stacked image is to "Stretch it." If you ask ten astrophotographers how to stretch an image you will most likely get ten different answers. However, the methods will be similar and most will produce the desired

11.2 Stretching Very Short Exposure Images Using a Curve Stretch

results. PhotoShop and similar programs offer two ways to stretch an image using either the "levels" tool or "curves" tool. Stretching with "levels" brings out midtones but reduces contrast. Non-linear stretching with "curves" provides far greater control over parts of the image that are stretched and the amount of stretching applied; thus, it is the preferred method by many astrophotographers.

For this discussion we will stretch an image taken of Messier Objects 81 and 82. This particular image has a total integrated exposure time of 3 h and 6 min (372 light frames × 30 s). It was made with an unmodified Canon EOS Rebel XS (1000D) DSLR camera at 1600 ISO using an Orion Short Tube 80 mm f/5 refractor on a SkyWatcher SynScan AZ GOTO mount. The image was stacked with DeepSky Stacker.

11.2 Stretching Very Short Exposure Images Using a Curve Stretch

Look at "Fig. 11.1." The dark rectangle making up the left side of Fig. 11.1 is the image from the autosave file from DeepSky Stacker. All that is visible in the image are a few stars and a hint of each galaxy's core. However, hidden in the darkness are many more stars and two galaxies that will become visible as we stretch the image. On the right side of the screen is a gray box titled "Curves" that has a graph inside. This is the "Curves Tool" that we will use for the stretching process.

Take a look at the Curves window in Fig. 11.1 (the gray box on the right). Within the window is a graph with a straight line running from the lower left corner to the upper right corner. Near the left vertical margin of the graph are two light gray vertical peaks running from the bottom of the graph to its top. Actually there are three peaks (red, green, and blue) but the green and blue peaks are too close

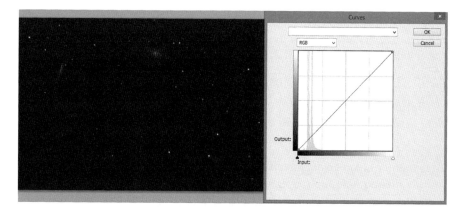

Fig. 11.1 Typical curve box and an unprocessed image

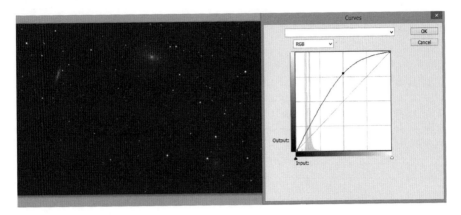

Fig. 11.2 First curve stretch

together to be noticeable in Fig. 11.1. This is the histogram for the image of M81 and M82 that we are using as an example. Notice there is a small gap between the left side of the histogram and the left vertical margin of the graph. This indicates that the image brightness is above background noise. Often with very short exposures this gap is merged with the left border and typically the histogram only has one peak (red, green, and blue are merged together). A histogram merged with the left border indicates that some of the image is lost to background noise.

How to stretch the image using the curves tool? Notice the small box under long narrow white box at the top of the curves graph. The long box is for retrieving preset curves. The small box designates exactly how the curve will be applied. For a 16 bit RGB color image, you can adjust the curve all three colors simultaneously (RGB composite) or adjust each color curve individually. For starters, the RGB composite curve is selected.

Notice that the graph is divided into a grid with 12 squares. To stretch the histogram, the cursor is moved to the middle of the diagonal line. The shape of the cursor changes from an arrow into a small "cross" (+) symbol as it nears the diagonal line. Left clicking and holding down the mouse button attaches the diagonal line to the mouse cursor. The line is then dragged upward one grid square then the mouse button released. This detaches the line which is now in the shape of a curve (see Fig. 11.2).

Notice that the curve starts at the lower left hand corner and ends at the upper right hand corner. Other than its ends, no part of the curve touches any part of the borders of the graph. Also notice that the curve is a smooth curve and not jagged or "S" shaped. The diagonal line running from the lower left corner to the upper right corner is now replaced with a much lighter gray line that has no functionality other than show the starting point; only the curved line remains active.

Take a look at the image. It is now slightly brighter and displays a few more details. A small change in the image during a curve tool application indicates that

11.2 Stretching Very Short Exposure Images Using a Curve Stretch

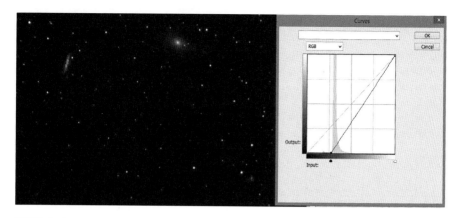

Fig. 11.3 Setting the black point with curves

stretching the histogram requires several applications of the curves tool. On the other hand, a significant change in the image indicates that few applications of the curves tools are needed. Here in our example, the change in the image from one application of the Curves Tool was small which indicates that several applications will be needed.

When to stop stretching? The answer to this question really comes with practice. As the curves tool is applied, our black image becomes brighter and details of the image emerge from the blackness. At some point:

- Areas of the image become so bright that details are lost or
- The overall image brightness is so intense that it masks details of our image.

The first case, loosing details of our image, indicates that the image is stretched too much and we are changing details into white; clipping on the white end. In this case, use the edit feature of the processing program, revert to the last stretch that enhanced details, and then set the black point for the histogram. The second case, image brightness masking details, also requires setting the black point of the histogram but not necessarily terminating the stretching process.

How to set the black point using the "Curves Tool" (see Fig. 11.3)? Enter into the curves tool box and look at the histogram of the image. The distance between the intersection of the left side of the histogram and the x axis of the graph (the bottom of the graph) is considerable. Place the mouse cursor on the baseline at the lower left corner of the graph and drag it across the x axis toward the right side of the graph until it meets the point where the lower left side of the histogram intersects with the x axis. Do not go past this point as data will be changed to black and faint details lost. This time, the baseline did not become a curve but remained a straight line. Click OK and the sky in the image becomes black. Select the curve tool again and observe the histogram. The intersection of the left side of the histogram with the x axis of the graph is at the left end of the x axis.

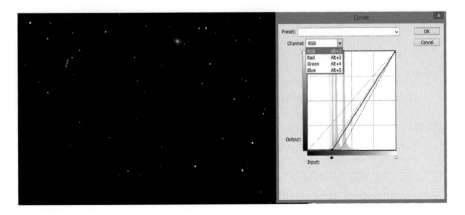

Fig. 11.4 Setting the black point with RGB curves

The histogram used to this point is a RGB histogram which is a combination of three color channels; red, green, and blue. Typically the histograms of each color channel for an image begins at the same point; e.g., the intersection between the x axis and the left side of the histogram for each of the three color channels has the same input value.

Recall that we are using an image of M81 and M82 as an example. Notice that the histogram for M81 and M82 now has three vertical spikes spread over the x axis of the graph and that the sky in the image is not black even though the black point was set (see Fig. 11.4). These spikes represent the red, blue, and green channels of the image's RGB histogram. Because they are widely separated, the RGB histogram must be broken down into its color channels to set the black point. This sometimes happens but is not typical and requires a variation of the process just described.

In the upper left corner of the curves tool box is a small box titled channels with "RGB" inside. Clicking on the "RGB" or the check mark immediately next to it brings up a menu offering the following options:

- RGB
- Red
- Green
- Blue

As previously mentioned, in order to use the RGB channel to set the black point, each of the three color channel histograms must start at the same value as the RGB histogram. This is not always the case. One indicator that the channels do not start with the same value is that setting the black point, produces a dark color other than black. Another indicator is two or three spikes in the RGB histogram.

11.2 Stretching Very Short Exposure Images Using a Curve Stretch

To verify the starting location of each color channel, simply click on the appropriate color in the Channels box and bring up the histogram for that color channel. Note the location where the left side of the histogram intersects the x axis of the graph. Do this for the other two color channels. The location of the intersection should be the same for all three color channels. If it is not, then independently set each color channel for black using the same process used for the RGB histogram. Click on the lower left corner of the baseline and drag it in the x direction until it meets the intersection of the left side of the channel histogram and the x axis. Repeat this for the histograms of the other two color channels. Once all three color channel histograms are adjusted, click on the OK button. Now the histogram of each color channel starts at the value and the sky is black.

Some general rules of thumb to remember when using curves to stretch an image are:

- Other than the end points of the curve, no part of the curve should ever touch the top or bottom boundaries of the graph
- the lower left part of the curve impacts shadows
- the upper right part of the curve impacts highlights
- the middle of the curve impacts mid tones

As the image is stretched, the histogram becomes wider and moves toward the right border of the graph. When stretching, never allow the histogram to actually reach the right border. Generally stopping before the histogram is in the middle of the graph is sufficient. If a gap exists between the left side of the histogram and black, set the black point again if the image is not dark enough to suit you (see Fig. 11.5).

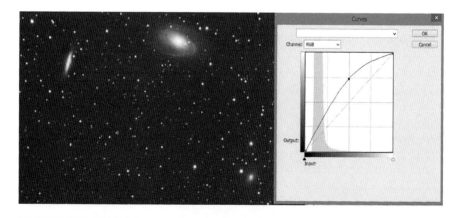

Fig. 11.5 Stretched image with black point set

11.3 Stretching Very Short Exposure Images Using a Levels Stretch

Some imagers prefer stretching and setting black points with the "Levels" tool rather than using the curves tool (see Fig. 11.6). The "Levels" tool box, like the Curve tool box, has a graph with the histogram of the image. A horizontal line makes up the x axis of the graph. At the left end of the x axis is a box with the number "0" in it and a black arrow head immediately above the box. This is a slide control for setting the "Black Point." A value of "0" is the value for black. Moving the slider to the right moves the Black Point to the right. At the far right of the horizontal line is another box with the number "255" and a white arrow head directly above the box. This is a slide control for setting the "White Point." A value of 255 is the value for white. Moving the slider control to the left, moves the white point to the left.

A third slider is provided to adjust middle gray (value 128). Underneath the x axis is a horizontal line with a gray arrow head in the middle and a box with 1.00 in it initially. Moving the arrow head to the left moves the middle gray point to the left while moving it to the right moves the middle gray point to the right. The number in the box is the gamma adjustment value and ranges from 0.01 to 10. Many versions of PhotoShop have the middle gray adjustment slide control on the x axis of the levels graph along with the slide controls for the black and white points (see Fig. 11.7).

How do you stretch with the levels tool? The first step is to adjust the color channels if they are not aligned (see Fig. 11.7). Recall from the discussion of the Curve Tool that the histogram for M81 and M82 has three vertical spikes spread over the x axis of the graph and their left borders did not coincide. Again, as with the Curves Tool, the starting location of each color channel must be verified.

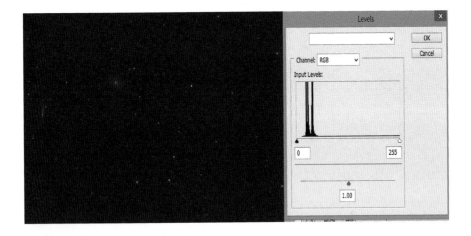

Fig. 11.6 Levels tool

11.3 Stretching Very Short Exposure Images Using a Levels Stretch

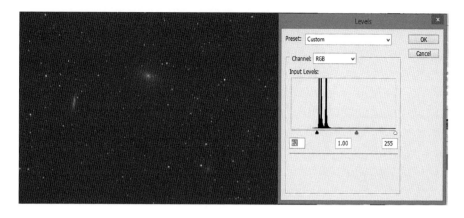

Fig. 11.7 Aligning histogram color channels

Simply click on the appropriate color in the Channels box and bring up the histogram for that color channel.

Note the location where the left side of the histogram intersects the x axis of the graph. Do this for the other two color channels. The location of the intersection should be the same for all three color channels. If it is not, then adjust each color channel independently. Move the black slider (the black arrow head above the box displaying "0") to the right until it just touches the point where left side of each color channel's histogram intercepts the x axis of the graph. As the slider is moved, the values in the black box will change displaying the position of the slider on the x axis. The gray slider and box will also move but its value will remain "1.00." The white slider (arrow) remains stationary and its value of 255 does not change.

Repeat this for the histograms of the other two color channels. Once all three color channel histograms are adjusted, click on the OK button. Now the histogram of each color channel starts at the value "0" and the sky is black.

Once the color channels are aligned, we adjust the gray and black points (see Fig. 11.8). To set the Black Point with the Levels Tool we need to move the histogram to where it just touches the left border of the graph. This is done by moving the black slider (the black arrow head above the box displaying "0") to the right until it just touches the point where left side of the histogram intercepts the x axis of the graph. As the slider is moved, the values in the black box will change displaying the position of the slider on the x axis. The mid gray slider will also move but its value will remain "1.00." The white slider (arrow) remains stationary and its value of 255 does not change.

Be careful not to clip the histogram by moving the Black Point arrow head where it is to the right of the intersection of the histogram and x axis as this throws away faint details of the objects in your image. Move the mid gray slider (the gray arrow in the middle of the x axis) until it just touches the point where right side of the histogram intercepts the x axis of the graph and click OK. The image is now stretched.

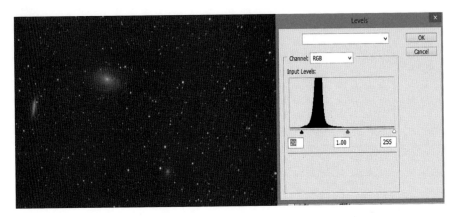

Fig. 11.8 Set the black and gray points

The White Point slide control is not moved. If you move it to the left, you move the white point to the left. This has a major but negative impact as it reduces or eliminates the colors of stars in the image.

11.4 Image Enhancement

Photo processing programs have a seemingly endless array of tools available to enhance images; far too many to do justice in one chapter of a book. Stretching a histogram is the first step in enhancing an image. From this point, there really is no standard road map to follow. In general, post stretching deals with these aspects of the image:

- contrast
- brightness
- midtones
- color balance
- sharpening
- softness
- noise

Photo processing programs capable of handling astrophotographs have tools that specifically designed to handle these chores. Perhaps the most powerful of the available tools is the curves tool. This tool has many capabilities other than stretching a histogram. The curves tool is suited for adjusting contrast, brightness, and mid tones of an image. Typically programs provide a group of pre-set curves with the curves tool that make good starting points for learning how to use this powerful tool. The ability to independently use the three color channels allows for fairly

Fig. 11.9 Contrast and Brightness tool

precise adjustments in color or color tones as well as for brightness. Here is a list of some curves that are often pre-set with the curves tool that demonstrate its flexibility:

- color negative image
- cross process
- darker image
- enhance monochromatic contrast
- enhance per channel contrast
- find dark and light colors
- increase contrast
- lighter
- linear contrast
- medium contrast
- negative
- snap neutral mid toned
- strong contrast
- custom

The levels tool, like the curves tool, can make subtle changes in each color channel to reduce the impact of light pollution or adjust the color of objects.

The Contrast and Brightness tool adjusts the contrast and brightness of an image by moving either the appropriate slider bar. As with most of image processing, making small adjustments then checking the impact of the adjustment often prevents some nasty surprises (see Fig. 11.9).

The color balance tool allows you to selectively adjust the color balance in shadows, midtones, and highlights. The tool has three sliders that adjust color tones between two colors (see Fig. 11.10):

- top slider: between cyan and red
- middle slider: between magenta and green
- lower slider: between yellow and blue

Fig. 11.10 Color balance tool

The Sharpening menu generally offers several sharpening tools. The one of particular interest to astrophotography is "Unsharp Mask." Unsharp mask is useful for emphasizing details in images of galaxies and nebula for deep space and surface features for planetary objects (see Fig. 11.11).

The Blur menu also offers several tools. Gaussian blur is used to reduce noise in images. While noise is reduced, details are also softened or lost.

Experiment with tools in the image adjustment menu. Save your work and save often just in case you go down a path from which you cannot recover. Keep in mind that noise is the enemy. Often a series of smaller adjustments produce the same result as one large adjustment but with less noise added to the image. This is especially true for tools like unsharp mask and contrast. Curves and levels tools are sensitive in that clipping data is easy to inadvertently do. Don't hesitate to mask off areas of an image that need special attention. This helps to keep the night sky and stars natural looking. Cropping images removes bloated stars and other aberrations that may exist near the outer edges.

Recall the solid black image of M81 and M82 that we started with in this discussion (see Fig. 11.1). Here is the same image processed using a Level Stretch, Curves, Contrast and Brightness, Color Balance, and Unsharp Mask Tools (see Fig. 11.12).

11.5 Processing Very Short Exposures Using 8 Bit Photo Processing Programs

Several very capable 8 bit based photo processing programs are widely used such as Corel PhotoPaint and Paint Shop Pro, Serif PhotoPlus, and GIMP. The 8 bit architecture of these programs limits their usefulness for processing very short

11.5 Processing Very Short Exposures Using 8 Bit Photo Processing Programs

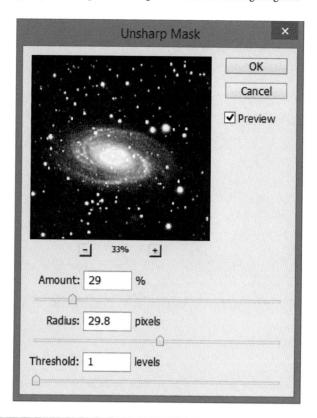

Fig. 11.11 Unsharp mask

exposures; especially the ability to stretch images without producing color banding and other artifacts. Fortunately there are two ways to work around this issue:

- Take your lights in JPG format or
- Use the photo processing capabilities of your stacking program to stretch the stacked image

DeepSky Stacker can stack JPG files. Reducing noise and adjustments to contrast, brightness, color balance, sharpness, etc. for JPG files are possible with most photo processing programs. While removing hot pixels via dark frame subtraction is not possible with JPG files; hot pixels are removable by using either the camera's dark frame subtraction feature or by using a statistical stacking process. The use of flats to correct for vignetting or removal of dust motes is another process that is not possible with JPG files. Last, the JPG format looses data when the image is saved and can introduce artifacts into the image, especially if substantially compressed.

The other and recommended way to work issues stretching with an 8 bit photo processing program is to stretch the image using the stacking program then process the stretched image with the 8 bit photo processing program.

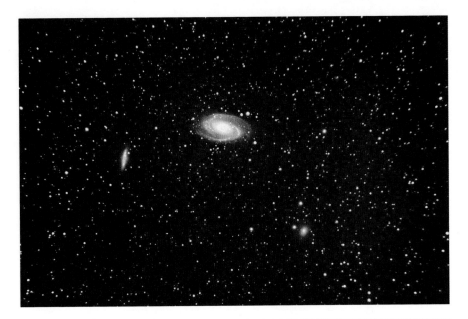

Fig. 11.12 M81 and M82

Recall that when DeepSky Stacker finishes stacking, it loads up the stacked image and has a graphics interface window showing the histogram of the image and some tools that can adjust the image. While tedious, these tools can stretch the image. If you are using an 8 bit photo processing program, this feature of DeepSky Stacker is very valuable for you.

DeepSky Stacker has the ability to stretch images with its "RGB Levels," "Levels," "Luminance," and "Saturation" features available with the program (see Fig. 11.13). These adjustments are tedious and a small adjustment can produce a large change.

In Fig. 11.13 are three colored horizontal bars to the left half of the graphics control window. The upper bar is red, the middle is green and the bottom bar is blue. These are the level adjustment bars for Red, Green, and Blue. Directly above the three colored bars are three tabs titled RGB/K Levels, Luminance, and Saturation. Left clicking on a tab brings up the controls for that particular feature. The Saturation Tab has only one slider allowing the adjustment for saturation from −50 to +50 %. The Luminance Tab provides access for shaping the Luminance Curve. Six sliders; two each for darkness, midtones, and highlights are available. One of the two sliders adjusts the angle that the curve makes to the horizontal axes and the other adjusts the luminance level.

The first step to prepare an image with DeepSky Stacker is to adjust the Luminance Curve (see Fig. 11.14). Often the curve is properly adjusted by the program but can also be a straight diagonal line running from the lower left side to

11.5 Processing Very Short Exposures Using 8 Bit Photo Processing Programs

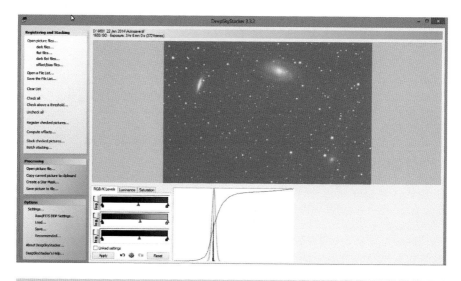

Fig. 11.13 DeepSky Stacker Levels controls

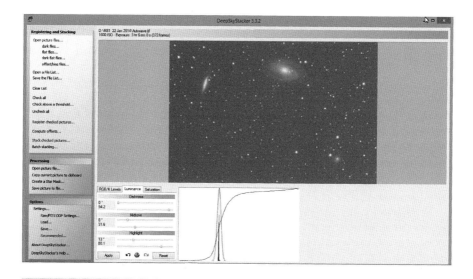

Fig. 11.14 DeepSky Stacker luminance controls

the upper right side of the graph. Six sliders—two each for darkness, midtones, and highlights—are available. One of the two sliders adjusts the angle that the curve makes to the horizontal axes and the other adjusts the luminance level. You need to adjust both the luminance and the angle slider for darkness, midtones, and highlights until you obtain a curve similar to the one shown in Fig. 11.14.

Table 11.1 Typical luminance settings

Tone	Angle (degrees)	Luminance value
Darkness	0	94.2
Midtones	8	31.6
High Light	13	80.1

Some typical values for the darkness, midtones, and highlights sliders and a good starting place are shown in Table 11.1.

The Levels Bars are very sensitive and require a steady hand.

Once you have the Luminance Curve properly shaped then you need to stretch using the RGB Levels. Lake a look at the curve in Fig. 11.13. It starts at the bottom of the graph, makes a curve and proceeds upward then makes another curve to join the upper limit of the graph. The curve line should just touch the upper limit. If it goes past the upper horizontal axis, the information contained in the part of the curve exceeding the upper boundary is chopped and lost. The angle slider for highlights adjusts this angle.

Next the image needs stretching using the RGB Levels. Looking again at Fig. 11.13; you see the "s" shaped curve produced by adjusting the luminance sliders.

Another curved graph is also there as a bell shaped curve. This curve is actually three histogram color channels (red, green, and blue) superimposed on each other. Look immediately beneath the three colored bars at the left side of the graphics interface. Three small triangles are present for each color, one at each end of the bar and one near the middle of the bar. Use the middle triangle to adjust the level for each color; do not move the two end triangles. Moving the middle triangle to the right stretches the image. Too far to the right and the image is very bright and washed out. Too far to the left and the image is very dark with no details. As the middle triangle is moved, the curve on the graph also moves in synchronization. Move theses triangle until you get the tones and details you desire. Note that if the curves are not superimposed, the color of the curve to the right of the other curves will dominate.

The saturation tab allows the degree of saturation wanted. A good starting point for the saturation reading is −6 % (see Fig. 11.15).

Once the image is satisfactory to you or you have processed it to the best of your abilities, save it as a 16 bit TIFF file using the option "apply adjustments to the saved image." Using the option "apply adjustments to the saved image" is very important as this is the only way to fix the adjustments so that they are still applied when you load the program in an 8 bit processing program. Also important, do not compress the file as some 8 bit programs can not open a compressed 16 bit TIFF file. Next, open the file in your 8 bit photo processing program and use its tools to enhance the image.

11.6 Processing Very Short Exposures Using PhotoShop Elements

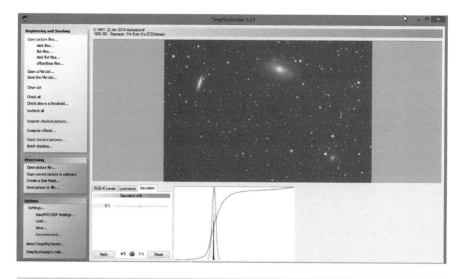

Fig. 11.15 Deepsky Stacker saturation control

11.6 Processing Very Short Exposures Using PhotoShop Elements

Adobe's PhotoShop Elements 12 is an interesting program in that it has a mix of 8 and 16 bit features. The program is capable of stretching and enhancing 16 bit images produced from stacking very short exposures with programs like DeepSky Stacker. It is also capable of processing "RAW" images in a roundabout way. When loaded on a computer, if it detects a program like Canon's "Camera RAW 8.0" it establishes a link in Element's file menu titled "Open in Camera Raw." Clicking on that item operates like any other open file menu item except when you click on "open" after selecting a file, the "RAW" processing program boots up with the selected file loaded. With Camera RAW, when you have completed your editing of the file you can either save it as a ".DNG" file or open the file directly in Elements 12.

Although Elements 12 is capable of 16 bit photo processing to a considerable degree, it does have the following 8 bit only tools and features:

- layers
- paste
- remove color cast
- auto smart tone
- auto smart fix
- adjust for skin tone

Of those six items, three are of interest for processing images of deep space objects (layers, paste, and remove color cast). Also, Elements 12 is not a full featured photo processing program and does not have the features contained in many photo processing programs. Four very useful missing features:

- magic wand masking tool (eliminated with Elements 12 but in earlier versions)
- color channels for curves
- color channel mixer
- paste in place between layers

The combination of some 8 bit only and these missing features creates some limitations, specifically related to color management, for using PhotoShop Elements 12 and earlier versions to process very short exposures of deep space objects. The end result is that the finial image produced often will not have the color depth and contrast attainable with fully featured programs. Results produced by Elements are competitive with results obtained with pure 8 bit programs. However versions going back to at least Elements 8 do have the capability to stretch and enhance images of deep space without producing color banding and other artifacts related to stretching and processing 8 bit images.

The curves command in Elements has no color channels capabilities and is limited to RGB composite only. This limitation makes using Elements curves rather cumbersome. For stretching an image, levels in Elements is the better method to use as Elements levels has the ability to make adjustments to color channels as well as RGB. Stretching can also be done with curves but the lack of color channels negatively impacts the usefulness of the feature as well as the ability to make small adjustments in colors, contrast, etc.

To process an image using Elements, stretch the image and set the black point before changing the working file from 16 to 8 bits.

11.7 Alternatives to Photo Processing Programs

One negative aspect of photo processing programs is that they are designed for traditional photography and astronomers must make do with that heritage. However, some programs are available that were designed from their initiation expressly for processing astrophotography images. Two such programs are PixInsight and StarTools. Unlike photo processing programs, these two programs are organized by function. Both are available as either 32 or 64 bit versions (see Fig. 11.16).

PixInsight can stack and processes an image. It is rather complex to learn to use as it depends upon the user to define the parameters of a particular function. This design philosophy gives the user complete control at the price of a steep learning curve. Once mastered, PixInsight provides all the tools necessary for processing astrophotography images starting with the RAW files in the camera and ending with the final finished image.

11.7 Alternatives to Photo Processing Programs

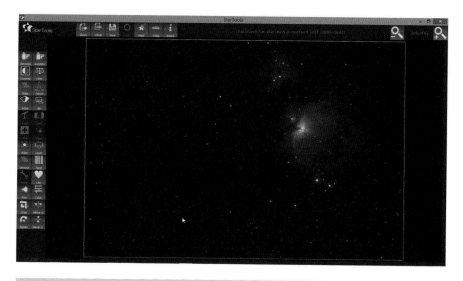

Fig. 11.16 StarTools user interface

StarTools is similar in many respects to PixInsight in that it works by functions. Unlike PixInsight, StarTools only processes images and does not have the ability to register and stack light frames. Also, StarTools can only work with FITS, uncompressed IBM byte ordered TIFF, or PNG files. The major difference between the two programs is that PixInsight is designed to give the user complete control over the program while StarTools has a user friendly interface with integrated onscreen help and uses predefined parameters that the user can adjust within some predefined limits. The final results are similar for either program. An example of what is meant by saying the program works by functions is stretching an image. StarTools does not have a level or curves command. To stretch an image, simply click on a button titled "Develop" and the program will stretch the image using a predefined routine with some limited adjustments allowed (see Fig. 11.17). The program also has routines for contrast, deconvoluting images,

StarTools has 24 command modules. Some modules are self explanatory while others are less obvious. Here is a list of each module with a broad definition:

- Band: Banding Reduction
- Bin: Reduce resolution to reduce noise
- Color: Color correction
- Contrast: Optimize local contrast
- Crop: Crop image to size
- Deconvolution: Recovers details from data limited by seeing conditions
- De-Noise: Wavelet based noise reduction
- Develop: Manual global stretching of stacked images
- Develop Automatic: Automated global stretching of stacked images

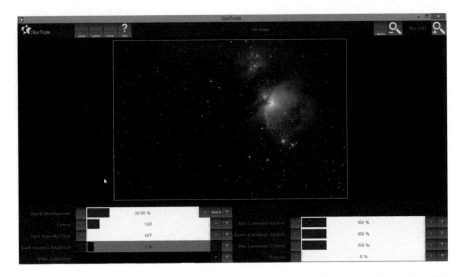

Fig. 11.17 StarTools development module

- Filter: Color based feature enhancement
- Flux: Automated detail recognition and enhancement
- HDR: Automated optimization of dynamic range
- Heal: Removal of unwanted features
- Layer: Enhancement at the pixel resolution
- Lens: Field flattening and distortion correction
- Life: Depth enhancement
- LRGB: Multi Channel image compositing
- Magic: Star enhancements
- Mirror h: image in the horizontal plane
- Mirror v: Mirror image in the vertical plane
- Repair: Star rounding and repair
- Sharp: Wavelet based sharpening of details
- Synth: Star resynthesis
- Wipe: Correction for light pollution, vignetting, and gradients

Some effort is required to learn how to use each module; however, real time help for features and adjustment controls is readily available within the program as pop-ups even with no internet connection. The program's web site has several excellent tutorials starting at the beginner level and continuing to the expert level. This learning curve for StarTools, while substantial, is much less than programs like PixInsight, PhotoShop, and other similar programs. The end results are competitive.

11.8 Which to Use; Photo Processing or Astronomical Processing?

One aspect to consider for people who want to use a photo processing program, is to realize that these programs are designed to enhance traditional photographs taken of people and places; not grossly underexposed images of distant deep space objects. Most of the image captured in an astrophotograph is considered as being black by many, perhaps nearly all, photo processing programs. While you can use them and some can produce a nice image, there is a reason why the world class award winning images you see made with a photo processing program are made using a late version of PhotoShop.

Astronomical processing programs like PixInsight and StarTools are designed specifically for processing the grossly underexposed images of distant deep space objects using a telescope. Either program cost significantly less than PhotoShop with StarTools being by far the lowest priced program available that is capable of producing world class, award winning, images of deep space objects. Between the three programs (PhotoShop, PixInsight, and StarTools), StarTools has the lowest learning curve; however, its learning curve is not trivial. It also has the least number of features but the ones it does have are more than adequate to produce images that are competitive with the other two programs.

Going back to the question stated as the title of this section, "which type program to use; photo processing or astronomical processing?" The answer is use the type program you best like. Regardless of which type program is used, the results produced are more dependent upon the skills of the photographer doing the processing than the type of program used. To obtain breathtaking final images requires knowing how to make subtle improvements in the image without introducing noise. This is very difficult to do unless the photographer has mastered the features available in the program being used. There is no short-cut. To be very blunt; astrophotography is not a hobby suited for people who are "computer illiterate."

Chapter 12

Lightweight Azimuth and Equatorial Mounts

12.1 Introduction

The typical advice given to newcomers when they ask the question what gear is needed for astrophotography is the mount is the most important component and is where you should not skimp. The traditional thought is that a mount suitable for astrophotography must be a heavy and rigid German equatorial mount with precision gearing and tracking. Without a doubt, such mounts have many positive attributes and do produce breathtaking images of deep space. As a matter of fact, to image many deep space objects requires a mount that is very precise in its tracking and exhibits no unwanted movements or vibration over long periods of time. For these objects the traditional, heavy, rigid German Equatorial Mount is required.

The minimum weight of a complete astrophotography setup using a traditional German equatorial mount (telescope, mount, tripod, camera, and counterweights) is approximately 55 lbs (25 kg). However, astrophotography setups weighting in excess 100 lbs (46 kg) are typical. While the traditional astrophotography community calls these heavy leviathans portable, "movable" is perhaps a more appropriate term.

A heavy German equatorial mount is definitely the best option for astrophotography if you are fortunate enough to have dark skies at your home and need not travel to another location. This is especially true if you can set up a permanent pier for your mount or, even better, if you have your own private observatory. However, if you must pack up your kit and travel with it, whether to a local park, a remote dark sky site, or to accompany you on a vacation or a business trip, a more portable configuration is advantageous and perhaps makes the difference between being able to pursue or not pursue the rewarding hobby of astrophotography.

Today several lightweight GOTO alt-azimuth and equatorial telescope mounts are available that are easily picked up and carried to another destination while walking, traveling on public transportation such as a city bus or subway, or even as carry-on luggage aboard a commercial airliner. A Complete astrophotography kit (telescope, mount, tripod, and camera) can weigh as little as 16 lbs (7.3 kg). It goes without saying that such a kit is very portable in comparison to the traditional astrophotography setup. These lightweight portable mounts can provide excellent images of deep space objects using unguided, very short exposure photography techniques. Three lightweight mounts currently available can even go further into deep space with unguided short exposures longer than 1 min and one lightweight mount is available that is capable of guided exposures of up to 30 min.

Lightweight and portable are two nice buzzwords that will have a different meaning to different people. Recall that earlier in this book a lightweight and portable mount and tripod were defined as a mount and tripod that:

- weighs no more than 16.5 lbs (7.5 kg)
- is easily separated into two or more components
- has a quick release OTA mounting such as the popular Vixen dovetail saddle and rail
- has a collapsible tripod with extendable legs

These characteristics are arbitrary but do define a kit, a portable observatory (mount, tripod, camera, telescope), that is easily taken aboard a city bus, hand carried aboard a commercial airliner, backpacked some distance to a dark spot, or included in the family car with other family members and luggage. You are free to go outside these bounds if you wish to do so but consider the impact that the additional weight or size may have upon portability. After all, a kit that will never travel aboard an airliner, be carried on a city bus, or be backpacked some distance can weigh more than 16.5 lbs (7.5 kg), need not have a quick release OTA, etc.

In this chapter we will explore the capabilities of lightweight GOTO mounts that are currently available on the world market. We will look at the payload capabilities; exposure times, cost, and other characteristics associated with lightweight mounts and also see how they compare technically and economically with a heavy German equatorial mount typically used for astrophotography. The objectives are to help you decide if you should use a lightweight or a traditional mount and, if you select a lightweight mount, which mount will best fit your needs. Motorized tracking mounts (alt-azimuth or equatorial) are not explored. However, if you have the necessary knowledge and skills, no reasons exist why one cannot be used to do unguided, very-short, exposure astrophotography.

12.2 Significant Attributes of Lightweight Mounts and Tripods Related to Astrophotography

Choosing the components of a lightweight astrophotography kit is not simple. As with traditional astrophotography, the mount is a major consideration and there are several mounts available to use. The attributes that make a lightweight mount

desirable for astrophotography are very similar to the attributes make a traditional German equatorial mount desirable:

- GOTO Accuracy
- Tracking Accuracy
- Payload
- Stability
- Weight

A GOTO capability is essentially required to use an alt-azimuth mount to photograph deep space objects. Typically we do a GOTO to a bright star near by the object we want to photograph, center the star, replace the eyepiece with the DSLR camera, then focus the camera. After focusing the camera, we do a GOTO to the object we want to photograph. The mount must be capable of taking the additional weight of the camera and maintaining its accuracy. The accuracy of the mount must be sufficient that the object to be photographed is in the center third of the camera's field of view if you hope to photograph objects like NGC 7000, M78, etc. that are too dim to be visible in light polluted skies with a small telescope. For brighter objects such as M8, M42, etc. that have easily recognizable star patterns or are visible in short exposures, the GOTO accuracy can be less but the mount must at least put the object in the field of view of the camera. A spiral search pattern used in visual work to find an object that a goto mount missed finding is not possible. An accurate GOTO is especially applicable for an alt-azimuth mount as field rotation will have a greater impact on objects outside the center of the field of view.

Needless to say, the mount must be able to track an object so that it remains near the center of the field of view for the duration of the exposure. For most lightweight GOTO mounts, if you center a star in a reticle eyepiece and return later, you will find that the star is no longer centered but has drifted off-center. Dependent upon the mount and the accuracy of the mount's alignment, the object may be close to the center of view, near the edge, or even not visible.

With lightweight mounts, an exposure session typically lasts 2–3 h. If a mount has excessive drift, then much information is lost in the stacking process. As an object drifts away from center, the impact of field rotation is enhanced which impacts the quality of the images. The closer a mount can keep an object near the center of view, the better the quality of the images and the fewer exposures ruined by tracking. Another aspect of tracking is periodic motion caused by imperfections in gearing as well as backlash between gears. Even thought a mount may keep an object near the center of view, it may do it in a jerky motion that produces star trails instead of well defined round stars.

The payload of the mount is an attribute of most interest. Needless to say, the mount must be able to support the weight of a telescope, mounting brackets, dovetail, adapters, camera, guide scope if used, etc. while maintaining both its tracking and GOTO accuracy. The published payloads for alt-azimuth mounts are excellent indicators of the mount's capabilities and are perhaps on the conservative side. For example, a SkyWatcher AZ GOTO mount is rated for a telescope tube of not

bigger than 130 mm weighing no more than 8 lbs (3.6 kg). However, it carries a 150 mm C6S OTA, focal reducer, adapters, and a DSLR camera with no noticeable degradation in GOTO or tracking accuracy; a total weight of 12.5 lbs (5.7 kg). This is not true for alt-azimuth mounts that use a wedge to operate in the equatorial mode. Here, the usable payload with the wedge is approximately 50–60 % of the mount's rated payload. A lightweight German equatorial mount fares better with a usable payload between 60 and 70 % of its rated payload. These values are approximate and other factors related to the OTA balance, size, and weight distribution also come into play.

Mount stability is another important factor for astrophotography. Mount vibration and the resultant blurry images are of obvious concern. For unguided, very-short exposure astrophotography, a mount need not be near as stable as required for guided, long-exposure work. All it must do is provide frequent periods of stability long enough to have a 60 % probability of capturing a very short exposure of 30 s or so. Most lightweight GOTO mounts are designed and constructed with sufficient precision to perform this task.

The biggest source of vibration associated with lightweight mounts is typically their tripods. The tripods on lightweight mounts tend to amplify mount movements caused by camera mirror lift, wind, an inadvertent bump, gear meshing, focusing, etc. Gross factors that govern tripod stability are leg diameter, materials used, and the weight supported (mount, counterweight, and payload). Soft plastic components tend to produce wiggly tripods especially if subject to heavy loads. The larger the diameter of the tripod legs, the better. Glued in place tripod legs are more rigid than legs held in place by rivets. These attributes provide criteria for a gross estimate of a mount's overall stability.

A survey of the worldwide market for telescopes shows that many lightweight mounts, mostly made by iOptron and SkyWatcher, are available as standalone items (no telescope bundled with them). Prices vary considerable due to the taxation policies of different countries and the marketing model used. Prices are the lowest in the USA where vendors buy directly from the manufacturer eliminating the need and expense for distributorships typically used in most countries. The following lightweight mounts are widely available on the world market either as standalone items or bundled with a telescope:

- Celestron NexStar SLT alt-azimuth Mount
- Celestron NexStar 4 SE and 5 SE alt-azimuth/Equatorial Mount
- Celestron NexStar 6 SE and 8 SE alt-azimuth Mount
- Celestron SkyProdigy alt-azimuth Mount
- iOptron Cube E alt-azimuth Mount
- iOptron Cube G alt-azimuth Mount
- iOptron Cube Pro alt-azimuth Mount
- iOptron Cube A alt-azimuth/Equatorial Mount
- iOptron SmartEQ German Equatorial Mount
- iOptron Smart EQ PRO German Equatorial Mount

- iOptron SkyTracker alt-azimuth Camera Mount
- Meade ETX 80
- Meade ETX 90
- Meade LS/LT
- SkyWatcher SynScan alt-azimuth Mount
- SkyWatcher EQ3 Pro German Equatorial Mount
- SkyWatcher All View alt-azimuth Camera Mount

12.3 Celestron Mounts

Celestron offers four lightweight GOTO mounts that are bundled with a telescope OTA but are sometimes available as a standalone item that are suitable for very short exposure astrophotography:

- NexStar SLT mount
- NexStar 4/5 SE mount
- NexStar 6/8 SE mount
- SkyProdigy mount

Celestron also has a GT mount essentially identical to its SLT mount that it sells bundled with telescopes through discount stores in the USA. All of these Celestron mounts are computerized GOTO mounts, are well built, and have an excellent reputation for dependability and accuracy. One of them, the 6/8 SE mount, exceeds the weight limits in our definition of lightweight and portable; however, if that is not important to you then there is no reason why you cannot use it for very short exposure astrophotography. The Celestron entry level LCM goto alt-azimuth mount is not that popular and has issues regarding payload and stability that are difficult to overcome for use as a platform for very short exposure astrophotography.

The "Celestron NexStar SLT Mount" is a lightweight and very portable single fork arm alt-azimuth mount with a published payload of 8 lbs (3.6 kg). The OTA is attached to the mount with a standard Vixen dovetail. The mount's tripod has 1.25 in. (32 mm) stainless steel legs and a center accessory tray. The hand controller's data base contains 4,000 objects which is appropriate for visual viewing with small telescopes but for astrophotography may require manually inputting coordinates for many objects. The mount has three tracking modes (alt-azimuth, EQ North, and EQ South) and three tracking rates (sidereal, solar, and lunar). Nine slew speeds are available from 3° per second to twice sidereal speed. The computerized hand controller is flash upgradeable. GPS is optional. Five alignment procedures are available including Sky Align (any three bright objects), Auto 2 Star Align, 1 Star Align, 2 Star Align, and Solar System Align. Computer control is possible. No self-guider port is provided. Voltage requirements are 12 vdc from either the mount's built-in battery compartment or an external power supply. The mount with tripod weighs 9.4 lbs (4.3 kg). Except for the automatic alignment

feature of the Celestron Prodigy mount and its larger database of objects, it is similar, almost identical, to the SLT mount.

The "Celestron NexStar 4 SE and 5 SE" use the same mount and tripod. The 4/5 SE mount is a lightweight and portable single fork arm, alt-azimuth/equatorial mount with a payload of 10 lbs (4.5 kg) in the alt-azimuth mode and approximately 6 lbs (2.7 kg) in the equatorial mode. The OTA is attached to the mount with a standard Vixen dovetail. The mount's tripod has a built-in wedge, 1.5 in. (38 mm) stainless steel legs, and a center accessory tray with cut-outs for 1.25 and 2.0 in. eyepieces. The hand controller's data base contains 38,181 objects providing a very comprehensive selection for photography. The mount has three tracking modes (alt-azimuth, EQ North, and EQ South) and three tracking rates (sidereal, solar, and lunar). Nine slew speeds are available from 4° per second to one half sidereal speed. The computerized hand controller is flash upgradeable. GPS is optional. Nine alignment procedures are available including Sky Align (any three bright objects), Auto 2 Star Align, 1 Star Align, 2 Star Align, Solar System Align, EQ Auto Align, EQ Two Star Align, EQ One Star Align, and EQ Solar System Align. Celestron's All Star Polar Alignment feature is also included to precisely polar align the mount when it is used in the equatorial mode. Computer control is possible. While the 4/5 SE mount has no self-guider port, it can be programmed to control a DSLR camera and the photography session. Voltage requirements are 12 vdc from either the mount's built-in battery compartment or an external power supply. The mount and tripod weight 16.4 lbs (7.5 kg).

The "Celestron NexStar 6SE and 8SE" use the same mount and tripod. The 6/8 SE mount is a lightweight and portable single fork arm, alt-azimuth mount with a payload of 12 lbs (5.5 kg). The OTA is attached to the mount with a standard Vixen dovetail. The mount's tripod uses the same 1.5 in. (38 mm) stainless steel legs used by the 4/5 SE mount. Unlike the 4/5 SE tripod, the 6/8 SE tripod does not have a built-in wedge. The tripod's center accessory tray has cut-outs for 1.25 and 2.0 in. eyepieces. The data base for the 6/8 SE contains 40,000 objects; making it slightly larger than the data base for the 4/5 SE and providing a very comprehensive selection for photography. The mount has three tracking modes (alt-azimuth, EQ North, and EQ South) and three tracking rates (sidereal, solar, and lunar). Nine slew speeds are available from 4° for second to one half sidereal speed. The computerized hand controller is flash upgradeable. GPS is optional. Nine alignment procedures are available including Sky Align (any three bright objects), Auto 2 Star Align, 1 Star Align, 2 Star Align, Solar System Align, EQ Auto Align, EQ Two Star Align, EQ One Star Align, and EQ Solar System Align. Computer control is possible. It has a ST-4 compatible self-guider port but, unlike the 4/5 SE mount, it cannot be programmed to control a DSLR camera and the nightly photography session. Although the mount can be placed on a wedge, very little success is reported attaining exposures longer than approximately 30 s. Voltage requirements are 12 vdc from either the mount's built-in battery compartment or an external power supply. The mount and tripod weigh 20 lbs (9.1 kg). This exceeds our lightweight and portable criterion of 16.5 lbs (7.5 kg) maximum.

12.4 iOptron Mounts

iOptron specializes in telescope mounts and offers an extensive selection of alt-azimuth and German equatorial mounts. Their offering covers a full range from a very lightweight alt-azimuth mount designed specifically for a DSLR camera to heavy traditional German equatorial mounts suitable for very long guided imaging in deep space. In this book we will consider seven of their offerings; one alt-azimuth camera mount, two German equatorial mounts, one alt-azimuth/equatorial mount, and three alt-azimuth mounts.

"The iOptron Cube E Mount" is a lightweight, portable, single-fork arm, alt-azimuth mount with a payload of 7 lbs (3.2 kg). The OTA is attached to the mount with a standard Vixen dovetail. The mount's tripod has 1 in. (25 mm) stainless steel legs and an accessory tray. The hand controller's data base contains 3,500 objects which is appropriate for visual viewing with small telescopes but may require manually inputting coordinates to image some objects. The mount automatically tracks the selected object (sidereal, solar, and lunar). Five slew speeds are available. The hand controller has a large four line screen and is flash upgradeable. GPS is optional. Two alignment procedures are available; 1 Star Align and 2 Star Align. Voltage requirements are 12 vdc from either the mount's built-in battery compartment or an external power supply. The mount with tripod weighs 8.6 lbs (3.9 kg).

The "iOptron Cube G Mount" is a lightweight, portable, single-fork arm, alt-azimuth mount with a payload of 7 lbs (3.2 kg). The OTA is attached to the mount with a standard Vixen dovetail. The mount's tripod has 1 in. (25 mm) stainless steel legs and an accessory tray. The hand controller's data base contains 50,000 objects providing a very comprehensive selection for photography. The mount automatically tracks the selected object (sidereal, solar, and lunar). Five slew speeds are available. The hand controller has a large eight line screen and is flash upgradeable. An internal 32 channel GPS is included. A USB port is provided and external computer control is possible. Two alignment procedures are available; 1 Star Align and 2 Star Align. Voltage requirements are 12 vdc from either the mount's built-in battery compartment or an external power supply. The mount with tripod weighs 8.6 lbs (3.9 kg).

The "iOptron Cube Pro Mount" is a lightweight, portable, single-fork arm, alt-azimuth mount with a payload of 8 lbs (3.64 kg). The OTA is attached to the mount with a standard Vixen dovetail. The mount's tripod has 1 in. (25 mm) stainless steel legs with metal leg hinges and an accessory tray. The hand controller's data base contains 130,000 objects providing a very comprehensive selection for photography. The mount automatically tracks the selected object (sidereal, solar, and lunar). Nine slew speeds are available ranging from sidereal time to 4° per second. The hand controller has a large eight line screen and is flash upgradeable. An internal 32 channel GPS is included. A USB port is provided and external computer control is possible. Three alignment procedures are available; 1 Star Align, 2 Star Align, and 3 Star Align. Voltage requirements are 12 vdc from either the mount's built-in battery compartment or an external power supply. The mount with tripod weighs 8.8 lbs (4.0 kg).

"The iOptron Cube A Mount" is a lightweight, portable, single-fork arm, alt-azimuth/equatorial Mount with a payload of 7 lbs (3.2 kg). The OTA is attached to the mount with a standard Vixen dovetail. The mount's tripod has 1 in. (25 mm) stainless steel legs and an accessory tray. The hand controller's data base contains 130,000 objects providing a very comprehensive selection for photography. The mount automatically tracks the selected object (sidereal, solar, and lunar). Nine slew speeds are available from 4° per second to 1 × sidereal time. The hand controller has a large eight line screen and is flash upgradeable. An internal 32 channel GPS is included. A USB port is provided and external computer control is possible. Three alignment procedures are available; 1 Star Align, 2 Star Align, and 3 Star Align in the alt-azimuth or in the equatorial modes. The Cube A design is unique in that when put on a wedge it transforms into a German equatorial mount instead of simply an equatorial mount. The impact of this is that unlike the 4/5 SE mount, the OTA can be balanced. Voltage requirements are 12 vdc from either the mount's built-in battery compartment or an external power supply. The mount with tripod weighs 8.8 lbs (4.0 kg).

The "iOptron SmartEQ Mount" is a lightweight, portable, German equatorial mount with a payload of 11 lbs (5.0 kg). The OTA is attached to the mount with a standard Vixen dovetail. The mount's tripod has 1.25 in. (31.75) stainless steel legs and an accessory tray. The hand controller's data base contains 50,000 objects providing a very comprehensive selection for photography. The mount automatically tracks the selected object (sidereal, solar, and lunar). Nine slew speeds are available ranging from sidereal time to 4° per second. The hand controller has a large eight line screen and is flash upgradeable. An optional illuminated polar scope is available. External computer control is possible. Three alignment procedures are available; Solar System, 1 Star Align and Multi Star Align (two stars or more). The hand controller has software to obtain a precise polar alignment without seeing Polaris using its "Bright Star Polar Alignment" command. Voltage requirements are 12 vdc from either the mount's built-in battery compartment or an external power supply. The mount and tripod weigh 11.9 lbs (5.4 kg). The supplied counterweight and shaft weigh 2 lbs (0.9 kg) making the total weight of the mount 13.9 lbs (6.3 kg).

The "iOptron SmartEQ PRO Mount" is a lightweight, portable, German equatorial mount with a payload of 11 lbs (5.0 kg). The OTA is attached to the mount with a standard Vixen dovetail. The mount's tripod has 1.25 in. (31.75) stainless steel legs and an accessory tray. The hand controller's data base contains 50,000 objects providing a very comprehensive selection for photography. The mount automatically tracks the selected object (sidereal, solar, and lunar). Nine slew speeds are available ranging from sidereal time to 4° per second. The hand controller has a large eight line screen and is flash upgradeable. An illuminated polar scope is included. External computer control is possible. Three alignment procedures are available; Solar System, 1 Star Align and Multi Star Align (two stars or more). The hand controller has software to obtain a precise polar alignment without seeing Polaris using its "Bright Star Polar Alignment" command. Voltage requirements are 12 vdc from either the mount's built-in battery compartment or an external power supply. The SmartEQ Pro mount and tripod weigh 12.5 lbs (5.7 kg). The

supplied counterweight and shaft weigh 2 lbs (0.9 kg) for a total of 14.5 lbs (6.6 kg). The differences between the SmartEQ and the SmartEQ PRO mounts are that the PRO version contains precision metal worm gearing, a ST-4 compatible autoguider port, and an illuminated polar scope. The precision metal worm gearing makes the SmartEQ PRO a far superior mount to the SmartEQ.

The "iOptron SkyTracker" is a lightweight, portable, equatorial tracking mount for a DSLR camera with a payload 8 lbs (3.5 kg). Its operational range is from 0° to 70° latitude north or south. The Mount is attached to a tripod with a 3/8th in. thread. Tracking is at 0.5 and 1.0 Sidereal. Voltage requirements are 6 vdc from either the mount's built-in battery compartment or an external power supply. The mount weighs 2.6 lbs (1.2 kg).

12.5 SkyWatcher Mounts

SkyWatcher offers a full product line of mounts ranging from manually operated alt-azimuth mounts to very heavy German equatorial computerized mounts capable of very long duration guided exposures of faint deep space objects. Two of their mounts are applicable for our use; an alt-azimuth goto mount and a camera mount.

The "SkyWatcher SynScan AZ Mount" is a lightweight and very portable single fork arm alt-azimuth mount with a payload of 8 lbs (3.6 kg). The OTA is attached to the mount with a standard Vixen dovetail. The mount's tripod has 1.25 in. (32 mm) stainless steel legs and a center accessory tray. The hand controller's data base contains 42,900 objects providing a very comprehensive selection for photography. The mount has three tracking rates (sidereal, solar, and lunar). Ten slew speeds are available from 4° per second down to sidereal speed. The hand controller is computerized and is flash upgradeable. GPS is optional. Two alignment procedures are available including Bright Star Align and 2 Star Align. Computer control is also possible. No self-guider port is provided. Voltage requirements are 12 vdc from an external power supply. The mount has no internal battery pack. The mount and tripod weigh 9.4 lbs (4.26 kg). It is very similar to the Celestron SLT mount in construction with many common components.

The "SkyWatcher AllView Multi-function Mount" is a lightweight and portable single fork arm alt-azimuth mount with manual release clutch. It has a payload of 11 lbs (5.0 kg). The OTA is attached to the mount with a standard Vixen dovetail. A ¼ in. thread is provided for cameras. The mount's tripod has 1.25 in. (32 mm) stainless steel legs and a center accessory tray with cutouts for 1.25 and 2 in. eyepieces. The hand controller's data base contains 42,900 objects providing a very comprehensive selection for photography. The mount has three tracking rates (sidereal, solar, and lunar). Ten slew speeds are available from 4° per second down to sidereal speed. The hand controller is computerized and is flash upgradeable. Two alignment procedures are available including Bright Star Align and 2 Star Align. Computer control is also possible. No self-guider port is provided. The mount can control a DSLR camera as well as the entire photographic session. Dual-encoders

are on each axis that allow manual movement without losing alignment or position information. Voltage requirements are 12 vdc from an external power supply. The mount has no internal battery pack. The mount and tripod weigh 21 lbs (9.5 kg). This exceeds our lightweight and portable criterion of 16.5 lbs (7.5 kg) maximum. However, if this is of no concern to you, the AllView Multi-function Mount is an excellent choice for an alt-azimuth mount.

The "Skywatcher EQ3 PRO Synscan GOTO German equatorial mount" is a relatively lightweight equatorial mount that is suitable for people who have no need for portability but do want something lighter than a traditional heavy weight mount. Its total weight is 19.4 lbs (8.8 kg) for the mount, tripod, and counter weight; slightly less than the SkyWatcher Allview Multi-function mount. Both exceed our lightweight and portable criterion of 16.5 lbs (7.5 kg) maximum. The mount's specifications are as follows:

- Payload Capacity: Approximately 11 lbs (5 kg) for imaging and 15 lbs (7 kg) for visual
- Positioning Accuracy up to 1 arcminute; accuracy enhanced by software collimation error (mount mechanical error) compensation
- ST-4 Auto Guiding interface
- Stepper motors with 1.8° step angle and 64 micro steps driven
- Slewing speed up to 3.4°/s (800×)
- Guiding speed selectable from 0.25×, 0.50×, 0.75×, or 1×
- Object database containing complete Messier, NGC, and IC catalogs
- Periodic Error Correction
- PC compatibility
- Upgradeable hand control via internet download
- Counter weight 1.8 kg

12.6 Meade Mounts

Meade only offers lightweight mounts as a packaged bundle with a telescope. Its entry level uses Mead's DS2000 series alt-azimuth mount. Meade's EXT line of telescopes is popular. However, the ETX mounts are designed for the weight, size, and shape of a specific telescope OTA. Interchanging OTAs is difficult and requires custom made adapters. Currently Meade has only an 80 mm f/5 refractor and a 90 mm f/13.8 Maksutov Cassegrain available in the ETX line having recently dropped the famed ETX 125. In addition to the ETX, Meade also has its LS series telescopes (LightSwitch) as well as its LT series. As with the ETX, the LS and LT mounts are designed specifically for the telescope tube bundled with it and cannot easily accept another OTA.

The Meade DS2000 alt-azimuth mount is bundled with its entry level telescopes and also offered as a standalone item for solar work. The DS2000 mount works very well for visual observations but its drive is on the tender side for astrophotography

12.6 Meade Mounts

and its tracking movements are often excessive. You can try one if you wish but keep the load balanced on the mount and the total weight under around 5–6 pounds (about 2.5 kg).

The "ETX 80 Mount" is a lightweight, portable, dual-fork, alt-azimuth mount with a payload of approximately 4 lbs (1.8 kg). The OTA is custom attached to the mount. Using a different OTA with the mount is difficult, requires custom made adapters, and is restricted to OTAs with apertures of 80 mm or less. The mount's tripod has lightweight aluminum legs with plastic leg hinges and an accessory tray. The hand controller's data base contains 1,400 objects which is appropriate for visual viewing with a small aperture telescope but may require manually inputting coordinates to image some objects. The mount automatically tracks the selected object (sidereal, solar, and lunar). Nine slew speeds are available ranging from twice sidereal time to 3° per second. The hand controller has a 2 line screen and is upgradeable. Three alignment procedures are available; Easy Align, 1 Star Align, and 2 Star Align. Clutches are provided in both azimuth and altitude to allow for true manual operation of the mount. Voltage requirements are 9 vdc from either the mount's built-in battery compartment or an external power supply. The telescope, mount, and tripod weigh 10 lbs (4.6 kg); making the ETX 80 a very portable telescope; one that can be easily backpacked for long distances.

The "ETX 90 Mount" is a lightweight, portable, dual-fork, alt-azimuth/equatorial mount with a payload of approximately 8 lbs (3.6 kg). The OTA is custom attached to the mount. Using a different OTA with the mount is difficult, requires custom made adapters, and is restricted to OTAs with apertures of 90 mm or less. The mount's tripod has a built-in wedge, 1.25 in. (32 mm) stainless steel legs with an accessory tray. The hand controller's data base contains 30,000 objects providing a very comprehensive selection for photography. The mount automatically tracks the selected object (sidereal, solar, and lunar). Nine slew speeds are available ranging from sidereal time to 4.5° per second. The hand controller has a two line screen and is upgradeable. Six alignment procedures are available; Easy Align, 1 Star Align, and 2 Star Align in the alt-azimuth mode and in the Polar mode. The mount also has setting circles to aid in manually locating objects. Clutches are provided in both azimuth and altitude to allow for true manual operation of the mount. Voltage requirements are 12 vdc from either the mount's built-in battery compartment or an external power supply. The telescope, mount, and tripod weigh 22 lbs (10.0 kg).

The "Meade LS Mount" is a lightweight, portable, single-fork, alt-azimuth mount with a payload of approximately 12 lbs (5.5 kg). The OTA is custom attached to the mount. Using a different OTA with the mount is difficult and requires custom made adapters. The mount's tripod has a built-in wedge, 1.25 in. (32 mm) stainless steel legs with an accessory tray. The hand controller's data base contains 100,000 objects providing a very comprehensive selection for photography. The mount automatically tracks the selected object (sidereal, solar, and lunar). Nine slew speeds are available ranging from sidereal time to 4° per second. The hand controller has a two line screen and is upgradeable. An internal GPS is included. Three alignment pro-

cedures are available; Automatic, 1 Star Align, and 2 Star Align. With the automatic alignment feature, you simply power up the telescope and it automatically aligns itself. Voltage requirements are 12 vdc from either the mount's built-in battery compartment or an external power supply. Meade has a variant of the LS mount called the LT mount. It differs from the LS in that it has no GPS, does not have the self-alignment capability, built-in camera, etc. The LS or LT comes with either a f/10, 6 or 8 in. Schmidt Cassegrain telescope with traditional optics or with Meade's Advanced Coma-Free (ACF) Optics. The 150 mm variants weigh 16.8 kg (37 lbs) and the 203 mm variants weigh 17.7 kg (39 lbs) making the LS/LT series telescopes almost as heavy as a traditional equatorial mounted telescope.

12.7 Traditional German Equatorial Mount

While there is no standard entry level traditional German equatorial mount, one of the following four mounts is often the first mount used for astrophotography because of price and capabilities:

- The Celestron Advanced VX Mount
- The iOptron ZEQ25
- SkyWatcher EQ5Pro
- Orion Sirius EQ-G

These mounts are competitively priced and are capable performers for their price range. Of the four, the Celestron Advanced VX is available on a global scale while the availability of the iOptron, SkyWatcher, and the Orion, while extensive, is limited in some areas. Also, Celestron sells the Advanced VX mount bundled with a 150 mm Newtonian for $100 over the price of the mount alone. The Newtonian has sufficient back focus for a DSLR camera and the package is the lowest cost traditional astrophotography configuration available on the world market. For these two reasons, its availability and its cost with the bundled Newtonian, the Celestron Advanced VX mount is used as a baseline in the comparisons in this chapter between lightweight and a traditional heavy duty mounts.

The "Celestron Advanced VX Mount" is typical of an entry level equatorial mount used in traditional astrophotography. Its rated payload capacity is 35 lbs (13.6 kg); however, its maximum usable payload for astrophotography is approximately 20 lbs (9 kg). The OTA is attached to the mount with a standard Vixen dovetail. The tripod has 2 in. (50.8 mm) stainless steel legs and an accessory tray with cutouts for 1.25 and 2 in. eyepieces. The hand controller's data base contains 40,000 objects providing a very comprehensive selection for photography. The mount automatically tracks the selected object (sidereal, solar, and lunar). Nine slew speeds are available ranging from sidereal time to 4° per second. The hand controller is flash upgradeable. The mount has a ST-4 autoguider port and can correct for periodic error making long exposure guided imaging possible. External computer control is possible and a GPS is optional. Five alignment procedures are available;

1-Star Alignment, 2-Star Alignment, Last Alignment Used, Quick Align, and Solar System Align. It is usable between 7° and 77° north or south. A precise polar alignment is attainable without seeing a pole star using its "All Star Polar Alignment" feature. Its voltage requirement is 12 vdc from an external power supply. The Mount, tripod, and counterweight weigh 21.4 kg (47 lbs) and from a traditional astrophotography perspective, not ours, it is considered lightweight and portable.

12.8 Mount Selection

Table 12.1 is a synopsis of some characteristics of the mounts available on the world market that meet our portability criteria. The mounts are sorted based upon purchase price starting with the least expensive to the most expensive. Data for the Celestron Advanced VX mount are included for comparison purposes. The cost data are the 2014 prices in the United States and are expressed in US dollars. While prices vary from country to country, the relative magnitude of the price differences among the different mounts remains pretty much the same; e.g., a 4/5 SE mount will cost proportionally more than a SLT mount and proportionally less than a SmartEQ PRO, etc. Three mounts immediately stand out in comparison to the others upon examination of the data in Table 12.1:

- SkyWatcher SynScan AZ GOTO mount
- Celestron 4/5 SE mount
- iOptron SmartEQ Pro mount

From a cost versus capability perspective, the SkyWatcher SynScan AZ GOTO mount stands out. Not only is it one of the lowest cost alt-azimuth mounts capable of unguided, very-short, exposure astrophotography; its capabilities equal or exceed some more expensive mounts. Like all alt-azimuth mounts used for photography, field rotation limits its maximum exposure times. Its larger data base makes it more attractive than the almost identical Celestron SLT mount. The OTAs that can be considered for this mount are considerable as it can handle up to 150 mm aperture telescopes weighing up to 12.5 lbs (5.7 kg) even though its rated payload is 8 lbs (3.6 kg) with a maximum aperture of 130 mm. I have used one for years in an overloaded condition carrying a Celestron C6S OTA (150 mm SCT). The mount is very rugged, durable, and accurate. It has no difficulty with tracking and goto accuracy operating at a 50 % overloaded condition (6 in. SCT, focal reducer, and a DSLR camera). No provisions exist in its programming for use with a wedge in the equatorial mode; thus, it is limited to alt-azimuth mount photography. The major weakness with the SkyWatcher SynScan AZ GOTO Mount is its tripod, specifically the tripod's soft plastic leg sockets and hinges. However, as discussed in Appendix B, the tripod is easily modified to improve its stability sufficient enough for use as a camera platform. The Celestron SLT, GT, and SkyProdigy mounts are very similar in capability as is the iOptron CubePRO mount.

The Celestron 4/5 SE mount has a built-in wedge and is capable of operating as an alt-azimuth mount or as an equatorial mount. Its hand controller is field

Table 12.1 Lightweight mount attributes

(a) English Units

Make and model	Type	Tripod leg diameter (inches)	Weight tripod, counter weight (lbs)	Weight mount (lbs)	Actual payload (lbs) AZ	Actual payload (lbs) EQ	Data base objects	Maximum unguided exposure time (s)	Price (US$)
iOptron CubeE	AltAz	1.00	5.0	3.5	7.0	–	3,500	20	270
SkyWatcher SynScan	AltAz	1.25	4.6	4.8	8.0	–	42,900	30	280
Celestron SLT	AltAz	1.25	4.6	4.8	8.0	–	4,000	30	280
iOptron CubeG	AltAz	1.00	5.0	3.5	7.0	–	50,000	20	370
Celestron 4/5 SE	AltAz EQ	1.50	11.0	6.4	10.0	6.0	38,181	75	380
iOptron SmartEQ	GEM	1.25	8.0	6.2	–	8.0	50,000	45	400
iOptron CubePro	AltAz	1.00	5.0	3.7	8.0	–	130,000	30	400
iOptron CubeA	AltAz EQ	1.00	5.7	3.5	7.0	6.0	130,000	30	420
iOptron SmartEQ Pro	GEM	1.25	7.9	6.2	–	8.0	50,000	120	500
Celestron AVX	GEM	2.00	30	17.0	–	20.0	40,000	120	800

(b) Metric Units

Make and Model	Type	Tripod leg diameter (mm)	Weight tripod, counter weight (kg)	Weight mount (kg)	Actual payload (kg)		Data base objects	Maximum unguided exposure time (s)	Price (US$)
					AZ	EQ			
iOptron CubeE	AltAz	25	2.3	1.6	3.18	–	3,500	20	270
SkyWatcher SynScan	AltAz	32	2.1	2.2	3.64	–	42,900	30	280
Celestron SLT	AltAz	32	2.1	2.2	3.64	–	4,000	30	280
iOptron CubeG	AltAz	25	2.3	1.6	3.18	–	50,000	20	370
Celestron 4/5 SE	AltAz EQ	38	4.6	2.9	4.54	2.75	38,181	75	380
iOptron SmartEQ	GEM	32	3.6	2.8	–	3.64	50,000	45	400
iOptron CubePro	AltAz	25	2.3	1.7	3.64	–	130,000	30	400
iOptron CubeA	AltAz EQ	25	2.6	1.6	3.18	2.75	130,000	30	420
iOptron SmartEQ Pro	GEM	32	3.6	2.8	–	3.64	50,000	120	500
Celestron AVX	GEM	50	13.6	7.7	–	9.00	40,000	120	800

programmable using the controller's key pad and can control a photographic session if a DSLR camera is used. The tripod for the mount has large diameter legs and, of all the lightweight mounts listed in Table 12.1, it provides by far the most stable platform for astrophotography as well as for viewing. In the alt-azimuth mode the maximum payload is approximately 10 pounds (4.6 kg) and field rotation limits exposure times to 30 s for most areas of the sky. In the equatorial mode the maximum payload is approximately 6 lbs (2.7 kg) and the mount has sufficient stability and tracking for unguided short exposures between 45 and 75 s dependent upon the focal length of the telescope used and the preciseness of the mount's polar alignment. Attaining a precise polar alignment necessary for exposures longer than approximately 75 s is difficult to do. The mount has Celestron's All Star Polar Alignment capability for a precise polar alignment even if a pole star is not visible. The mount's weaknesses are that its latitude adjustment bar must be modified to provide a way to do the fine adjustments in altitude needed for a precise polar alignment and no way exists for fine adjustments in azimuth except for actually moving the tripod. This greatly inhibits consistency in polar alignments from session to session when the mount is used in the equatorial mode.

Like most one arm alt-azimuth mounts on a wedge; the 4/5 SE mount is inherently off-balanced in the equatorial mode. As the mount tracks through the zenith, the shifting of weight can result in significant movement of the image in the field of view. In the alt-azimuth configuration, the 4/5 SE mount has no difficulty operating at its rated payload capacity of 10 lbs (4.6 kg) and probably can handle 12 lbs (5.5 kg) with no issues. However, stability declines significantly in the equatorial configuration when loads exceed 6 lbs (2.7 kg). The alt-azimuth/equatorial nature of 4/5 SE mount along with its capabilities provides a powerful tool for astrophotography with a lightweight mount.

Without a doubt, the best performing lightweight mount on our list is the iOptron SmartEQ PRO. This small German equatorial mount is capable of guided long exposures of 30 min and perhaps more and unguided exposures of a couple of minutes. It has a built-in computerized routine to assist obtaining a precise polar alignment. Unlike the 4/5 SE mount, the SmartEQ PRO has both the azimuth and latitude controls required to make the fine adjustments needed for a precise polar alignment and to do it in a consistent manner. It also has a standard ST-4 self guider port and precision metal worm gears to reduce periodic error. Except for payload, it competes one on one with the larger and more expensive Celestron AVX German equatorial mount. For long duration guided exposure work, the published 11 lb (3.6 kg) payload of the SmartEQ PRO's is very restrictive regarding potential OTAs as well as guidescopes, cameras, and other accessories. For guided photography, the SmartEQ PRO must always be on a diet so to speak. Having said that, the published payload of the SmartEQ appears to be close to the mark as users report 30 min guided exposures with 8 pounds worth of telescope, camera, etc. attached to its dovetail saddle. The SmartEQ/PRO tripod is very similar to that used by SkyWatcher AZ and Celestron SLT mounts and has similar issues that are easily corrected. The less expensive iOptron SmartEQ mount does not have the precision metal gearing or ST-4 compatible self guider port that are required for guided long

exposure work. Periodic error limits unguided exposures to approximately 45 s. However, all other things being equal, a 45 s exposure obtained using an equatorial mount will have a better signal to noise ratio than a 30 s exposure obtained using an alt-azimuth mount. Unlike most iOptron mounts, the SmartEQ/PRO does not have GPS.

The remaining iOptron mounts on the list are also usable for unguided very short exposure astrophotography. Except for the CubePro, their tripods are their weak links and have vibration issues. With the exceptions of the iOptron CubeE alt-azimuth mount and the SmartEQ/PRO mounts, all the iOptron mounts on the list have a 32 channel GPS unit that is handy if your viewing locations vary significantly. All the iOptron mounts provide a very compact package for storage and transportation; especially aboard commercial airliners.

Notes:

- The equatorial payloads are actual payloads handled by the mount, not the manufacturer's published payload.
- The Celestron AVX and the iOptron SmartEQ PRO mounts are capable of long duration guided exposures of approximately 30 min.
- For dual mode mounts (alt-azimuth/EQ), the maximum unguided exposure time given in the table is for the mount in the equatorial mode.
- To convert kilograms into pounds divide by 2.2.
- To convert mm into inches divide by 25.
- The weight of a counter weight is not included as part of a mount's payload.
- The weight of a DSLR camera, focal reducer, and adapters must be subtracted from a mount's payload to calculate the maximum weight of an OTA and its accessories (finder, mounting brackets, etc.).

12.9 Lightweight Alt-Azimuth and Equatorial Mounts and Telescope OTA Characteristics

What optical tube assembly should you use with a lightweight alt-azimuth or equatorial mount for very short exposure astrophotography? Two major aspects to consider are image size and image brightness. A short focal length OTA will have small images and is more appropriate for objects that cover a large area of the night sky while a long focal length OTA is more appropriate for imaging smaller objects. However, the longer the focal length of an OTA, the greater the need for mount stability which is not a strong attribute of lightweight mounts and tripods. Experience indicates that acceptable results are obtainable with focal lengths between 400 and 1,000 mm. Mount stability is not optimal for longer focal lengths and the image size associated with focal lengths less than 400 mm provide rich field images containing objects rather than images of objects.

Recall, the lower the focal ratio of a telescope, the brighter but smaller the image produced. Very short exposures do not have a lot of time to produce an image with a high signal content; thus, a telescope with a low focal ratio is preferred. Focal ratios

Table 12.2 Bundled lightweight telescopes and mounts

Make	Model	Description	Mount	Type	Objects	Exposure time (s)	Price ($)
Celestron	90 SLT	90 mm f/14 Maksutov	SLT	Alt/Az	4,000	30	390
Celestron	102 SLT	102 mm f/6.5 Refractor	SLT	Alt/Az	4,000	30	430
Celestron	130 SLT	130 mm f/5 Newtonian	SLT	Alt/Az	4,000	30	480
Celestron	127 SLT	127 mm f/11.8 Maksutov	SLT	Alt/Az	4,000	30	520
Celestron	4 SE	102 mm f/13 Maksutov	4/5 SE	Alt/Az/EQ	38,181	30	500
Celestron	5 SE	130 mm f/10 Schmidt	4/5 SE	Alt/Az/EQ	38,181	30	700
Celestron	SkyProdigy 90	90 mm f/14 Maksutov	SkyProdigy	Alt/Az	10,000	30	600
Celestron	SkyProdigy 102	102 mm f/6.5 Refractor	SkyProdigy	Alt/Az	10,000	30	700
Celestron	SkyProdigy 130	130 mm f/5 Newtonian	SkyProdigy	Alt/Az	10,000	30	700
Celestron	SkyProdigy 6	150 mm f/10 Schmidt	SkyProdigy	Alt/Az	10,000	30	1,000
iOptron	Cube E R80	80 mm f/5 Refractor	Cube E	Alt/Az	3,500	20	315
iOptron	Cube E MC90	90 mm f/13.3 Maksutov	Cube E	Alt/Az	3,500	20	450
iOptron	Cube G R80	80mm f/5 Refractor	Cube G	Alt/Az	50,000	20	420
iOptron	Cube G MC90	90 mm f/13.3 Maksutov	Cube G	Alt/Az	50,000	20	550
iOptron	SmartEQ Z71	71 mm f/5.9 Refractor	SmartEQ	EQ	50,000	45	800
iOptron	SmartEQ PRO Z71	71 mm f/5.9 Refractor	SmartEQ PRO	EQ	50,000	>120	930
SkyWatcher	StarTravel 102	102 mm f/5 Refractor	SynScan AZ	Alt/Az	42,900	30	380
SkyWatcher	SkyMax 102	102 mm f/13.8 Maksutov	SynScan AZ	Alt/Az	42,900	30	410
SkyWatcher	SkyMax 127	127 mm f/11.8 Maksutov	SynScan AZ	Alt/Az	42,900	30	580
Meade	ETX80	80 mm f/5 Refractor	ETX	Alt/Az	1,400	30	260
Meade	ETX90	90 mm f/13.8 Maksutov	ETX	Alt/Az	30,000	30	400
Celestron	AVX 6 N	150 mm f/5 Newtonian	AVX	EQ	40,000	>120	930

less than around f/6.5 are best. The signal level for images made from telescopes having a focal ratio higher than f/6.5 start placing some restrictions on the quality of images produced. This is not to say that you cannot use a telescope like a f/13 Maksutov. You can and you will obtain an image but the quality of the image will not be commensurate with the effort required to obtain it.

Telescopes having focal ratios larger than around f/6.5 are used with great success by astrophotographers. An acceptable signal is achieved by simply increasing the exposure time. With lightweight alt-azimuth mounts field rotation limits exposure times to approximately 30 s or less; thus, the option of increasing exposure time to use a telescope with a high focal ratio is not viable.

The total weight of the OTA with mounting brackets, finders, etc. is also important, especially for lightweight equatorial mounts. Alt-azimuth mounts tend to be capable of handling their published payloads with a few issues that are primarily associated with the mount's tripod. However, lightweight equatorial mounts, like their heavier traditional counterparts, tend to be very sensitive to payload weight and balance and have issues carrying loads greater than about 60–70 % or their published payloads.

12.10 Lightweight Mount and OTA Bundles

An option to purchasing a mount and OTA independently is to purchase a bundled mount and OTA. Telescope manufacturers sell a large selection of telescopes and mounts as a bundled package that is generally significantly cheaper than buying the same components separately. If you already own one of these telescopes you may not need to purchase a mount or telescope. This will significantly lower the cost for you to explore astrophotography or to have a very portable astrophotography kit. Table 12.2 is a compilation of some bundled packages that have lightweight and portable mounts capable of supporting unguided, very-short, exposure astrophotography that also meet our definition of lightweight and portable. Noticeably missing are Meade's LS and LT series telescopes and Celestron's 6 SE and 8 SE telescopes. These are excellent telescopes but are on the heavy side of our criteria. If you have one and it meets your portability needs, use it by all means. Also on the list for comparison purposes is the Celestron Advanced VX 6N which is the low cost entry point for a traditional astrophotography kit.

A quick look at Table 12.2 will reveal that based upon the offerings, the most popular OTA bundled with a lightweight GOTO mount is a Maksutov Cassegrain Telescope, followed very closely by a refractor. Newtonians and Schmidt Cassegrain Telescopes are a very distant third and forth respectively. The refractor telescopes on the table have few issues regarding using them for unguided, very-short, exposure astrophotography. The same is not true for the Maksutov and Schmidt Cassegrain OTAs or the Newtonian OTAs.

A variety of Maksutov Cassegrain Telescopes are sold bundled with light weight goto mounts. Most have a focal ratio of f/13 and larger. These telescopes are optically

very slow. For a Maksutov OTA, a focal reducer is required to obtain images having acceptable signal to noise ratios for unguided, very-short exposure astrophotography. Even then, imaging will be limited to the brighter deep space objects and vignetting can be a problem when using a DSLR camera. If you have a Maksutov OTA on a suitable mount, keeping the MAK for viewing and buying a short tube refractor for photography is probably the best option.

Refractor telescopes are a very close second on the list of bundled telescopes contained in Table 12.2. With the exception of the ETX 80, all are suitable for unguided, very-short, exposure astrophotography. Nearly all have rack and pinion focusers with some made of plastic. Obtaining a fine focus can be a bit tedious. Apertures vary from 70 to 102 mm. Focal ratios vary between a fast f/5 and a medium f/6.5; sufficient for obtaining exposures having good signal to noise ratios. If you have one of these refractors, all you need to get started is a DSLR camera, a T ring, and for some models a T ring adapter. These telescopes vary widely in quality and construction. All have sufficient back focus for a DSLR camera and all have optics suitable for unguided, very-short exposure astrophotography. All of these refractors except the iOptron Z71 are achromatic and will have issues with chromatic aberration.

The iOptron Z71 is in an entirely different class from the other refractors listed in Table 12.2. It is a 71 mm, f/5.9, refractor designed specifically for astrophotography and is bundled with the SmartEQ PRO German equatorial mount that is capable of guided, long-exposure, astrophotography. It has a 2 in. rotatable focuser with a 1:10 dual speed microfocuser. Needless to say, it is far more expensive than the other refractors listed.

The ETX 80 is a great visual telescope for grab and go as well as for backpacking. However, its design has issues with attaching a DSLR camera to the telescope and its drive motors and gearing often have issues with the weight of a DSLR camera. If you have one, it will cost you little to try it but be careful of tube strikes and strain on your gearing.

Newtonian telescopes were a distant third on our list of bundled telescope offerings. Newtonian telescopes are widely used for astrophotography. They often have very fast optics and are not subject to chromatic aberration. One of the major issues related to astrophotography associated with Newtonian telescopes is that most do not come to focus far enough outside their focuser's draw tube to allow focusing a DSLR camera; in other words, they have what is commonly known as "insufficient back focus." This is true for all the Newtonian OTAs listed in Table 12.2; none as configured by their manufacturer can be used with a DSLR camera for astrophotography.

Two options are available for using these Newtonian telescopes. The first option is to modify the telescope by moving its mirror forward to provide sufficient back focus for a DSLR camera. While the process is not difficult, it does require knowledge of telescope optics as well as being handy with hand tools. If you do not want to modify your telescope then you can use a Micro Four Thirds Interchangeable Lens Digital Camera instead of a DSLR camera. These cameras are recently introduced on the market and have no track record regarding their usage as an astro-

12.10 Lightweight Mount and OTA Bundles

Table 12.3 Traditional astrophotography configuration

Item	Model	Price ($)
Telescope	Celestron Advanced VX 6 in. Newtonian	930
Mount	Celestron Advanced VX GEM	
Optical Tube Assembly	Celestron 150 mm f/5 Newtonian	
Camera	Canon EOS T3 DSLR camera (unmodified)	350
T Ring	T Ring for Canon EOS DSLR camera	25
Interval timer	Timer and remote controller for Canon EOS DSLR camera	25
Total cost		1,330

Table 12.4 Lightweight Kit No. 1: Budget Configuration

Item	Model	Price ($)
Mount	Celestron SLT/SkyWatcher SynScan AZ GOTO	280
Optical Tube Assembly	Orion ST-80A/SkyWatcher StarTravel 80	200
Camera	Canon EOS T3 DSLR camera (unmodified)	350
T Ring	Celestron T Ring for Canon EOS DSLR camera	25
Interval timer	Timer and remote controller for Canon EOS DSLR camera	25
Total cost		880
Cost of a traditional kit		1,330
Cost difference		450
Percent difference		51 %

nomical camera. Regardless of which option you take, the relatively large size of the Newtonian OTAs and the lightweight nature of the mounts and tripods make them susceptible to vibration even in low wind conditions. Another approach is simply to use the lightweight mount and tripod and purchase an 80 mm short tube refractor for astrophotography.

Two SkyWatcher Newtonians, the Explorer 130PDS and the Explorer 150PDS, are available in Europe but not the USA that are specifically designed for astrophotography. Unfortunately they are not bundled with a mount. The Explorer 130PDS will fit a Celestron SLT or a SkyWatcher SynScan AZ goto mount with no difficulty. The 150PDS needs a heavier duty mount like Celestron's Advanced VX mount.

All the Schmidt Cassegrain Telescopes listed in Table 12.2 are suitable for unguided, very-short, exposure astrophotograph. For all practical purposes a 0.63 SCT focal reducer is essential if you want to images with a good signal to noise ratio; images that are worthy of the time you will spend obtaining and processing them. A SCT focal reducer screws directly onto the rear threads of a SCT. No adapters are required. The outside threads of a SCT focal reducer are identical to

Table 12.5 Lightweight Kit No. 2: Intermediate Configuration

Item	Model	Price ($)
Mount	Celestron 4 SE	380
Optical Tube Assembly	Orion ST-80A	200
Camera	Canon EOS T3 DSLR camera (unmodified)	350
T Ring	Celestron T Ring for Canon EOS DSLR camera	25
Interval timer	Timer and remote controller for Canon EOS DSLR camera	25
Total cost		980
Cost of a traditional kit		1,330
Cost difference		350
Percent difference		34 %

the rear threads of a SCT; thus, all SCT accessories designed to screw onto the rear of a SCT will still be usable. Like the Maksutov Cassegrain Telescope, the relatively long focal length of a SCT produces large images. This sometimes can be a problem with large objects such as the Rosetta Nebula. These objects are too large to fit in one image and a composite is needed. On the other hand, chromatic aberration is not an issue.

12.11 Economics of Using Lightweight Mounts and Tripods

One oxymoron in astronomy is an inexpensive astrophotography kit. There is no such thing, only less expensive. The lowest cost kit (OTA, mount, tripod, and camera) is about $880; a significant sum of money for most people.

In this section we will compare the cost of three astrophotography configurations that use a lightweight mount and tripod to the cost of a traditional entry level astrophotography setup using a heavy German equatorial mount. All the configurations use the same unmodified Canon entry-level camera. Only the cost of the telescope, mount, tripod, camera, T ring, and interval timer are considered as these items are the foundation of any astrophotography kit. In this analysis, the following astrophotography configurations were evaluated:

- Traditional Configuration (heavy German equatorial mount)
- Budget Configuration (lightweight entry level alt-azimuth mount)
- Intermediate Configuration (lightweight alt-azimuth/equatorial mount)
- Advanced Configuration (lightweight German equatorial mount)

The "Traditional Configuration" entry level astrophotography setup selected for cost comparison is a Celestron Advanced VX 6 in. f/5 Newtonian (see Table 12.3).

Table 12.6 Lightweight Kit No. 3: Advanced Configuration

Item	Model	Price ($)
Mount	iOptron SmartEQ PRO	450
Optical Tube Assembly	Orion ST-80A	200
Camera	Canon EOS T3 DSLR camera (unmodified)	350
T Ring	Celestron T Ring for Canon EOS DSLR camera	25
Interval timer	Timer and remote controller for Canon EOS DSLR camera	25
Total cost		1,050
Cost of a traditional kit		1,330
Cost difference		280
Percent difference		25 %

This bundled package is perhaps the lowest cost, traditional German equatorial mount and telescope configuration capable of astrophotography. The components in this configuration are capable of unguided short exposures of several minutes, perhaps as long as 5 min dependent upon the accuracy of the polar alignment and environmental conditions. The Traditional Configuration can be upgraded with computer, self guider, and smaller OTA providing the capability of guided long exposures as long as 30 min. The total weight of this configuration is 57 pounds (25.9 kg) without the camera.

The "Budget Configuration" is the lightest weight, most compact and least expensive configuration in the comparison (see Table 12.4). Its cost is $880 and it is perhaps the lowest priced configuration available capable of imaging deep space. The Celestron SLT mount was selected for the comparison based upon availability, price, payload, and tripod stability (1.25 versus 1.00 in. legs). Since the SLT mount is an alt-azimuth mount, the images are impacted by field rotation. This limits the configuration to unguided, very-short, exposure astrophotography of 30 s or so. Even so, the budget configuration can produce excellent images of deep space objects including nebulae and galaxies. Its rated payload is 8 pounds (3.6 kg) but can carry significantly more weight if balanced. No upgrades in capabilities are possible other than that obtained by adding a higher quality OTA or camera.

In comparison, the Traditional Configuration is capable of unguided short exposures of several minutes and can be upgraded to guided, long exposure work. Its operational payload is around 20 pounds (9 kg). The cost difference between the two configurations is $450. The total weight of the Budget Configuration with the OTA but without the camera is 12.8 pounds (5.8 kg). The Traditional Configuration weighs 57 pounds (26 kg). The Budget Configuration does not require a precise polar alignment, thus, is usable in areas with a limited window to the night sky making it very attractive for urban dwellers.

The "Intermediate Configuration" uses a mount capable of both alt-azimuth and equatorial operation (see Table 12.5). The Celestron 4 SE mount was selected for the comparison based price and stability (1.5 versus 1.00 in. legs). In the alt-azimuth mode the mount is limited by field rotation to very short exposures of 30 s or less. However, in the equatorial mode, this configuration is capable of unguided short exposures, possibly as long as 120 s if the photographer gains the required alignment skills. However, typically maximum unguided exposures are around 75–90 s. Out of the box the mount is not capable of operations on a wedge until its latitude adjustment bar is modified (see Appendix C). The mount is theoretically capable of guided long exposures of a few minutes if a computer is used in the field at night; however, a search of the internet did not find any credible reports of the mount used with a self-guider. In comparison, the Traditional Configuration is capable of unguided short exposures of several minutes and can be upgraded to obtain guided, long exposures of up to about 30 min. The cost difference between the two configurations is $350. The total weight of the intermediate Configuration with the OTA but without the camera is 19.8 pounds (9.0 kg). In comparison, the Traditional Configuration weighs 57 pounds (26 kg). Like the Budget Configuration, the Intermediate Configuration in the alt-azimuth mode does not require a precise polar alignment, thus, is usable in areas with a limited window to the night sky making it very attractive for urban dwellers.

The "Advanced Configuration" uses a lightweight German equatorial mount that is capable of unguided, short-exposure astrophotography of 120 s or more dependent upon the accuracy of the polar alignment (see Table 12.6). The iOptron SmartEQ PRO was selected based upon its precision gearing and capability for guided long exposures. The configuration can be upgraded with a self guider and exposures as long as 30 min are possible. The Advanced Configuration is by far the most capable of the lightweight astrophotography kits. With the exception of payload, its capabilities and up-grade potential are the same as that associated with the Traditional Kit. The cost difference between the Advanced and Traditional Configurations is $280. The total weight of the Advanced Configuration including the OTA but without the camera is 17.4 pounds (7.9 kg). In comparison, the Traditional Configuration with OTA weighs 57 pounds (26 kg). Both the Advanced Configuration and the Traditional Kit must be precisely polar aligned which may limit their usefulness in some urban settings.

A quick comparison of the three lightweight configurations is interesting. The Budget Configuration with the SLT mount has the lowest cost and is by far the lightest in weight. It also requires the smallest volume for storage or transport. The Intermediate Configuration is heavier than the Advanced Configuration and does not have its capabilities. The price spread between the three configurations is only $170. Buying a 4 SE mount that was used in the intermediate configuration makes little economic or technical sense unless the mount is moved between sites where a precise polar alignment is not possible and areas where it is or if the telescope will be primarily used for visual work and occasionally used for astrophotography. Based upon features versus cost, the Advanced Configuration with the iOptron SmartEQ PRO mount is by far the most capable and is the best choice. However,

12.11 Economics of Using Lightweight Mounts and Tripods

one can make the same argument concerning the Traditional Configuration as it is only $440 more expensive than the Budget Configuration and $280 more than the Advanced Configuration.

So exactly what does this tell us?

- Cost is a factor only where severe economic constraints exist or where components are already available.
- A traditional heavy German equatorial mount provides the best performance versus cost ratio.
- A lightweight astrophotography kit is appropriate where logistics, personal constraints, or other factors make using a heavy traditional German equatorial mount not feasible or too cumbersome.

This takes us back to the reason for Astrophotography on the Go; to expand the number of people who can enjoy the hobby of astrophotography especially in our light polluted cities where heavy traditional kits frequently cannot go. Going back to the questions in the first paragraph of this book:

- Yes, even if you live in a high rise apartment in the middle of a large city and have no way to store or handle a large bulky telescope and mount, you can still go out at night and photograph deep space.
- Yes, you can safely hand- carry an astrophotography kit onboard an airliner as you fly on business or pleasure.
- Yes, you can use your existing alt-azimuth goto mount to photograph what you see in your telescope to show family and friends.
- Yes, you can use your entry level goto telescope to see if astrophotography is something you want to do.
- Yes, you can photograph deep space without using heavy equipment.

Chapter 13

Portable Observatories

13.1 Introduction

"Astrophotography on the Go" means portability; astrophotography with a portable observatory you can easily pack-up and carry in one trip whether across town using public transportation, down several flights of stairs followed by a short walk to a local park, or carried aboard commercial airlines on a holiday abroad. By "portable observatory" we mean a complete kit having everything you need for a night of imaging under the stars. Specifically, we are talking about a fast, small aperture telescope on a lightweight alt-azimuth or equatorial GOTO mount and tripod using a DSLR camera controlled by either a tablet or an interval timer.

The advantages of "Astrophotography on the Go" with its portable observatories are many. This is especially true for the downtown apartment dweller, suburban condominium owner, or others who do not have the advantage of a dark back yard to set up their gear or the space to store a heavy mount, tripod, and telescope typically used for astrophotography. A portable observatory is freedom. It is lightweight and is easy to setup. These are characteristics that appeal to many astronomers, especially people who do not have the strength needed to manhandle the heavy mounts and tripods traditionally used for astrophotography. The ability to use entry level equipment appeals to people who want a relatively inexpensive way to occasionally image what they see in the eyepiece of their telescopes. Last, but not least, a portable observatory can go where traditional kits cannot go including flying with you on your next business trip or holiday.

As of 2014, the estimated population of Canada, the European Union, and the United States was 857 million people. Most, probably nearly all, of these people

have never viewed the night sky with a telescope. The World Health Organization estimates that 80 % of people in developed countries live in an urban setting. This would equate to 686 million people in these three geopolitical areas. Eighty percent is a very high percentage of the population and a detailed research and analysis of population and population trends is outside the scope of this book. However, if we are very conservative and say that 60 % of the population in Canada, the European Union, and the United States live in urban areas we are talking about approximately half billion people.

A portable observatory gives the night sky back to these millions of city dwellers should they ever wish to take advantage of its capabilities. Strangely enough, telescope manufacturers concentrate their marketing efforts toward amateur astronomers and completely ignore this large potential market. Urban housing, more so in Europe than in North America, tends to be high density with a sizeable percentage being apartments, condominiums, and other type dwellings that typically have no back yards or areas where residents can set up and view with a telescope. Even with traditional housing, yards and gardens, especially those in the inner cities, tend to be on the smallish size with views often blocked by two story houses and trees. Access to the night sky is limited and dark skies are difficult to find.

A portable observatory is ideal in this situation. Storage space requirements are minimal. Being small and lightweight means the observatory is easily carried by one person in one trip from the apartment, etc. to a local park or other viewing spot. Here, a lightweight telescope, mount, and tripod can go where a telescope on a traditional heavy German equatorial mount cannot go and is the difference between practicing astronomy or reading about it. For people with a limited window into the night sky with no hope of ever doing a precise polar alignment required for an equatorial mount, an alt-azimuth mount is often the difference between being able to photograph deep space or not.

A portable observatory is ideal for carrying a telescope along in the family car on vacation, especially for families with children. This involves competition with clothing, kid's toys, recreational gear, and sometimes Spot, the family dog. For the sake of family tranquility, the family astronomer must often leave the telescope at home for lack of space in today's smaller, energy efficient cars. This no longer needs to be true.

Probably the most demanding travel scenario involves flying aboard commercial aircraft. Airline travel today is not like it was at one time. Once large pieces of luggage weighing 32 kg (70 lbs) or more were common and two pieces of luggage per person were allowed. Today, luggage restrictions are 23 kg (50 lbs) per piece of luggage and very often one piece of luggage per person. Substantial fees are charged for extra luggage and even higher fees charged for overweight luggage.

Airport baggage handlers are notorious for their mistreatment of checked luggage. While you can buy a protective case for your telescope, checking it as luggage is an excellent way to convert it to worthless shards of glass. Pretty much if you want to travel by air with your telescope, taking it with you as "carry-on" baggage in the passenger compartment of the airplane is the best option. With carry-on baggage comes size and weight constraints that vary among the airlines as well as the nature of the flight; domestic, international, or transoceanic.

13.2 Three Portable Observatories

Let's take a look at three portable observatories based upon the three lightweight configurations analyzed in Chap. 12 (Tables 12.4, 12.5, and 12.6). Portable Observatory No. 1 is based upon the "Budget Configuration" that used an alt-azimuth mount and was limited to very short exposures of 30 s or less. The foundation for Portable Observatory No. 2 is the "Intermediate Configuration" with an alt-azimuth/equatorial mount with the capability for unguided short exposures of less than 2 min. Portable Observatory No. 3 is based upon the "Advanced Configuration" and uses a German equatorial mount with the capability to do guided long exposures.

Each of these three portable observatories can be hand carried to a local park, travel with the family on holiday, or fly in the friendly skies. The contents of each portable observatory will fit inside a 44 Liter backpack that complies with airline carry-on restrictions. If airline travel is not a consideration, a larger backpack can be used. The lowest cost components are typically used for each observatory. There is no reason why a higher quality camera, telescope, or other components cannot be used. A ten cell rechargeable NiMH AA power pack is used for a power supply. A portable power pack or jump start battery can also be carried with a free hand if so desired and if it need not be carried very far. Instead of a backpack, a carry-on bag with wheels is a viable alternative. If the DSLR camera is in a camera bag with shoulder straps, it can be carried separately. For air transport, some items as well as the tripod must travel in checked luggage.

A tablet is a very useful option for any of the three portable observatories as it greatly simplifies composing the image and focusing the camera. A lap top can perform these functions too; however, the logistics needed to support a lap top computer in the field far out weight the benefits provided. The Orion ST-80A variant of the short tube refractor is used instead of the less costly (ST-80 and ST-80T) because it, like the SkyWatcher StarTravel 80, has tube rings that allow optimum positioning of the OTA on a mount for balance and usage.

Table 13.1 is an inventory list for Portable Observatory No. 1 based upon the budget configuration described in Chap. 12. Since Portable Observatory No. 1 uses an alt-azimuth mount it is limited to unguided, very short exposures of around 30 s. Of the three portable observatories, it is the lightest, most compact, and least expensive. The cost of the major components, less accessories, is $880. Portable Observatory No. 1 is ideal for an urban astronomer who must travel to an observing site away from home or has very limited space available for storage. It is also ideal for situations where the observing site is a balcony or small garden with a very limited view of the night sky or other settings that hinder obtaining a precise polar alignment with an equatorial mount. Portable Observatory No. 1 also flies very well aboard commercial airliners.

Portable Observatory No. 2 is based upon the intermediate configuration described in Chap. 12. Table 13.2 provides a list of its components which, except for the mount, is pretty much the same as Portable Observatory No. 1. Portable Observatory No. 2 uses the Celestron 4/5 SE mount; thus, it has the capability to

Table 13.1 "Portable Observatory No. 1" inventory list

Item number	Item	Description
1	Orion ST-80A	Fully multicoated, f/5, achromatic, 80 mm short tube refractor, tube brackets, dovetail, and piggyback mount (SkyWatcher StarTravel 80 in Europe)
2	Finder scope	Refractor or red dot finder, your preference
3	Finder scope bracket	Finder bracket if required
4	Light pollution reduction filter	1.25 in. Astronomic CLS LPR filter or equivalent
5	20 mm eyepiece	Orion Expanse, wide field of view eyepiece and case or equivalent
6	9 mm eyepiece	Orion Expanse, wide field of view eyepiece and case or equivalent
7	Reticle eyepiece	12.4 mm with self-illuminated cross hairs and case
8	Reticle batteries and case	Check batteries for freshness
9	Star diagonal	1.25 in. 90° mirror star diagonal
10	Celestron SLT Mount	AltAz GOTO mount (SkyWatcher SynScan AZ GOTO in Europe)
11	Hand Controller	NexStar Hand controller (SkyWatcher SynScan AZ in Europe)
12	Cable, hand controller	NexStar Hand controller cable (SkyWatcher SynScan AZ in Europe)
13	SLT Tripod	1.25 in. (32 mm) stainless steel tripod
14	Tripod accessory tray	SLT tripod accessory tray
15	DSLR Camera, unmodified	Canon EOS Rebel T3/1100D Digital Single Lens Reflex Camera
16	DSLR battery	Fully charged and installed in camera
17	Camera lens	Canon EFS 18–55 mm Lens (optional)
18	Piggyback lens (optional)	Fuji 55 mm f2.2 Camera Lens with Pentax/Cannon Lens Adapter
19	Interval timer	Inexpensive with no brand name
20	Android tablet (optional)	Nexus 7, 32 GB memory, DSLR Controller App
21	Cable, tablet USB (optional)	Nexus 7 host cable to Canon DSLR
22	Cable, USB host (optional)	Nexus 7 host cable
23	Screwdriver kit	Small screw driver set with two flat and three Philips (cross) head bits
24	Electricians tape	One roll, always handy to have around
25	Pliers	Always handy to have around
26	Log book	Keep a record of nightly events
27	Pen and pencil	Record keeping and sketching
28	Flash light	Hand powered, LED flash light, red lens

(continued)

13.2 Three Portable Observatories

Table 13.1 (continued)

Item number	Item	Description
29	Battery pack	Fully charged; ten pack, rechargeable AA NiMH batteries with cable
30	Camp Stool	Collapsible metal frame, canvas camp stool
31	Clean towel	Always handy to have around
32	Bungee cords	Two pair to secure tripod and camp stool to the back pack
33	Backpack	44 L volume (23 × 35 × 55 cm)

Table 13.2 "Portable Observatory No. 2" inventory list

Item number	Item	Description
1	Orion ST-80A	Fully multicoated, f/5, achromatic, 80 mm short tube refractor, tube brackets, dovetail, and piggyback mount (SkyWatcher StarTravel 80 in Europe)
2	Finder scope	Refractor or red dot finder, your preference
3	Finder scope bracket	Finder bracket if required
4	Light pollution reduction filter	1.25 in. Astronomic CLS LPR filter or equivalent
5	20 mm eyepiece	Orion Expanse, wide field of view eyepiece and case or equivalent
6	9 mm eyepiece	Orion Expanse, wide field of view eyepiece and case or equivalent
7	Reticle eyepiece	12.4 mm with self-illuminated cross hairs and case
8	Reticle batteries and case	Check batteries for freshness
9	Star diagonal	1.25 in. 90° mirror star diagonal
10	Celestron 4/5 SE Mount	Alt-azimuth/equatorial mount
11	Hand Controller	NexStar Hand controller
12	Cable, hand controller	NexStar Hand controller cable
13	SLT Tripod	1.25 in. (32 mm) stainless steel tripod
14	Tripod accessory tray	SLT tripod accessory tray
15	DSLR Camera, unmodified	Canon EOS Rebel T3/1100D Digital Single Lens Reflex Camera
16	DSLR battery	Fully charged and installed in camera
17	Camera lens	Canon EFS 18–55 mm Lens (optional)
18	Piggyback lens (optional)	Fuji 55 mm f2.2 Camera Lens with Pentax/Cannon Lens Adapter
19	Interval timer	Inexpensive with no brand name.

(continued)

Table 13.2 (continued)

Item number	Item	Description
20	Android tablet (optional)	Nexus 7, 32 GB memory, DSLR Controller App
21	Cable, tablet USB (optional)	Nexus 7 host cable to Canon DSLR
22	Cable, USB host (optional)	Nexus 7 host cable
23	Screwdriver kit	Small screw driver set with two flat and three Philips (cross) head bits
24	Electricians tape	One roll, always handy to have around
25	Pliers	Always handy to have around
26	Log book	Keep a record of nightly events
27	Pen and pencil	Record keeping and sketching
28	Flash light	Hand powered, LED flash light, red lens
29	Battery pack	Fully charged; ten pack, rechargeable AA NiMH batteries with cable
30	Compass	For finding North
31	Camp Stool	Collapsible metal frame, canvas camp stool
32	Clean towel	Always handy to have around
33	Bungee cords	Two pair to secure tripod and camp stool to the back pack
34	Backpack	44 L volume (23×35×55 cm)

operate as either an alt-azimuth mount or as an equatorial mount. This provides a lot of flexibility for an urban astronomer. In the alt-azimuth mode, the Intermediate Level Observatory can image in areas where a precise polar alignment is not possible. On the other hand, in areas where a precise polar alignment is possible, unguided short exposures up to approximately 90–120 s are possible but 75–90 s are more likely. The cost of the major components of Portable Observatory No. 2 is $980. Of the three portable observatories, Portable Observatory No. 2 is the least portable. This is because the 4/5 SE tripod is larger and heavier, thus sturdier, than the tripods used on most lightweight mounts and because of the large diameter of its azimuth base. If the 4/5 SE mount is included as carry-on baggage, the rubber feet of its azimuth base must be removed to meet size restrictions for many airlines.

Portable Observatory No. 3 is an expanded version of the "Advanced Configuration" considered in Chap. 12 and is by far the most capable of the three observatories. The iOptron SmartEQ PRO mount is used and a self-contained self-guider and guide scope are added. See Table 13.3 for a list of components. It is also the most expensive with the major components, including the self-guider and guide scope, costing $1450.

Portable Observatory No. 3 is capable of unguided very short exposures, unguided short exposures, and guided long exposures of 5 min or more. The mount cannot operate in the alt-azimuth mode and may not be usable in some urban

13.2 Three Portable Observatories

Table 13.3 "Portable Observatory No. 3" inventory list

Item Number	Item	Description
1	Orion ST-80A	Fully multicoated, f/5, achromatic, 80 mm short tube refractor, tube brackets, dovetail, and piggyback mount (SkyWatcher StarTravel 80 in Europe)
2	Finder scope	Refractor or red dot finder, your preference
3	Finder scope bracket	Finder bracket if required
4	Light pollution reduction filter	1.25 in. Astronomic CLS LPR filter or equivalent
5	20 mm eyepiece	Orion Expanse, wide field of view eyepiece and case or equivalent
6	9 mm eyepiece	Orion Expanse, wide field of view eyepiece and case or equivalent
7	Reticle eyepiece	12.4 mm with self-illuminated cross hairs and case
8	Reticle batteries and case	Check batteries for freshness
9	Star diagonal	1.25 in. 90° mirror star diagonal
10	iOptron SmartEQ PRO Mount	German equatorial mount
11	Hand Controller	iOptron Hand controller
12	Cable, hand controller	iOptron hand controller cable
13	iOptron SmartEQ Tripod	1.25 in. (32 mm) stainless steel tripod
14	Tripod accessory tray	SmartEQ tripod accessory tray
15	Self contained self guider	Celestron NexGuide/SkyWatcher SynGuider
16	Orion mini 50 mm guidescope	f/3.2 refractor with rings and helix focuser; replaces OTA finder
17	DSLR Camera, unmodified	Canon EOS Rebel T3/1100D Digital Single Lens Reflex Camera
18	DSLR battery	Fully charged and installed in camera
19	Camera lens	Canon EFS 18–55 mm Lens (optional)
20	Piggyback lens (optional)	Fuji 55 mm f2.2 Camera Lens with Pentax/Cannon Lens Adapter
21	Interval timer	Inexpensive with no brand name.
22	Android tablet (optional)	Nexus 7, 32 GB memory, DSLR Controller App
23	Cable, tablet USB (optional)	Nexus 7 host cable to Canon DSLR
24	Cable, USB host (optional)	Nexus 7 host cable
25	Screwdriver kit	Small screw driver set with two flat and three Philips (cross) head bits
26	Electricians tape	One roll, always handy to have around
27	Pliers	Always handy to have around

(continued)

Table 13.3 (continued)

Item Number	Item	Description
28	Log book	Keep a record of nightly events
29	Pen and pencil	Record keeping and sketching
30	Flash light	Hand powered, LED flash light, red lens
31	Compass	For finding North
32	Battery pack	Fully charged; ten pack, rechargeable AA NiMH batteries with cable
33	Camp Stool	Collapsible metal frame, canvas camp stool
34	Clean towel	Always handy to have around
35	Bungee cords	Two pair to secure tripod and camp stool to the back pack
36	Backpack	44 L volume (23 × 35 × 55 cm)

settings having a limited view of the night sky. The iOptron mount is compact and can travel as carry-on baggage aboard commercial airlines. It also can use rechargeable NiMH AA batteries in its internal battery compartment.

Two self-guider options are feasible. One option is a small camera and guide scope that uses a lap top computer to control telescope movements. This option requires that a lap top computer becomes part of the observatory and brings with it the logistics of supporting a computer in the field (power supply, small computer table, cables, etc.). The addition of the requirement for a kit to include a computer and its associated logistics requirements strains our definition of portable; "the entire kit movable in one trip."

The second option is a self-contained, self-guider. This eliminates the need for computer and its supporting logistics. However, self-contained, self-guiders tend to perform better with guide scopes having a focal length of 400 mm or more and having an aperture of 80 mm or more. In other words, the short tube refractors used as the OTAs in the Portable Observatories make excellent guide scopes for a self-contained self-guider. When the weight of a suitable guide scope and its adjustable brackets along with the weight of the self-guider are included, the weight can become excessive for the iOptron SmartEQ PRO mount. For this reason, a 50 mm guide scope is used in Portable Observatory No. 3. This scope replaces the finder scope that comes with the short tube refractor which reduces the weight of the OTA by 0.61 pounds (0.275 kg). It also reduces the ability for the self guider to remain locked onto a guide star which probably will limit the duration of guided exposures to around 5 min or so.

13.3 Downtown City Apartment or Urban Condo Dweller

The types of housing in today's urban setting covers a very wide range from traditional low density single family houses with private back yards to high density skyscraper apartment buildings. In between these two extremes are duplexes,

condominiums with common grounds, apartments that can be multistoried with no elevators, zero lot lines, retirement trailer parks, etc.

Urban dwellers are the majority of the population in developed countries. A very high percentage of urban dwellers live in high density housing and do not have the luxury of a private back yard. They must observe at a site remote from their home such as a public park. This means that they must carry their portable observatory from their home to their observing site and return. In assembling a portable observatory, the following must be considered:

- the location of the observing site
- the area of the night sky that is visible from the observing site
- how the kit is transported to and from the observing site
- security concerns at the observing site as well as at the dwelling
- storage space for the kit when it is not in use

For some people storage is not an issue that has an impact upon the size and weight of a portable observatory while for others storage issues create major constraints. Storage varies greatly in urban condos, duplexes, zero lot line units, apartments, retirement trailer parks, etc. Some have enclosed garages that are excellent places to store large telescopes, etc. while others have little more than perhaps a hall closet, a small storage locker, or storage compartments beneath a bed.

The observing site is another factor that has an impact upon the size and weight of a portable observatory. Two major issues are transportation to and from the site and security at the site. How are you going to take your observatory from its storage location to the observing location? In other words are you going to walk, ride a bicycle, take public transport, or drive your car? Walking or bicycling requires compact and lightweight equipment. Public transport is less demanding but still places major constraints upon size and weight. If you will drive your car, it will have little impact upon size and weight of your observatory; however, one security issue related to driving a car will. Can you park your car and take more than one trip to unload and set up your equipment? In other words, can you leave part of your kit unattended at your observing site while you walk back to where your car is parked to get the rest then return to the observing site and find everything still there, unmolested, and undamaged? If the answer is no, then you will need to take everything in one trip even though you are driving a car. This same issue may be a problem at your home location if you cannot leave a parked car unattended to make more than one trip with your kit to load or unload your car.

One observing site frequently used by apartment dwellers is a balcony or a roof top. Dependent upon the construction practices in your area, this may or may not be usable for astrophotography. Buildings made completely of reinforced concrete often have balconies and roofs that are very stable and vibration free. On the other hand, lighter weight construction produces roofs and balconies that are bouncy and while they may be usable for visual observing they are unsuited for photography. Quite often roof tops and especially balconies have a very limited view of the night sky. This can create problems finding suitable stars for aligning a mount and often make obtaining a precise polar alignment needed for an equatorial mount

impossible to do. In this instance, an alt-azimuth mount can be the difference between using the location or not.

Any one of the three portable observatories previously discussed can work in an urban setting. Portable Observatory No. 1 is especially suited where portability is the dominate issue or where access to the night sky is rather limited. Portable Observatory No. 2 is suited where portability is an issue but bulk is not. If the observatory will be used at many different sites with some having limited sky access, then the ability of Portable Observatory No. 2 to operate in either an alt-azimuth or an equatorial mode is a very valuable capability to have. Portable Observatory No. 3 is especially useful for people who use their telescopes in an urban area but also carry their observatory on trips either in an automobile or commercial air to areas having dark night sky. Its major negative characteristic is that it must be polar aligned which is difficult to do in some urban settings.

13.4 Vacation in the Family Car

Vacation time and what do we take with us? We all know the drill. This situation is for the case where you do not have room for a traditional astrophotography kit using your favorite SCT, Newtonian, or APO refractor and especially room for a heavy traditional GEM. Any one of the three portable observatories will work with the family car. If you don't have space for a full 44 Liter backpack, the strategy here is dispersed components. Break the observatory into several small packages that are safely stuffed here and there. Short tube refractors are easily carried in a small soft sided telescope bag that also has room for some small accessories. Any one of the three mounts used in the observatories is rugged and storable without being in a protective case as long as some care is taken to locate it where some heavy shifting object cannot strike it. The tripod collapses into a very small package that does not need a case for protection if some care is exercised. After all, you, not some airport gorilla, are handling your equipment with care and can find safe spots for it. A very small case will hold the DSLR, t ring, and either the interval timer or tablet. A NiMH battery kit, eyepieces, and other accessories can be in another small case or bag. Add a foldable camp stool and a power supply for a laptop if it is wanted and you are in business. A portable jump start battery with its built-in air compressor is also nice to have just in case of an emergency while your travel.

13.5 Commercial Air

My personal experience and that of others who have carried telescopes on international and transoceanic flights between Europe, the United States, and Canada is very positive. Travel to countries that have political instability or totalitarian governments is a different matter. If this applies to you, check with your state department or your embassy located in the particular country.

The safest way to carry your telescope aboard a commercial airplane is as carry-on baggage. At first glance, this seems simple enough and the first concern that often comes to mind is "how will airport security personnel react?" Airport security personal, at least those located in North America and Europe, are often intrigued with telescopes but let them through security check points without delay. In North America and Europe the problem is not at security but is at the airline check-in desk and the question "what qualifies as carry-on baggage?"

A quick check on the internet reveals a simple fact; no consistencies exist among airlines regarding the size and weight allowed for carry-on baggage. Each is airline pretty much free to do its own thing and they do. Carry-on baggage size and weight varies among the airlines and can vary upon whether the flight is domestic, international, transoceanic, etc. as well as the type aircraft being used. Fortunately most, if not all, airlines have this information available on their websites.

Before taking a telescope with you as carry-on baggage, decide which airline and which flights you will use. Next, contact the airline to determine their rules for carry-on baggage for the particular flights you want to use. The last thing you want is to show up at the airport and have the airline check-in people tell you that your carry-on baggage is too big or too heavy and must go as checked baggage.

If you are flying on small regional airlines, carry-on baggage is very restricted. However, many put carry-on baggage in a luggage compartment as you board and return it to you as you deplane at your destination bypassing the dreaded airport baggage handlers. Here again, homework ahead of time is the difference between an uneventful journey and an eventful one.

Most airlines allow passengers to have one carry-on bag and one smaller hand bag such as a large purse, laptop computer, etc. The size and weight restrictions of the hand bag are smaller than the carry-on bag. Some airlines also have a maximum weight for the total of both bags.

Generally speaking, if you are traveling on an US airline you will be OK with a carry-on bag measuring $22 \times 35 \times 56$ cm ($9 \times 14 \times 22$ in.) and a handbag measuring $22 \times 25 \times 43$ cm ($9 \times 10 \times 17$ in.). These dimensions are width, height, and length measurements that comply with the requirements of all the major US airlines. Some US airlines have a larger allowance. Check before you fly. No weight restrictions are mentioned in the USA but one airline states that the passenger must be able to place the carry-on bag and hand bag in the overhead compartment without assistance from anyone. I don't know how they apply this rule to short people like my wife.

Travel aboard European airlines is similar to the USA except for weight restrictions. The width, height, and length dimensions, $23 \times 35 \times 55$ cm, for a carry-on bag that complies with all the European airlines meets all but the most stringent US airline but the European hand bag dimensions of $10 \times 30 \times 40$ cm are more restrictive. Unlike the USA, European airlines have weight restrictions for the carry-on bag and the hand bag. The typical maximum allowable weight per bag is 8 kg. A few European airlines allow heavier weights. One European airline limits the total weight of the carry-on and hand bag to 12 kg. Checking ahead before you fly is definitely a prudent thing to do before showing up at the airport with a telescope in a carry-on bag.

The rest of the world is similar to Europe. In Canada, the carry-on bag dimensions are 23×40×55 cm with a maximum weight of 10 kg and the handbag dimensions are 16×33×43 cm with a maximum weight of 10 kg. Canada, like the USA, has regional airlines that use small aircraft that have little space in their interior for hand carried luggage and bags. Check before flying. Japan allows a carry-on bag measuring 25×40×55 cm and a handbag measuring 23×25×43 cm. The maximum weight of the carry-on bag is 10 kg with no weight restriction for the handbag. The most restrictive is Australia. The carry-on bag dimensions are 23×35×56 cm weighing no more than 7 kg. A handbag or laptop computer is allowed. The laptop bag must be a slim case, not much thicker than the laptop. No weight restriction on the handbag.

And there are the discount airlines in America and Europe with rules written by a Philadelphia lawyer… beyond understanding. If you plan to fly aboard a "Value Jet" kind of airline, definitely check with the airline ahead of time and read the fine print.

Excluding the discount airlines, a size and weight can be calculated for a carry-on bag that is acceptable to all major airlines worldwide. Such a bag will have the dimensions no more than 22×35×55 cm (9×14×22 in.) and will weigh no more than 8 kg (7 kg if you are flying an Australian airline). The weight allowance includes the weight of the carry-bag as well as its contents. The physical size of a 22×35×55 cm carry-on bag is sufficient to carry a wide variety of telescopes, mounts, and cameras; however, the 8 kg weight allowance is limiting. Also, the size is too small for a tripod; thus, the tripod must be dissembled and carried in your checked luggage with your clothing. As a matter of note, I use a hard back, leather salesman's sample case to carry my telescopes when I fly. Its dimensions are 20×33×45 cm. It is heavy at 3 kg and I should replace it with a larger but lighter bag. Except for the tripod my 20×33×45 cm bag can hold Portable Observatory No. 1 if weight is not a factor. If weight is a factor, it can hold the telescope, mount, and camera which are the delicate components of the observatory.

Here are three photographs of Portable Observatory No. 1 showing the observatory assembled, disassembled, and packed (see Figs. 13.1, 13.2, and 13.3).

One aspect of traveling with a telescope that cannot be stressed too much; before flying, check with the airlines you will use. The airlines can and do change their rules. Also, most have more lenient allowances than the one discussed in the previous paragraphs.

Let's take a look at how the three portable observatories discussed earlier in this chapter relate to flying on commercial airlines. The major components for Portable Observatory No. 1 along with their prices and weights are provided by Tables 13.4 and 13.5. All the major components of Portable Observatory No. 1 easily fit in a carry-on bag without exceeding weight constraints and with a margin left over to cover padding and the carry-on bag. Power supplies are not an issue as the mount uses disposable AA batteries. The camera and interval timer (intervalometer) also use internal batteries.

Tables 13.6 and 13.7 provide the weights and prices for the major components used for Portable Observatory No. 2. This observatory is the only one of the three that has a major issue with the carry-on rules for some airlines. The diameter of the

13.5 Commercial Air

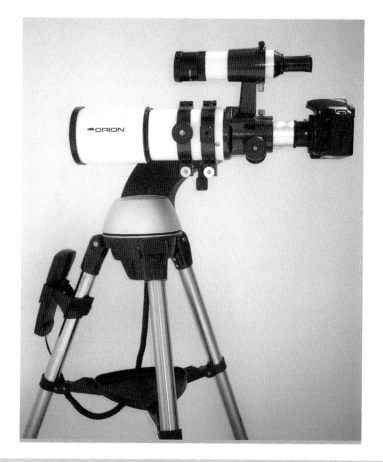

Fig. 13.1 Alt-azimuth astrophotography kit assembled

azimuth base of the 4/5 SE mount exceeds the minimum width restrictions that some airlines have for carry-on baggage. Removing the rubber feet off the azimuth mount reduces the effective diameter of the base so that it can board the most restrictive airlines if a backpack is used. The weight of the major components leaves an adequate margin for the weight of the carry-on bag and possibly a few accessories. The Celestron 4SE mount's useful payload in the equatorial mode using its built-in wedge is approximately 6 pounds (2.73 kg). As with the Portable Observatory No. 1, a tablet is a very useful item to have while the logistics of a lap top computer makes its utility questionable.

Portable Observatory No. 3 is capable of long-exposure, guided, astrophotography of approximately 5 min or so. Tables 13.8 and 13.9 provide a list of the major components as well as their weights and prices. This configuration has the additional weight and volume of a self-guider camera, guide scope, and guide scope mounting bracket.

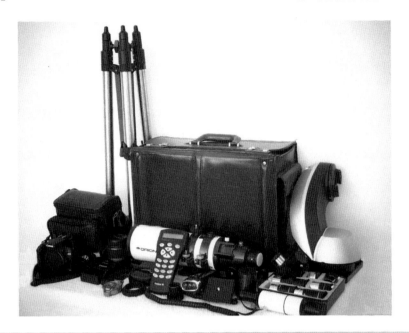

Fig. 13.2 Alt-azimuth astrophotography kit ready for packing

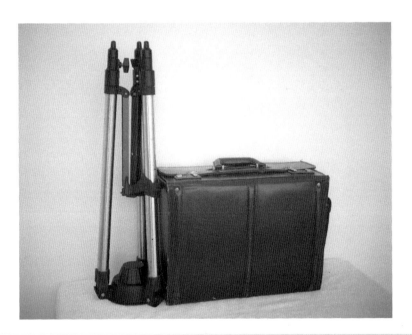

Fig. 13.3 Alt-azimuth astrophotography kit packed

13.5 Commercial Air

Table 13.4 Portable Observatory No. 1 attributes (United States)

Item	Description	Cost	Weight (lbs)	Remarks
OTA	Orion ST-80A	$200	4.27	Lightweight, f/5, achromatic, 80 mm short tube refractor, 8×40 finder scope, tube brackets and dovetail
Mount	Celestron SLT	$280	4.95	AltAz GOTO mount. The weight is for mount head that is in the carry-on baggage, the tripod is in checked luggage
Self Guider	None			Not Applicable
Guidescope	None			Not Applicable
Camera	Canon EOS Rebel T3	$375	1.32	Unmodified, 12.20 megapixel DSLR, Live View, T ring, battery
Interval Timer	Any brand	$25	0.22	Any of the low cost specials available on the internet will suffice; not needed if a computer or tablet is used
Total		$880	10.77	6.83 lbs in reserve for weight of carry-on bag, padding, and other accessories
Tablet	Nexus 7	$350		Optional, carried on person, not in the carry-on bag; if used an interval timer is not needed
Lap Top				Not required for image acquisitioning but needed for image processing only; carried aboard as hand baggage not carry-on
Payload	Mount load		5.60	Maximum mount payload is 8 lbs

Table 13.5 Portable Observatory No. 1 attributes (Europe)

Item	Description	Cost	Weight (kg)	Remarks
OTA	SkyWatcher Star Travel 80 mm	€150	1.94	Lightweight, f/5, achromatic, 80 mm short tube refractor, 8×40 finder scope, tube brackets and dovetail
Mount	SkyWatcher Syn Scan AZ GOTO	€255	2.25	The weight is for mount that is in the carry-on baggage, the tripod is in checked luggage
Self Guider	None			Not Applicable
Guidescope	None			Not Applicable
Camera	Canon EOS 1100D	€310	0.60	Unmodified 12.20 megapixel DSLR, Live View, T ring, battery
Interval Timer	Any brand	€30	0.1	Any of the low cost specials available on the internet will suffice
Total		€745	4.89	3.11 kg in reserve for weight of carry-on bag, padding, and other accessories
Tablet	Nexus 7	€350		Optional, carried on person, not in the carry-on bag; if used an interval timer is not needed
Lap Top				Not required for image acquisitioning but needed for image processing only; carried aboard as hand baggage not carry-on
Payload	Mount load		2.54	Maximum mount payload is 3.6 kg

13.5 Commercial Air

Table 13.6 Portable Observatory No. 2 attributes (United States)

Item	Description	Cost	Weight (lbs)	Remarks
OTA	Orion ST-80A	$200	4.3	Lightweight, f/5, achromatic, 80 mm short tube refractor, 8 × 40 finder scope, tube brackets and dovetail
Mount	Celestron 4/5 SE	$380	6.4	The weight is for mount that is in the carry-on baggage, the tripod is in checked luggage
Self Guider	None			Not Applicable
Guidescope	None			Not Applicable
Camera	Canon EOS Rebel T3	$375	1.3	Unmodified 12.20 megapixel DSLR, Live View, T ring, battery
Interval Timer	Any brand	$25	0.2	Any of the low cost specials available on the internet will suffice; not needed if a computer or tablet is used
Total		$980	12.2	6.84 lbs in reserve for weight of carry-on bag, padding, and other accessories
Tablet	Nexus 7	$350		Optional, carried on person, not in the carry-on bag; if used an interval timer is not needed
Lap Top				Not required for image acquisitioning but needed for image processing only; carried aboard as hand baggage not carry-on
Payload	Mount load		5.6	Maximum mount payload is 10 lbs

Table 13.7 Portable Observatory No. 2 attributes (Europe)

Item	Description	Cost	Weight (kg)	Remarks
OTA	SkyWatcher Star Travel 80 mm	€150	2.0	Lightweight, f/5, achromatic, 80 mm short tube refractor, 8×40 finder scope, tube brackets and dovetail
Mount	Celestron 4/5 SE	€500	2.9	The weight is for mount that is in the carry-on baggage, the tripod is in checked luggage
Self Guider	None			Not Applicable
Guidescope	None			Not Applicable
Camera	Canon EOS 1100D	€310	0.6	Unmodified 12.20 megapixel DSLR, Live View, T ring, battery
Interval Timer	Any brand	€30	0.1	Any of the low cost specials available on the internet will suffice
Total		€990	5.5	2.5 kg in reserve for weight of carry-on bag, padding, and other accessories
Tablet	Nexus 7	€350		Optional, carried on person, not in the carry-on bag; if used an interval timer is not needed
Lap Top				Not required for image acquisitioning but needed for image processing only; carried aboard as hand baggage not carry-on
Payload	Mount load		2.6	Maximum mount payload is 4.5 kg

13.5 Commercial Air 257

Table 13.8 Portable Observatory No. 3 attributes (United States)

Item	Description	Cost	Weight (lbs)	Remarks
OTA	Orion ST-80A	$200	3.7	Lightweight, f/5, achromatic, 80 mm short tube refractor, tube brackets and dovetail; without a finder scope
Mount	iOptron SmartEQ Pro	$500	6.16	The weight is for mount that is in the carry-on baggage, the tripod and counterweights are in checked luggage
Self Guider	Celestron NexGuide	$300	0.8	Self contained self guider, ST-4, mount loading 0.42 lbs
Guide Scope	Orion Mini 50 mm Guidescope	$100	1.0	f/3.2, 50 mm refractor with rings, helix focuser; replaces OTA finder
Camera	Canon EOS Rebel T3	$350	1.32	Unmodified 12.20 megapixel DSLR, Live View, T ring, battery
Interval Timer	Any brand	$25	0.22	Any of the low cost specials available on the internet will suffice; not needed if a computer or tablet is used
Total		$1,475	13.16	4.44 lbs in reserve for weight of carry-on bag, padding, and other accessories
Tablet	Nexus 7	$350		Optional, carried on person, not in the carry-on bag; if used an interval timer is not needed
Lap Top				Not required for image acquisitioning but needed for image processing only; carried aboard as hand baggage not carry-on
Payload	Mount load		6.40	Maximum mount payload is 11 lbs

Table 13.9 Portable Observatory No. 3 attributes (Europe)

Item	Description	Cost	Weight (kg)	Remarks
OTA	SkyWatcher StarTravel 80 mm	€150	1.67	Lightweight, f/5, achromatic, 80 mm short tube refractor, tube brackets and dovetail; without a finder scope
Mount	iOptron SmartEQ Pro	€550	2.80	The weight is for mount that is in the carry-on baggage, the tripod and counterweights are in checked luggage
Self Guider	SkyWatcher SynGuider	€270	0.36	Self contained self guider, ST-4, mount loading 0.19 kg
Guide Scope	William Optics 50 mm Guide Scope	€120	0.60	f/4, 50 mm refractor with rings, helix focuser; replaces OTA finder
Camera	Canon EOS 1100D	€310	0.60	Unmodified 12.20 megapixel DSLR, Live View, T ring, battery
Interval Timer	Any brand	€30	0.1	Any of the low cost specials available on the internet will suffice
Total		€1,430	6.13	1.87 kg in reserve for weight of carry-on bag, padding, and other accessories
Tablet	Nexus 7	€350		Optional, carried on person, not in the carry-on bag; if used an interval timer is not needed
Lap Top				Not required for image acquisitioning but needed for image processing only; carried aboard as hand baggage not carry-on
Payload	Mount load		3.06	Maximum mount payload is 5 kg

The additional weight of the guide scope and self guider has an impact on the carry-on luggage used. The previous two kits, weight wise and volume wise, easily fit in a commercial carry-on luggage with wheels and collapsible handle. The additional weight of the self guider and guide scope increases the weight of the kit so that it plus the carry-on luggage may exceed 8 kg. For airlines that do not have weight limits or limits higher than 8 kg, this is not a problem. But for airlines with an 8 kg maximum weight limit some decisions must be made. One alternative is to put something in with the checked luggage such as the camera or guide scope. Another alternative is to use a lightweight back pack that complies with the size restrictions; however, such a pack does not provide as much protection as a typical carry-on piece of luggage.

The addition of a self contained self guider is a major increase in sophistication and capability for Portable Observatory No. 3. An astronomer electing to use a self-guider may want to use an apochromatic refractor as well as a modified DSLR camera. However, apochromatic refractors are fairly heavy and typically slow. Given the lightweight nature of the mount used a telescope with a focal ratio in the f/6 neighborhood or faster is desired. Tube length can also be a problem. If the airline has a weight limit of 8 kg, then a lightweight piece of luggage or case that offers little protection must be used. For these reasons, a light-weight, 60 or 70 mm apochromatic refractor around f/6 may make an excellent choice.

13.6 Air Transportable Power Supplies

Batteries are an issue for air transport due to some very valid safety concerns. Countries around the world regulate the transport of batteries aboard commercial aircraft. While the regulation varies, some basic rules appear consistent.

Except for some medical devices, wet cell batteries are not allowed. Dry cell batteries can be transported in carry-on or, for many but not all countries, as checked baggage. This includes dry cell alkaline batteries (sizes AA, AAA, C, and D) as well as dry cell rechargeable batteries such as nickel metal hydride (NiMH) and nickel cadmium (NiCd) batteries. Batteries not in consumer products, must be in their original packing, a case, or a pouch such as a plastic bag (one battery per bag) to prevent short circuits. Some countries allow taping over battery contacts but most do not. The United States is one country that allows dry batteries in checked luggage.

Regulations for batteries containing lithium are more stringent. Lithium batteries in consumer products such as cell phones, cameras, laptops, iPads, tablets, etc. are allowed as carry-on items. Only two large lithium ion batteries such as used in laptop computers, video equipment, etc. are allowed per passenger. Lithium ion batteries cannot exceed 8 g of equivalent lithium content or 100 W h per battery. For lithium metal batteries, up to 2 g of lithium content per battery are allowed.

One preferred power supply among amateurs is an automotive jump start battery. However, it is rather bulky and heavy. Also, it is a wet cell battery and not allowed

Fig. 13.4 Ten cell NiMH AA battery pack

aboard commercial aircraft. Using the internal batteries for your mount and simply buying regular non-rechargeable batteries on the local market is one simple solution. After all, a vacation or business trip typically is only a week or two and the observatory will probably be used for only a few nights.

For portability, a ten cell pack of rechargeable 2,300 mAhr, AA, nickel metal hydride batteries in series is very suitable (see Fig. 13.4). This provides over 4 h of operating time with either a SkyWatcher SynScan AZ GOTO mount or a 4SE mount. A DSLR camera and a tablet have internal rechargeable batteries. Verify that they can last for about 4 h. Remember that battery life is considerably shortened in cold weather.

The iOptron Smart EQ PRO uses 8 AA batteries in internal compartments. Unlike many computerized mounts, the iOptron SmartEQ PRO can use rechargeable NiMH AA batteries. Battery life is estimated as 6 or more hours.

Since most imaging sessions using lightweight equipment seldom exceed 4 h, the equipment's internal batteries and or NiMH battery packs are more than sufficient for a night's work. The downside of using NiMH batteries is several hours are needed to recharge one NiMH battery. To get a 1 day turn around for battery charging, you will need to charge ten batteries simultaneously. This takes two chargers with the capability to charge four batteries simultaneously and one charger with a capacity for two batteries. Three battery chargers all total. While the additional weight and volume is not significant, the "hassle level" may be for many people. Also, finding three unused power receptacles in a hotel room can prove interesting.

Powering a laptop computer is an issue that you need to resolve before considering to use one for imaging in the field if you are flying to some destination. You are allowed to carry a total of two large lithium batteries aboard in either your carry-on bag or your hand bag (lap top computer case) as long as the batteries are internal to their device. You will need to run tests with your computer battery to determine how long it will operate in the field. Many computers operate at voltages higher than 12 vdc; thus, the option of simply going to a local discount store at your destination and purchasing a jump start battery often does not exist.

The issue of portable power for a laptop in the field can be a show stopper. The same is true for a tablet. If you plan to use a tablet to control the photographic process, verify that its internal battery can last long enough to do the job; if not, a tablet is still very useful for focusing and for composing the image.

Chapter 14

Eye Candy in the Night Sky to Photograph

14.1 Introduction

Photographing the night sky, especially making snapshots of what you see in the eyepiece of your telescope, is fun. The fun quadruples when you show off your images to your friends and family as they "ooo and aah" in admiration of your work. And then there are the cold, cloudy winter nights when you can revisit the heavens with your images, photographs made by you and no one else.

What objects can you photograph using very short exposures and a lightweight mount? The answer is simple; if you can see it in your telescope, you can certainly photograph it. The list of objects to photograph is varied and long; far too long to do justice in one chapter of a book. As is true for visual observing, the Messier list is an excellent place for anyone to start photographing the night sky. Table 14.1 can help you do exactly that. The table contains all the Messier Objects and identifies the month when each object crosses the meridian at midnight. This lets you know when the object is high in the night sky. Don't forget to adjust for daylight savings time if appropriate.

The old saying "a picture is worth a thousand words" is most often very true. If you want to see the work done with a lightweight mount and telescope, take a look at the images in this chapter. All of them were taken with a kit that is easily backpacked to a remote dark location, carried on a city subway or bus system, or transportable aboard commercial airlines. From a technical perspective, the images benefit only from the use of dark frames as no flats or bias frames were used during their processing. The images were stacked in DeepSky Stacker and processed with Photoshop.

Many of the images were among the very first astrophotographs I made and have errors caused by my lack of knowledge and skills at the time; not limitations caused by the equipment used.

The imaging location was an urban area with a significant level of light pollution. To the west of the meridian, the light glow from a city of three million people drowns all but the brightest stars. To the east of the meridian is the open sea and relatively dark skies. The Milky Way is visible but very washed out and fading towards the horizon. Clouds are easily visible as they reflect the light glow from the metropolitan area. On the darkest of nights, a flashlight is not needed for walks as the skyglow makes sidewalks clearly visible.

The images are presented in a meteorological seasonal setting; not an astronomical setting. With the meteorological model, December through February is winter, March through May is spring, summer is June through August, and fall is

Table 14.1 Messier object midnight transit of the meridian

Month	Messer objects
January	M41, M44, M46, M47, M48, M50, M93
February	M67, M81, M82
March	M40, M49, M61, M65, M66, M84, M85, M86, M87, M88, M89, M90, M91, M95, M96, M97, M98, M99, M100, M105, M106, M108, M109
April	M3, M51, M53, M58, M59, M60, M63, M64, M68, M83, M94, M101, M104
May	M4, M5, M80, M102, M107
June	M6, M7, M8, M9, M10, M12, M13, M14, M16, M17, M18, M19, M20, M21, M22, M23, M24, M25, M28, M62, M69, M92
July	M11, M26, M27, M29, M54, M55, M56, M57, M70, M71, M75
August	M2, M15, M30, M39, M72, M73
September	M52
October	M31, M32, M33, M74, M76, M103, M110
November	M34, M45, M77
December	M1, M35, M36, M37, M38, M42, M43, M78, M79

Table 14.2 Eye Candy

Summer	Fall	Winter	Spring
North American Nebula	Andromeda Galaxy	Great Orion Nebula	Whirlpool Galaxy
Eagle Nebula	Pleaides	Horsehead Nebula	PinWheel Galaxy
Lagoon Nebula	Silver Coin Galaxy	Bode's Nebula	Leo Triplet
Trifid Nebula	Triangulum Galaxy	Open Cluster Messier Object 36	Rosetta Nebula
Dumbbell Nebula		Messier Object 81 and 82 with Sn2014J	
Sagittarius Star Cloud			

September through November. This approach better fits three major constellations of photographic note; Orion, Scutum, and Sagittarius.

Each image is accompanied with a brief discussion of the equipment used for the photograph as well as some facts about the object. Table 14.2 provides a list of the images in this chapter.

14.2 Summer; June, July, and August

Summer is a good time to start your photographic journey to capture the night sky. The nights are short but the sky is filled with delights to photograph. Look up and you see the Milky Way stretching across the night sky. Look to the south at the constellations of Sagittarius and Scutum and you see into the heart of our galaxy, the Milky Way. Not surprising, the Constellations of Sagittarius and Scutum offer many attractive objects that astrophotographers like to photograph.

Our first image, Fig. 14.1, is Messier Object 8; known as the Lagoon Nebula and is very popular with astrophotographers. The Lagoon Nebula is really two objects, a star cluster (NGC 6530) discovered by Flamsteed in 1680 and an emissions nebula (NGC 6523) discovered by Gentil in 1749. It is located in the Constellation Sagittarius and is some 4,310 light years from earth. The magnitude of M8 is 5.8 and its apparent diameter is 7 arcminutes. The emission nebula has a magnitude of 4.6 and an apparent size of 90×40 arcminutes.

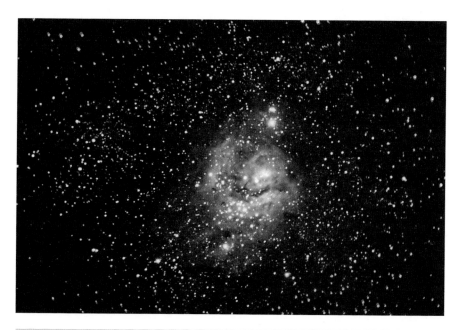

Fig. 14.1 The Lagoon Nebula

Figure 14.1 was made on 21 June 2012 using a 102 mm f/10 Meade 2045 LX3 SCT with a 0.63 focal reducer, an unmodified Canon Rebel XS (1000D) DSLR at 1600 ISO, and a Celestron 4SE mount in the equatorial mode. The total integrated exposure time was 27 min (18 × 90 s).

Figure 14.2, is Messier Object 16; known as the Eagle Nebula that NASA made famous worldwide with the Hubble Telescope photograph called the "Pillars of Creation." Like the Lagoon Nebula, it too is very popular with astrophotographers. Also similar to the Lagoon Nebula, the Eagle Nebula is really two objects, a star cluster (NGC 6611) discovered by Cheseaux in 1746 and an emissions nebula (IC 4703) discovered by Barnard in 1895. The nebula is located in the Constellation Serpens approximately 5,600 light years from earth. The magnitude of M16 is 6.0 and its apparent size is 21 arcminutes.

Figure 14.2 was made on 26 June 2012 using a 150 mm f/10 Celestron C6S SCT with a 0.63 focal reducer, an unmodified Canon Rebel XS (1000D) DSLR at 1600 ISO, and a SkyWatcher SynScan AZ GOTO alt-azimuth mount. The total integrated exposure time was 32 min 25 s (41 × 20 s + 75 × 15 s).

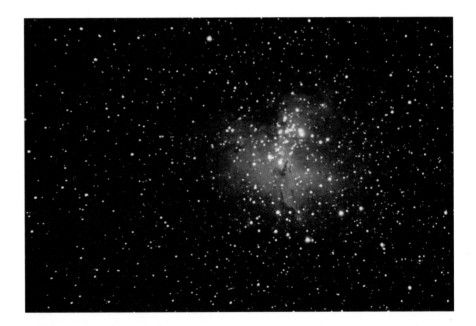

Fig. 14.2 The Eagle Nebula

14.2 Summer; June, July, and August

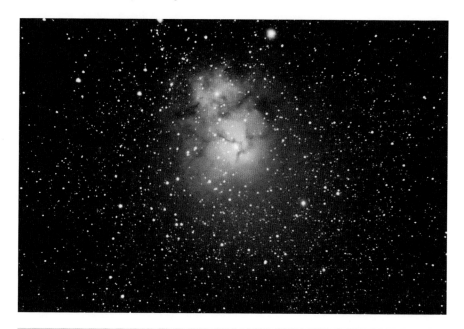

Fig. 14.3 The Trifid Nebula

Next is Messier Object 20 (Fig. 14.3) known as the Trifid Nebula. This object is an emissions nebula (NGC 6514) and was discovered by Messier in 1764. It is located in the Constellation Sagittarius and is approximately 2,660 light years from earth. The magnitude of M20 is 8.5 and its apparent size is 20 arcminutes.

Figure 14.3 was made on 16 June 2012 using a 102 mm f/10 Meade 2045 LX3 SCT with a 0.63 focal reducer, an unmodified Canon Rebel XS (1000D) DSLR at 1600 ISO, and a Celestron 4SE mount in the equatorial mode. The total integrated exposure time was 41 min (41 × 60 s).

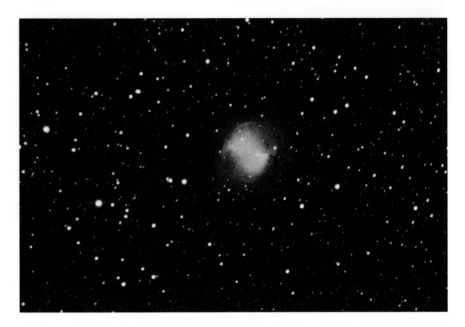

Fig. 14.4 The Dumbbell Nebula

Messier Object 27 (Fig. 14.4) is also known as the Dumbbell Nebula. This planetary nebula was discovered by Charles Messier in 1764. It is located in the Constellation Vulpecula and is approximately 1,150 light years from earth. The magnitude of the nebula is 7.4 and its apparent size 8.4×6.1 arcminutes.

Figure 14.4 was made on 8 July 2011 using a 102 mm f/10 Meade 2045 LX3 SCT with a 0.63 focal reducer, an unmodified Canon Rebel XS (1000D) DSLR at 1600 ISO, and a Celestron 4SE mount in the equatorial mode. The total integrated exposure time was 1 h 48 min (108×60 s).

14.2 Summer; June, July, and August

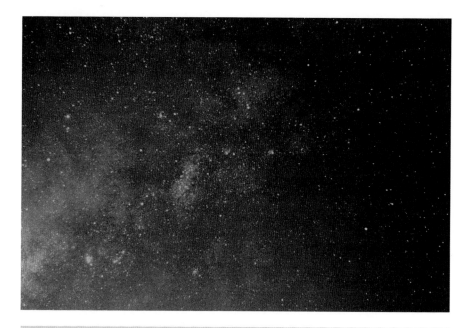

Fig. 14.5 The Sagittarius Star Cloud

You will find our next object, Fig. 14.5, by looking into the heart of the Milky Way in Sagittarius; Messier Object 24, the Sagittarius Star Cloud. This object is a star cloud 12,000–16,000 light years from earth. It has a magnitude of 2.5 and an apparent size of 90×30 arcminutes. It was discovered by Messier in 1764.

Figure 14.5 was made in 3 August 2010 with a Canon Rebel XS (1000D) at 1600 ISO piggybacked on a Celestron C6S SCT OTA using a SkyWatcher SynScan AZ GOTO alt-azimuth mount. Thirty second exposure, 55 mm lens at f/2.2.

From Sagittarius follow the Milky Way upward into the sky to the Constellation Cygnus. Not far from the star Deneb is our next object, NGC 7000, the North American Nebula. This object is an emission nebula located 2,200 light years from earth in the Constellation Cygnus and covers an area spanning 50 light years. It has a magnitude of 4 and was discovered by W. Herschel in 1786.

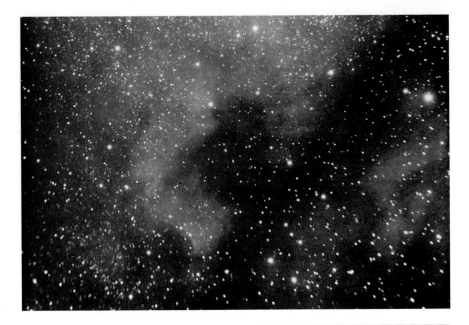

Fig. 14.6 The North American Nebula

Figure 14.6 was made on 5 July 2013 using an 80 mm f/5 Orion ST-80A refractor, an unmodified Canon Rebel XS (1000D) DSLR at 1600 ISO, and a SkyWatcher SynScan AZ GOTO alt-azimuth mount. The total integrated exposure time was 22 min 50 s (55×25 s).

14.3 Autumn; September, October, and November

On a dark night our next object (Fig. 14.7) and nearby neighbor to the Milky Way in space is easily seen with the naked eye high in the sky. This object is a galaxy known as the Andromeda Galaxy and denoted as Messier Object 31. It is approximately 2.57 million light years from earth and is located in the Constellation Andromeda. The galaxy has a magnitude of 3.4, and an apparent diameter of 3.5×1 arc degrees. The earliest recorded reference to the Andromeda Galaxy was made in 964 by Al Sufi in Persia. Two other Messier Objects are also in the photograph. The bright oval shaped object about 1/3 the way down from the top middle of the photograph is the companion galaxy, M110 discovered by Charles Messier in 1773 but he never included it on any of his lists. M110 is 2.6 million light years from earth, has a magnitude of 8.0 and an apparent size of 21.9×11 arcminutes. Also in the photograph is another companion galaxy, M32 discovered by Guillaume LeGentil in 1749. M32 is 5.57 light years from earth, has an apparent size of 8.7×6.5

14.3 Autumn; September, October, and November

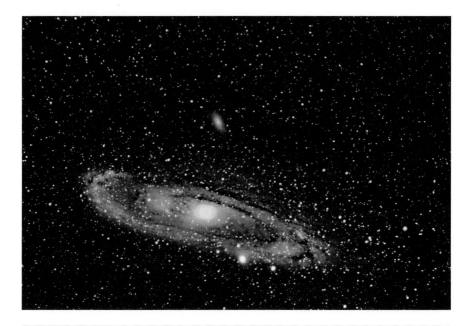

Fig. 14.7 The Andromeda Galaxy

arcminutes and a magnitude of 8.1. In the photograph, it is the large fuzzy dot about 1/5th the way up from the bottom middle of the image.

The image of the Andromeda Galaxy (Fig. 14.7) was made on 22 November 2013 using an 80 mm f/5 Orion ST-80A short tube refractor, an unmodified Canon Rebel XS (1000D) DSLR at 400, 800, and 1600 ISO, and a Celestron 4SE mount in the equatorial mode. The total integrated exposure time was 2 h (120×60 s).

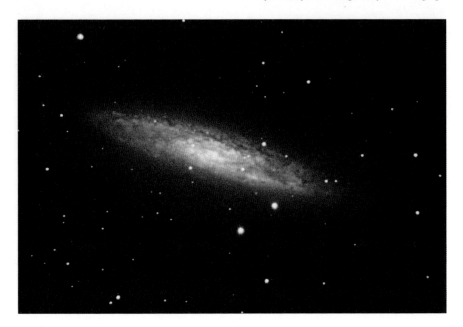

Fig. 14.8 The Silver Coin Galaxy

Our next photograph, Fig. 14.8 is a galaxy in the Constellation Sculptor. NGC 0253 is also known as the Silver Coin Galaxy. It is located in the Sculptor Constellation. NGC 0253 was discovered in September 1783 by Caroline Herschel. It is 10 million light years from Earth, has an apparent size 27.5×6.8 arcminutes, and a magnitude 8.0. This galaxy is low on the southern horizon and difficult to see at latitudes much greater than 40° north.

The image in Fig. 14.8 was made on 9 November 2012 using a 150 mm f/10 Celestron C6S SCT with a 0.63 focal reducer, an unmodified Canon Rebel XS (1000D) DSLR at 1600 ISO, and a SkyWatcher SynScan AZ GOTO alt-azimuth mount. The total integrated exposure time was 61 min 30 s (123×30 s).

14.3 Autumn; September, October, and November

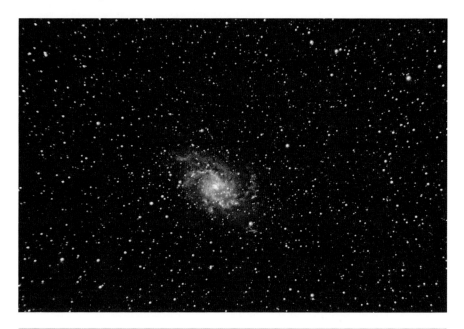

Fig. 14.9 The Triangulum Galaxy

Our next example for the Autumn is Messier Object 33, the Triangulum Galaxy (Fig. 14.9). M33 is approximately 2.7 million light years from earth. It has a magnitude of 5.7 and its apparent diameter is 71×42 arcminutes. The Triangulum galaxy is in the Constellation Triangulum and is one of the nearest galaxies to the Milky Way. It was discovered by Charles Messier in 1764.

Figure 14.9 was made on 1 November 2013 using an 80 mm f/5 Orion ST-80A short tube refractor, an unmodified Canon Rebel XS (1000D) DSLR, and a Celestron 4SE mount in the equatorial mode. The total integrated exposure time is 2 h, 17 min, and 30 s (22×75 s @ 800 ISO, 52×60 s @ 800 ISO, and 58×60 s @ 1600 ISO).

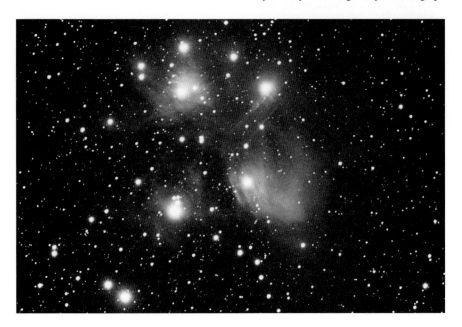

Fig. 14.10 The Pleiades

Figure 14.10 is an image of Messier Object 45, the Pleiades or Seven Sisters. This open cluster is well known around the globe dating back to prehistoric times as it is easily seen with the unaided eye. The M45 star cluster is passing through a dust cloud and contains several reflection nebulae. M45 is located in the Constellation Taurus and is about 425 light years from earth. It has a magnitude of 1.5 and an apparent diameter of 2 arc degrees.

Figure 14.10 was made on 8 December 2013 using an 80 mm f/5 Orion ST-80A short tube refractor, an unmodified Canon Rebel XS (1000D) DSLR at 1600 ISO with a Astronomik CLS light pollution reduction filter, and a Celestron 4SE mount in the equatorial mode. The total integrated exposure time was 46 min (46×60 s).

14.4 Winter; December, January, and February

With the Pleiades climbing high in the night sky, ancient man knew winter would soon follow. Our first winter month, December, brings forth one of the most prominent features of the night sky, the Constellation of Orion and the Great Orion Nebula; Messier Object 42 (Fig. 14.11). M 42 is both a reflection and an emissions nebula and is estimated to be from 1,300 to 1,500 light years from earth. It has an apparent diameter of 90×60 arcminutes and a magnitude of 3.7. M42 was first reported by Nicholas Peiresc in 1611. Also in the image is M43, discovered in 1733 by de Mairan. M43 is located almost dead center of the photograph. Today M43 is considered part of M42. NGC 1973, 1975, and 1977, known as the running man nebula, are visible in the upper center of the photograph.

Figure 14.11 was made on 29 December 2013 using an 80 mm Orion f/5 ST-80A short tube refractor with an Astronomik CLS light pollution reduction filter, an unmodified Canon Rebel XS (1000D) DSLR at 1600 ISO, and a SkyWatcher SynScan AZ GOTO mount and tripod. The integrated exposure time was 59 min 30 s (119×30 s).

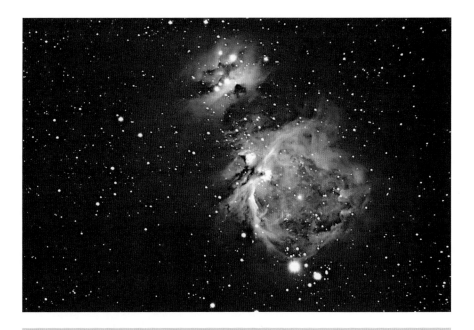

Fig. 14.11 The Great Orion Nebula

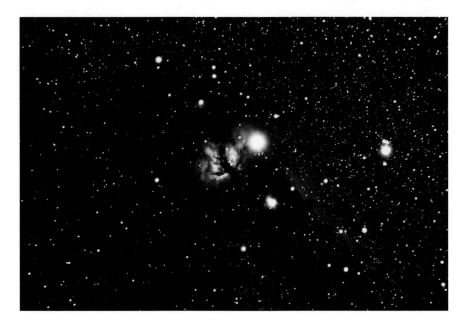

Fig. 14.12 The Horse Head and Flame Nebulae

Located in the Constellation of Orion is another world famous object, the Horse Head Nebula, also known as Barnard 33 located in the emission nebula IC 434 (Fig. 14.12). The Horse Head Nebula also shares the sky with the Flame Nebula (NGC 2024). The Horse Head Nebula is a dark nebula discovered by Williamina Fleming in 1888. It has an apparent size of 90×30 arcminutes. The nearby Flame Nebula is an emissions nebula and shares the same molecular cloud with the Horse Head Nebula. The bright star near the Flame Nebula is Alnitak the eastern most star of Orion's Belt. This beautiful deep space object is approximately 1,500 light years from earth.

Figure 14.12 was made on 6 December 2013 using an 80 mm f/5 Orion ST-80A short tube refractor, an unmodified Canon Rebel XS (1000D) DSLR at 1600 ISO, and a Celestron 4SE mount in the equatorial mode. The total integrated exposure time was 69 min 30 s (56×60 s and 9×90 s).

14.4 Winter; December, January, and February

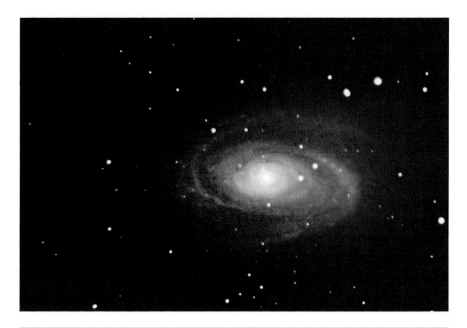

Fig. 14.13 Bode's Nebula

Figure 14.13 is an image of Messier Object 81. Also known as Bode's Nebula, it is a spiral galaxy located 11.8 million light years from earth in the Constellation Ursa Minor. It has an apparent size of 26.9 × 14.1 arcminutes and a magnitude of 6.8. It was discovered by Johann Bode in 1774.

Figure 14.13 was made on 14 January 2012 using a Celestron 150 mm C6S SCT with a 0.63 focal reducer, an unmodified Canon Rebel XS (1000D) DSLR at 1600 ISO, and a SkyWatcher SynScan AZ GOTO alt-azimuth mount. The total integrated exposure time is 84 min 20 s (253 × 20 s).

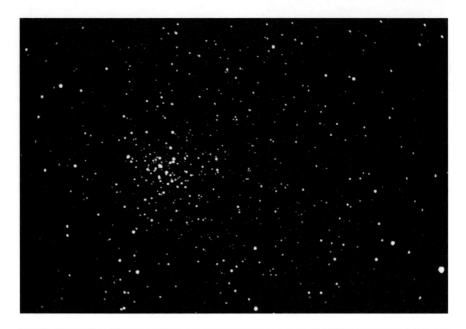

Fig. 14.14 M36 Open Star Cluster

The photograph in Fig. 14.14 is Messier Object 36, an open star cluster in the Constellation Auriga approximately 15 light-years from earth. It was discovered by Giovanni Hodierna in 1654. It has an apparent diameter of 12 arcminutes and a magnitude of 6.0.

Figure 14.14 was made on 5 February 2011 using a Celestron 150 mm C6S SCT with a 0.63 focal reducer, an unmodified Canon Rebel XS (1000D) DSLR at 1600 ISO, and a SkyWatcher SynScan AZ GOTO alt-azimuth mount. The total integrated exposure time is 12 min (24×30 s).

14.4 Winter; December, January, and February

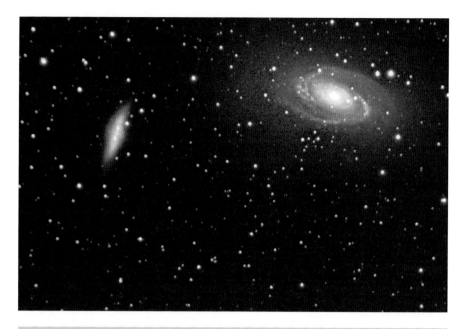

Fig. 14.15 M81 and M82 with Sn2014J

Figure 14.5 is an image of Messer Objects M81 and M82. These are two neighboring galaxies located in the Constellation Ursa Major and are approximately 11–12 million light years from earth. M81 has a magnitude of 6.8 and a surface brightness of 21.9 mag per square arcsecond. M82 is also known as the Cigar Galaxy due to its elongated shape. It has a magnitude of 8.4 and a surface brightness of 21.7 mag per square arcsecond. Both galaxies were discovered by Bode in 1774.

M82 was recently the home galaxy of a type Ia super nova, Sn2014J, that was discovered on the night of 21 January 2014. The image of M81 and M82 in Fig. 14.5 was made on the night of 22 January and contains the nova. The first light frame used for Fig. 14.5 was obtained almost exactly 24 h after was Sn2014J discovered; however, the photographer was not aware of the nova until the 23rd of January. M82 is the edge-on spiral galaxy on the left side of the image. Three stars are visible near the center of the galaxy that are aligned with the long axis of the galaxy. If you say that M81 is at the top of the image, then Sn2014J is the top star of these three stars. A very faint circle is drawn around the Ns2014J to highlight it.

Figure 14.15 was made on 22 January 2014 using an 80 mm Orion f/5 ST-80A short tube refractor with an unmodified Canon Rebel XS (1000D) DSLR at 1600 ISO, and a SkyWatcher SynScan AZ GOTO mount and tripod. The integrated exposure time was 3 h 6 min (372×30 s).

14.5 Spring; March, April, and May

Messier Object 51 (Fig. 14.16) is known as the Whirlpool Galaxy and is our first photograph for the Spring. This object is two galaxies interacting with one another. M51 is an estimated 26.8 million light years from earth in the Constellation Venatici. The galaxy has a magnitude of 8.4 and an apparent size of 11.2×6.9 arcminutes. It was discovered by Charles Messier in 1773.

Figure 14.16 was made on 4 April 2013 using an 80 mm f/5 Orion ST-80A short tube refractor, an unmodified Canon Rebel XS (1000D) DSLR at 1600 ISO, and a SkyWatcher SynScan AZ GOTO alt-azimuth mount. The total integrated exposure time is 54 min (162×20 s).

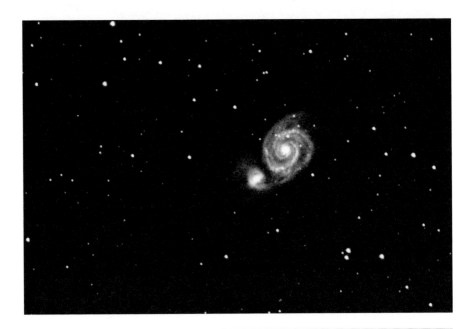

Fig. 14.16 The Whirlpool Galaxy

14.5 Spring; March, April, and May

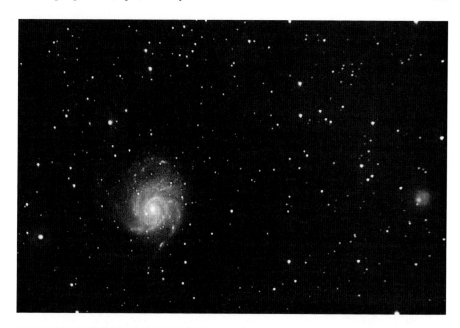

Fig. 14.17 The Pinwheel Galaxy

Next is Fig. 14.17, Messier Object 101 also known as the Pinwheel Galaxy. M101 is a spiral galaxy located in the Constellation Ursa Major and is an estimated 21.8 million light years from earth. It has an apparent size of 28.8×26.9 arcminutes and a magnitude of 7.7. The Pinwheel Galaxy was discovered in 1781 by Pierre Mechain.

Figure 14.17 was made on 12 April 2013 using an 80 mm f/5 Orion ST-80A refractor, an unmodified Canon Rebel XS (1000D) DSLR at 1600 ISO, and a Celestron 4SE mount in the equatorial mode. The total integrated exposure time was 77 min 20 s (116×40 s).

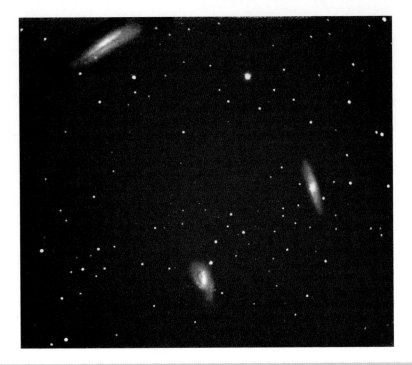

Fig. 14.18 The Leo Triplet

The Leo Triplet, Fig. 14.18, is a very popular object for astrophotographers. It contains three galaxies; Messier Objects, M65 and M66 with magnitudes of 9.3 and 9 respectively, and a third galaxy, NGC 3628. Located in the Constellation Leo, M65 and M66 have an estimated distance of 94,000–87,000 light-years from earth respectively. These two objects were discovered by Charles Messier in 1780.

Figure 14.18 was made on 19 February 2010 using a 150 mm f/10 Celestron C6S SCT with a 0.63 focal reducer, an unmodified Canon Rebel XS (1000D) DSLR at 1600 ISO, and a SkyWatcher SynScan AZ GOTO alt-azimuth mount. The total integrated exposure time is 31 min 15 s (75×25 s).

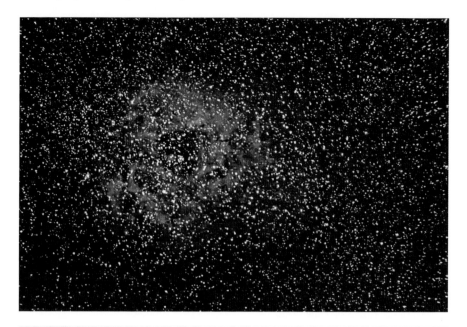

Fig. 14.19 The Rosetta Nebula

The Rosetta Nebula (Fig. 14.19) is a challenge to capture and process using very short exposure photography but well worth the effort. This Nebula has four New General Catalog designations (NGC 2237, 2238, 2239, and 2246). A star cluster (NGC2244) is at the center of the nebula. The Rosetta Nebula is large diffuse emissions nebula covering about 1.3° of the sky and is approximately 5,200 light years from earth located in the Constellation Monoceros. It was discovered by John Flamsteed in 1690.

Figure 14.19 was made on 2 March 2013 using an 80 mm f/5 Orion ST-80A short tube refractor, an unmodified Canon Rebel XS (1000D) DSLR at 1600 ISO, and a Celestron 4SE mount in the equatorial mode. The total integrated exposure time was 30 min 45 s (41×45 s).

This completes a very short tour of the universe and a sampling of images taken using lightweight, portable mounts and tripods. Most, but not all, were made using very short exposures of less than 1 min. Keep in mind these photographs were taken in the urban area of a large city with significant light pollution robbing the images of their faint details. A list of the equipment used to obtain the photographs of deep space objects presented in this book is as follows:

- Camera: Canon EOS Rebel XS (1000D) Digital Single Lens Reflex.
- Mounts:
 - SkyWatcher SynScan Azimuth/Altitude GOTO mount
 - Celestron 4SE Azimuth/Altitude Mount with a modified built-in wedge
 - Celestron CG5 German Equatorial Mount
- Telescope Optical Tube Assemblies or Camera Lens:
 - Orion ST-80A, 80 mm f/5 Refractor
 - Meade 2045LX3, 102 mm f/10 Schmidt Cassegrain Telescope
 - Celestron 4SE, 102 mm f/13 Maksutov Cassegrain Telescope
 - Celestron C6S, 150 mm f/10 Schmidt Cassegrain Telescope
 - Fujica 55 mm lens at f/2.2
- Accessories:
 - Hirsch 0.63 Schmidt Cassegrain Telescope focal reducer
 - Fotga Intervalometer Timer
 - Baader Semi APO filter
 - Astronomik CLS Light Pollution Reduction Filter
- Computers:
 - Nexus 7 (7 in. android tablet)
 - Lap top computer (Windows XP/Windows 8)
- Programs:
 - Deep Sky Stacker
 - Photoshop Elements 8
 - Photoshop CS5
 - Corel Draw Photo Paint 8
 - NoiseWare Community Edition
 - Meade Envision
 - DSLR Controller

While not verified, the processes and procedures described in the book should be applicable to the following and similar mounts such as:

- Celestron's SLT, Prodigy, and 6/8 SE Mounts,
- SkyWatcher's EQ3 mount with SynScan GOTO as well as the SkyWatcher and Orion GOTO Dobsonian mounts,

- Meade's ETX, LS, and LT mounts, and
- iOptron's Cube A, Cube E, Cube G, and Cube Pro mounts as well as its SmartEQ and SmartEQ PRO Mounts

The book is applicable for other digital single lens cameras, dedicated astrophotography cameras, and for optical tube assemblies that have sufficient back focus for and a focuser capable of supporting the weight of a digital single lens reflex camera. As time marches on, the telescope manufacturers will introduce new mounts, telescopes, and cameras. If the past is any guide for the future, then the technology advances in newly introduced equipment will serve to enhance the processes described in this book and extend the depth that we can photograph deep space with lightweight and very portable equipment.

Appendix A

Planning an Astrophotography Imaging Session

One way to obtain a high percentage of successful photographs is to look at imaging a deep space object as a project. The first step of any project is to define the project's goals and objectives followed by detailed planning and then executing the plan. Perhaps the best way to explain an astrophotography project is by an example.

For our example, let's assume a location at 38° north latitude in a suburban area with moderate levels of light pollution with a skyglow of magnitude 19 per arcsecond squared. The imaging kit is an Orion ST-80A 80 mm f/5 refractor, a Canon EOS T3/1100D camera with an interval timer and a Celestron 4 SE mount on a wedge. The current time of the year is early summer and we see an image of the galaxy NGC 2403 posted by someone on an internet forum, in an astronomy magazine, etc. The galaxy looks interesting and we decide that we would like to make our own image of it.

Before getting heavily involved in planning we need answers to the following questions:

- Is the galaxy visible at our viewing location?
- When is the optimum time to photograph the galaxy?
- Is our equipment capable of capturing a decent image of NGC 2403?

The literature tells us that NGC 2403 has an apparent magnitude 8.4, an apparent size of 21.4×10.7 arcminutes, and is located in the Constellation Camelopardalis. It is object number 7 in the Caldwell list for small telescopes and is often observed with a pair of binoculars.

At 38° North latitude, Camelopardalis is a circumpolar constellation and is highest in the sky during January and February. For photographing galaxies and nebulae,

the moon is an enemy. A quick check on our nearest neighbor and we determine that the nights of 3 December, 1 January, 30 January, and 28 February have no moon. These nights and three or four nights before and after them will be ideal for imaging NGC 2403. We also note that the highest NGC 2403 rises in the sky is 62.5°; thus, either an alt-azimuth or an equatorial mount is usable. (Please note that the above dates are examples only as the actual dates for nights with no moon change continuously.)

How did we find the above information? Many sources are available. A simple internet search using the object's name is all that is typically needed. Several online sites provide lunar calendars. Planetary computer programs are another source and are very popular with amateur astronomers. Some of the more popular ones such as Stellarium are freeware and are capable of controlling telescope mounts. Books and astronomy magazines are other sources.

Now we need to verify that our equipment can image the galaxy 2403. In other words:

- Is the object bright enough to provide a usable signal to noise ratio with our camera and telescope combination?
- Will the apparent size of the object be too large to fit into the camera's field of view?
- Will the size of the image that we obtain of the object be large enough to show interesting details?

Determining if the surface brightness of an object is sufficient to produce a usable signal to noise ratio is not a straight forward exercise. Here the best guide is experience with your astrophotography equipment and your location that you will develop over time. Many variables have an impact upon the signal to noise ratio; the major ones being the camera and telescope's characteristics, exposure duration, and atmospheric conditions that impact seeing, visibility, and our nemesis light pollution as well.

NGC 2403 is also on the Caldwell List. This list is a compilation of non-Messier Objects that are visible in small telescopes under dark skies. Since NGC 2403 is visible in binoculars and small telescopes, we know that our equipment is capable of photographing it. However our observation location is in an urban area having artificial skyglow estimated at 19 magnitude per sq arcsec; hardly a dark sky.

Objects with a surface brightness three magnitudes dimmer than skyglow can be photographed with some details and contrast but with fainter areas washed out. We know the apparent magnitude of the object as well as its apparent size but do not have its surface brightness. Recall that apparent magnitude is the light from an object concentrated into a point source like a star. Surface brightness is that same light spread evenly over the surface area of the object and is expressed as magnitude per square arcsecond. Since the magnitude measurement is logarithmic, we cannot simply divide the apparent magnitude by the apparent area to get the average surface brightness but use the following equation instead:

$$S = M + 2.5 \times \log_{10}(A)$$

Appendix A

where,

S = surface brightness (magnitude per squared arcsecond)
M = apparent magnitude
A = apparent area (square arcseconds)

Doing the arithmetic, we determine that the surface brightness of the galaxy NGC 2403 is approximately 23 magnitude per sq arcsec. Our estimated skyglow is 19 magnitude per sq arcsec. This tells us that photographing NGC 2403 at our location will be tricky. We will need a dark night with no moon and clean air to reduce the artificial skyglow component. We also need to schedule the imaging session when NGC 2403 is high in the sky.

The next concern is the apparent size of the object. Our telescope, the ST-80A has a focal length of 400 mm and the camera has an APS-C size sensor. From Table 3.3; notice that the field of view for this combination is $3.2° \times 2.1°$ or 190.8×127.2 min. (To convert degrees into minutes multiply the number of degrees by 60.) Recall the apparent size of galaxy NGC 2403 is 21.4×10.7 min. If we divide the apparent height and width of the galaxy by the apparent height and width of the field of view produced by our telescope and camera combination and then express the two ratios obtained as a percentage, we will find that the apparent height and width of the galaxy is 8.4 and 11.2 % respectively of the length and width of the field of view. Since both percentages are less than 100 %, the field of view produced by our telescope and camera combination is sufficient to capture the galaxy's image.

Now determine if the size of the galaxy NGC 2403 in the photograph that is produced is sufficient to show any significant details. Table 3.4 shows that the maximum size of a printed photograph at 300 dots per inch using a 12.0 megapixel camera is 9.4×14.1 in. Assuming that the photograph contains the field of view produced by our camera and telescope combination with no cropping or vignetting, then the resulting size of the actual image of the galaxy in the photograph will be 8.4 % of the photograph's height and 11.2 % of the photograph's width. For a printed photograph at 300 dots per inch, the image of the galaxy will be 0.8 in. high by 1.6 in. wide. A reduction of the image resolution to 150 dots per inch, increases the size of the galaxy in the photograph to 1.6×3.2 in. The actual image size of the galaxy is not very large for either case but it is sufficient to display the nature of the galaxy, spiral arms, and other large features, thus, worth imaging.

Keep in mind that the above process concerning image size is based upon some assumptions that are close but are not exact and upon a specific DSLR sensor size; thus, the results are approximations. However, they are accurate enough to determine if an object will fit in a camera/telescope field of view and provide an approximate size of an object in a printed photograph.

Now we know, our equipment is sufficient to photograph the galaxy NGC2403. We also know that with a little luck with the weather, we can obtain sufficient details to make it worth the effort to image. Now to decide how we want to go about imaging NGC 2403 and what dates we want to do the imaging. One thing to keep

in mind is "the weather." Any plan must consider the weather. Weather is what it is and we cannot rely upon it being what we want when we want.

The first thing to do is to check our social, business, and astrophotography calendars. We have no other objects scheduled to image or any planned business trips during the nights available. However the social calendar shows that we will spend the Christmas and New Year's holidays with relatives who are located in a large urban area. Our planned stay, including travel, is from 20 December through 5 January so we eliminate this time period as possible nights to image the galaxy. This leaves the following nights available to schedule the imaging session:

- 1–6 December
- 28–30 January
- 1–2, 26–28 February
- 1–3 March

We note in our business and social calendars that these nights are scheduled for an astrophotography session.

Since we cannot control the weather, the strategy is to schedule the imaging session on the first available night, 1 December, weather permitting. If the weather does not cooperate, then we will reschedule for the next suitable night, 2 December. If 2 December is not satisfactory, then we reschedule for 3 December, etc. until we successfully image our object. This strategy maximizes our probability of being able to obtain an image of the galaxy. Also put a note in your astrophotography calendar that we need to identify an alternative object to image for January and February to cover the possibility of successfully obtaining an image of NGC 2403 in December.

The last step in our planning process is to identify the equipment that is needed to make the image. This will vary dependent upon the components in the kit being used. However, many accessories are independent of the OTA, mount, camera, etc. Here is a check list of useful accessories to include.

1. Viewing chair
2. Small folding camping table
3. Electricians tape, one roll
4. Screwdriver set
5. Needle nose pliers
6. Allen wrench set
7. Red flashlight
8. White flashlight
9. Spare batteries, red flashlight
10. Spare batteries, white flashlight
11. Spare batteries, interval timer
12. Watch synchronized with GMT
13. Small calendar
14. Binoculars
15. Ground pad

16. Entertainment (radio, CD, grab and go telescope, etc.)
17. Thermos, hot coffee
18. Observing log
19. Mechanical pencil with spare lead
20. Small notebook
21. Star Chart of the night's sky
22. Insect repellant
23. Hand warmer
24. Small towel
25. Compass

Most of the items on the list are self explanatory. The ground pad is used for protection from ground moisture if we have to get down on hands and knees to see the camera's display screen or use its viewfinder. Batteries are difficult to quantify as they are impacted by the duration of the session, their usage and capacity, and the ambient temperature. Rechargeable batteries must be fully charged and regular, non-rechargeable batteries must be fresh.

Planning the actual imaging session is dependent upon the equipment used. This part is covered in Chaps. 5 and 6 for alt-azimuth and equatorial mounts respectively.

Appendix B

Lightweight Mount Tripod Modifications

"My telescope vibrates too much" is a common complaint about many lightweight telescope mounts, including GOTO telescope mounts. "My gotos are not accurate" is another common complaint; this one obviously associated with GOTO mounts only. As far as the mounts themselves go, they are typically innocent bystanders. The tripod is most often the culprit that causes both of these complaints. Fortunately, the cure is easy and cheap to administer and, better still, requires no special tools or skills.

Take a look at the tripod used to support the SkyWatcher SynScan AZ goto mount (see Fig. B.1). The tripod is identical to the one used by Celestron on its SLT mount. Its design is also very similar in concept to the tripods used by iOptron on its Cube E, G, and A series mounts and its SmartEQ mounts, Meade's ETX mounts, and Celestron's SE series mounts. One major complaint on the internet forums about many of these mounts is that they vibrate too much. The Celestron SLT and SkyWatcher SynScan AZ goto mounts receive the most complaints as they are by far one of the most popular and widely used lightweight mounts and tripods.

However, not all of these mounts have vibration issues. The Celestron 4/5 SE mount is exceptionally sturdy and accurate. If we examine the tripods and compare the ones that are "shaky" to the ones that are sturdy, several characteristics related to tripod stability are obvious:

- All the tripods use stainless steel tubular legs. The diameters of the legs vary between 1 and 1.5 in. (25–38 mm). Tripod leg diameter contributes to stability, increasing the size of tripod legs is not a simple or an inexpensive effort and outside the scope of a simple modification. Fortunately, factors other than leg diameter also have an impact upon tripod stability and are easier to correct.

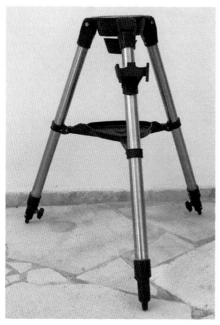 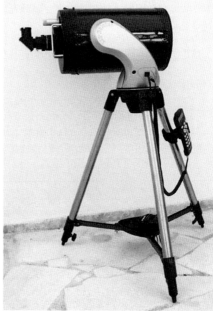

Fig. B.1 SkyWatcher SynScan AZ goto mount tripod

- The sturdy tripods use either hard plastic or metal for their leg sockets and guides while the shaky tripods use soft plastic (see Fig. B.2).
- The legs of the sturdy tripods are either screwed or glued into their leg sockets and guides while the legs of the shaky tripods are held in place by inline rivets (see Fig. B.3).
- The center brace of sturdy tripods is located to inhibit resonances in the tripod legs while the center brace of some shaky tripods is located in a position that allows vibration at twice the resonant frequency of the tripod leg.
- The center brace of sturdy tripods puts tension on the tripod legs while the center brace of shaky tripods simply keep the legs together.

Issues related to using soft plastic materials, inline rivets, and poor leg brace locations are easily mitigated. Mitigated is perhaps the wrong word as vibration and mount movement will remain but at a reduced amplitude and frequency. The lower frequencies and vibration levels provide sufficient stability to use the tripods for very short exposure astrophotography and also improve the viewing experience for visual observing. Only a few hand tools and other materials are needed. Like any modification, there is a risk that the tripod can be damaged so be sure you feel comfortable doing any modification before you proceed and are willing to risk damaging your equipment. In other words, proceed at your own risk. Also, the old saying, "if it ain't broke, don't fix it" applies. All tripods will induce some vibration. If your vibration levels are not excessive, the best bet may be to leave the tripod alone.

Fig. B.2 Tripod leg socket and guide

Fig. B.3 Inline rivets

"Tripod Leg Attachment" Tripods having upper leg sockets made of soft plastic often have poor goto and tracking characteristics. This is caused by tripod flexure. One bolt attaches the upper tripod leg socket to the tripod head and although seemingly tight, typically is loose enough to allow the mount to flex as the mount and telescope rotate in azimuth or right ascension, sort of like a rotating Tower of Pisa (see Fig. B.2). This deflection is very small and is not noticeable to the human eye. However, it does impact goto accuracy and can sometimes be severe enough to prevent successful alignments or to produce "closetos" instead of "gotos." The fix is to tighten the bolt that attaches each upper tripod leg socket to the tripod head. Even if the bolt appears tight, tighten it some more but be careful not to strip the threads of the bolt.

"Inline Rivet Fasteners" If you examine sturdy tripods, you will notice that the upper tripod legs are either screwed or glued with epoxy into the upper leg sockets and lower leg guides. This produces a homogenous connection that has no play that allows wiggle or vibration. The tripods used by many lightweight mounts use two inline rivets to attach the upper tripod leg sockets and leg guides to the upper tripod leg (see Fig. B.3). Close inspection of these joints reveals nothing that should be problematic. The joint appears very tight and the gap between the metal tripod leg and the plastic leg socket is miniscule; essentially invisible. However, this is deceiving as the soft plastic used for the leg socket easily deflects and allows the tripod to move in a torsional motion (a twisting type motion). The fix is to force epoxy in the tiny crack between the soft plastic leg socket using a toothpick, a thin piece of metal such as an artist's pallet knife, or even a plastic shirt collar stay. An alternative to epoxy is cyanoacrylate or "super glue" as it is commonly called. Be sure to get the epoxy or super glue as deep into the crack as possible and also cover the entire circumference of the tripod leg. Once the soft plastic is securely glued to the metal leg it is transformed into a rigid structural member that greatly reduces the torsional movement of the tripod (see Fig. B.4).

"Tripod Leg Spreader" Sturdy tripods use their tripod tray to spread the tripod legs and force a rigid connection between the tripod legs and the tripod head (see Fig. B.5). The spreader is attached to the tripod by a threaded rod with a hand nut that is used to push up on the spreader and place the tripod in tension. This makes a very rigid configuration that is resistant to vibration. Notice that the spreader also serves as an accessory tray and is located not too far beneath the tripod head.

However, some tripods locate the spreader and accessory tray at the midpoint of the upper tripod legs and simply bolt the spreader to the tripod leg. An accessory tray is used to lock the spreader bars in place. This type of spreader's basic function is to keep the legs from spreading too far outward and the tripod from collapsing (see Fig. B.6). The design does not place the tripod in tension to stiffen it. Since this design does not stiffen the tripod, it is very susceptible to vibration and movement. With this design, the most important thing to do is always install the accessory tray and lock it in place. Often, on the internet forums, you will hear of people who put a 5 pound (2.5 kg) sand bag on the accessory tray to stiffen the tripod. This pulls downward on the leg spreader putting the tripod legs in tension. The downside of this intervention is the loss of the use of the accessory tray and the 5 pound bag of sand is just one more thing to have to fool around with.

Fig. B.4 Leg socket with epoxy

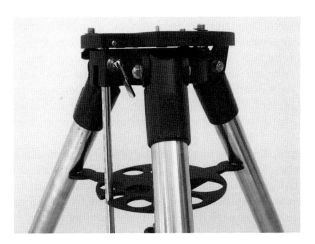

Fig. B.5 Sturdy tripod leg spreader

There are three alterations that can improve upon this poor design. The easiest one is moving the center brace down 4 in. (100 mm). This will prevent the tripod leg from vibration in the second harmonic of its natural frequency. However, the greatest benefit from moving the center brace downward is the angle the tripod legs

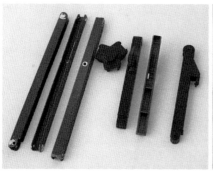 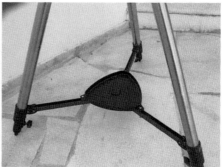

Fig. B.6 New spreader bars

make with the ground becomes steeper. The steeper angle of the tripod legs increases the downward force vector transmitting more of the weight and other forces related to the mount and telescope downward into the earth instead of horizontal as a force vector giving rise to vibration. Moving the center brace down reduces the overall footprint (the distance between the ends of the tripod legs) of the tripod and should be done with caution as the stability of the tripod decreases as the size of its footprint decreases.

The second alternative to reduce leg vibration is more complex. A new set of longer spreader bars can be made of 11 mm aluminum "U Channel" so that the tripod's footprint remains the same when you lower the spreader bar to the bottom of the upper tripod legs (see Fig. B.6). The stock center hinge is retained as is the stock accessory tray. This alternative retains the tripod's foot print; thus, does not have a negative impact upon the tripods stability. The stock spreader bars are 16 cm long (6.25 in.). The bolt holes that attach the spreader bar to the center hinge and the leg hinges are separated by 15 cm (6 in.) center to center. This intervention does little by itself but depends upon the third alternative, bolt the center tray to the spreader bars.

If you replace the spreader bars you will also need to modify the tripod tray. The tripod tray fits on the spreader hinge and is held in place by a friction fit between the tray and the spreader bar (see Fig. B.7). Since the replacement spreader bar will not have the tab necessary for a friction fit, it must be bolted into place. This is done by drilling a small diameter hole in each of the accessory tray's three friction tabs and the spreader bar beneath each one then using a small bolt and wing nut to hold everything in place. This greatly improves the rigidity of the tripod by reducing rotational movement and is the biggest benefit resulting from replacing the spreader bars. Bolting the accessory tray in place is not an option with the original spreader bars as the design has a large open slot directly beneath the friction tab.

The spreader bars are attached to the upper tripod leg with a small screw and nut using a soft plastic leg hinge (see Fig. B.7). Be careful tightening this screw as you can easily pull the nut through the soft plastic leg hinge. Once you are satisfied with the location of the leg hinge on the tripod leg, epoxy or glue the leg hinge in place.

Appendix B

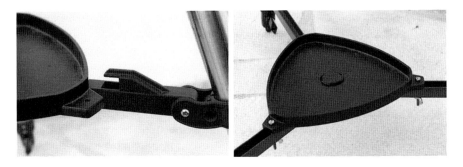

Fig. B.7 Accessory tray friction fit

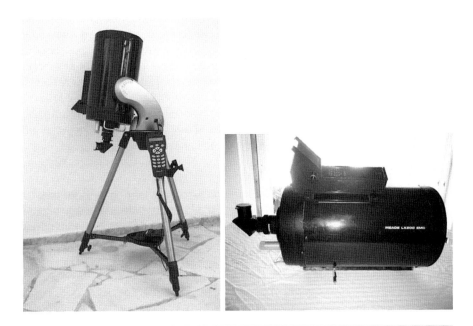

Fig. B.8 Extension legs and determining the balance point

"Tripod Extension Legs" The most effective method to reduce vibration associated with tripod extension legs is not to extend them at all. This puts the telescope close to the ground and invariably the user will be down on hands and knees looking through finders or DSLR camera's view screen or finder. If you do use your extension legs, do not extend them more than about 33 % of their length for a photography session. For visual work, you can extend the legs as much as you want but the greater the extension, the less the stability from a vibration perspective (see Fig. B.8).

"Vibration Dampening" The last improvement involves using the extension legs of the tripod as vibration dampeners. This effort is more complex than the other alterations discussed and few people do it. If you do this modification, it must be done before you epoxy the leg guides to the upper tripod legs. First you must remove the tripod extension legs from the tripod. For some tripods you will need to drill out the two inline rivets that attach the leg guide to the lower end of the upper tripod legs. Once the extension legs are removed, wrap at least the last 4 in. (10 cm) of the upper end of each extension leg with foam tape, the kind used for weather stripping. Make sure that you have the leg guide on the leg before wrapping the leg with tape. Also make sure that the tape is firmly pressed into place on the extension leg.

The tricky part of this alteration is getting the proper thickness of tape on the extension leg. The difference between the radius of the upper leg and the radius of the extension leg of the SLT tripod is 5 mm; almost a fifth of an inch. The foam insulating tape is not that thick; thus, one layer of insulating tape will not fill the gap and dampen vibration. Use multiple layers of duct tape to build up the extension leg to a point where one layer of insulating foam tape fills the gap. The layers of tape wrapped around the extension leg should be enough to make a snug fit when you reinsert the leg into the upper tripod leg but loose enough to not unduly impede movement of the leg as you adjust its length.

While this modification reduces the effective length of the extension legs by 4 in. (10 cm), it can also notably dampen vibration. Four inches is the minimum, more is better. Keep in mind that the length of the taped part of the extension leg is no longer available; thus, the effective length of the extension leg is shortened accordingly.

An unknown factor related to putting foam insulating tape on extension legs is the longevity of the alteration; how long will it be effective? Since the tape will not be exposed to sunlight and weather, the alteration should last several years from that perspective especially if the tripod is not exposed to long periods of very high temperatures or lubricants. Another unknown factor regarding longevity is usage; how well does the tape wear over time? This is unknown but will be dependent upon how often the legs are moved.

"Alteration Priority" Each alteration provides a small incremental improvement. However, by far the three most effective alterations are:

- tightening the bolts that attach the tripod leg sockets to the tripod head
- using epoxy to firmly attach the upper tripod leg sockets and tripod leg guides to the tripod legs
- modifying the extension legs with foam tape

Do the first two alterations if you do nothing else and the third if you want to use your extension legs during an imaging session.

The alterations discussed in this appendix can transform a wiggly tripod into one that is more than acceptable for both viewing and for very short exposure astrophotography. While vibration will still be present, its frequency, magnitude, and duration is significantly reduced.

"Optical Tube Assembly" While not an alteration, the length of an OTA as well as how well it is balanced on its mount play a major role in the stability of lightweight mounts and tripods. A telescope like a Newtonian will tend to be longer than refractor or Cassegrain telescopes typically used on lightweight mounts and tripods. It offers more "sail area" to the wind and a longer moment arm for its mirror; thus, it will be more susceptible to bumps and wind gusts.

Another source of vibration associated with the OTA is the practice by some manufacturers to directly attach a short dovetail to the telescope tube by using two short bolts instead of more expensive tube rings. The telescope tube is made of thin metal that will flex under the load creating a source of vibration. The fix is to remove the dovetail and attach it using tube rings.

"Balance" Regardless of the type of OTA used, a balanced telescope will be more stable than an unbalanced one. Since most lightweight goto mounts are alt-azimuth mounts without free moving altitude or azimuth axes, the traditional method of balancing an OTA on a mount will not work. The telescope's balance point must be determined off the mount.

One simple and widely used method is to remove the OTA from the mount and place it on a level table resting on its dovetail. Place a pencil under and at right angles to the dovetail then move the OTA back and forth until the balance point is found; like is done on a child's see saw (see Fig. B.8). When the balance point is determined, mark the balance point on the telescope's dovetail bar. When you attach the telescope to the mount, the mark on the dovetail showing the balance point should be in the center of the mount's dove tail saddle. Many people put two balance point marks on their dovetails; one for the OTA with their adapters, focal reducers, camera, etc. attached (photography mode) and another with only a diagonal and medium power eyepiece attached (visual mode). A dap of iridescent white fingernail polish makes an excellent mark that is easily seen at night using a red flashlight.

Appendix C

Using a 4 SE Mount with a Wedge in the Equatorial Mode

The Celestron 4 SE telescope mount is a single arm, alt-azimuth mount that has a tripod with a built-in wedge. It is identical to the mount used for the 5 SE telescope. The 4 SE mount with its 1.5 in. (38 mm) stainless steel legs is very rigid and provides a vibration free platform for small telescopes. At first glance, the mount ought to do well as a portable, lightweight, platform for astrophotography when the wedge is used. Unfortunately, this is not the case. However, if some simple modifications are made to the mount, it is capable of unguided exposures between 1 and 2 min duration.

Three major issues exist that must be resolved to obtain unguided exposures between 1 and 2 min with any consistency. These are as follows:

- The wedge on the 4 SE tripod does not have any provisions for a precise polar alignment. For adjustments in latitude, the tripod does have what Celestron calls a "latitude adjustment bar." This bar is graduated in 5° increments. With some care, the wedge can be setup with a 2–3° error in latitude. Close enough for visual work but not for photography. No provisions are provided for adjustments in azimuth other than physically rotating the tripod. Fortunately, the latitude adjustment bar can be modified and with a little luck an adequate azimuth adjustment can be made to obtain a precise polar alignment.
- The 4 SE mount has considerable gear lash and axis wobble. Some of the gear lash is removable by adjusting the drive motors but much will remain. Axis wobble is also adjustable but requires an iterative process over several nights of testing.
- The design of the mount does not allow balancing the OTA while in the equatorial mode. This greatly reduces the payload of the mount when in the equatorial mode.

Fig. C.1 4 SE tripod and wedge

Working around these issues requires modifying or adjusting your mount and most likely will void any warranty that you may have. Do them at your own risk. Keep in mind, anytime a modification or adjustment is done, a possibility does exist that the mount can be damaged or destroyed. Do not do anything to your mount that you do not feel comfortable doing and do nothing that you cannot reverse. If you do elect to open up your mount, keep good notes and take plenty of pictures of electrical connections, etc.

"Precise Polar Alignment" The Celestron NexStar 4 SE mount has a tripod with a built-in wedge allowing the mount to be used in either the azimuth or equatorial mode (see Fig. C.1). Included in the 4 SE mount's hand controller programming is a very nice feature; Celestron's "All Star Polar Alignment" routine. This feature greatly simplifies obtaining a precise polar alignment that is needed for astrophotography. It works even if the celestial pole is not visible. For those not familiar with this method, after a two star equatorial alignment is achieved, a bright star is selected from the hand controller's data base. The 4 SE mount will then slew to that star. The star is then centered in the eyepiece using the hand controller. After that, the telescope will automatically slew to the location in the sky where the star should be if the mount were accurately polar aligned. The mount is then manually moved in azimuth and altitude to center the star in the eyepiece. Manual movement means physically moving the telescope mount in azimuth and adjusting the wedge angle

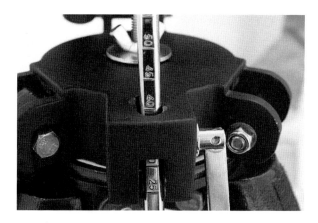

Fig. C.2 Latitude Adjustment bar

for altitude; not using the hand controller to move the telescope. Here lies the Achilles' heel of the NexStar 4 SE mount.

The 4 SE mount does not have the mechanisms needed to make minute adjustments in azimuth or altitude required to obtain a precise polar alignment. Instead, for adjustments in azimuth, the tripod must be actually moved in azimuth. Needless to say, this is difficult to do with any precision. However, after a lot of trial and error, one can achieve a reasonable alignment in azimuth. For the altitude alignment, the tripod has a graduated latitude adjustment bar (see Fig. C.2). To use the bar, the tripod's latitude adjustment bar lock must be released and the wedge manually moved either up or down to center the star. Unlike movements in the azimuth direction where one can move the scope then easily view the results through the eyepiece, viewing through the eyepiece is not easily done when doing altitude adjustments. Centering in altitude is virtually impossible and a matter of luck as you must fight the weight of the telescope and mount as soon as the latitude adjustment bar lock is loosened. Invariably the attempts will destroy the mount's equatorial alignment.

The lack of precision adjustment controls for azimuth and altitude essentially make the "All Star Polar Alignment" programming a questionable feature for the 4 SE mount. This same deficiency also makes doing a traditional drift alignment very difficult to achieve. Fortunately, a substitute latitude adjustment bar that allows controlled adjustments in altitude is simple and cheap to make using only hand tools (see Fig. C.3).

The latitude adjustment bar that comes on the 4 SE mount has a diameter of 10 mm (about 3/8ths an inch) and a length of 240 mm (about 10 in.). The upper end has a 5 mm hole (about 3/16th an inch) for the rod's retaining pin. The latitude adjustment bar is graduated in 5° increments for adjustments between 25° and 85° latitude. The latitude adjustment bar is locked in place with a toggle bolt. Adjustments in latitude are made by releasing the toggle bolt that locks the bar in

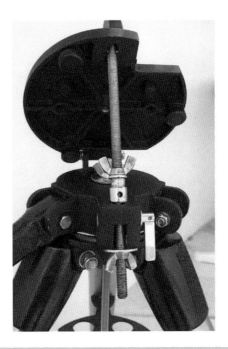

Fig. C.3 Modified latitude adjustment bar

place, and physically moving the wedge up or down. This is impossible to do with any degree of precision, especially when moving the weight of a telescope and mount attached to the wedge.

The modified fine latitude adjustment bar is essentially identical to the stock bar that comes with the telescope except that the bar is threaded. Two wing nuts are on the bar to allow movement of the wedge in a controlled manner and also prevent the mount from falling when the toggle bolt that locks the bar in place is released. To adjust the latitude, the toggle bolt is released and the wing nuts used to control the movement of the latitude adjustment bar up or down. This can be done while actually viewing through the telescope allowing the minute adjustments in altitude needed for a polar alignment.

The modified latitude adjustment bar shown in the photographs was constructed from a 240 mm long 10 mm diameter threaded rod. A metal sleeve was ground with an angle of 25° to guide the bar through the toggle bolt. In retrospect, a round end is better. A nylon sleeve is better than a metal sleeve and will provide a smoother adjustment but will also wear a bit faster. No latitude markings are present on the modified latitude bar so a magnetic protractor, pitch angle indicator is used instead (see Fig. C.4). One nice feature of the modified latitude adjustment bar is that you can easily remove it and restore the mount to its factory configuration. (Note: Even with the factory graduated latitude bar, an angle indicator is required as the precision of the factory markings are at best within 2–3°.)

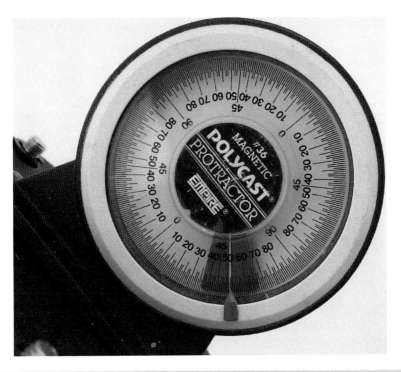

Fig. C.4 Magnetic protractor

Setting the angle of a wedge for an azimuth fork mount is an activity that a substantial percentage of beginners get wrong. When setting a German Equatorial Mount the RA axis is set equal to the latitude of the observing location. When setting the angle of a wedge for an azimuth fork mount, the angle of the wedge is set to 90° minus the latitude of the observing location. This will make the angle of the altitude arm equal to the latitude of the observing location. This correction is built into the index on the stock 4 SE latitude adjustment bar. For it, you enter the latitude on the latitude adjustment bar. When it is set say to 38°, the wedge actually makes an angle of 52°.

Adjustments in azimuth are done by physically moving the tripod. This takes some finesse but with care an accurate alignment in azimuth can be achieved. Other than setting the 4 SE tripod head on another tripod, no simple modification that can be made with the 4 SE mount for azimuth adjustments. However, unlike the latitude adjustment, manually moving the mount in azimuth can produce an accurate alignment after many trials. Two aspects are important. The site where the tripod is located must be level and preferably a smooth hard surface. Making small adjustments on a grass or rough surface is very difficult. If the surface is slopped then error is introduced when you rotate the tripod in azimuth. This is true even if you have adjusted the tripod legs to counter the slope.

Fig. C.5 Upper threaded bar protrusion, retaining washer, and nut

Even with the modified adjustment bar and patience moving the tripod in azimuth, obtaining a precise polar alignment is about as much luck as it is science and skill. Two iterations enhance the accuracy of the alignment. Like any skill, the more you practice, the better you will become at doing it. Practicing polar aligning is a good exercise for the nights of the month when the moon is high and bright. If you align using the All Star Polar Align you will not need to repeat the equatorial alignment afterwards as the program will compensate for the movements in azimuth and altitude made to precisely polar align the mount. Your goto accuracy should not change unless you made some substantial movements in either azimuth or altitude. In that case, do a goto to the first star you used for the equatorial alignment, enter the align menu and select alignment stars. Now replace your first alignment star with itself. Repeat for your second alignment star. Your goto accuracy is now restored. If you now enter the Polar Alignment menu and select stars, the error of your alignment will be displayed.

If portability is not that important to you and you have a spare tripod such as a CG4, EQ3, CG5, etc. you can make a setup that allows you to align in azimuth without moving the tripod. To do this you will need a 10 mm diameter threaded rod that is about 35 cm (14 in.) long. You will also need two 10 mm wing nuts, two regular 10 mm nuts, and four large 10 mm washers about 40 mm outer diameter.

- Remove the center brace from your tripod and substitute the mounting rod with the 10 mm threaded rod. Note: an 11 mm rod is too large. While an 8 or 9 mm rod will work, a 10 mm rod works best. Use the regular nuts to secure the threaded rod but only finger tight for the moment. Put washers in first, one on either side of your tripod head to protect it from the nuts.
- Adjust the length the threaded rod until it protrudes about 7 cm (3 in.) above the tripod head (see Figs. C.5 and C.6). Tighten the two regular bolts.
- Now remove all the legs from the 4 SE tripod, install the modified latitude adjustment bar, and adjust the wedge for your latitude.

Appendix C

Fig. C.6 Lower retaining washer and nut

Fig. C.7 4 SE tripod head on 10 mm threaded rod

- The 4 SE tripod head has a threaded 11 mm hole in its center. Place the 4 SE tripod head on top of your tripod's head with the 10 mm rod protruding through the 11 mm threaded hole in the head of the 4 SE tripod. Install a washer on the threaded rod and tighten in place with a wing nut (see Fig. C.7).
- Install the center tray brace in its normal position and tighten with the second wing nut. To adjust in azimuth, slightly loosen the wing nut on the tripod head. You can now rotate the 4 SE wedge in azimuth. You can improve upon this by using a large sheet of plastic or Teflon to make a bearing surface between the two tripod heads and another smaller bearing surface between the steel washer and the 4 SE tripod head (see Figs. C.7 and C.8).

Fig. C.8 Plastic azimuth bearing

Fig. C.9 Altitude axis and drive motor

"Gear Backlash" The 4 SE mount uses metal spur gears to move the mount in both azimuth and altitude (RA and Dec). The tolerances between the bull and pinion gears are more than adequate for visual work. However, for astrophotography, the back lash created by the large tolerance allows play in the gears and is a source of gear tracking movements in exposures. The SE mount has a feature that adjusts the mount for backlash but does not eliminate the problem. The typical work around for the SE mount is to make the last two movements centering an object or acquiring an object in the eyepiece in the same direction as the mount's last movement in altitude and azimuth. This often is difficult to do (see Fig. C.9).

The motors on the 4 SE mount are held in place with two screws. The mounting holes on the drive motors are rather large providing some room to move the drive motor and adjust the working depth of the pinion gear. The mounting screws are loosened and the drive motor pushed toward the center of the bull gear then tightened while keeping pressure on the motor.

The altitude axis drive motor is easy to access and adjust. However, with a good polar alignment, it is not much of a factor as a source of tracking movement. The same is not true of the azimuth drive motor that is the prime mover of the mount in the equatorial mode and is difficult to access. To make gear adjustments for the azimuth drive requires a substantial disassembly of the altitude arm and azimuth base to access the motor's mounting screws. Unless you are the type that likes to take things apart to see how they tick, adjusting the azimuth pinion and bull gear is something to do if you need to dissemble your mount for some other reason such as a motor replacement, etc. Some clearance is needed for the gears to mesh smoothly and allow for imperfections in the gearing, etc. A thin piece of paper is placed between the bull gear and pinion gear before pushing the two gears together as tight as you can. A Mars Snicker candy bar wrapper is ideal for maintaining the required clearance. After you tighten the drive motor, the paper will be wedged in between the pinion and bull gears. Remove it by using the hand controller to move the axis. The mount will promptly spit out the paper.

"Axis Wobble" The Celestron 4 SE mount does not have any roller or ball bearings for its azimuth or altitude axes but uses a nylon washer and aircraft locking nut as a thrust bearing on one side of the axis and three nylon pads on the other side. If the locking nut is too loose, the axis will wobble and the play will produce star trails in photographs. Also, as the mount crosses the meridian the telescope will flop over ruining several exposures in the process. If the locking nut is too tight, the axis can bind and move in a jerky motion or even worse overload and damage the drive motor. The wobble can be adjusted out of the mount but is something better done by people who are mechanically inclined and understand what they are doing. No photograph is worth destroying your mount to obtain.

To adjust the altitude axis you will first have to remove the hand set from its holder in the altitude arm. Inside the arm is a plastic shroud held in place by three small screws. Remove the shroud and you will see the altitude axis and a self locking nut holding it in place (see Fig. C.9). If your altitude axis has movement, slightly tighten the self locking (aircraft) nut about 1/8th of a turn. Check to see if any wobble still remains by physically grasping the mount's dovetail saddle and trying to wiggle the axis. Next run the mount for one revolution of the bull gear (the large round gear). Listen for any signs of motor strain that is different from what you normally hear. If the wobble still exists and the motor sounds OK, tighten the self locking nut again by the same amount then check to insure the motor is not straining. Repeat this process until the wobble is gone or the motor begins to strain. If you stop because of motor strain, loosen the self locking nut by 1/8th a turn before putting the mount back together.

Access to the azimuth axis is more difficult. First remove the inner shroud on the altitude arm. Next remove the battery cover and battery holder and push some plastic

Fig. C.10 Access to azimuth axis bolt and nut

shrouds out of the way. Now you will have very limited access to the self locking nut for the azimuth axis. Adjust it the same way as the altitude axis was adjusted (see Fig. C.10).

"Altitude Clutch Slippage" Occasionally the altitude clutch comes from the factory not properly set or wears during service. One symptom is that the weight of a camera, etc. will cause the telescope to move even though the mount is not running. The clutch adjustment is simple to do (see Fig. C.11). Remove the telescope from the mount then remove the hand bolt that clamps the telescope's dovetail to the dovetail saddle on the mount. Look inside at the altitude axis. There you will see a self locking nut just like the one on the other side of the altitude axis for the thrust bearing adjustment. Tighten this nut. Generally a half turn is more than enough. If you get the nut too tight, no damage to your mount will result but the clutch will be stiff and not offer the same protection from tube strikes as it could.

"OTA Balance in the Equatorial Mode" One problem with the 4 SE in the equatorial mode is that the OTA cannot be balanced on the mount. This means that the loads on the drive motors vary considerably. In some cases the weight of the OTA, camera, etc. is moved against gravity by the drive motors and in other cases the drive motors act as a break against gravity. In other words, in the equatorial mode the mount works through the bruit force of its drive motors. This is in contrast to the mount in the alt-azimuth mode where the primary force on the drive motors is the inertia of starting or stopping a slew. The impact of this imbalance is considerable. The useful payload of the 4 SE mounts drops from a published load of 10 pounds (4.5 kg) to around 6 pounds (2.7 kg). This has a big impact upon the size and weight of the OTA that can successfully be used with the mount in the equatorial mode for photography. After allowing weight for the camera and other

Fig. C.11 Altitude axis clutch adjustment

accessories, approximately 4.5 pounds (2 kg) are available for the weight of an OTA with dovetail bracket and a finder. This effectively limits the 4 SE mount to OTAs like Orion ST-80A or the SkyWatcher StarTravel 80 80 mm f/5 short tube refractors or the vintage Meade 2045 102 mm SCT. This is not to say that a heavier OTA cannot be used but that it will be more problematic.

Even though the OTA cannot be balanced throughout the movement of the 4 SE mount in the equatorial mode, it can be balanced in the alt-azimuth mode and for some locations in the equatorial mode. You cannot balance the OTA while attached to the 4 SE mount but have to remove it first and find the balance point using the pencil method described in Appendix B.

Index

A

Absorption nebulae, 2
Achromatic, 15, 19, 76, 232, 242, 243, 245, 253–258
ADC. *See* Analog to digital converter (ADC)
Afocal coupling, 46
Airport security, 249
Air transportable, 259–261
Alignment star, 77, 78, 85, 93, 103, 105, 107, 113–115, 117, 308
Alkaline, 259
All Star Polar Align, 113, 114, 117, 218, 225, 228, 304, 305, 308
Alt-azimuth mount, 4, 21, 48, 73, 89–105, 107, 125, 160, 215, 240, 266, 301, 303
Analog to digital converter (ADC), 39, 40
Android, 8, 154–158, 242, 244, 245, 284
Android tablet, 8, 242, 244, 245, 284
Andromeda Galaxy, 129, 264, 270, 271
Aperture, 5, 18, 19, 34–36, 54, 65, 66, 68, 74, 76, 94, 150, 223, 225, 232, 239, 246
Apochromatic, 15, 19, 74, 76, 77, 259
APS-C sensor, 65
Arcminute, 12, 111, 113, 117, 129, 222, 265, 267, 271–274, 280, 287
Arcsecond, 12, 13, 23, 30, 113, 129, 142, 143, 156, 279, 287–289
Artificial sky glow, 8, 30, 31, 56, 90, 107, 134, 138, 139, 141–143, 288, 289
Ascension, 11, 12, 296
Astronomical camera, 42, 157
Astronomical CCD, 41–43, 46, 47, 58, 67, 69, 79, 90, 148, 160, 169, 170, 174
Astronomical unit (AU), 12
Astronomy myth, 89, 90
Astro Trac TT320X AG, 127

B

Back focus, 18–20, 37, 46, 47, 75, 91, 127, 224, 232, 285
Bahtinov mask, 68, 69, 105
Balance, 77, 101, 102, 104, 109, 110, 177–179, 200–203, 216, 231, 241, 301, 312, 313
Bar galaxy, 25, 26
Barn door mount, 127
Battery, 8, 58, 83, 119, 158, 217–224, 241–246, 248, 253–261, 311
Battery life, 83, 158, 260
Bias frame, 60, 84, 86–88, 100, 101, 105, 116, 118, 119, 130, 166, 180, 183, 188, 263
8 Bit, 136, 160, 191, 192, 202–208
16 Bit, 160, 161, 163, 186–188, 191, 192, 194, 206, 207
Black point, 195–199, 208
Bode's Nebula, 264, 277
Broadband filter, 147, 149

C

Calibrate GOTO command, 85, 118
Camera settings, 39, 80, 135
Canada, 239, 240, 248, 250
Carry-on baggage, 108, 240, 244, 246, 249, 251, 253–258
Carry-on luggage, 4, 214, 259
Celestial coordinates, 10–12, 21
Celestial North Pole, 10
Celestial South Pole, 10
Celestial sphere, 10–12, 21, 89
Celestron C5, 76
Celestron CG4, 126
Celestron Prodigy, 218
Celestron SE, 77, 85, 110, 224
Celestron 4 SE, 230, 234, 236, 287, 303, 311
Celestron 4/5 SE, 108, 225–227, 241, 243, 255, 256, 293
Celestron 5 SE, 230
Celestron 6 SE, 4–5, 231
Celestron 8 SE, 231
Celestron SLT, 7, 90, 103, 127, 221, 225–228, 233, 235, 242, 253, 293
Chester Hall, 15
Chromatic aberration, 7, 15, 17–20, 75–77, 125, 232, 234
Color channels, 196–201, 206, 208
Color wheel, 148
Commercial air, 248–259
Commercial airliner, 4, 214, 229, 241
Compression, 39, 46
Computer, 1, 3, 8, 9, 18, 21, 22, 41–43, 50, 58, 67, 69, 80, 90, 92, 98, 109, 125, 126, 128, 131, 136, 151–161, 164, 168, 185, 186, 188, 192, 207, 211, 217–221, 224, 235, 236, 241, 246, 249–251, 253, 255, 257, 259, 261, 284, 288
Constellation, 13, 100, 115, 128, 131, 153–155, 157, 265–270, 272–283, 287
Curves tool, 193–196, 198, 200, 201

D

Dark frame, 37, 38, 58–60, 80, 86–88, 100, 116, 119, 133, 136, 166, 173, 174, 179, 180, 203, 263
Dark noise, 57, 58
Deep Sky Hunter Star Atlas, 153, 154
Deep Sky Illustrated Observing Guide, 153, 154
DeepSky Stacker, 159, 161, 163–189, 192, 193, 203–205, 207, 263

Deep Sky Watch, 153
Deep space, 2–4, 6, 9, 13, 14, 20, 22, 24–30, 33, 35, 40–43, 46, 48, 54, 60, 63, 66, 67, 69, 70, 73–79, 84, 91–93, 98, 99, 103, 107, 108, 110, 123, 125, 127–130, 138, 147, 152–156, 158, 202, 208, 211, 213–215, 219, 221, 232, 235, 237, 240, 276, 284, 285, 287
Deep space object, 2–4, 6, 13, 14, 20, 24–30, 35, 40–42, 46, 48, 54, 60, 63, 66, 69, 70, 73–75, 77–79, 84, 91–93, 98, 99, 103, 107, 108, 110, 125, 127, 138, 152–156, 158, 208, 211, 213–215, 221, 232, 235, 276, 284, 287
Dew shield, 140
Digital single lens reflex (DSLR), 2, 34, 75, 90, 110, 121, 140, 151, 169, 191, 215, 239, 266, 289, 299
 camera, 2–4, 19, 35, 67–69, 90, 157, 179, 242, 243, 245
 camera control, 157–158, 239
Direct pollution, 139
Discount airlines, 250
Drift alignment, 111–113, 305
Dry cell, 259
DSLR. *See* Digital single lens reflex (DSLR)
Dumbell Nebula,
Dust mote, 58, 59, 203

E

Eagle Nebula, 28, 264, 265
Elements, 15, 124, 159, 160, 192, 207–208, 284
Elliptical galaxy, 25–27
Emission nebulae, 27, 28, 71, 147, 148
Equatorial mount, 1, 20, 48, 73, 90, 107–119, 125, 191, 213–237, 240, 284, 288, 307
Europe, 75, 91, 137, 233, 240, 242, 243, 245, 248–250, 254, 256, 258
Exposure efficiency, 54, 55
Exposure time, 17, 34, 73, 90, 107, 128, 142, 173, 193, 214, 266
Eyepiece projection, 46, 47

F

Fanned stack, 53
Field of view, 18–20, 34, 35, 46, 48, 50, 64–67, 84–86, 88, 93, 108, 114, 125, 128–130, 133, 215, 228, 242, 243, 245, 288, 289

Index

Field rotation, 22, 49–54, 73, 78, 84, 86, 93–99, 102, 104, 105, 107, 108, 111, 115, 126, 163, 168, 215, 225, 228, 231, 235, 236
Flat field frame, 37, 38, 59
Flat frame, 58, 59, 86–88, 101, 105, 116, 119, 130, 166, 180
Focal length, 15, 18–20, 34–36, 46, 55, 64–66, 75, 76, 103, 123, 124, 126–129, 132, 169, 228, 229, 234, 246, 289
Focal ratio, 17–20, 35, 36, 44, 46, 54–57, 62, 63, 65, 66, 74–76, 81, 90, 91, 123, 128, 133, 229, 231, 232, 259
Focal reducer, 4, 7, 19, 20, 22, 46, 54–57, 63, 74–77, 91, 94, 101, 110, 216, 225, 229, 232, 233, 266–268, 272, 277, 278, 282, 284, 301
Four thirds mirrorless interchangeable lens camera, 123
Fringe filter, 76
Full frame sensor, 65, 132
Full well capacity, 39, 40, 79

G

Galaxy, 14, 25–28, 30, 33, 49, 64, 129, 142, 143, 193, 264, 265, 270–273, 277, 279–282, 287–290
Galileo, 15
German equatorial mount, 1, 4–7, 21, 48, 62, 84, 109–112, 118, 126, 127, 213–217, 219, 220, 222, 224–225, 228, 232, 234–237, 240, 241, 245, 284, 307
GIMP, 159, 160, 192, 202
Globular cluster, 24, 25, 29, 35
Goto mount, 1–6, 48–50, 73, 74, 77, 84, 86, 89–94, 98, 102, 103, 126, 127, 151, 193, 214–217, 221, 225, 231, 233, 237, 239, 242, 253, 260, 275, 279, 284, 293, 294, 301
Goto telescope, 2–4, 9, 100, 112, 127, 155–157, 237, 293
Gradient, 58, 59, 210
Great Orion Nebula, 264, 275
Gregorian Telescope, 16
Gregory, James, 16
Guillaume Cassegrain,

H

Hand bag, 249, 253–258, 261
Hand controller, 84, 86–88, 91, 93, 102, 104, 105, 109–111, 113, 114, 117, 118, 217–221, 223–225, 242, 243, 245, 304, 305, 311

Hartman mask, 105
High density housing, 5, 138, 247
Histogram, 63–64, 78, 186, 191, 194–200, 204, 206
Horsehead Nebula, 90, 264
Hot pixel, 38, 49, 172, 173, 176, 181, 203

I

IC. *See* Index Catalogs (IC)
Image enhancement, 160, 161, 169, 200–202
Image size, 18, 19, 35, 36, 46, 64–67, 69, 70, 153, 168, 169, 229, 289
Image Stacker, 135, 136
Index Catalogs (IC), 29, 156, 222, 266, 276
Integrated exposure time, 60–62, 81–83, 86, 87, 90, 100, 116, 119, 193, 266–268, 270–283
Intervalometer, 84, 92, 104, 250, 284
Interval timer, 4, 8, 44, 80, 83, 84, 86, 88, 92, 103–105, 118, 158, 233–235, 239, 242, 243, 245, 248, 250, 253–258, 287, 290
iOptron Cube, 7, 108, 109, 111, 113, 127, 216, 219, 220, 225–227, 229, 230
iOptron Cube A, 108, 109, 111, 113, 127, 216, 220
iOptron Cube A mount, 7, 109
iOptron SkyTracker, 127, 217, 221
iOptron SmartEQ, 7, 108, 109, 118, 126, 216, 220, 225–230, 235, 236, 244–246, 257, 258, 260
iOptron SmartEQ PRO, 7, 108, 109, 126, 220, 225–230, 235, 236, 244–246, 257, 258, 260
Iris, 35, 36, 159–161
Irregular galaxy, 28
ISO, 38–40, 44, 58, 59, 62, 78–80, 86, 88, 100, 101, 105, 116, 132–135, 173, 184, 193, 266–283
ISO setting, 38–40, 44, 58, 59, 62, 78, 79, 86, 88, 101, 105, 116, 132–135, 173, 184

L

Lagoon Nebula, 264, 265
Latitude adjustment bar, 109, 110, 228, 236, 303, 305–308
LCD screen, 105
Leightweight alt-azimuth mount, 4, 54, 74, 78, 86, 94, 101, 102, 110, 219, 231
Lenticular Galaxy, 27
Levels tool, 192, 193, 198, 199, 201, 202
Light flux, 143, 144, 149
Light frame, 37, 73, 94, 115, 142, 152, 163, 193, 273

318 Index

Light pollution, 3, 5, 6, 9, 30, 59, 70–71, 90,
 99, 108, 115, 134, 138, 139, 141, 142,
 147–150, 157, 201, 210, 242, 243, 245,
 264, 274, 275, 284, 287, 288
Light pollution reduction filter, 138, 142,
 147–150, 242, 243, 245, 274, 275, 284
Light screen, 71, 139, 140
Light shield, 140
Light trespass, 139
Lightweight
 equatorial mount, 74, 78, 108–110, 115,
 116, 222, 231
 portable mount, 1, 127, 214, 284
Light year (ly), 12, 13, 27, 265–270, 272–283
Line filter, 147, 148
Linux, 135, 154–156, 159
Lippershey, Hans, 14
Lithium, 259, 261
Live view, 43, 44, 67–69, 80, 86, 90, 103, 105,
 117, 123, 129, 133, 150, 156–158,
 253–258
LPRF, 149
ly. *See* Light year (ly)

M
Mac iOS, 155, 158
Mac OS X, 155–157
Magnitude, 5, 21, 24, 29–30, 49, 67, 78, 89,
 104, 114, 139, 141–143, 145–147, 153,
 154, 156, 160, 225, 265, 269–275,
 277–281, 287–289, 300
Maksutov Cassegrain telescope, 7, 16, 18–20,
 37, 55, 56, 74, 75, 91, 231, 234, 284
Maxim DSLR, 159, 160
Meade LS, 127, 217, 223
Memory card, 83, 116, 118, 119, 158
Meridian, 10–12, 87, 98, 110, 113–116, 150,
 263, 264, 311
Messier objects, 24, 28, 29, 85, 99, 115, 150,
 154, 193, 263–270, 273–275, 277, 278,
 280–282, 288
M42 lens adapter, 124
Mount stability, 54, 93, 216, 229
Mount tracking, 49, 91, 93, 100, 105
Movable, 2, 20, 126, 213, 246

N
Narrowband filter, 148
Natural sky glow, 138, 142, 147, 148
Nebulae, 14, 24, 27–30, 35, 71, 74, 81, 83,
 119, 142, 147–150, 155, 157, 235, 274,
 276, 287

Nebulosity, 116, 159, 160, 192
Negative projection, 47
New General Catalog, 29, 283
Newtonian telescope, 16–20, 37, 43, 44, 55,
 75–77, 232
NGC, 25–29, 85, 90, 154, 156, 215, 222,
 265–267, 269, 272, 275, 276, 283,
 287–290
Nickel cadmium (NiCd), 259
Nickel metal hydride (NiMH), 241, 243, 244,
 246, 248, 259, 260
Nightscape, 33, 34, 46, 121–136
NiMH. *See* Nickel metal hydride (NiMH)
Noise, 3, 35, 73, 90, 107, 123, 143, 159, 180,
 191, 229, 288
Noise reduction, 56–60, 80, 133, 136, 209
North America, 91, 124, 129, 137, 139, 240,
 249, 264, 269, 270
North American Nebula, 124, 129, 139, 264,
 269, 270

O
Open cluster, 24, 29, 116, 264, 274
Open Cluster Messier Object 36, 264
Orion AstroView, 126
Orion ST-80A, 7, 76, 233–235, 241–243, 245,
 253, 255, 257, 268, 271, 273, 274, 276,
 280, 281, 283, 284, 287, 313
OTA, 8, 74, 75, 77, 84, 91, 94, 101, 102, 104,
 110, 214, 216–225, 228–236, 241, 245,
 246, 253–258, 269, 290, 301, 303,
 312, 313

P
PaintShop Pro, 159–161
Parsec (pc), 13
Payload, 22, 78, 93, 94, 109, 110,
 214–229, 231, 235, 236, 251,
 253–258, 303, 312
Periodic error, 50, 54, 77, 103, 222, 224,
 228, 229
Photograph, 1, 9, 33, 73, 90, 107, 121,
 138, 151, 208, 214, 240, 263–285,
 287, 303
Photo processing program, 3, 136, 161, 163,
 186–188, 200, 202–211
PhotoShop, 8, 135, 136, 159–161, 188,
 192, 193, 198, 207–208, 210, 211,
 263, 284
Piggyback camera, 45, 122, 127–130
PinWheel Galaxy, 264, 281
PixInsight, 159–161, 192, 208–211

Index

Planetarium program, 154–157
Planetary imager, 41, 42, 44, 46–48
Pleiades, 8, 24, 99, 100, 115, 130, 131, 192, 274, 275
Point and shoot camera, 46, 123
Polar alignment, 7, 48, 54, 78, 84, 85, 109–118, 125, 126, 218, 220, 225, 228, 235, 236, 240, 241, 244, 247, 303–306, 308, 311
Polar scope, 22, 109, 112, 220, 221
Portability, 4, 43, 74, 90, 109, 151, 192, 214, 222, 225, 231, 239, 248, 260, 308
Portable, 1, 2, 4–6, 8, 20, 22, 42, 43, 73, 74, 84, 92, 107–119, 126, 127, 138, 139, 141, 148, 149, 154, 191, 213, 214, 217–223, 225, 231, 239–261, 284, 285, 303
Portable observatory, 8, 214, 239–248, 250, 251, 253–259
Positive projection, 46, 47
Power supplies, 41, 92, 250, 259–261
Prime focus, 20, 35, 44–46, 75, 77, 84, 129
Public transportation, 4, 141, 154, 214, 239

Q

Quantum efficiency (QE), 39

R

Rated payload, 22, 109, 110, 216, 224, 225, 228, 235
Read noise, 57, 58, 79
RedShift, 155
Reflection nebulae, 27, 147, 148, 274
Refractor telescope, 14, 15, 19, 74, 76, 140, 231, 232
Remote shutter cable, 104
Retention rate, 83, 86, 87, 100, 103, 104, 116
RGB histogram, 196, 197
Rosetta Nebula, 76, 85, 124, 128, 129, 234, 264, 283
30/15 Rule, 98
500 Rule, 132, 134

S

Sagittarius Star Cloud, 29, 129, 264, 269
Schmidt Cassegrain telescope, 16–18, 20, 46, 55, 57, 63, 75, 76, 94, 128, 224, 231, 233, 284

Self-guider, 50, 84, 90, 92, 108, 148, 152, 217, 218, 221, 228, 235, 236, 244–246, 251, 253–259
Short tube refractor, 5, 6, 57, 76, 232, 233, 241–243, 245, 246, 248, 253–258, 271, 273–276, 279, 280, 283, 313
Shot noise, 57–59
Signal, 39, 40, 54, 56–63, 70, 74, 78, 79, 81–83, 90, 94, 100, 103, 107, 108, 142–148, 191, 229, 231
Signal to noise ratio, 3, 54–58, 60–63, 73, 74, 78, 81–83, 86, 90, 91, 93, 107, 115, 145, 189, 191, 229, 232, 233, 288
Silver Coin Galaxy, 264, 272
Sky glow, 8, 30–31, 56, 57, 59, 70, 71, 90, 99, 107, 133–135, 138, 139, 141–150, 164, 287–289
Sky-Map.org, 153
SkySafari, 155, 156
SkyWatcher AllView Multifunction, 127
SkyWatcher EQ3, 6, 7, 49, 75–77, 90, 91, 94, 103, 105, 113, 114, 126, 127, 193, 215–217, 221–222, 224–228, 230, 233, 241–243, 245, 254, 256, 258, 260, 264, 269, 272, 275, 277–280, 282, 284, 293, 294, 313
SkyWatcher Explorer 130PDS, 75–77
SkyWatcher StarTravel 80, 76, 233, 241–243, 245, 258, 313
SkyWatcher SynScan AZ GOTO mount, 6, 49, 90, 94, 103, 127, 193, 225, 233, 260, 275, 279, 293, 294
The SkyX, 100, 155, 157
Solar system, 14, 22–24, 33–35, 75, 78, 155–157, 217, 218, 220, 225
Solar system objects, 22–24, 34, 75, 78, 156
Spiral galaxy, 25, 27, 277, 279, 281, 289
Stacking, 3, 37, 38, 53, 54, 58, 60–62, 73, 79, 81, 82, 88, 94, 99, 104, 105, 134, 136, 145, 148, 151, 152, 159–161, 163–167, 169, 170, 172–174, 177, 179, 180, 182–186, 188, 192, 203, 204, 207, 215
Star Atlas, 153, 154
Star circles, 34, 131, 134–136
StarMap, 155, 156
Stars, 2, 10, 34, 74, 89, 107, 121, 138, 153, 163, 193, 215, 239, 264, 288, 304
StarStaX, 135, 136
StarTools, 159–161, 192, 208–211

StarTracer, 136
StarTrails, 135, 136
Stellarium, 100, 155–157, 288
Stellar magnitude, 29
Stray light, 125, 139–141, 145
Stretching, 79, 188, 192–200, 203, 206–209, 265

T
Tonight's Sky, 100, 152–154
Transit, 154, 264
Travel kit, 4
Triangulum Galaxy, 264, 273
Trifid Nebula, 264, 267
T ring, 36, 37, 90, 91, 110, 117, 124, 232 235, 248, 253–258
T ring adapter, 36, 37, 90, 91, 110, 232
Tripod, 1, 20, 34, 73, 90, 109, 121, 213, 239, 275, 293, 303

U
Ultra high contrast filter (UHC), 148
United States, 5, 75, 77, 137, 225, 239, 240, 248, 253, 255, 257, 259
Universal time, 77, 85, 102, 117
Urban dweller, 137, 138, 235, 236, 247
Urban observer, 99, 115
USA, 7, 76, 216, 217, 233, 249, 250

V
Very short exposures, 1, 3, 4, 6, 20, 34, 35, 40, 44, 48, 50, 53–56, 60, 62–64, 70, 73–88, 90, 92, 93, 107, 108, 116, 126, 148–153, 158, 160, 171, 172, 174, 180, 191–211, 214, 216, 217, 225, 229, 231–233, 235, 236, 241, 244, 263, 276, 294, 300
Video astronomy, 35, 67
Vignetting, 38, 58, 59, 64, 125, 203, 210, 232, 289
Visual back, 37, 38, 70, 77, 91
Vixen GP2 Photo Guider, 126, 127
Vixen Polarie Star Tracker, 127

W
Web camera, 34, 35, 41, 42, 44, 46–48, 67, 69
Wedge, 5, 7, 20, 48, 50, 109–113, 117, 118, 126, 209–313
Wet cell, 259
Whirlpool Galaxy, 264, 274, 280
White point, 40, 135, 198, 200
Windows, 100, 131, 139, 154–157, 168, 170, 179, 181, 186–188, 193, 204, 235, 236, 240, 284
World Health Organization, 5, 137, 240

Z
Zenith, 12, 21, 52, 78, 98, 100, 103, 105, 108, 115, 228